Renaissance Intarsia

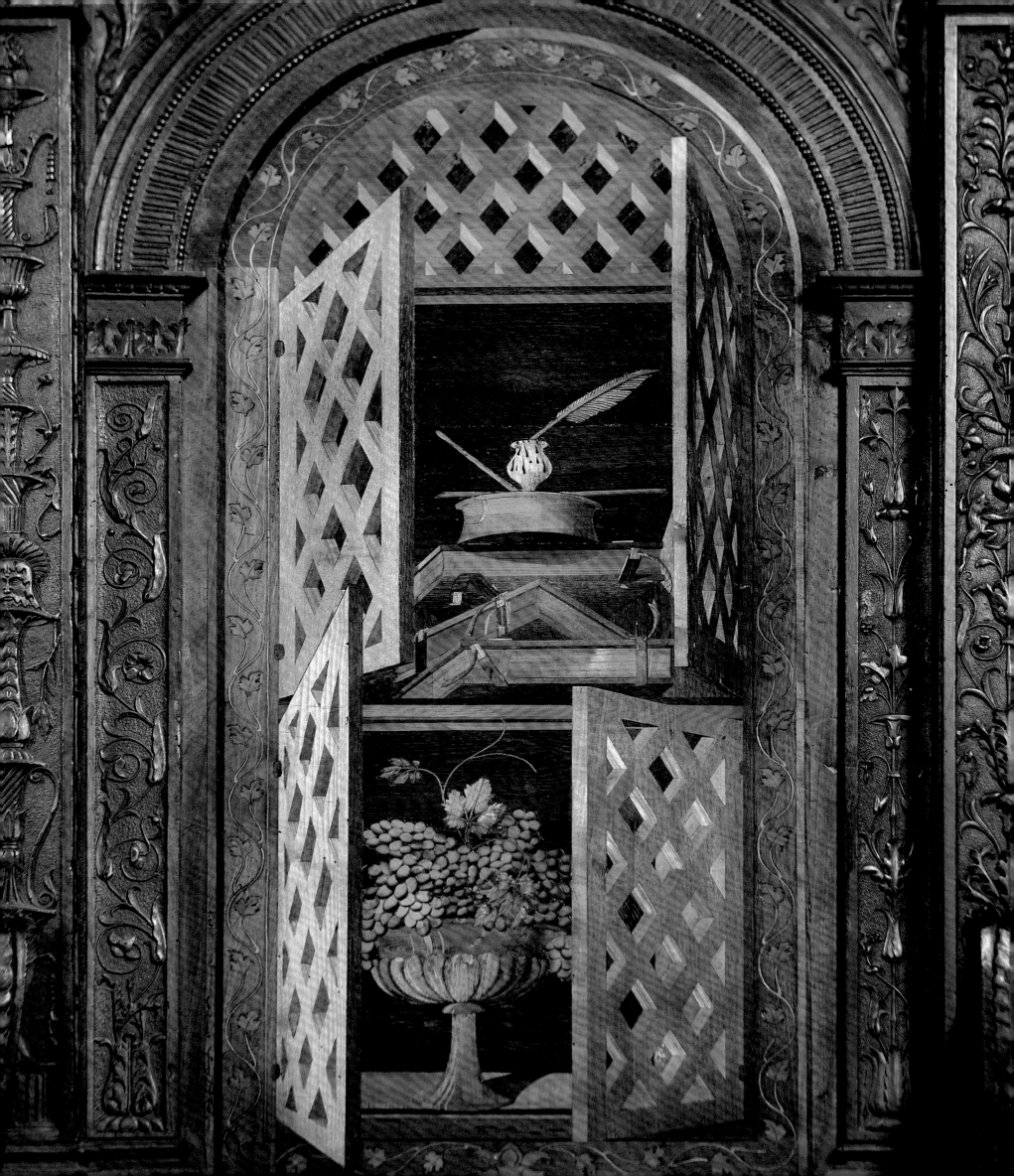

RENAISSANCE INTARSIA

Masterpieces of Wood Inlay

EDITED BY LUCA TREVISAN

PHOTOGRAPHY BY LUCA SASSI

Translated
from the Italian
by Marguerite Shore

Abbeville Press Publishers

NEW YORK LONDON

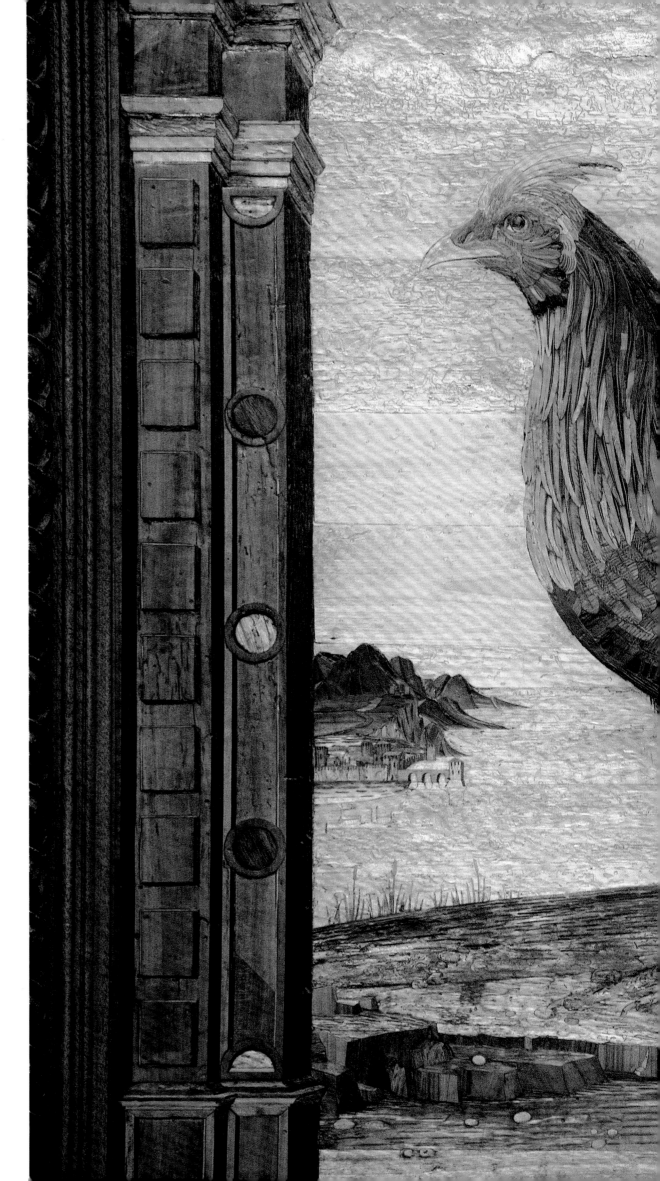

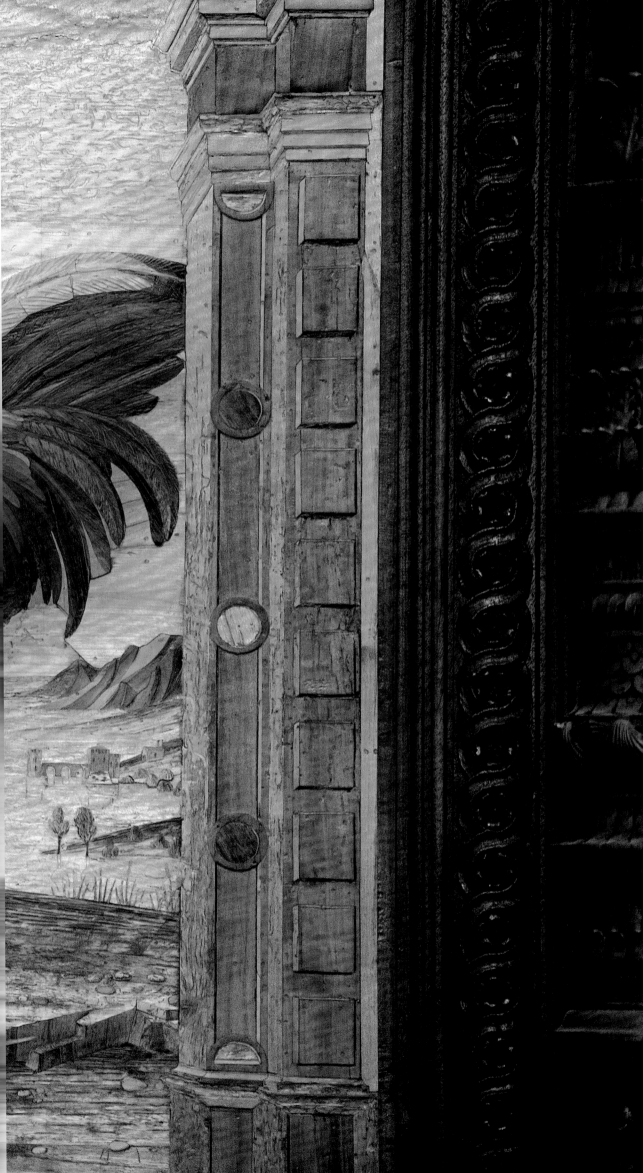

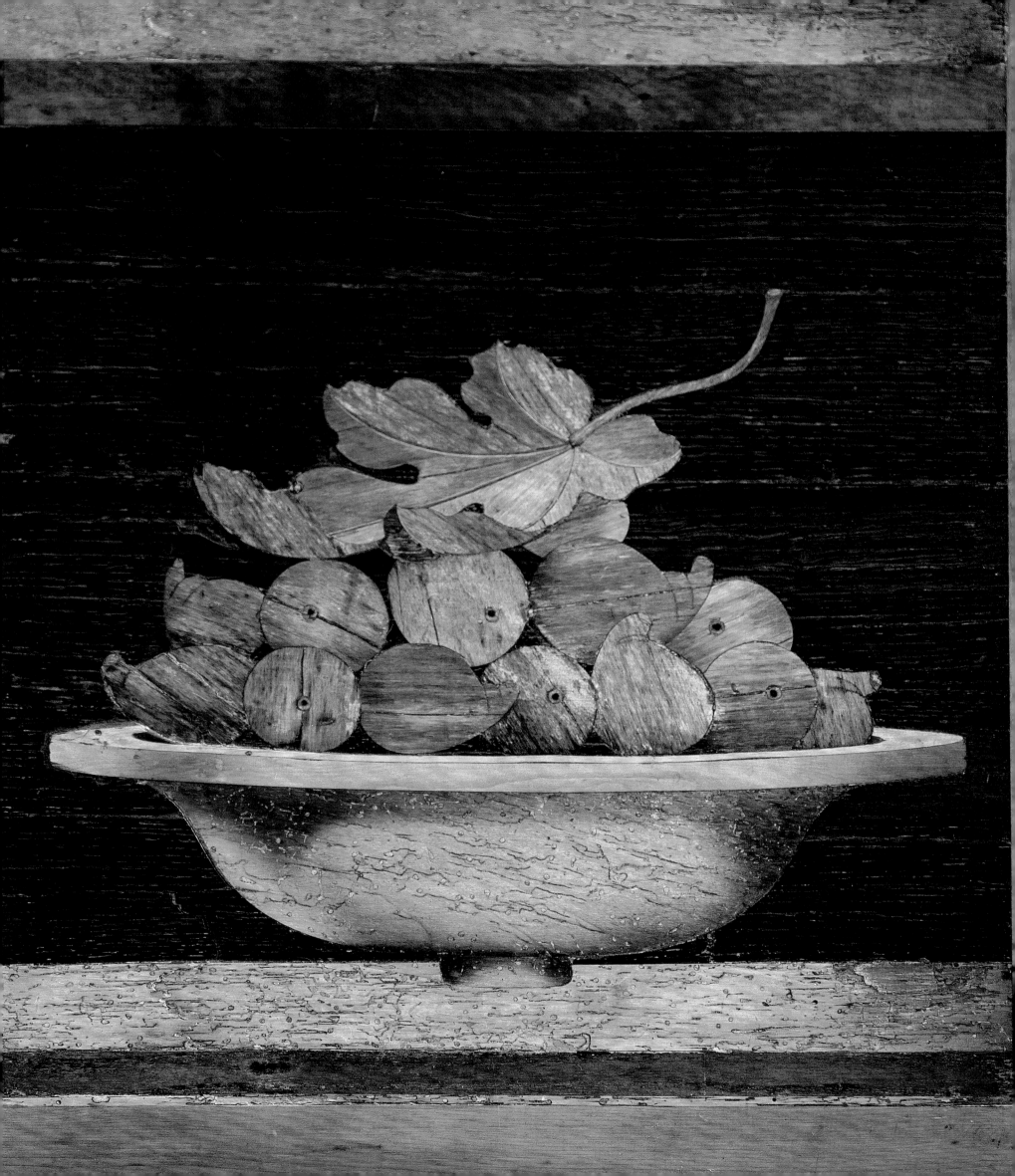

Contents

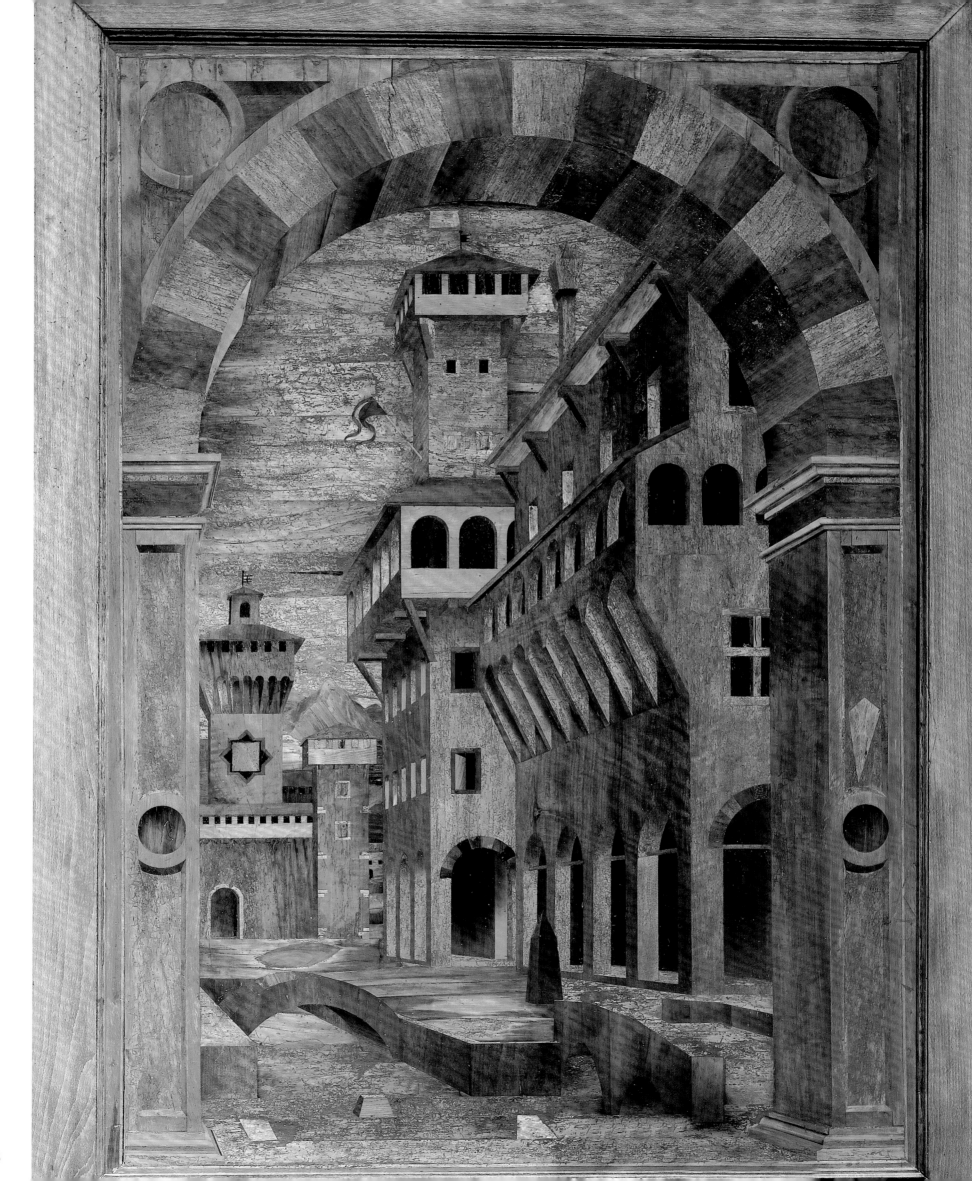

FOREWORD

By Loredana Olivato
Professor of Art History
University of Verona

The discovery of perspec... h-
century Florence was one... nt
intellectual and artistic exp... s-
sance. While depictions of f... ɡs
and attempts to structure p... re
not new in the history of... s-
chi's scientific approach t... e-
dimensionality, relying on... ıe
use of optical instruments,... ɔ-
pealing to the artists and ir... e.
It is well known, for exam... 's
Trinity in Santa Maria Nov... :e
articulated by the painter, ... h
the figures are arranged, ... y
discussions about the repr... :-
tive by means of the princi... a
Alberti would soon system... y
successful treatise *De pictur*... a
Forli's foreshortenings in ... d
the perspectival views of F... —
who was, moreover, the au... *a*
pingendi (plate 7)—attest t... ɔf
the new method among pa... d
not remain unknown to scu... e
seen in Donatello's applica... e
stiacciato, or flattened, tech... d
Padua (plate 9), in which the... t
convergence of lines on a va... d
him to suggest spatial deptl...

Within the revitalized c... e
era, the city emerged as a fc... ı
is reflected not only in the... l
entrusted to the expertise o... -
who were identified ever n... s
of a new society, and ever le... -
cal" (or artisanal) concepti... t
also in painters' representa... -
vironment, regularized acco... 7
mastered precepts of persp... -
ization of the "constructed"... -
called *Ideal City* at Urbino is...

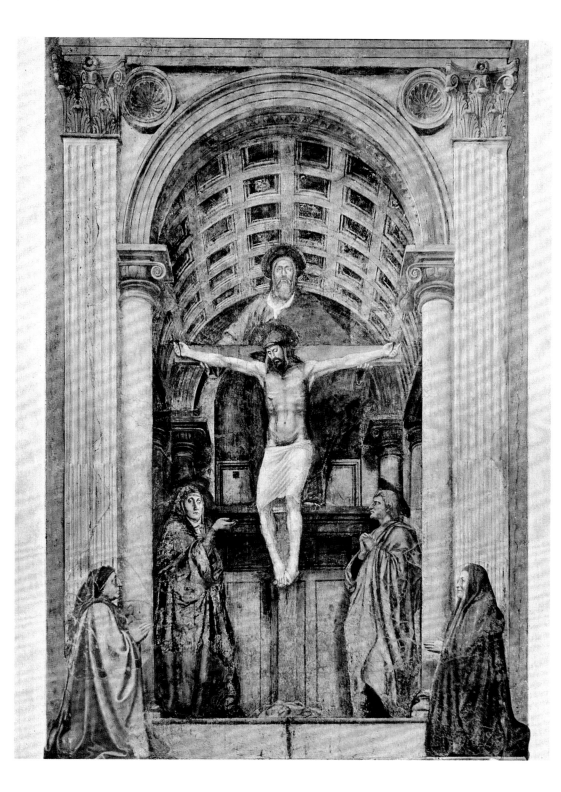

OPPOSITE PAGE
4. Pier Antonio degli Abati, c. 1430–1504
Urban View
Museo Diocesano, Padua

ABOVE
5. Masaccio, 1401–1428
Trinity, 1426–28
Santa Maria Novella, Florence

9

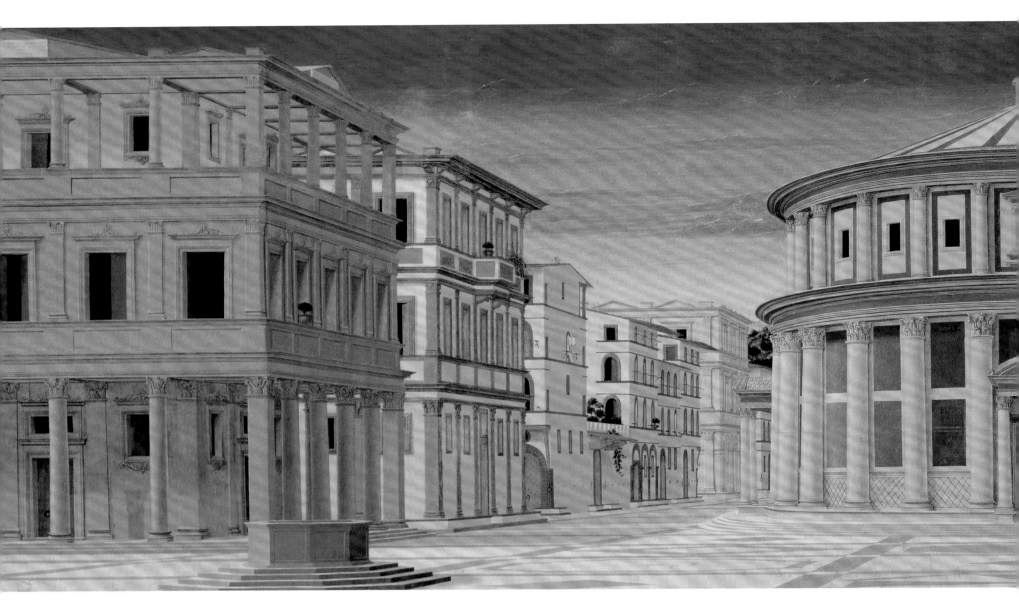

But it was in a new art form—namely, wood intarsia—that the interest in the representation of the city, through enchanted piazzas and elusive streets, seemed to find particular success. From about the 1430s until the mid-sixteenth century, a great many church choirs throughout Italy, as well as some splendid *studioli*, or private studies, were decorated with intarsiated panels depicting collections of implements, which, at least in the former context, were intended to signify the values of religious meditation, rather than the principles of ethics shared by the enlightened humanists of the time. Often these spaces were also adorned with wonderful city views that illustrate the innovations of Renaissance architecture, bolstered by the authority of other structural details of a clearly medieval flavor.

The handsome volume that these lines serve to introduce retraces a fascinating journey—the history of Italian Renaissance intarsia—through an examination of the context in which some of the principal intarsia cycles were created, and an interpretation of their style and iconography.

Edited by Luca Trevisan, whose introduction skillfully frames the subject at hand, this book is divided chronologically into three parts, together comprising eleven chapters by various authors, and concludes with an appendix on the techniques of intarsia. These texts are illustrated by a valuable selection of photographs that help to restore an appropriate dignity to a medium that enjoyed great success in the fifteenth and sixteenth centuries, but which has not received equal critical acclaim, often being studied, unfairly, as an episode of craft whose development was bound to that of its major sister arts. One need only leaf through these pages to understand that, on the contrary, *legni tinti*, or "tinted woods"—as intarsia was called by Giorgio Vasari, who always recognized its value—occupy a by-no-means marginal chapter in the history of art.

FAR LEFT
7. Piero della Francesca, c. 1410–1492
Views of a Foreshortened Head, from *De prospectiva pingendi* (facsimile), before 1482
Biblioteca Ambrosiana, Milan

NEAR LEFT
8. Leon Battista Alberti, 1404–1472
De pictura, Lucca codex, ms. 1448,
c. 23r (facsimile), dated February 13, 1518
Biblioteca Governativa, Lucca

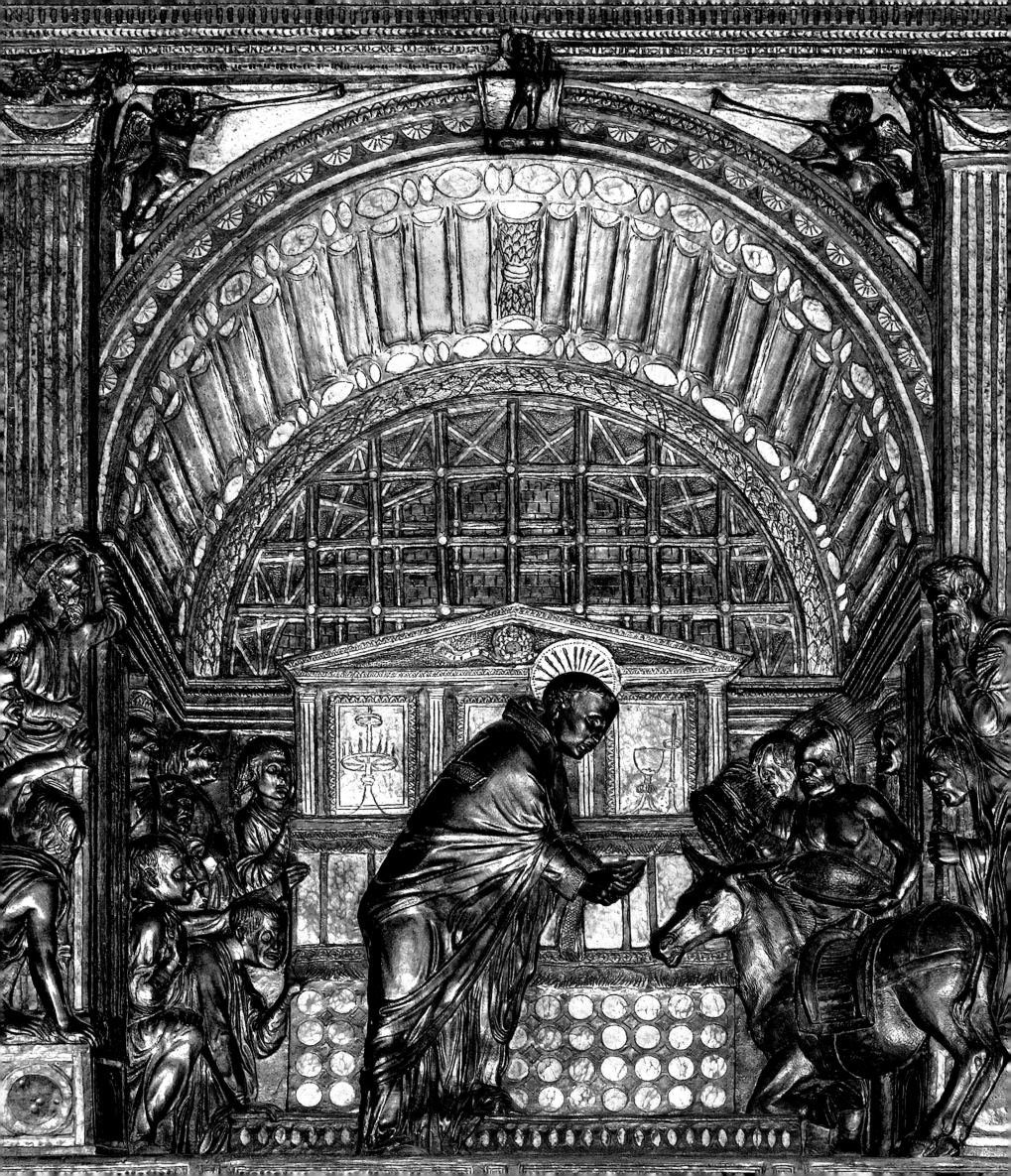

uca Trevisan

Among the arts that flouris[...]
aissance, that of wood inta[...]
paratively little critical att[...]n
we trace the course of its [...]e
Quattrocento (when it was [...]o
the Italian peninsula) and th[...]
dium takes on an undeniab[...]
ing—in spite of the regiona[...]n
certain intarsia cycles—a s[...]

Intarsia is neither sculpt[...],
perhaps, *pittura di legno*, [...]"
Pier Luigi Bagatin's appr[...]a
paraphrase of Giorgio Vas[...]
or "tinted wood"), nor, in [...].
Or perhaps, on second thou[...]s
together. Composed on a t[...]e
and according to chromatic[...]l
tested in painting, intarsi[...]e
based on material that is c[...]l
thus "sculpted," and it rea[...]
inherent potential in the re[...].
dimensional objects, namel[...].
lated into meticulously pr[...]
perspectives.

As Massimo Ferretti note[...]
of perspectival intarsia take[...]
of about one century; and t[...]
steadfast consistency betwe[...]
tion and geometric structure[...]
duration."[2] We are dealing [...]
of necessity, finds expressio[...]
of an encounter between dis[...]
timately fell to the intarsist [...]
orchestrate his inlays, he usu[...]
the painter who furnished h[...]
cartoons. Intarsia often had [...]
with architecture as well, v[...]
visible in the work of the Can[...]
Antonio degli Abati.

It is now unanimously ag[...]
opment of Italian intarsia beg[...]

tion of the choir of the Orvieto cathedral, which around the middle of the fourteenth century was entrusted to the master builder Vanni di Tura dell'Ammanato and a small team of Sienese intarsists who used "cartoons of notable quality." The elegance of these designs would seem to be confirmed by a large scene depicting the Coronation of the Virgin, today in Orvieto's Museo dell'Opera del Duomo, the sole remnant of a more complex decorative scheme. At that time, in fact, most such commissions went to Sienese craftsmen, who entered into contracts for the intarsias of the choirs in the Fiesole cathedral and in the duomo and the church of Santa Croce in Florence (the latter being definitely assignable to Francesco da Siena), all of which have been lost. Likewise no longer extant is the work executed by Nicolò dei Cori for the duomo in Siena, although his contribution to the chapel of the Palazzo Pubblico in the same city had a more fortunate fate and still survives.[3]

The genre's destiny was interwoven with the progressive development of perspective in Florence, where Filippo Brunelleschi and Leon Battista Alberti applied this modern technique to architecture, as Donatello did to sculpture. Intarsists were strongly influenced by the literature on perspective and its subsequent practical development in painting: beginning in the 1430s, the Florentine workshops turned toward the depiction of geometric solids or perspectival views, which would serve as the basis of a fully evolved art form, elaborated in panels of extreme skill.[4] To this context belong the highly effective and exquisitely executed intarsias on the side walls of the Sacrestia delle Messe in the duomo, commissioned from Antonio Manetti and Agnolo di Lazzaro in 1436.[5] The end walls of the same sacristy would be decorated with further intarsias in the 1460s, by Benedetto and Giuliano da Maiano. Before leaving Florence, the latter brother—who would also work on the choirs of the Pisa and Perugia cathedrals—

OPPOSITE PAGE
9. Donatello, c. 1386–1466
Miracle of the Mule (detail), 1446–53
Basilica del Santo, Padua; high altar

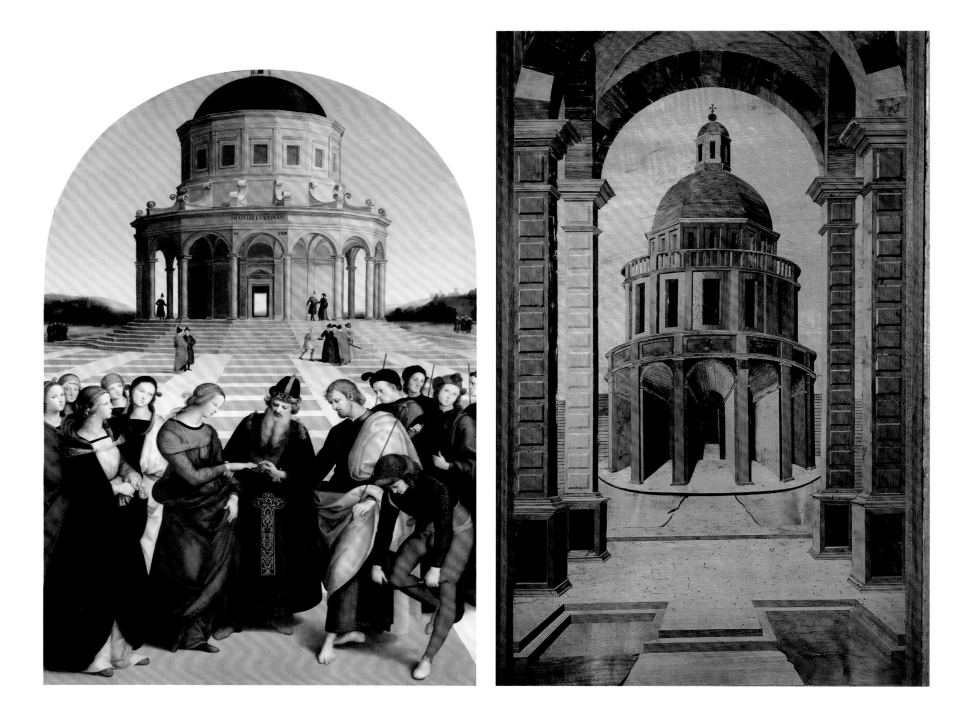

ABOVE LEFT
10. Raphael, 1483–1520
The Marriage of the Virgin, 1504
Pinacoteca di Brera, Milan

ABOVE RIGHT
11. Fra Giovanni da Verona,
1457/58–1525
*Urban View with Circular
Tempietto*, 1506–10
Sant'Anna dei Lombardi, Naples;
Oratory of San Carlo Borromeo

collaborated with the intarsist Il Francione (Francesco di Giovanni) on the figures of Dante and Petrarch, based on cartoons by Botticelli or Filippino Lippi, for the doors of the audience chamber in the Palazzo della Signoria.[6]

Soon enough, intarsia, which in the fifteenth century was usually applied in ecclesiastic settings, being the preferred means of decorating choir stalls, also found success in the private sphere, in studioli, or private studies. If the choir was a place of religious meditation and prayer, the studiolo was intended for contemplation of a cultural kind, by the wealthy humanist devoted to his studies, to literature, and to intellectual reflection.[7] Thus it is not surprising that we find a similar array of implements depicted on both the backs of choir stalls and the cabinets or wainscoting of studioli. These are symbols of the transience of life, glimpsed through the half-open shutters of illusionistic niches: stacked or open books, scientific instruments, allegorical arms, etc. Perhaps the finest, and best-known, examples of the secular application of intarsia are the two studioli of Federico da Montefeltro: that in the Palazzo Ducale in Urbino (plates 12, 14, and 15), executed between 1474 and 1476, perhaps again by the da Maiano brothers (the attribution to Baccio Pontelli now having been rejected) from drawings by Botticelli, and that formerly in the palace in Gubbio, and now in the Metropolitan Museum of Art in New York (plate 13).[8] Here we should also mention, because of its refinement and similar overall

treatment, the later work̶ ̶olo
Mola in the Grotta of Isab̶ ̶9

The further disseminat̶i ̶ed
context may be illustrate̶ ̶ne
workshop in particular, ̶ ̶he
northern part of the penir̶ ̶m
assembled by the brothers̶ ̶zo
Canozi, originally from th̶ ̶in
the Polesine region (now ̶ ̶n-
trusted with important c̶ ̶le
cities. These two artists' i̶ ̶ct
a direct knowledge of the̶ ̶la
Francesca, in which figure̶ ̶t-
ric presence are inserted i̶ ̶ıs
perspectival settings, as w̶ ̶rt
to engage with the proto̶ ̶c-
ture of the time. Unlike oth̶ ̶ıe
Canozi oversaw their own̶ ̶s,
demonstrating that they w̶ ̶ıe
practice of painting and acc̶ ̶ıt
perspectival techniques. Fr̶ ̶y
worked together in Padua,̶ ̶r
engaged them to create a ch̶ ̶)
for the Basilica del Santo,̶ ̶d
also later decorate the doo̶ ̶ı-
net in the adjoining sacrist̶ ̶10
They began working separ̶ ̶o
was active in Venice, whe̶ ̶-
pletion the intarsias in the̶ ̶,
while Cristoforo moved b̶ ̶s
of Parma and Modena, whe̶ ̶o
was also involved.[11]

Pier Antonio degli Abat̶ ̶-
renzo Canozi who worked̶ ̶)
brothers, created his fines̶ ̶-
1480s, in the choirs of Mon̶ ̶ı
Bartolomeo, and Santa Cor̶ ̶
completing those three pro̶ ̶-
haps be compared to Bar̶ ̶
paintings of the same period̶ ̶l
on, at the end of the decade̶ ̶
executed intarsia work in t̶ ̶
and the church of San Gio̶ ̶
the latter, he also tried his̶ ̶
a discipline for which he h̶ ̶
interest, which was most ̶ ̶
his encounter with Lorenz̶ ̶

his stay in Vicenza.[12] Finally, in the same period, Giovanni Maria Platina, one of the Canozi's best pupils, was active in Cremona, where he intarsiated a splendid reliquary cabinet (1477–80) and the choir stalls (1483–90) in the duomo.[13]

Between the end of the fifteenth and the beginning of the sixteenth century, perspectival intarsia seems to have become more firmly established, with the bold spatial treatment of solids (objects and implements of various types, duly represented in the finest detail) and the crystalline definition of city views reaching new lyrical heights. The greatest interpreter of this intensified interest

12. Studiolo of Federico da Montefeltro, Palazzo Ducale, Urbino.

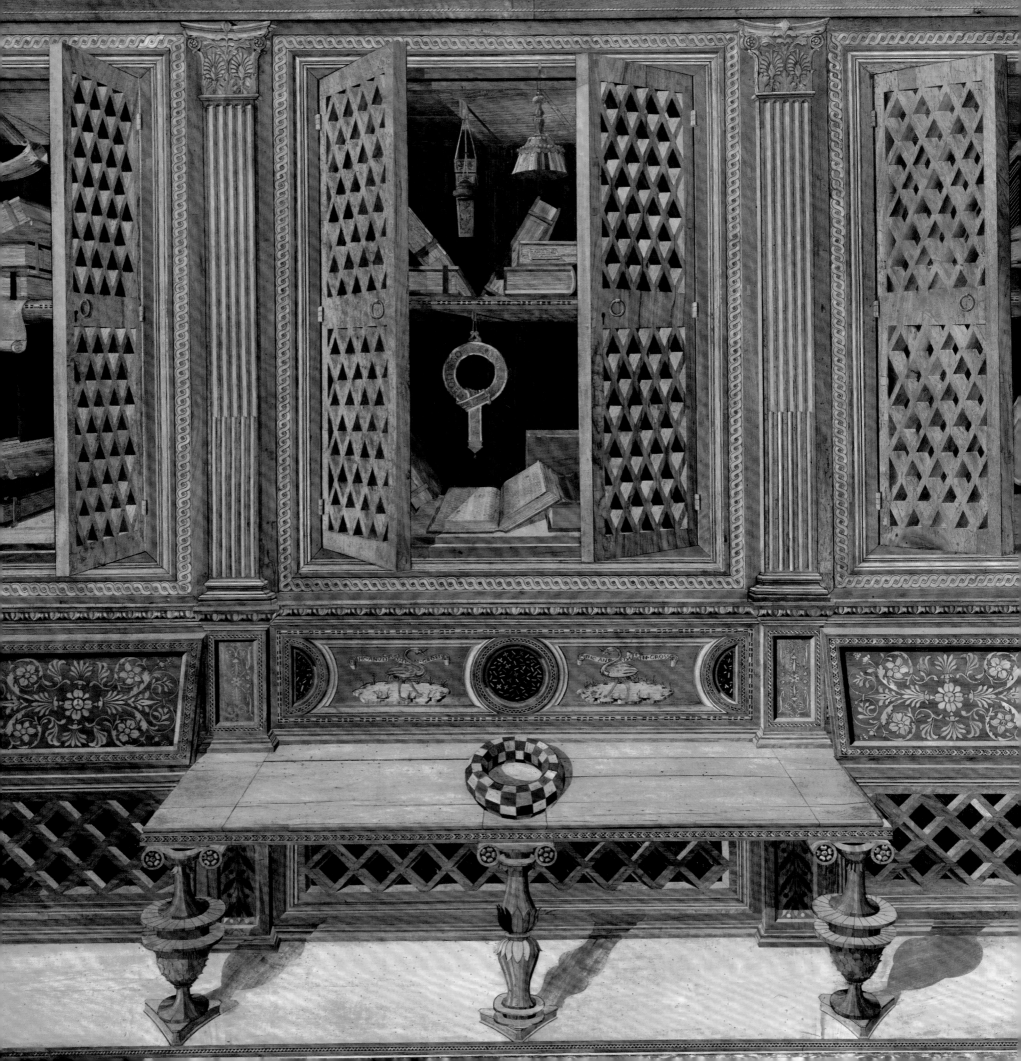

OPPOSITE PAGE
13. Giuliano da Maiano, 1432–1490
Trompe-l'oeil Bench with Mazzocchio
and *Cabinet with Order of the Garter,
Books, Inkstand, Container for Quill
Pens, and Brush*, 1478–82
The Metropolitan Museum of Art,
New York; Studiolo of Federico da
Montefeltro, formerly in the Palazzo
Ducale, Gubbio (panel 7)

THIS PAGE
14. Benedetto da Maiano, 1442–1497
Cage with Birds, 1474–76
Studiolo of Federico da Montefeltro,
Palazzo Ducale, Urbino; detail of one
of the two doors

PAGES 18–19
15. Benedetto da Maiano, 1442–1497
Musical Instruments (detail), 1474–76
Studiolo of Federico da Montefeltro,
Palazzo Ducale, Urbino

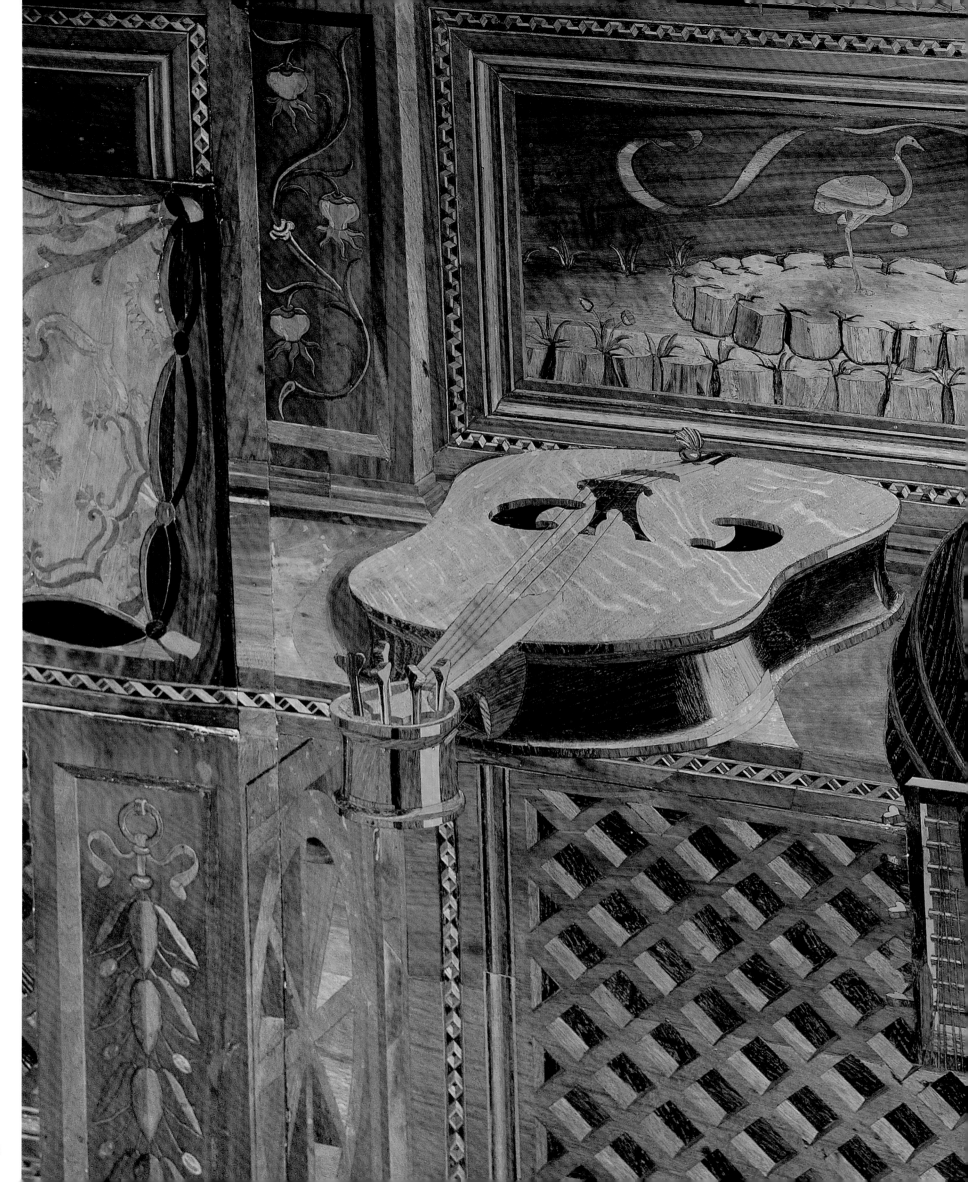

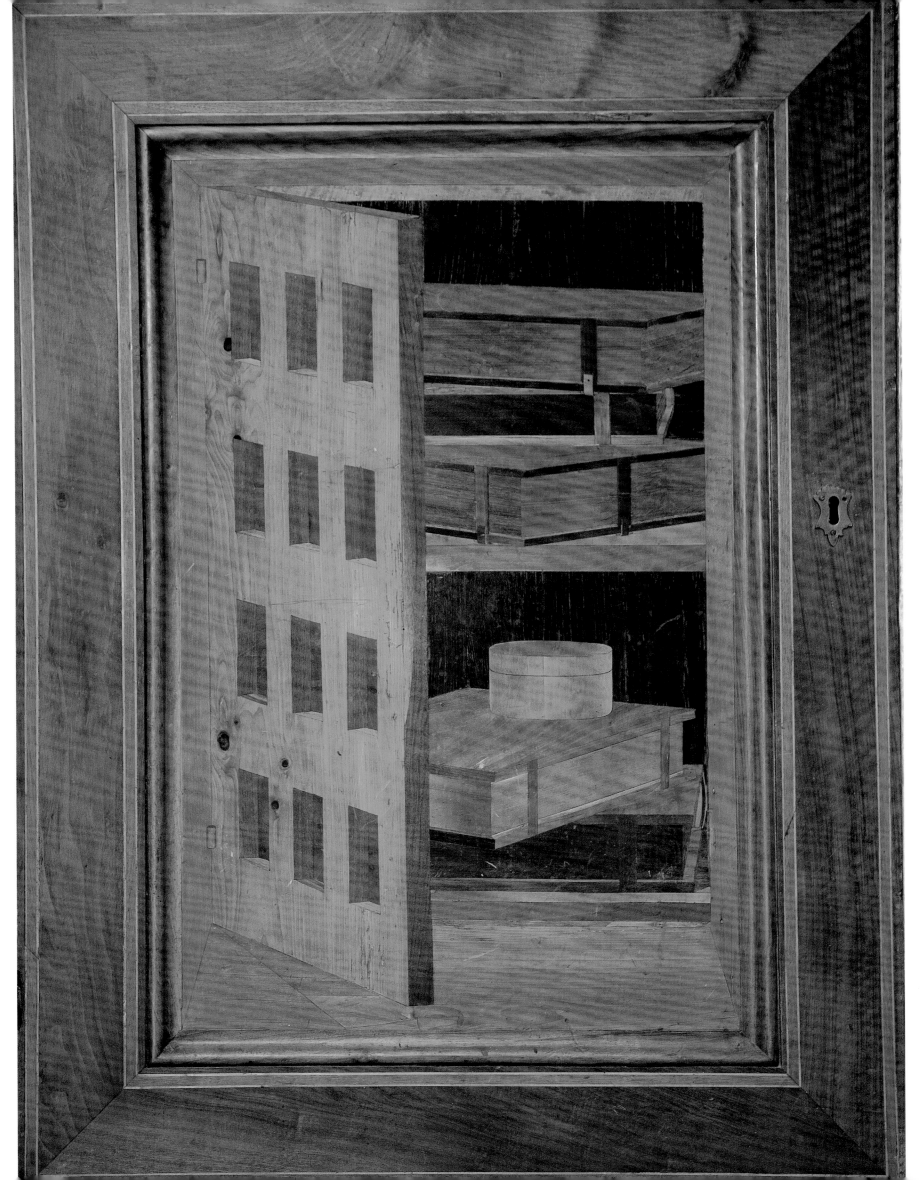

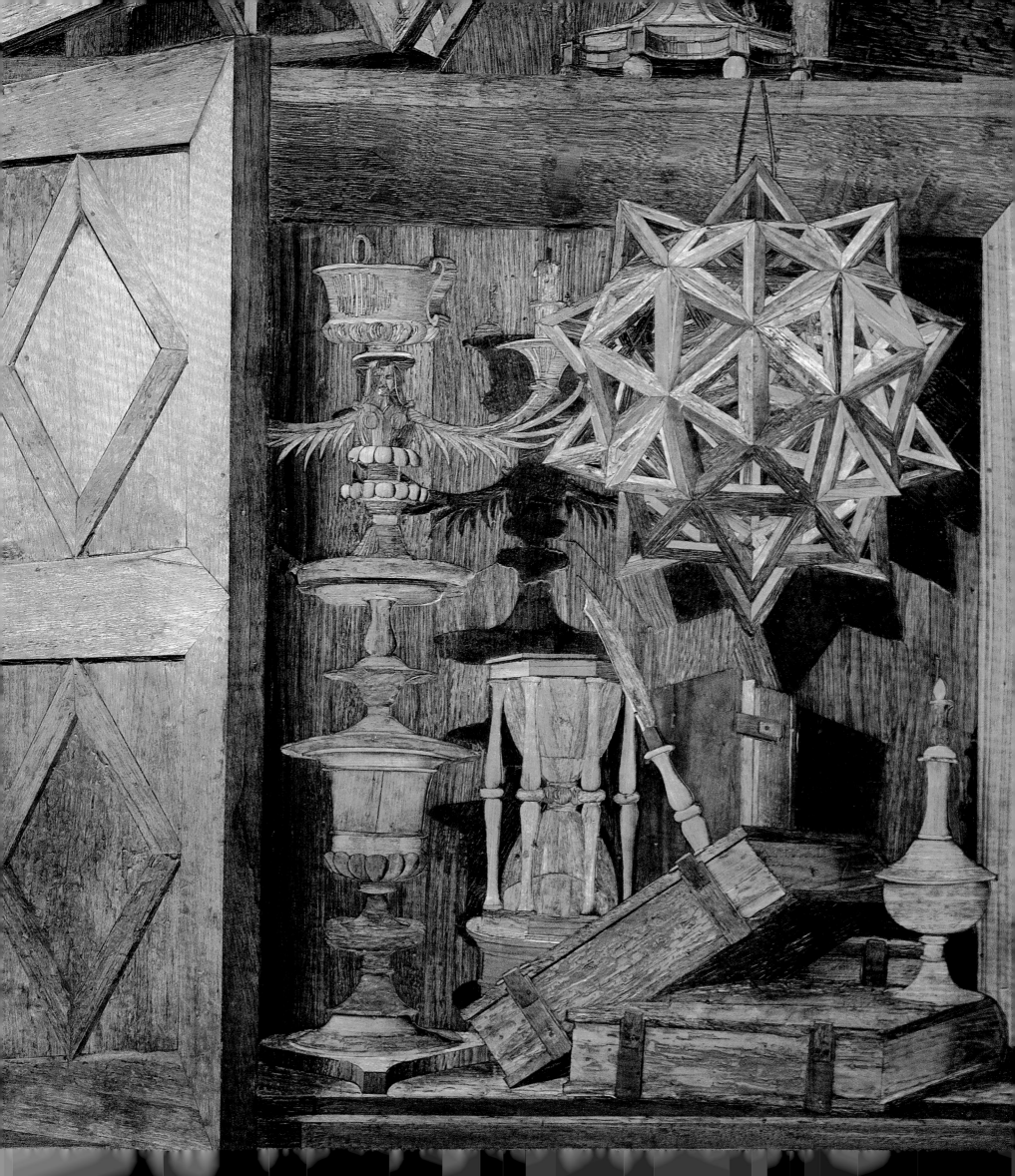

in perspective was certain[...]e-
rona, who was able to tra[...]o-
metric repertoire notably [...]at
of earlier masters of persp[...]oy
giving life to his wonde[...]els
(plate 11). In the 1490s, [...]iis
native city, where he ex[...]ng
choir of the Olivetan chu[...]in
Organo (plates 1, 2, and [...]nd
burgeoning fame led him [...]es
within the network of the[...]he
first decade of the sixteent[...]ed
the choirs of the order's [...]na
and its church in Naples ([...]m-
bardi).[15] His work in the [...]ise
to a small school that disse[...]ns
throughout central Italy.

Having reached the en[...]re-
search into perspective, th[...]ar-
sia was characterized, beg[...]by
an attempt to establish a [...]on
with painting. This can b[...]of
the choir of Santa Maria M[...]x-
ecuted by Giovan Frances[...]sis
of Lorenzo Lotto's marve[...]19
and 20).[16] The Bergamo c[...]gh
point of the art of intar[...]he
beginning of its inevitab[...]ng
with the tradition of en[...]ity
views and collections of [...]in
perspectival space, it faile[...]set
of conventions of equiva[...]he
relaxation of perspectival[...]sue
a more expressive mode [...]ant
venturing into territory [...]not
in fact compete with pai[...]ing
decades, as intarsia conti[...]the
geometric themes to wh[...]ed,
and to align itself with ca[...]its
own, it lost its importanc[...]art
form. If we add to this th[...]ent
use of dyes to obtain new[...]the
wood, and the attempt t[...]nes

accommodate an ever more complex iconography, we can understand how intarsia finally allowed itself to be lowered to the status of a "marginal" art, dependent on painting, and relegated to projects of an artisanal nature.

The pursuit of perspectival virtuosity was, however, carried on for a time by the intarsist Fra Damiano Zambelli, whose study of Baldassarre Peruzzi's theatrical scenery, enriched by a knowledge of Bramante's architecture in Lombardy, resulted in the "pictorial" quality that is particularly visible in his work at Bologna in the second quarter of the sixteenth century (plates 21 and 22).[17]

The purpose of this book, then, is to trace the *fil rouge* connecting the most significant moments in the history of Italian Renaissance intarsia, which experienced its rise, greatest success, and consequent decline between the beginning of the fifteenth and the middle of the sixteenth century. Faced with the well-established body of specialist literature that already exists on intarsia, we shall attempt a brief, but serious, recapitulation—supplemented by a body of photographic material of indisputable quality—that can serve as a general assessment of an artistic genre whose critical fortunes (or misfortunes . . .) have, even today, rendered it more obscure than its sister arts of painting, sculpture, and architecture. The various essays include many new insights into fundamental issues in the study of intarsia (often provided by recently discovered documents and drawings), which enrich our analysis of the artistic techniques and historical contexts that conditioned the creation of these cycles of work. The final product is entrusted to the reader—whether a specialist or someone who simply wants to know more about an important but often undervalued art form—to whom we would like to transmit a discriminating awareness of these wonderful masterpieces, the fruit of expert hands and enlightened minds.

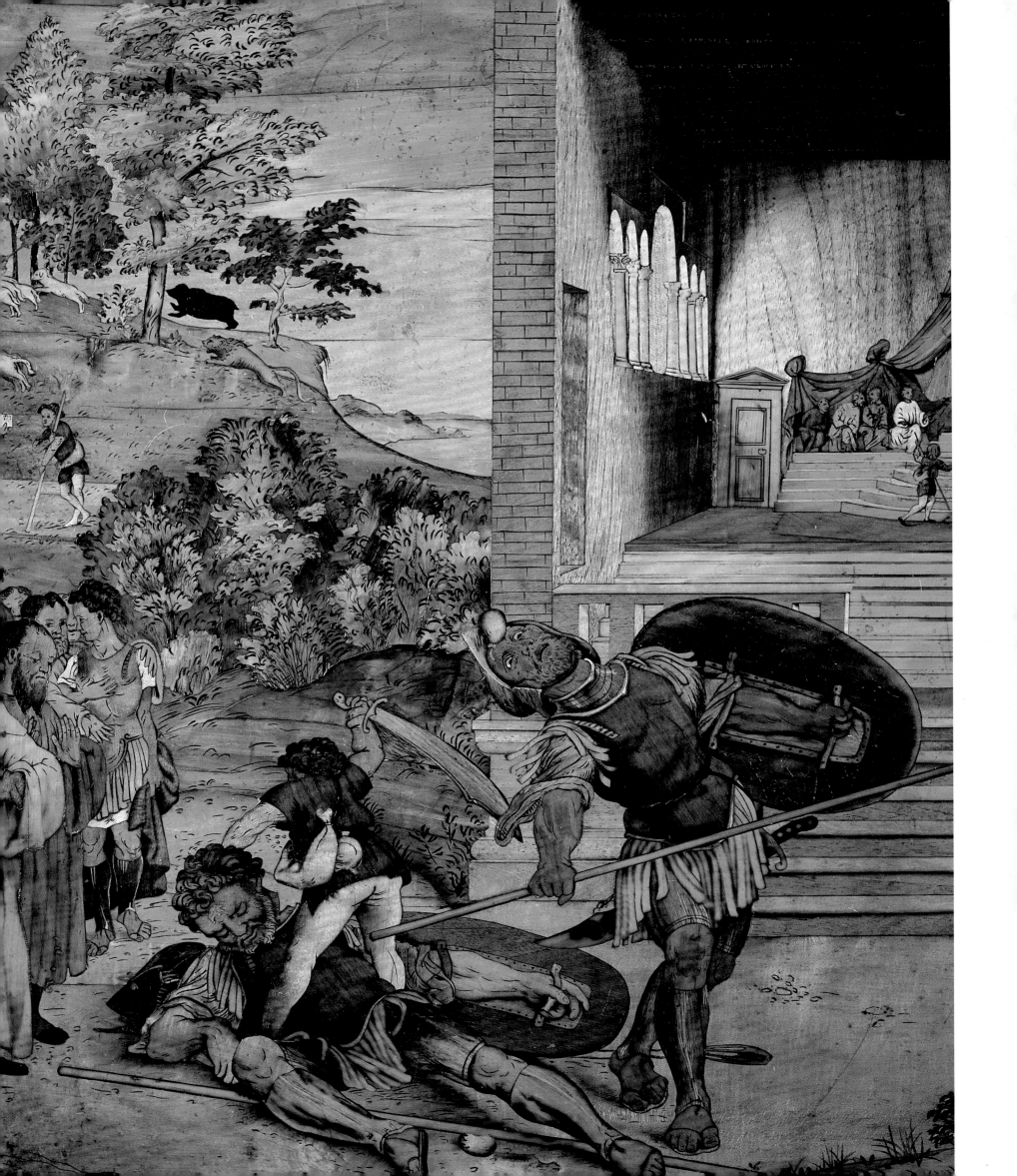

19, 20. Giovan Francesco Capoferri,
1497–1534, after a drawing by Lorenzo
Lotto, c. 1480–1556/57
David and Goliath (details), c. 1525–26
Basilica di Santa Maria Maggiore,
Bergamo; choir, outer side of the
iconostasis

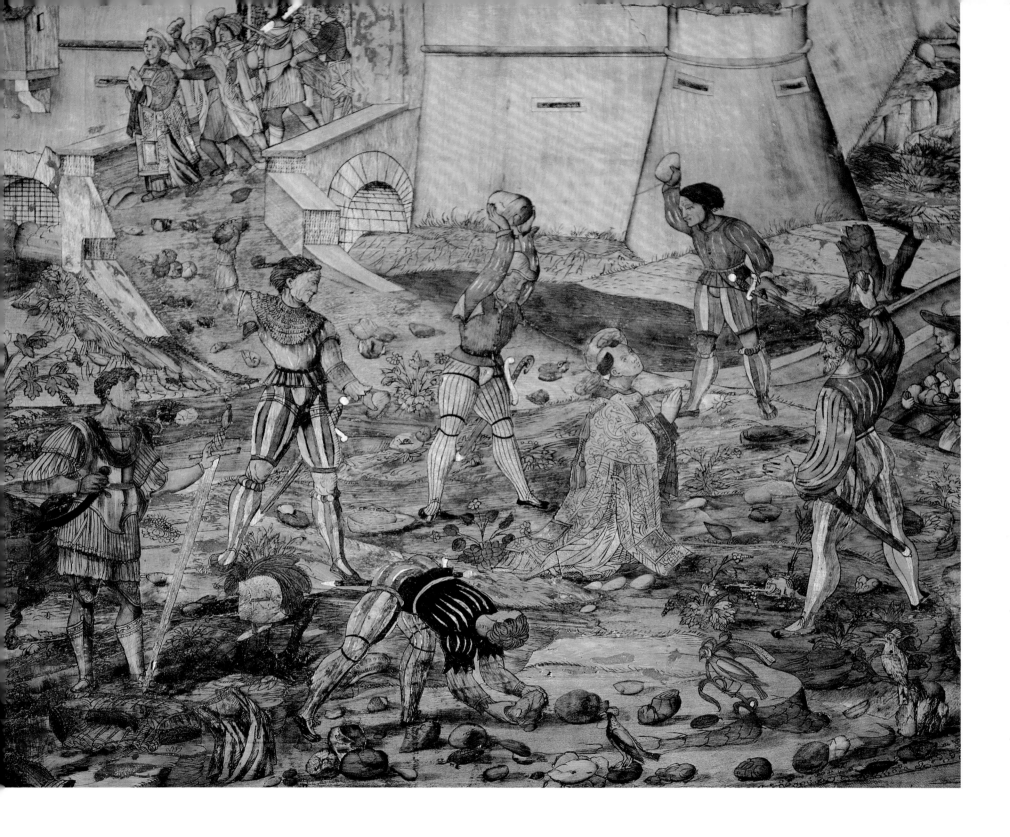

1. Bagatin 2004.

2. Ferretti 1982, p. 487. While there i
large scholarly literature on intarsi
for the purpose of this preface it su
fices to refer to the exhaustive essa
by Ferretti (particularly pp. 487–5(
which discusses the principal them
and episodes of the medium's rathe
vast and complicated history, and
points the reader toward further
bibliography.

. 489–90.

. 490–95.

olin's essay in this

521.

. 484–86.

amperini's essay on
olo in this volume
ubbio intarsia, see

9. See Paolo Bertelli's essay in this
volume (p. 105).

10. See Monica Molteni's essay in this
volume (p. 67).

11. Bagatin 1990 and 2004.

12. See the essay by Luca Trevisan in this
volume (p. 81).

13. Puerari, ed., 1967; Bandera, Foglia
2000; Lucco, ed., 2009.

14. See Alessandra Zamperini's essay in
this volume (p. 119).

15. See the essays in this volume by Cris-
tina Beltrami (p. 137) and Pierbarnaba
Leonardelli (p. 153), respectively.

16. Ferretti 1982, pp. 550–54. See also the
essay by Maria Teresa Franco in this
volume (p. 177).

17. Ferretti 1982, pp. 554–60. See also
the essay by Alessandra Bigi Iotti and
Giulio Zavatta in this volume (p. 221).

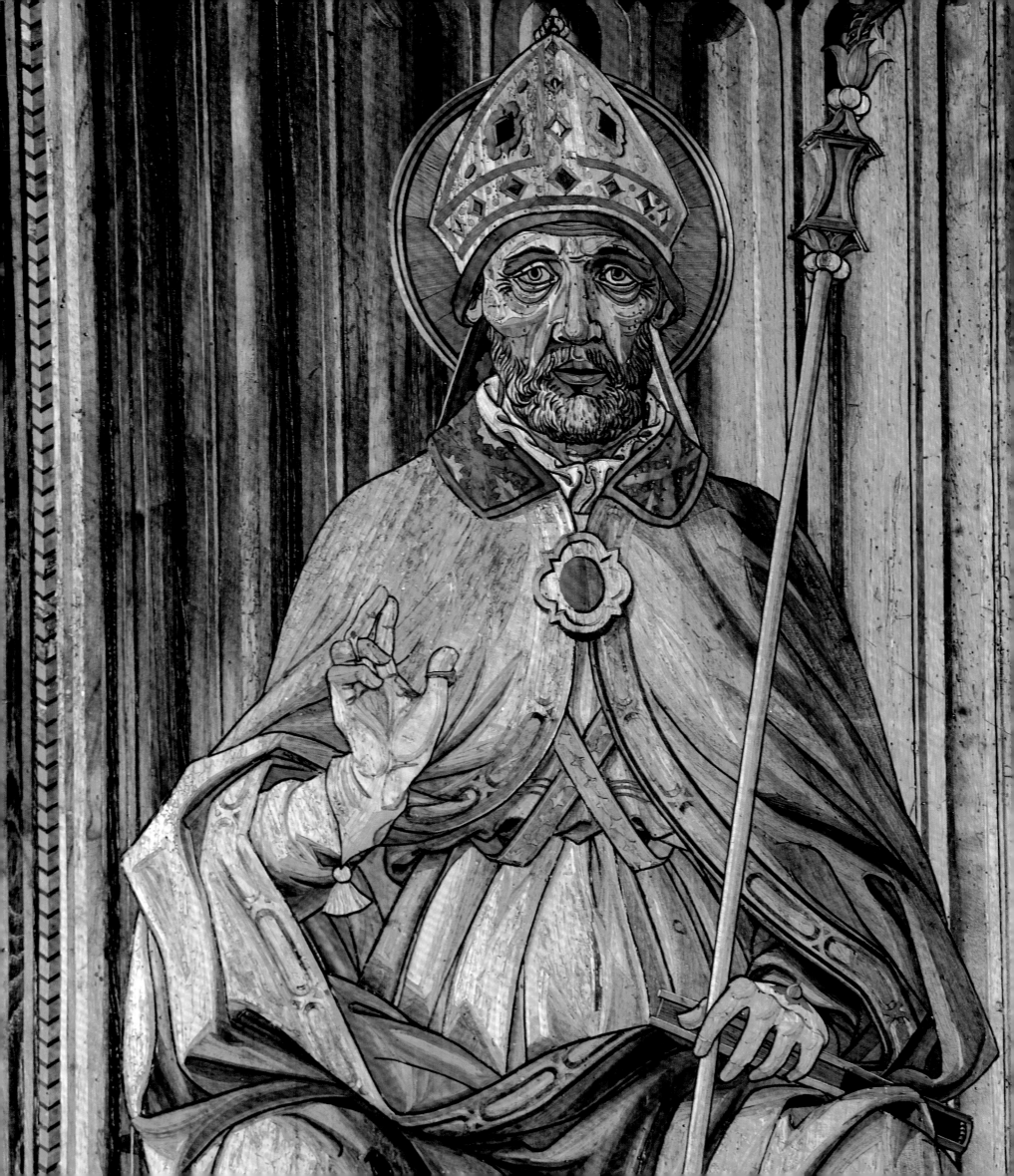

Part I

✳

NATURE & IDEAL

The Birth of Perspectival Intarsia

in the Quattrocento

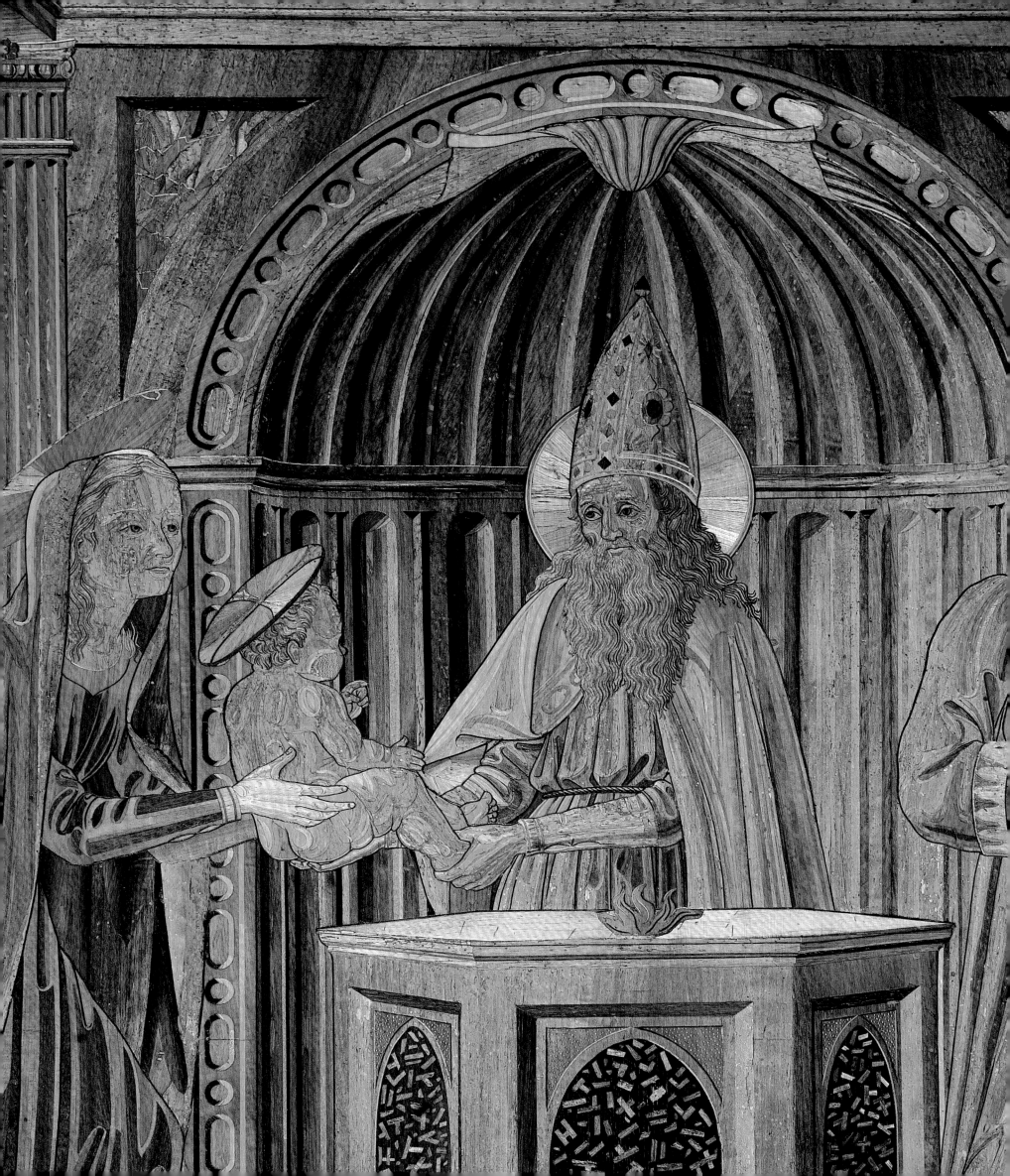

A bronze door and a glaze
by Luca della Robbia[1] lead ii
intarsiated jewel box that i
Messe, or Sacrestia Vecchia (S
or Old Sacristy), in Florence's
del Fiore.[2] This room is a ma
importance, both historical
mously acknowledged as one
examples of perspectival inta
by virtue of their amply dem
indeed be considered "master

The technique of perspec
was adopted in the first half
by Florentine woodworkers, v
in the twelfth century, had a
ing importance. Indeed, by
tury, woodworking was one
commercial activities—along
tion of wool, silk, and preciou
Florentine workshops were ca
high-quality wooden furnishin
powerful of other Italian cities

Intarsia took on a role of pa
within the panorama of Flore
Vasari, who places the genre
painting,[7] states in his *Lives of*
Painters, Sculptors, and Archite
city's intarsists created "many
that brought fame and benef
many years."[8] Vasari grants to
nity of the work of art in ever
ing the Florentine convention,
fifteenth and sixteenth centu
any distinction between major
so as to avoid any further disc
the newly enfranchised mechan
titude is attested most clearly
chapter of the essay "On Paint
where he turns to the masters o
tarsia, describing how they "pu
that made the plane of the work

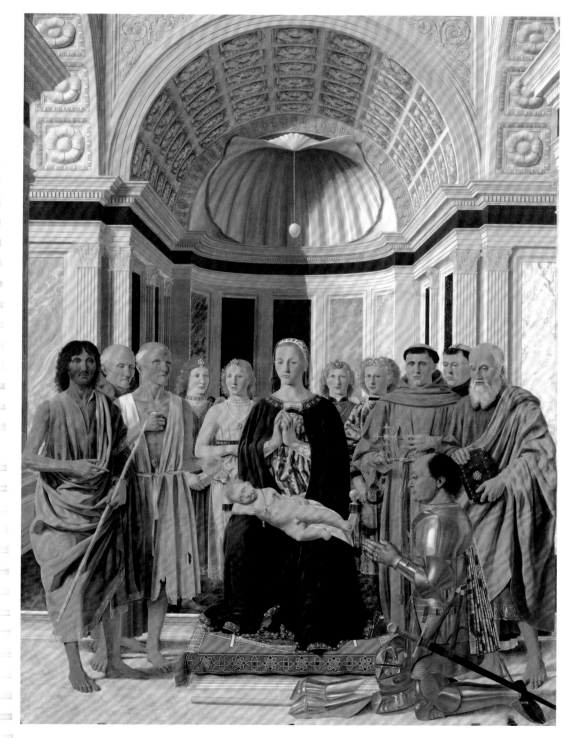

PAGE 28
23. Giuliano da Maiano, 1432–1490
Saint Zenobius, Bishop of Florence, Between Saints
Eugene and Crescentius (detail), 1463–65
Duomo, Florence; Sacrestia delle Messe, east wall.

OPPOSITE PAGE
24. Giuliano da Maiano, 1432–1490
Presentation of Jesus in the Temple (detail), 1465–68
Duomo, Florence; Sacrestia delle Messe, west wall

ABOVE
25. Piero della Francesca, c. 1410–1492
Montefeltro Altarpiece, c. 1472
Pinacoteca di Brera, Milan

piece, although it was made up of more than a thousand."[10]

The decoration of the north sacristy of Santa Maria del Fiore, which belongs to the context of large public commissions for ecclesiastic furnishings, was made possible by the papal dispositions that entrusted the bureaucratic and economic management of the cathedral's development to the Opera del Duomo (the Cathedral Works) and the Consoli della Lana (the leaders of the Wool Guild).[11]

The result was a forty-year undertaking, beginning in 1436, by the major Florentine workshops of the time, involving the city's finest intarsists: Antonio di Manetto Ciaccheri and Agnolo di Lazzaro d'Arezzo (known as "dei Cori")[12] in the first phase, and Giuliano da Maiano and Giovanni da Gaiole in the second.

The place and time urge a consideration of the possible influence of both Filippo Brunelleschi and Leon Battista Alberti on the work in the sacristy— if not directly on the composition, at least on the principles employed for the objective representation of space, and on the intellectual climate within which these exceptional intarsia panels came into being.[13] While Brunelleschi, according to Vasari, influenced the intarsists' renewed decorative repertoire and instructed them in his perspectival methods, which each of them internalized and adapted according to his own personal abilities, Alberti could have influenced the unified conceptions of space presented in the sacristy.[14]

The first phase of work began when the Opera hired two supervisors—Giuliano di Tommaso Gucci and Chimenti di Cipriano di Ser Nigi—to oversee the preparation of this sacred space. Agnolo di Lazzaro and Francesco di Lucchese da Poggibonsi were brought in to create the wooden counters, doors, and interior decorations; subsequently they were joined by two assistants.[15] But the most important work executed in this phase was the intarsiated paneling of the north and south walls, which the later decorative cycles took as a model and point of reference, at least in structural terms. On both walls, this paneling was conceived as a classicizing facade structured in two orders, with intarsiated scenes enclosed in architectural

OPPOSITE
26. Agnolo di Lazzaro, c. 1382–after 1454
Intarsia panels, 1436–40
Duomo, Florence; Sacrestia delle Messe, south wall

PAGE 34
27. Antonio Manetti, 1404/5–1460
Liturgical Objects and Books, 1436–45
Duomo, Florence; Sacrestia delle Messe, north wall

PAGE 35
28. Antonio Manetti, 1404/5–1460
Liturgical Objects, 1436–45
Duomo, Florence; Sacrestia delle Messe, north wall

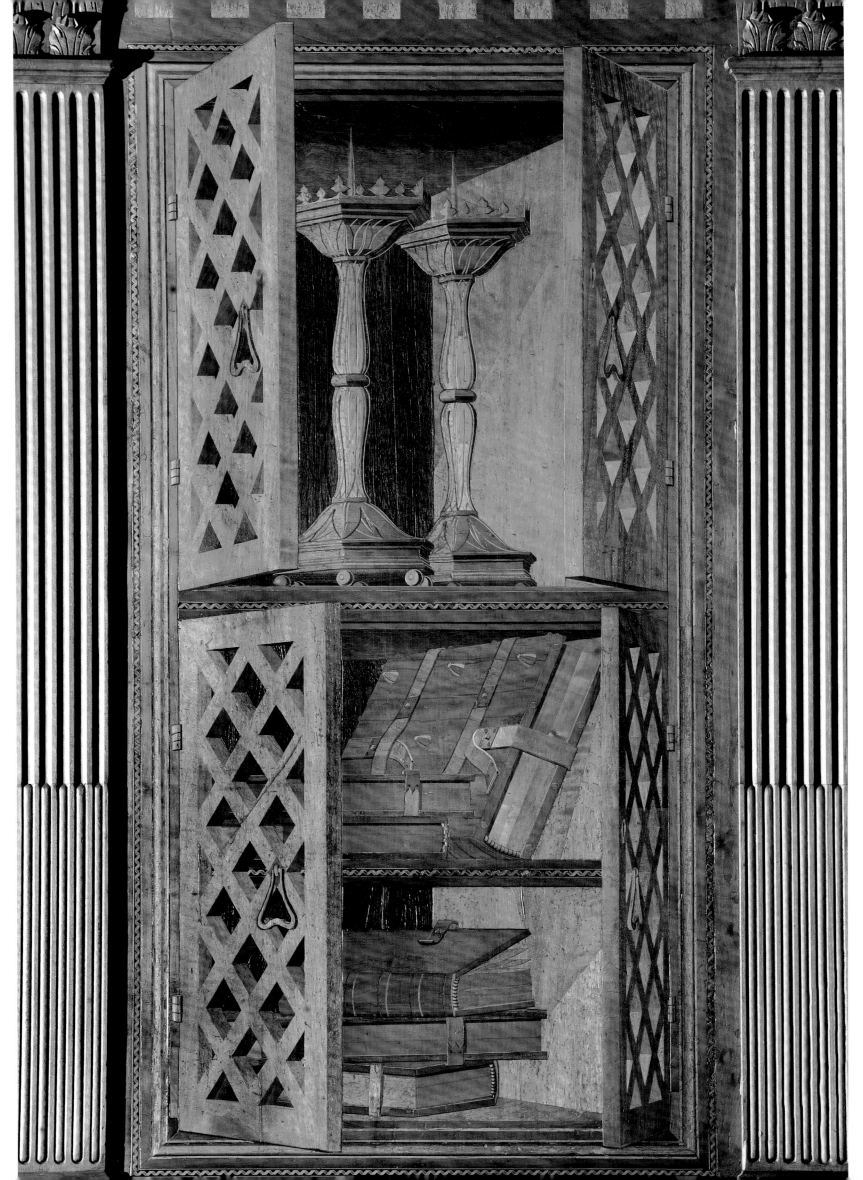

frames.[16] On the lower level ...

in the masonry structure cr... ...

(plate 26) that were decorate... ...

nets rendered in perspectiv... ...

doors open to varying degre... ...

implements for the sacristy ...

cathedral as Santa Maria de... ...

consecrated on March 25, 1... ...

Annunciation, in the presenc... ...

One of the intarsists invol... ...

membered more for his exper... ...

tive than for his contribution ...

of intarsia, was Antonio Ma... ...

collaborator, as well as a riv... ...

The system of motifs that M... ...

the Sacrestia delle Messe—th... ...

with half-open grated shutter... ...

sible to glimpse the objects ...

would remain one of the favore... ...

work until the end of the cent... ...

In the best-preserved niche... ...

executed under Manetti's dire... ...

and 1445, there may be seen "... ...

nets a few, well-organized ob... ...

the usual implements of the lit... ...

candlesticks to the left, and a... ...

on a lectern to the right (plates ...

while, the central armaro, or c... ...

garet Haines notes, "an excelle... ...

sensitivity of the designer to the ...

In fact, nothing is seen in the c... ...

tain is drawn across its lower ha... ...

In the other niche along the n... ...

surviving decorated panel depi... ...

rangement of books, in which ...

intarsiated volumes are handle... ...

brilliance as the perspectival con... ...

ing a composition that can be co... ...

finest still lifes of Quattrocento F... ...

Manetti's wall is characterize... ...

skill and visual impact. The h... ...

drawing and concrete realiza... ...

breathless, despite the expressi... ...

the intarsia worker with respect ...

The objects appear to have rea... ...

they might almost be called mo... ...

way they make a display of their ...

the work also fully exploits the natural light: the rays of the sun, entering through the window to the right, emphasize the chromatic play of the wooden facets of the intarsia.[24] There is no attempt to apply perspective to the other parts of the paneling, which are instead decorated with two-dimensional motifs: on the tall rectangular faces of the pilasters, amphorae with lilies, palms, and olive fronds, symbols of the Virgin; and on the wider panels of the upper register, beribboned garlands of oak and laurel, each enclosing a radial motif.[25]

This north wall may represent the era's most significant application of the science of perspective. Here all the directional axes of the drawing are rendered rigorously and effectively, thanks to acute "intellectual and artistic reasoning."[26] All lines perpendicular to the picture plane converge on a central vanishing point placed three *braccia* (about 1.75 meters, or just under six feet) from the ground, creating a relationship of perfect harmony with the gaze of a viewer occupying a central position in the hall.[27]

Regarding the origin of the cartoons for the intarsia on this wall, critics have suggested the name of Manetti himself with increasing insistence; however, there are clearly some inconsistencies between the surfaces and the motifs, even if these are well compensated for by inventiveness and a highly evolved taste. Other names that have often been put forth for the authorship of these drawings, still at a hypothetical level, are those of Brunelleschi, Alberti, and Paolo Uccello.[28]

To the right of the entrance is the south wall, decorated by Agnolo di Lazzaro and his assistants (1436–40), including Masaccio's younger brother, Giovanni di Ser Giovanni (known as Lo Scheggia, "the Splinter"), to whom critics would like to attribute the cartoons for the intarsia on this wall.[29] Here too, the decoration of the niches in the lower register depicts open cabinets containing books (plate 29), interspersed with little angels and floral canopies, to form what Haines calls "complex still lifes of an 'ecclesiastic' theme." In the upper register, the intarsia creates the illusionistic motif of six windows, partially enclosed by a parapet decorated with *mazzocchi* (a type of circular head-

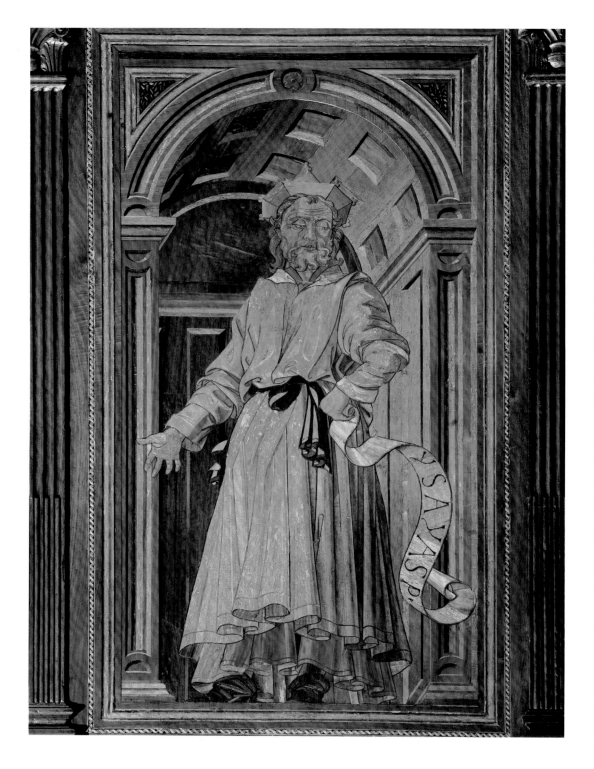

ABOVE
30. Giuliano da Maiano, 1432–1490
Prophet Isaiah, 1463–65
Duomo, Florence; Sacrestia delle
Messe, east wall

OPPOSITE PAGE
31. Agnolo di Lazzaro,
c. 1382–after 1454
Agnus Dei, 1436–40
Duomo, Florence; Sacrestia delle
Messe, south wall

viewpoint. In her excellent study of the sacristy, Margaret Haines emphasizes that "the passion with which the new play has been exploited does not correspond to rigor in its application."[32]

The decoration of the sacristy with intarsia was interrupted for two decades, and it was not until 1463–68 that the master woodworkers of the next generation, including Giuliano da Maiano[33] and Giovanni da Gaiole,[34] made their contributions. The former was entrusted with the work on the east wall, located at the back of the sacristy and third in order of execution. (This wall was later altered on multiple occasions—in 1659, 1830, and 1883—and reassembled in 1971.)[35] The artist took only two years (1463–65) to complete his part of the project, which consisted of two registers enclosing early examples of narrative scenes in perspectival intarsia. Haines emphasizes the striking unity of perspective over the entire surface of the wall, as well as da Maiano's effort to harmonize his work with that surrounding it, particularly Manetti's, whose motifs he took as a model, embellishing them, however, with "new and surprising openings of architectural spaces populated in turn by figures."[36]

On the lower register of this fascinating decorative scheme, between two faux cabinets whose grated doors are opened to reveal books and candlesticks, the artist inserted, with some small incongruities of design, a wooden altarpiece depicting the triad of Florentine saints, with Zenobius at the center and Eugene and Crescentius at the sides (plate 32; detail of Zenobius, plate 23).[37] This was the devotional fulcrum of the space, in which the figures, standing in niches with shell-shaped vaults, represented, as Haines notes, "a model of priestly behavior for the clergy when they were preparing the Mass."[38]

The upper register of the wall was dedicated entirely to biblical themes. At the sides are two sturdy niches containing the prophetic figures of Amos, usually associated with the invocation of the Lord for humanity's salvation from death, and Isaiah (plate 30), who had predicted the birth of the Virgin. These introduce the principal theme of the Annunciation (plates 33–35), set in a foreshortened Renaissance courtyard enclosed by

gear) surrounding geometric motifs or the *Agnus Dei*[30] (plate 31). In the illusionistic depth that lies beyond, one can see a heavy festoon hung from a foreshortened coffered ceiling.[31] On both registers, the panels are divided by pilasters decorated in monochrome intarsia, with vases of lilies on their lateral faces and putti on their central ones. The decoration of this wall is magnificently concluded by the imitation of damask in the ceilings of the niches, which creates the illusion of an applied ornament. But here the perspective is less rigorous than on the opposite wall, and the effects multiply until one cannot recognize a single valid

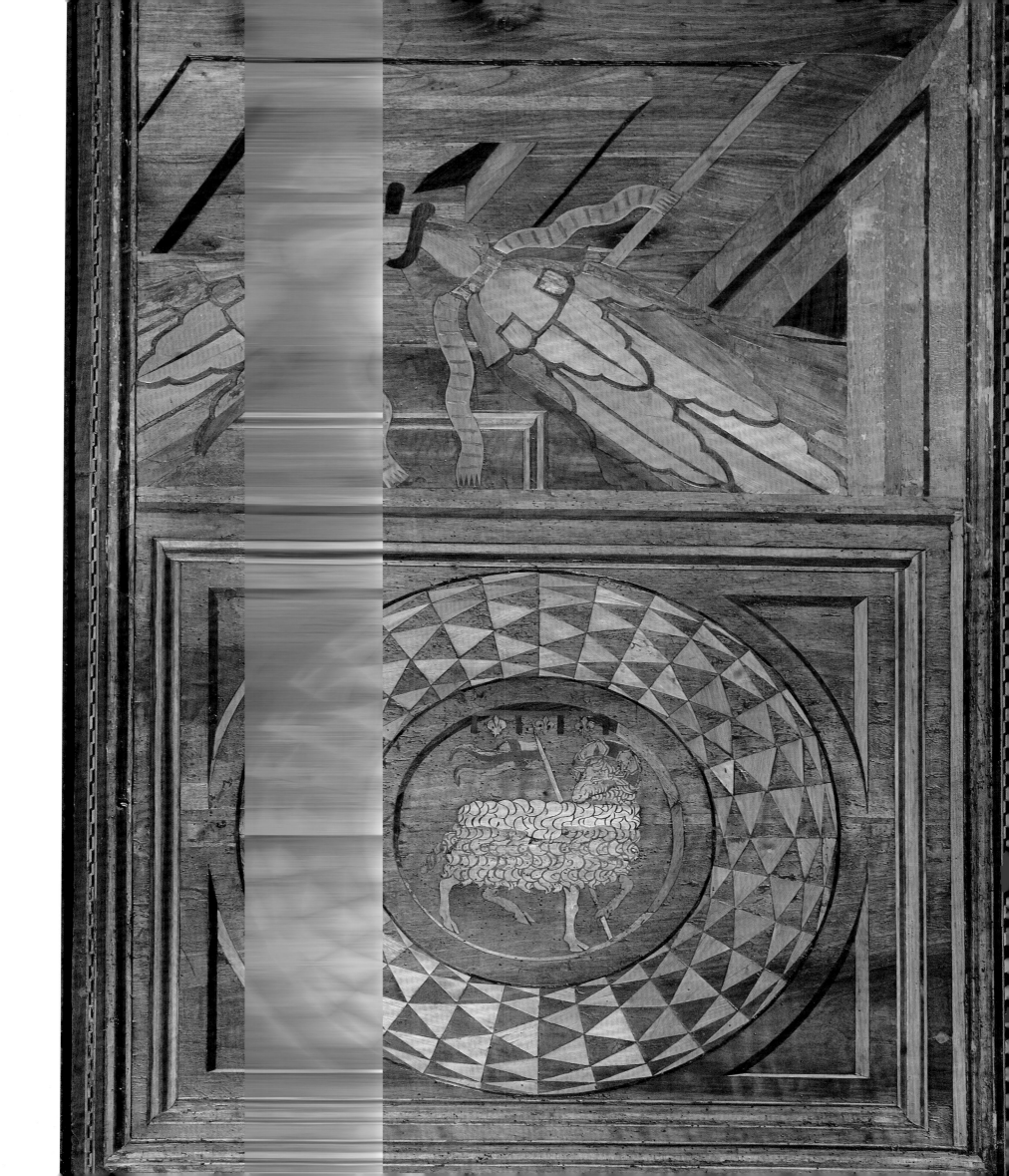

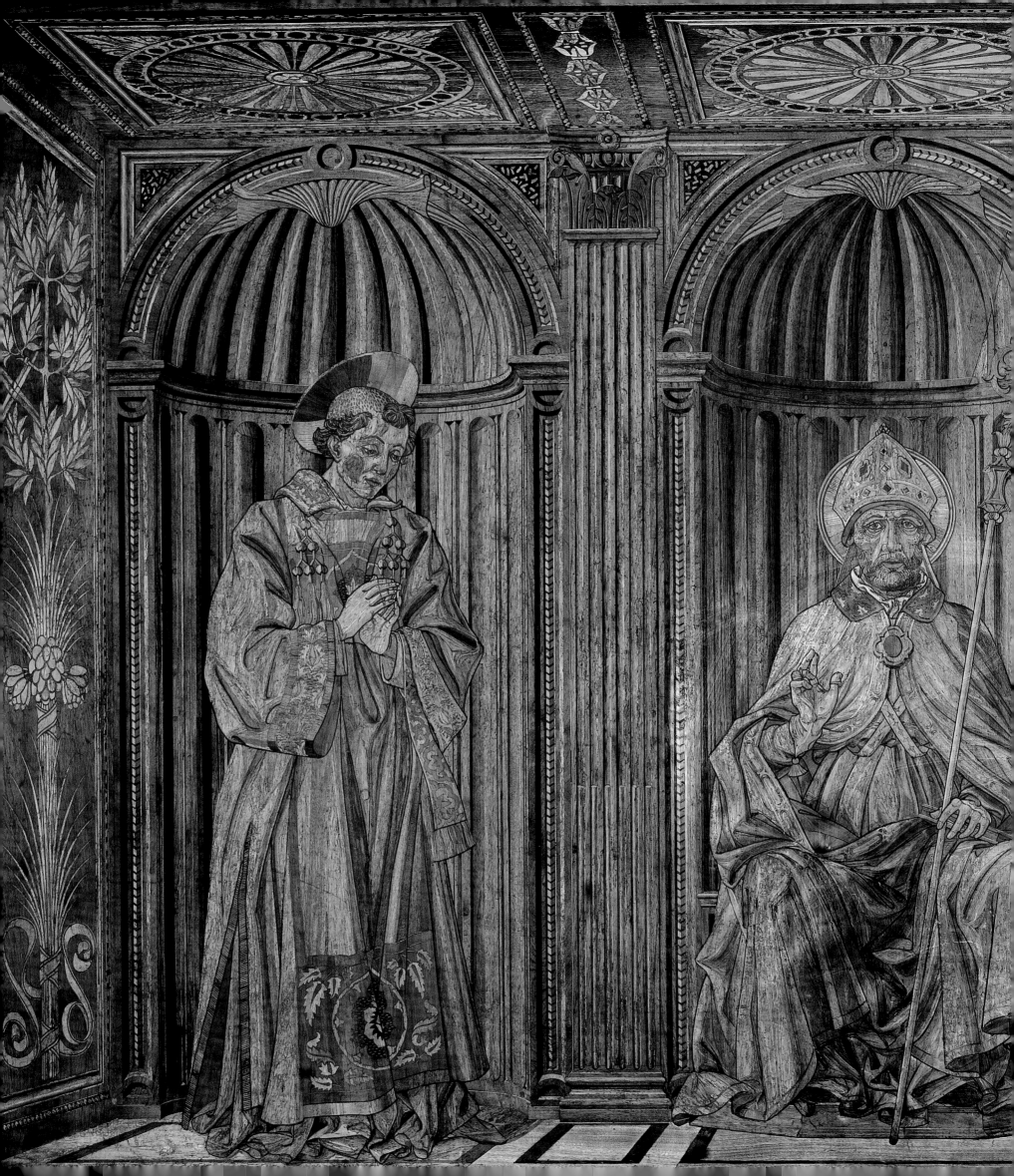

32. Giuliano da Maiano, 1432–1490
Saint Zenobius, Bishop of Florence, Between Saints Eugene and Crescentius, 1463–65
Duomo, Florence; Sacrestia delle Messe, east wall

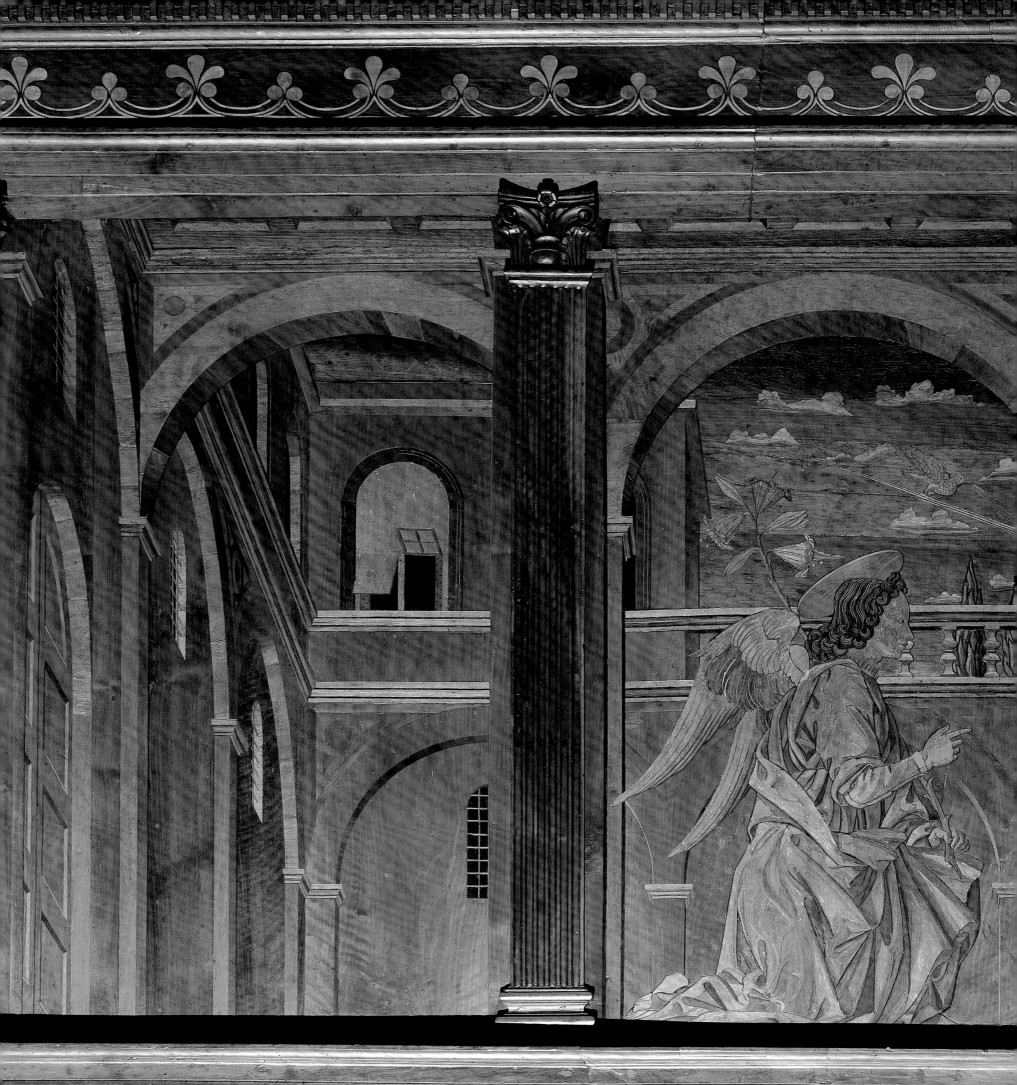

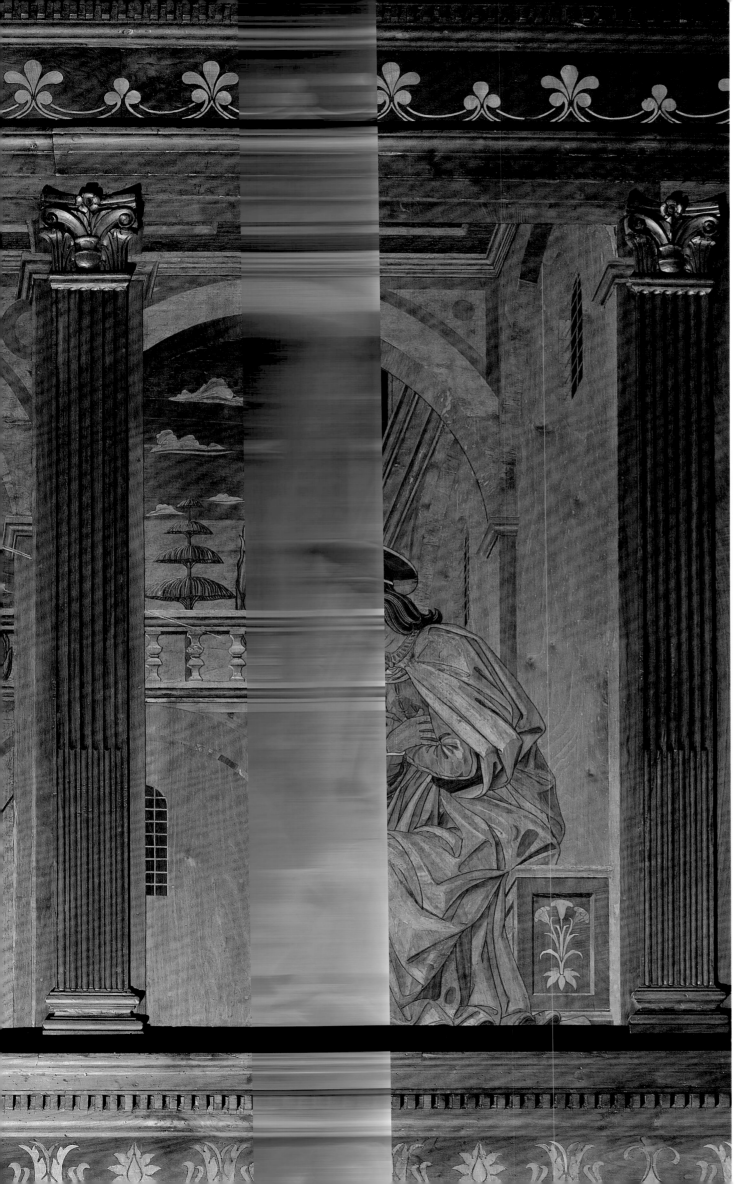

33. Giuliano da Maiano, 1432–1490
Annunciation, 1463–65
Duomo, Florence; Sacrestia delle
Messe, east wall

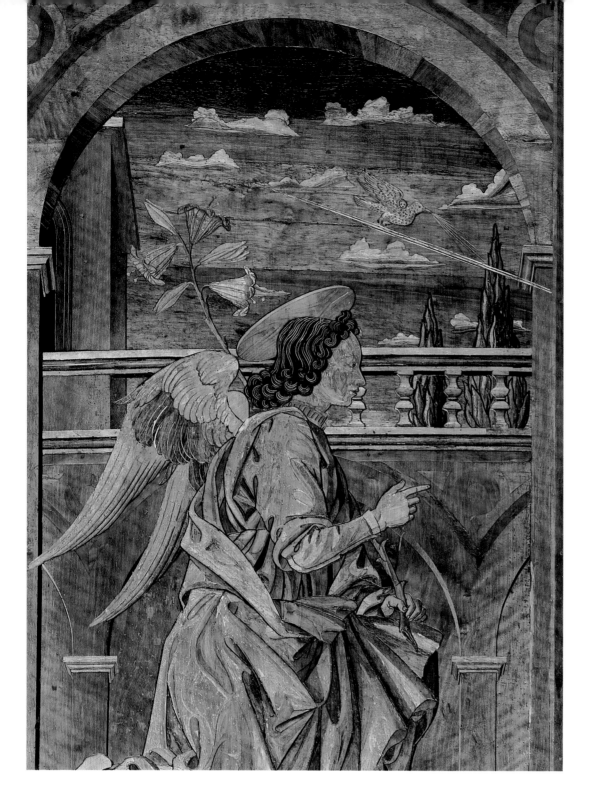

that is, the womb of the Virgin, in which, just as Christ assumed human nature to descend into the world, the priest puts on his garments before officiating at the Mass."[41]

While we know the identities of those who actually executed the intarsia work here, the documentation does not supply the names of the painters who provided the cartoons. Suggestions have included Maso Finiguerra and perhaps Alessio Baldovinetti, while the name of Antonio del Pollaiuolo has been advanced for the Prophets; but it is probable that Giuliano da Maiano himself can be credited with the details of the lower register (except the figures) and the niches of the upper one.[42]

Between 1465 and 1468, da Maiano and his collaborators decorated the last remaining wall, the west one, through which the sacristy is entered, and against which are placed two marble sinks in niches. Two intarsia panels present religious subjects: the Nativity (plate 36), after a drawing by Baldovinetti,[43] and the Presentation of Jesus in the Temple (plates 24 and 37),[44] episodes that normally followed the Annunciation, making up the three fundamental events in the life of the Virgin. Both the *Nativity* and the *Presentation of Jesus in the Temple* must be described as outright paintings: space and volume are skillfully articulated through the use of perspective, and the figures are rendered lifelike through the careful management of tone (with the Christ child being a particularly successful passage). The handling of such naturalistic details as the folds of the drapery, the landscape background, and the fire on the altar are all the more remarkable when one considers the technique employed, although the quality of execution is undoubtedly lower than that of the east wall, created by the same artist's workshop.[45]

The Opera del Duomo procured the materials that were used in the sacristy, and the surviving documentation enables us to identify the woods specifically employed for the intarsia work, which included walnut, poplar, black oak, pear, maple, and mulberry. It was not a large number, but sufficient in variety to create the chromatic nuances of a wooden mosaic that is still considered a masterpiece.

decorated pillars, which is, according to Haines, "an innovative iconographic solution that merges in a single image the significance of the closed and private space (behind the *janua clausa*) and that of the garden of virtues (*hortus conclusus*)."[39] In the various churches of Florence, the Annunciation was often represented theatrically on special platforms set up in the naves, with a supporting apparatus that created light and sound effects, encouraging emotional and devotional involvement.[40] Haines points out that "the iconography of the third wall of the sacristy . . . can also be interpreted as the fullest figurative expression of the medieval concept of the sacristy: the *sacrarium* . . .

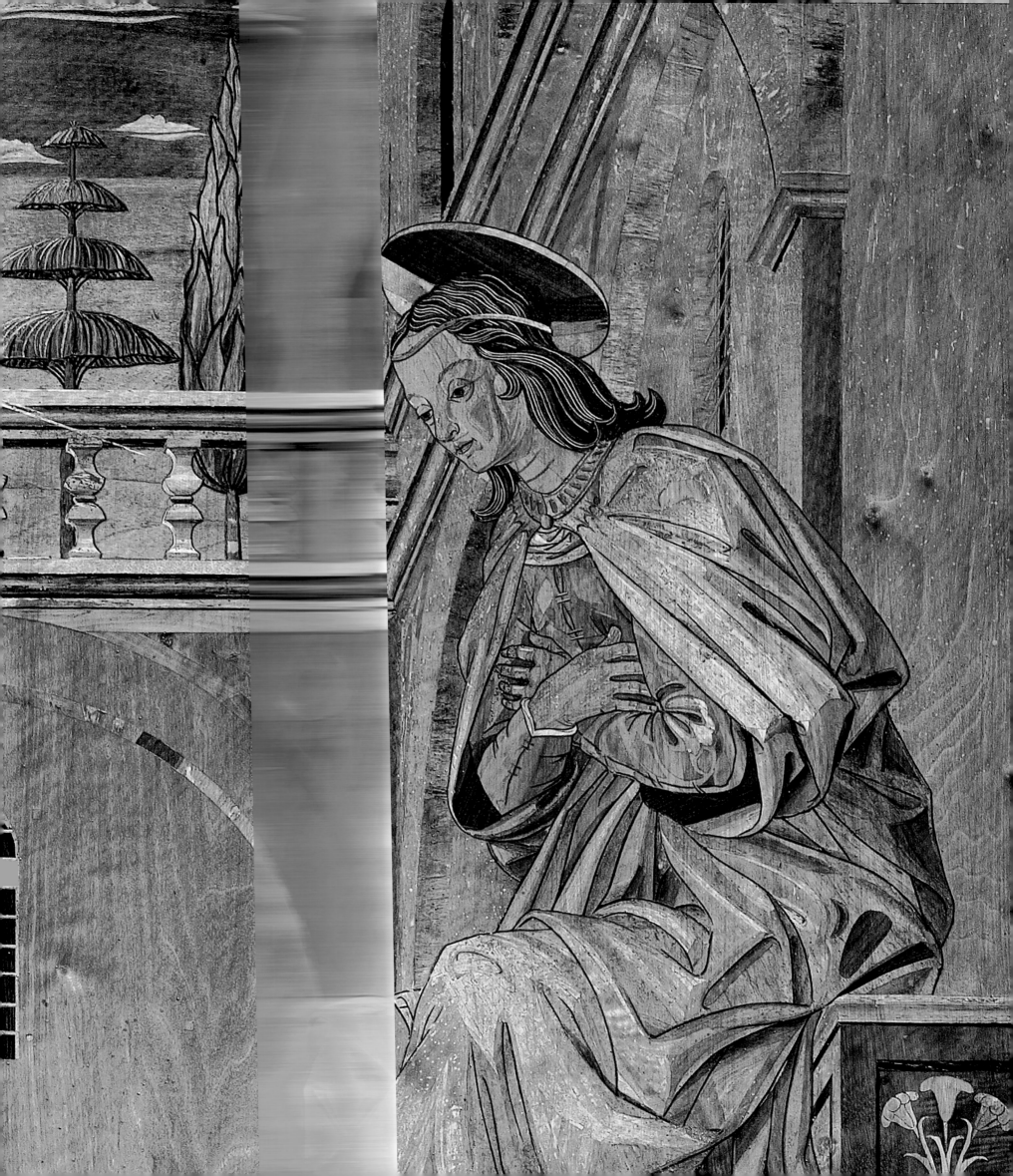

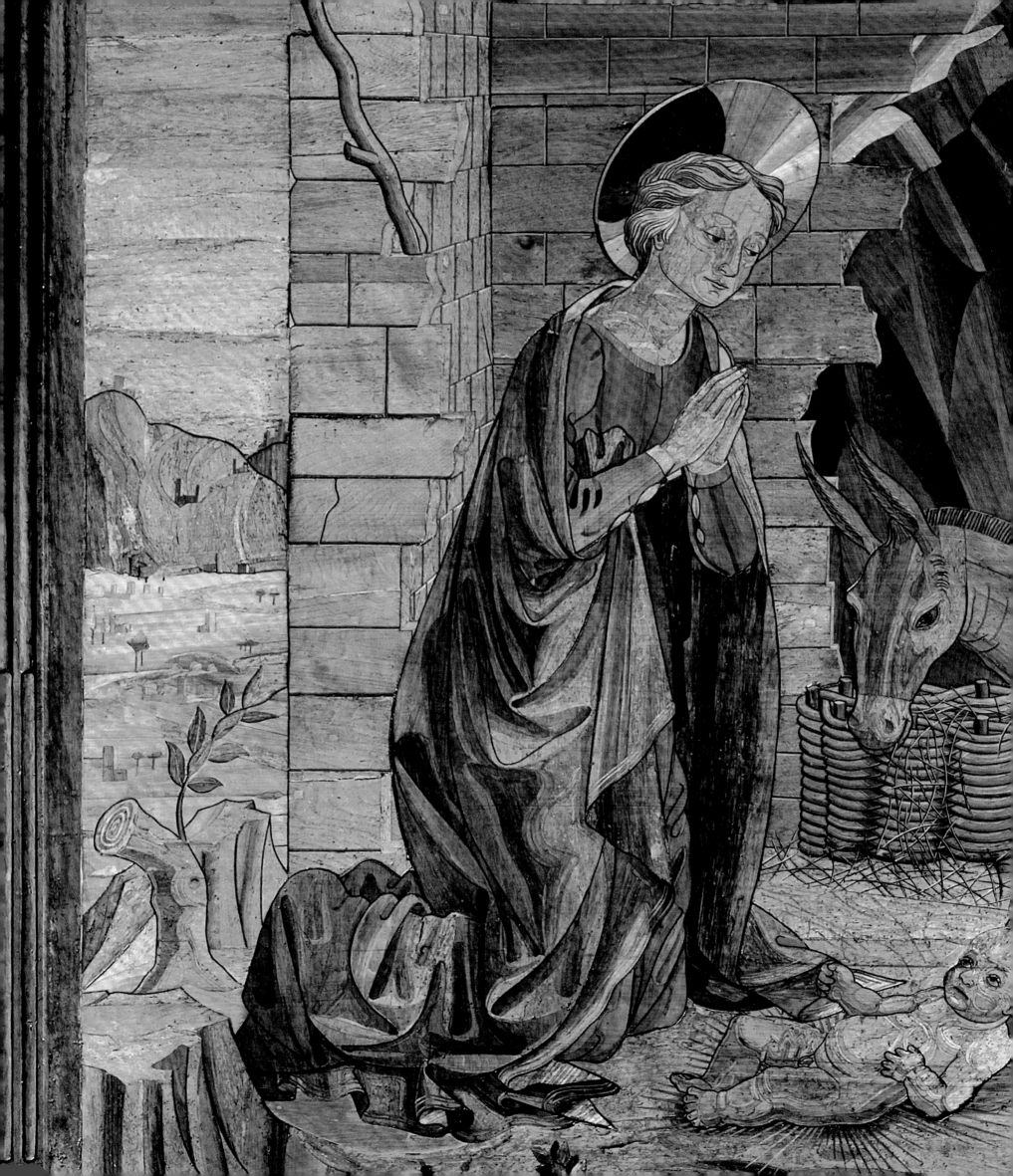

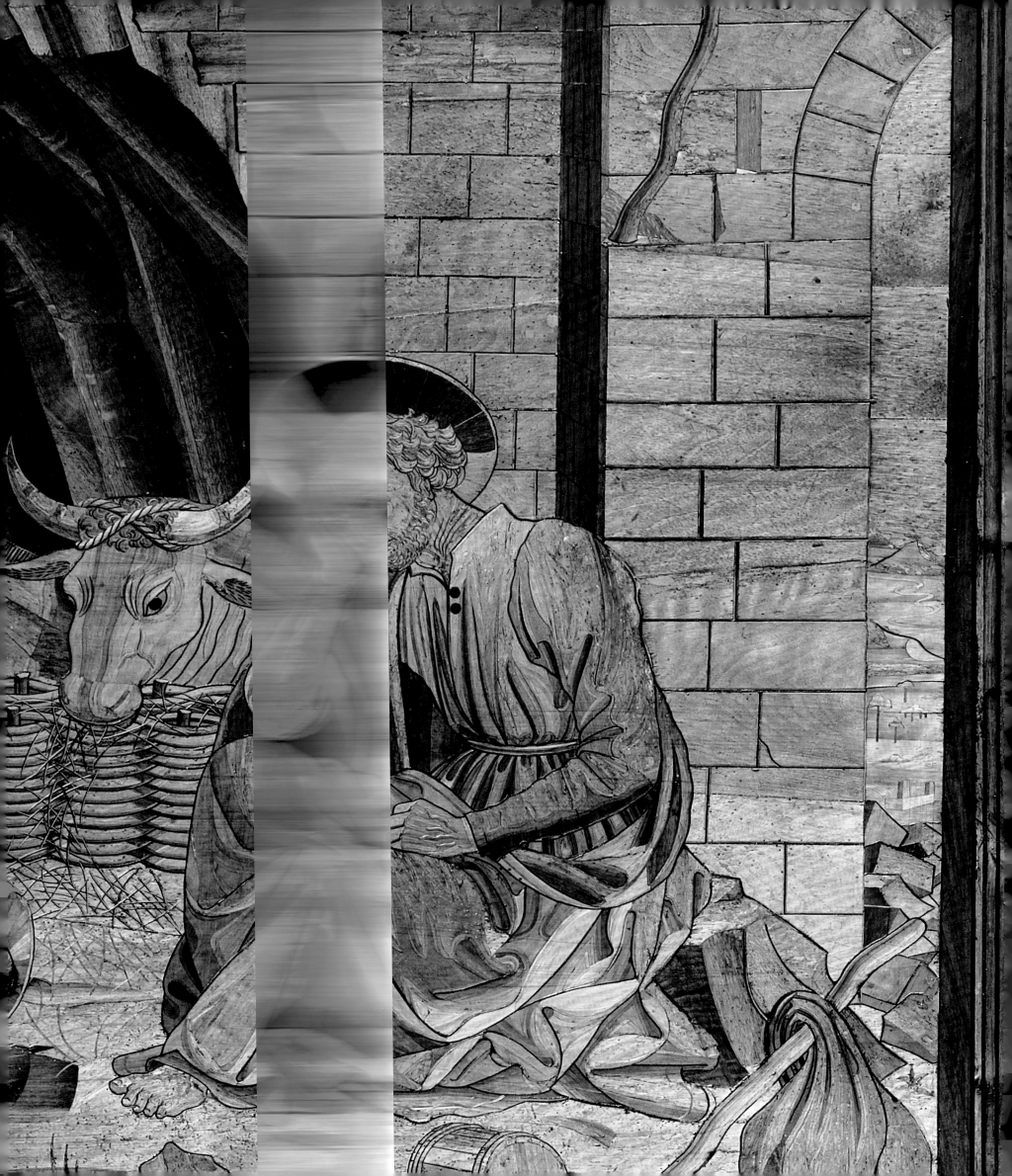

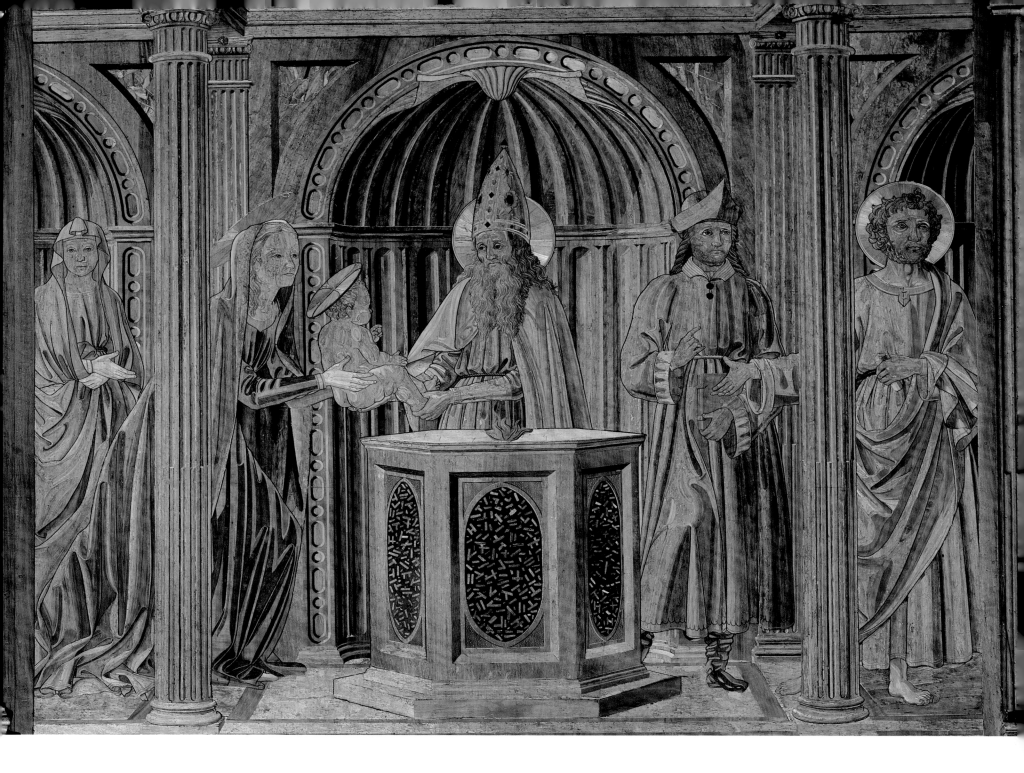

37. Giuliano da Maiano, 1432–1490
Presentation of Jesus in the Temple, 1465–68
Duomo, Florence; Sacrestia delle Messe,
west wall

The woodwork of the Sacrestia delle Messe has undergone various alterations over the years, including some irremediable mishaps, such as the disassembly of the cabinets in 1883.[46] The material itself immediately showed its organic fragility, and indeed the earliest documented restoration took place in 1463. The first significant changes to the furnishings were made in 1655, followed by an extensive "modernization" in 1659, when the counters were destroyed and replaced with new cabinets. In the following centuries, the sacristy was variously furnished, and wardrobes, chests, desks, and confessionals obscured the splendid intarsia work. After a discouraging restoration in the seventeenth century, there was a major intervention in 1830–31, when the side walls were cleaned, and wood- and stuccowork were added. The latest important restoration campaign was undertaken between 1971 and 1982.[47]

1. Haines 1983, pp. 122–26; Acidini Luchinat 1994, pp. 15, 90–91. The glazed terra-cotta lunette depicts the Resurrection, while the door—initially but unsuccessfully entrust[ed] to Donatello in 1437 and finally executed by della Robbia, in competition with Michelozzo and Maso di Bartolomeo—has two shutters divided into five sections each, containing, from top to bottom, the Madonna and Child with Saint Joh[n] the Evangelists, and the four Docto[rs] of the Church; the door panels are framed by small heads of the Proph[ets] in full relief.

2. Santa Maria del Fiore has two sacristies, the Sacrestia delle Messe, at the north end, and the Sacrestia dei Canonici, at the south. Built to the specifications of 1367, the two room[s] were carved out of the dome, and it is precisely because they are smalle[r] than other great sacristies of the sam[e] period that efforts were concentrate[d] on the development of a magnificent decorative scheme, though the competition for papal privileges als[o] played a role. See Crispolti 1937, p. 441; Haines 1983, pp. 36–37, 51.

3. Haines 1983, p. 23; Paolucci 1993, p. 96.

4. Haines 1983, p. 61; Paolucci 1993, p. 96; Haines 2001, p. 99; Camerota 2006, p. 70. Perspectival intarsia called for a technique of execution very dissimilar to those of the applie[d] arts. The larger pieces were mounte[d] first, and the principal details were subsequently inlaid onto these, followed by the minor ones; see Haines 1983, p. 102. Artists had to be endowed with an absolute mastery of inlay work, as neither corrections no[r] errors of execution were permitted. The pieces of these wooden mosaics were shaped according to precise drawings that were fully defined in every detail.

pp. 70–72; Haines designation "maestri s found in the list of ...ho in 1470 compiled sans in the city of ...ainters and sculptors, names of fourteen

...6, p. 1. It should ...at in the fifteenth ...re three methods for ...tive in wood: tarsia ...nblage of different ...nto a large block, ...t into slices in which ...vides a pattern); (lighter wood inlaid ...rker ground); and ...rsia. See Haines 1983,

...4, p. 33: "Making ...oured woods, which ...nslation by De Vere,)

...4, p. 329.

37.

...4, p. 90. However, by emphasizing ...ts of the technique ...namely the darken-...nd their relatively ...e to both woodworm

...37–41; Filetti Mazza

).

...0.

...04–6; Haines 2001, ...006, p. 70. The assis-...ni, son of Agnolo, ...ovanni, both of ...teen years old. ...ation regarding ...ee Haines 1983. ...142; Haines 2001,

Antonio Manetti ...ry, and sometimes

still conjectural, but with the gradual discovery of new evidence, he has emerged as a figure of greater significance than has been recognized in the traditional historiography. Indeed, he should now be considered an important figure in early Renaissance architecture in Florence. Born in that city in 1404 or 1405, Antonio began his career as a woodworker and maker of architectural models, but between 1430 and 1460 his skills were such that he was engaged on projects designed by Brunelleschi (who was first his master, then his "enemy") and Michelozzo. He worked on the dome and lantern of the Florence duomo (and built a famous model of them), as well as the churches of San Lorenzo, Santo Spirito, and Santissima Annunziata. Manetti's importance was already recognized by historians of his own era, if one considers that Benedetto Dei's aforementioned list of artisans (n. 5) opens with his name. For a more complete study of the artist and the man, see Hyman 1981, pp. 76–78; Haines 1983, pp. 64–66.

19. Haines 2001, p. 99.

20. Camerota 2006, p. 70. The author cites later and better-known examples of this type of decoration, which can be seen in residences of the Montefeltro family in Urbino and Gubbio, dating, respectively, to 1474–76 and 1478–82.

21. Haines 1983, p. 93; Acidini Luchinat 1994, pp. 91–92.

22. Haines 1983, p. 93.

23. Piglione 2000, p. 40.

24. Haines 1983, p. 92; Haines 2001, p. 99.

25. Haines 1983, p. 94.

26. Acidini Luchinat 1994, p. 91; Haines 2001, p. 99.

27. Acidini Luchinat 1994, p. 91; Haines 2001, p. 100.

28. Haines 1983, pp. 96, 108–111; Haines 2001, p. 100.

29. Haines 1983, p. 107; Acidini Luchinat

1994, p. 91; Haines 2001, p. 99. This attribution was reached through a comparison with the fragmentary fresco of the martyrdom of Saint Sebastian, now in the church of San Lorenzo in San Giovanni Valdarno, which bears the signature of Giovanni di Ser Giovanni.

30. The *Agnus Dei* has more than just religious significance in this context; it was, in fact, the symbol of both the Arte della Lana and the Opera del Duomo, whose role in the creation of the decoration for this space has been discussed previously.

31. Haines 1983, pp. 89–90.

32. Haines 2001, p. 99, but also Haines 1983, p. 89.

33. Giuliano's is the second name on Benedetto Dei's list (n. 5); see Haines 2001, p. 99. Da Maiano's workshop included some of the woodworkers who had taken part in the decoration of the famous Urbino studiolo (p. 51).

34. See Acidini Luchinat 1994, pp. 92–93.

35. See Haines 1983, pp. 145–48.

36. Haines 2001, p. 100.

37. Haines 1983, p. 149. The three saints had been responsible for various miracles in Florence, and their relics, long venerated in the city, were transferred first to the crypt of Santa Reparata and then to the nave of Santa Maria del Fiore.

38. Haines 1983, pp. 149–50.

39. Haines 1983, p. 172.

40. Haines 1983, p. 151.

41. Haines 1983, p. 151.

42. Haines 1983, pp. 164, 168; Acidini Luchinat 1994, p. 92.

43. On the derivation of the drawing for the *Nativity* from the fresco in the atrium of the Santissima Annunziata, see Haines 1983, p. 188.

44. Acidini Luchinat 1994, p. 92.

45. Haines 1983, p. 191.

46. Acidini Luchinat 1994, p. 93.

47. Haines 1983, pp. 81–83, 85–89.

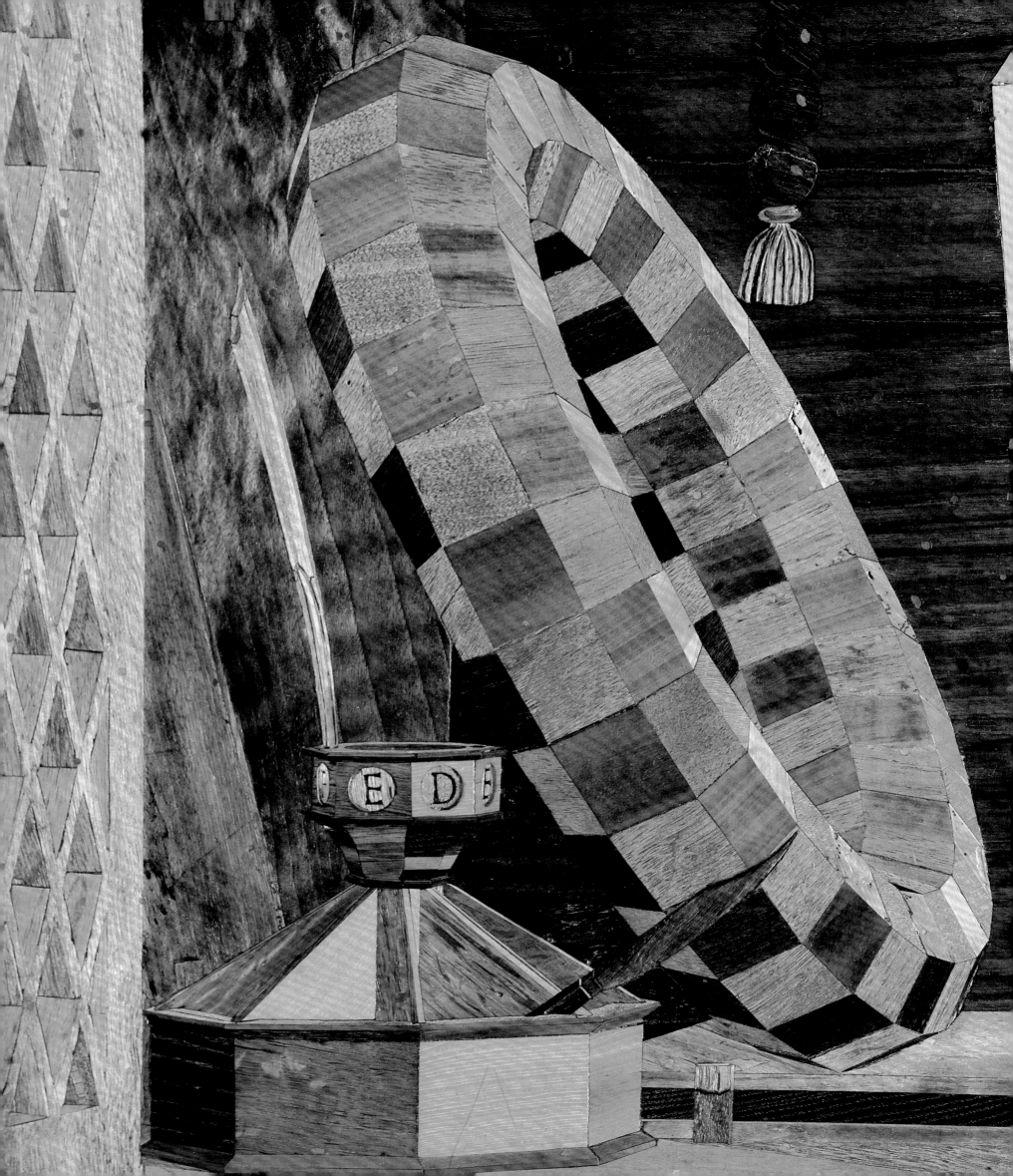

2

URBINO[...] OF FEDERICO DA MONTEFELTRO
[...]ZO DUCALE, 1474–76
[...]to da Maiano
[...]ndra Zamperini

The year 1474 was a golder[...]
Montefeltro, the lord of Urbin[...]
dottiero (commander of merc[...]
Sixtus IV granted him the tit[...]
I, king of Naples, named him[...]
of the Ermine; and Edward[...]
admitted him to the equally[...]
the Garter. But these events [...]
nowhere; at the time, Federic[...]
for about three decades. Du[...]
had skillfully strengthened t[...]
domain, foiling plots by co[...]
adversaries' demands, and fc[...]
the papal court, which he, a[...]
church, understood to be cru[...]
tion of an authority that—a[...]
lucidly explained in *The Prii*[...]
put at risk by enemies both fc[...]

If war, then, had been the[...]
power, fame, and wealth, tl[...]
in Urbino was intended to es[...]
from which his entire range[...]
might emanate. In this struct[...]
tier and writer Baldassarre [...]
city in the form of a palace,"[...]
interwove to create a harmon[...]
not only satisfied the practica[...]
mon to all centers of power,[...]
with laudatory evocations of t[...]
source of well-being and justi[...]

Indeed, studies of the arch[...]
palace have always remarked[...]
tion of public and private spa[...]
cal arrangements and the dec[...]
to have been conceived from[...]
tematic attempt to reconcile t[...]
with a veil of panegyric. As on[...]
rooms (which must be imagin[...]
nal tapestries and furnishing[...]
ly known only through docu[...]
sculpted on the frames of the[...]

ways or inlaid in the door panels and the walls of the studiolo—all drawn from a repertoire that ranges from the heraldic to the scientific, passing through mythology and allegory—still seem able to conjure forth an image of the duke as an advocate of peace through war. This phrase may seem paradoxical at first, but it is easily justified if viewed in terms of Renaissance ideals, particularly that of *virtus*, a word that encapsulated the positive values of faith and culture, values that Federico associated with his own person and regarded as the motivation of both his military campaigns and his political strategies.

It follows that the entire iconographic system presented in the various rooms of the palace must be interpreted as an organic text, in which the sculpted panoplies on the pilasters of the doorways celebrate, as a first step, the duke's profession as a soldier of fortune. This text then revealed—to those who were trained to connect these symbols with the others around them (for example, the allegories of the Virtues or the Liberal Arts that were represented in intarsia on some of the doors)—his function as an enlightened guide who found in virtue and knowledge not only his primary source of power but also a legacy to protect and dispense to his realm.

This is the framework within which we should view the iconographic program of the palace's studiolo, the only private room of the Renaissance whose intarsia decoration has remained intact and *in loco*, still covered by its original coffered ceiling. Modeled on royal studioli and located on the piano nobile of the palace, toward the facade with the small towers, this small space (approximately twelve by eleven feet, or 3.6 by 3.35 meters) was, significantly, positioned above the Temple of the Muses and the Chapel of Absolution on the floor below, forming a triad that unites classical culture and Christian faith. Placed between the public part of the palace and the duke's private

OPPOSITE PAGE
38. Benedetto da Maiano, 1442–1497
Mazzocchio and Inkstand with Letters Spelling "FEDE" (Faith), 1474–76
Studiolo of Federico da Montefeltro,
Palazzo Ducale, Urbino

PAGE 52
39. Benedetto da Maiano, 1442–1497
Armor of Federico da Montefeltro, 1474–76
Studiolo of Federico da Montefeltro,
Palazzo Ducale, Urbino

PAGE 53
40. Benedetto da Maiano, 1442–1497
Federico da Montefeltro, 1474–76
Studiolo of Federico da Montefeltro,
Palazzo Ducale, Urbino

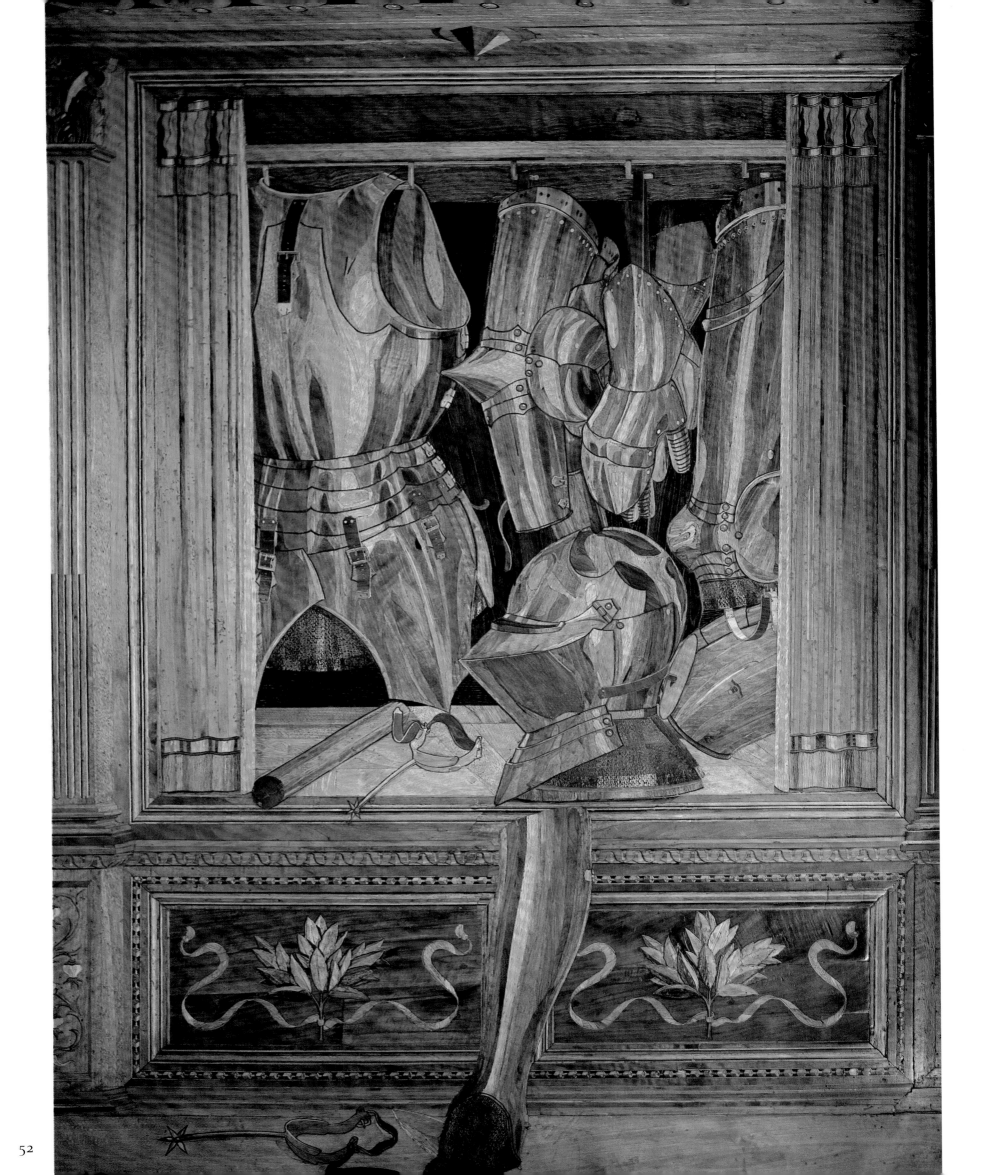

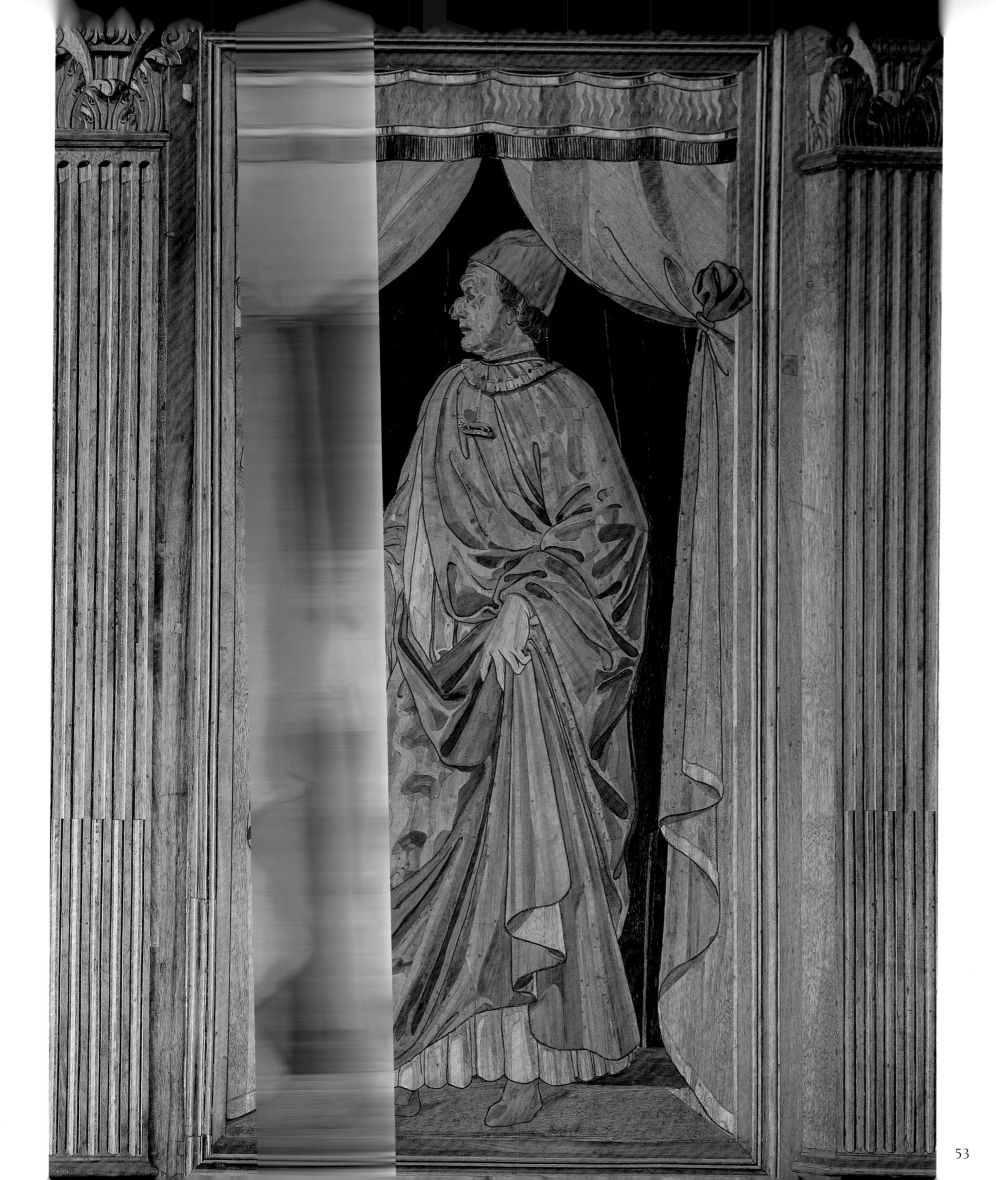

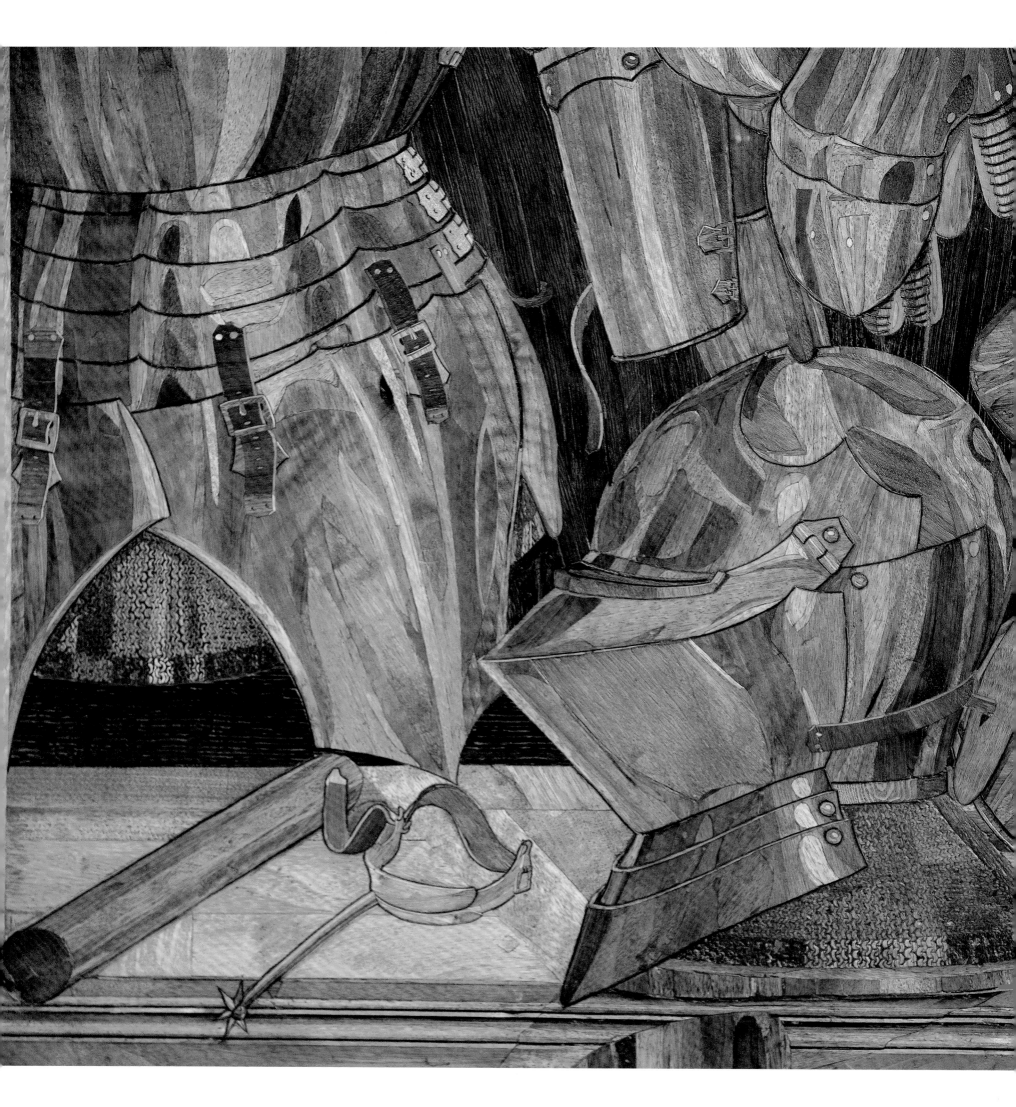

apartments, as if to mirror th
Federico, it raised these ideals
in both form and content, be
sort of "virtual self-portrait"

We know that the studiol
1476, since this date is incl
tion that runs along the up
space, listing Federico's title
When work began is a matter
although most critics agree th
have been time enough to ca
and therefore place the star
which, as we have noted, was
duke's career. As for the desig
of convincing documentatio
were initially advanced includ
of the Renaissance in Urbino,
Francesco di Giorgio Martin
Francesca, due to the rigorous
ture that informs the work as
vincing comparisons with the i
Sacrestia delle Messe, the nor
ence's duomo (completed in tw
to 1445 and from 1463 to 146
an attribution to the worksho
Maiano, aided by his brother
the long-proposed name of the
tect Baccio Pontelli), while the
figures have been almost unani
Sandro Botticelli.[4]

Undoubtedly, the similarity
intarsia work to that of the F
helps us to understand the cho
made as a patron; he would ha
and ready to seize on, the inno
from one of the most up-to-date
the time, where perspective had
several decades of development,
the 1430s, it had found in intars
able for the rigorous representa
foreshortening.

To confirm the success of this
bino studiolo, we need only obs
istic bench that runs along the lo
paneling, on which rest, with c
ness, various objects rendered in
instruments, a greave from Feder

39), some books, an open box, two figs. Some sections of this bench have been lifted up to reveal the vine-branch motifs on their underside (on the north wall, the space thus left free is occupied by the duke's sword, and on the south wall, by a mace), simulating the articulation of different planes in this mimesis of reality.

Further examples are, of course, almost endless: on the east wall are the window that faces onto a loggia and the projecting shutter of the half-open cabinet beneath (plate 45), while on the north wall is the closed grille through which one can glimpse the outlines of the books kept inside. Finally, inside the cabinet on the south wall is a *mazzocchio* (plate 38), the circular headgear that became a veritable emblem of perspectival research in the drawings of Paolo Uccello and Piero della Francesca.

Not unlike the sacristy of the Florence duomo, the Urbino studiolo exhibits a collection of themes centered around landscape, still life, and the human figure. The devices of perspective allow the panels to be adapted to each of these subjects, transforming them, according to need, into windows, cabinets, and niches, in which a suitable detail (a windowsill, a half-open shutter, a pedestal) suggests fictive depth or projection, creating a constant dialogue with the viewer's space and forming its mathematical (and thus perfect) extension.[5]

It is no accident that, in a reassertion of the simultaneously constructive and mimetic potential of perspective, the east wall reproduces the corner of a studiolo, perfectly echoing the actual space. If, however, this extension of the planes can be conceived as the ideal counterpart of reality, it is by no means incongruous that within the intarsia, the iconographic unfolding does not stop with "objective" fact, but implies symbolic concepts with moral value. This is all the more significant because the studiolo of a prince—it must not be forgotten—was both a place of ceremony, by virtue of its owner's rank, and a space for private thought and meditation, as was its intended purpose in Renaissance culture.

With the understanding that the idea of "privacy," in the case of a ruler of that time, still implied a certain "publicity," we can see that both

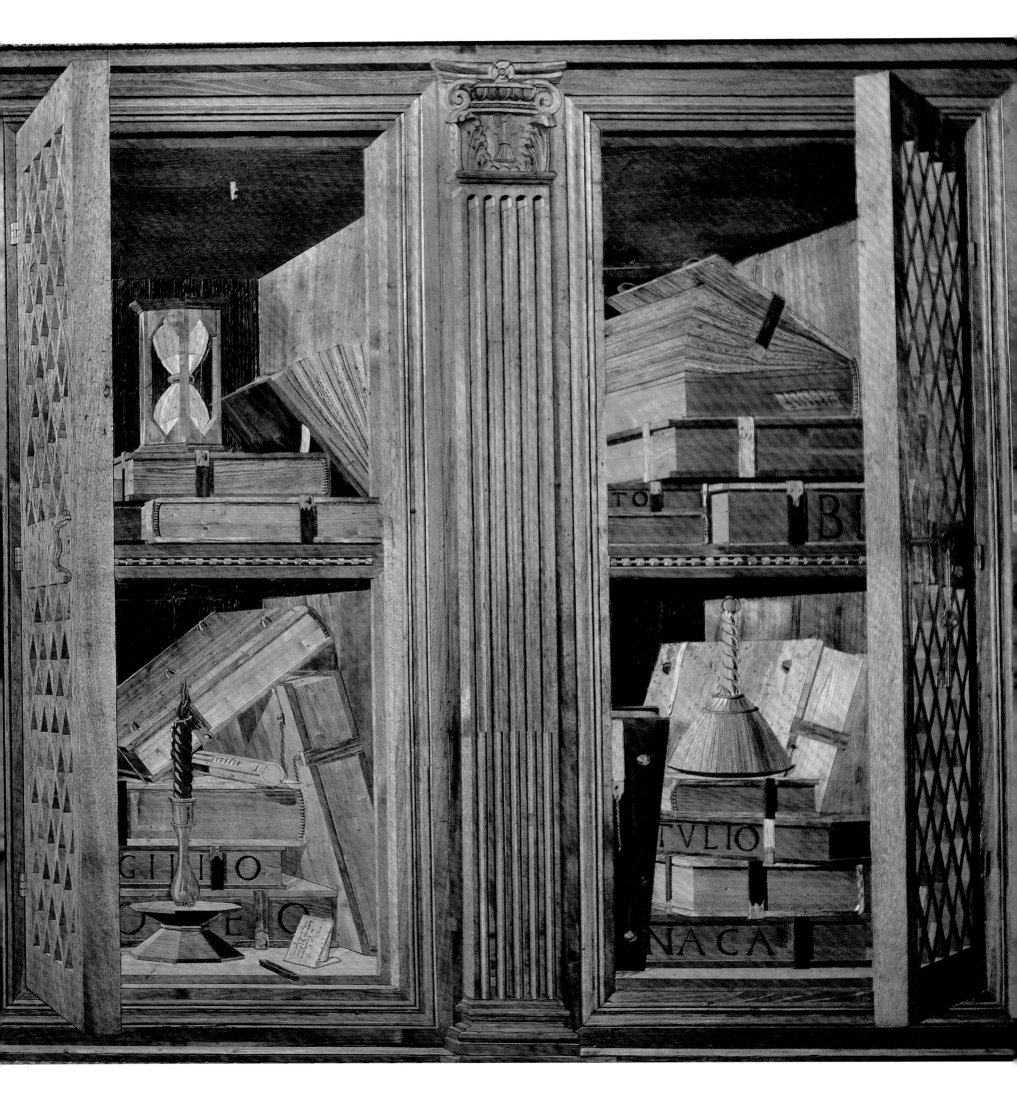

of these requirements were s
sia of the Urbino studiolo. I
been emphasized that the ch
no means casual or simply d
repertory of the intarsia wor
books (plate 42), hourglasse
instruments (plates 15 and 4
paratus (plate 47), and even
(plate 14) can be found in m
other contexts, the entire coll
tended, on a higher level, to
sal harmony theorized by Ne
on the symbolism of music, th
bodies, and poetry. But in a r
phorical reading, they also su
nition ("By virtue, one reach
the Latin motto on a bit of pa
north wall), as well as a tribu
the duke, for whom the mathe
literature were a reflection of t
desired for the state under his

The selection of objects th
messages, both exhortative and
same time. It has also been not
positions subtly symbolize the
the active and the contemplati
was widely debated in the fi
the Urbino studiolo, it found
expression in the Illustrious
twenty-eight paintings (some i
that were placed in two banc
sia work (plate 12), and grou
pairs that illustrate this dualit
discourse is couched in terms
would seem to refer to the du
own life represented a balanc
and contemplation: sources h
to us the image of a command
or leisure, took pleasure in va
pecially music, astronomy,
without disregarding archaeolc
ticularly those related to antiqu
its organs, lutes, armillary sp
and mechanical clocks, the inta
lack for reminders of these int
tium, or the absence of leisure,
litical figure and a Christian sol

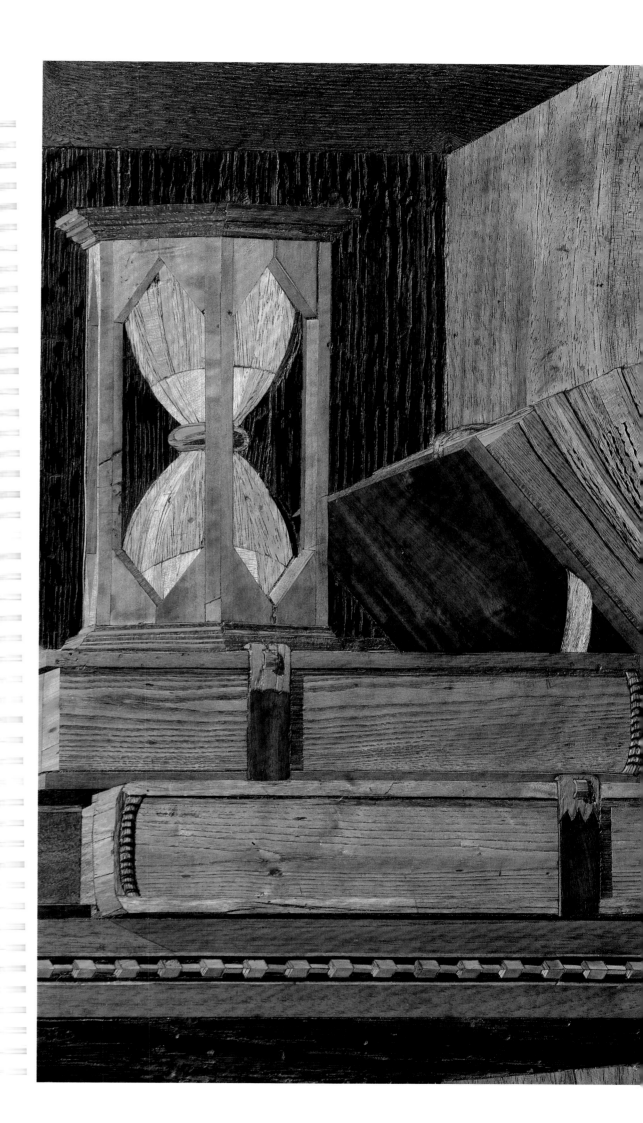

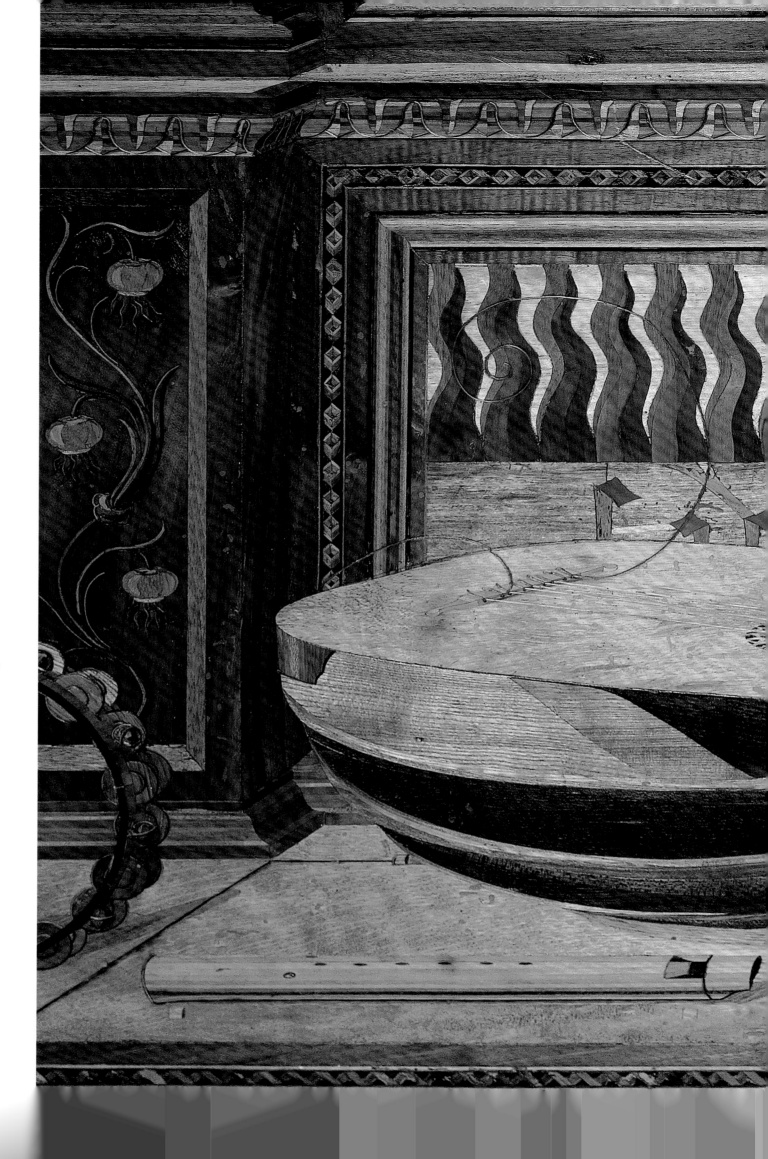

44. Benedetto da Maiano, 1442–1497
Lute and Flutes, 1474–76
Studiolo of Federico da Montefeltro,
Palazzo Ducale, Urbino

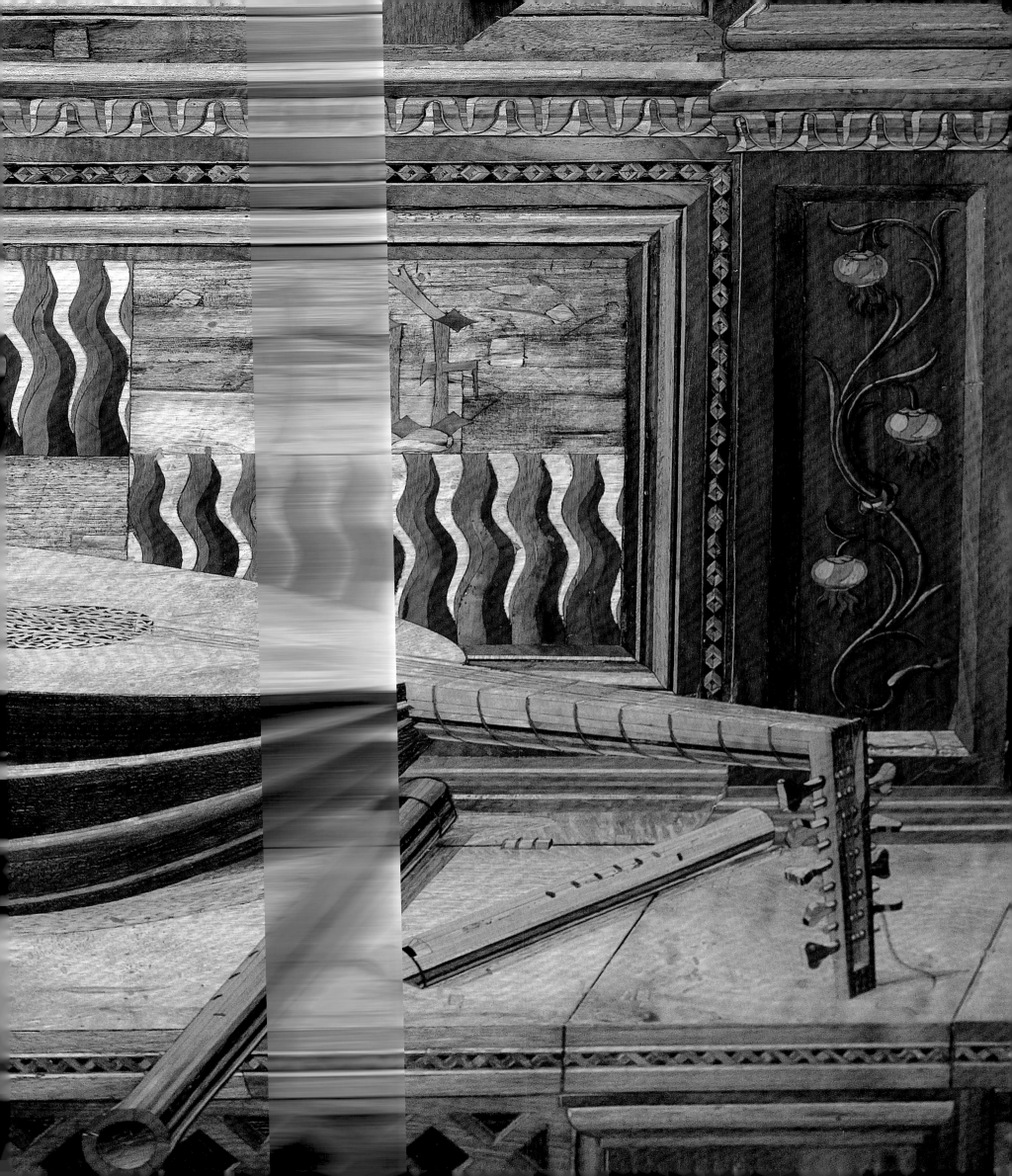

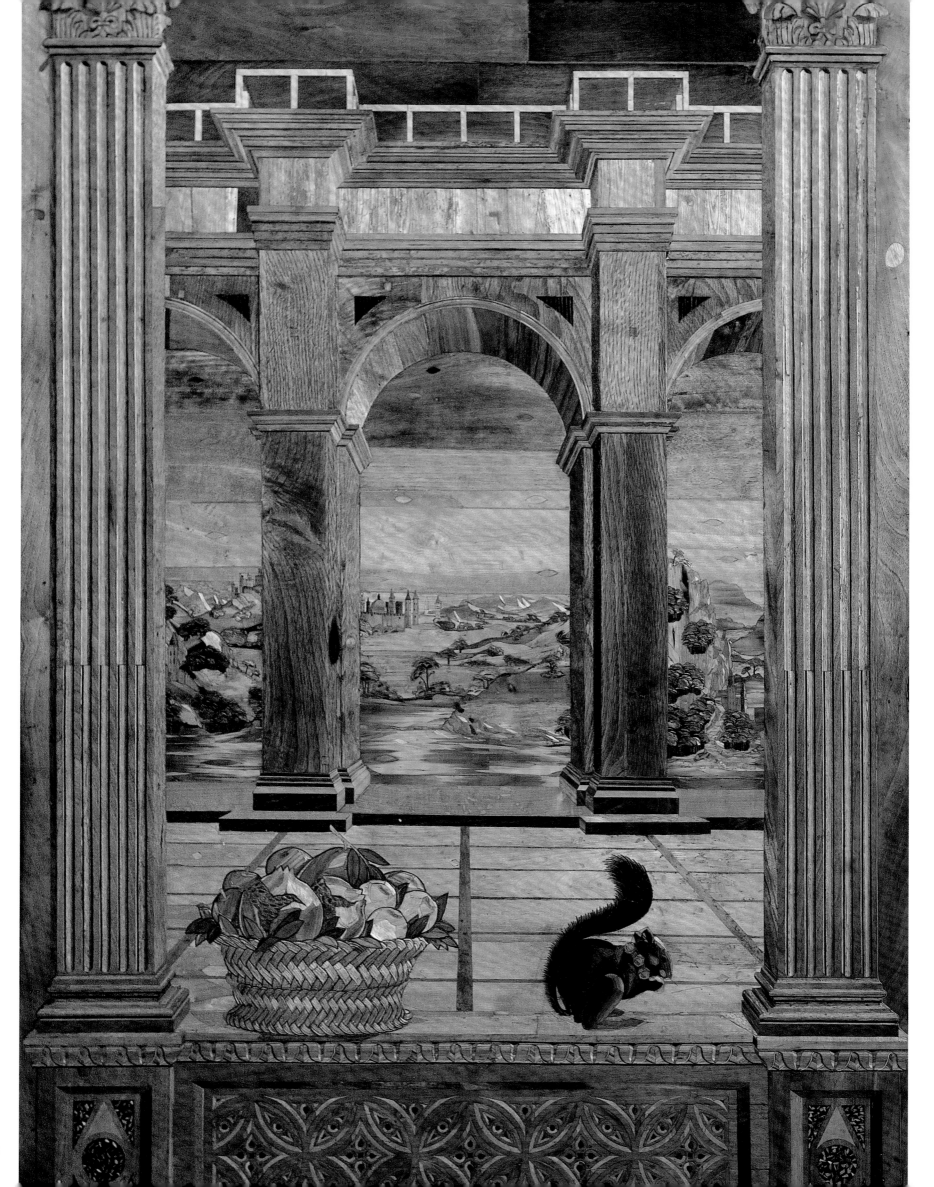

(however self-interested) of ▓▓▓▓
a champion of the faith. The ▓▓▓▓
cabinet of the east wall refe▓▓▓▓
mace placed beneath the pe▓▓▓▓
on the south wall, the theolo▓▓▓▓
turgical objects, and even th▓▓▓▓
rated in the intarsia work, w▓▓▓▓
name "Federico," reveals tha▓▓▓▓
faith (plate 38).[8]

But it is the intarsia of the e▓▓▓▓
sizes most clearly the equilibr▓▓▓▓
ideals. Here the depictions ▓▓▓▓
studiolo (emblems of the act▓▓▓▓
plative life) are placed on the▓▓▓▓
mutually reinforced by the ic▓▓▓▓
central panel (plates 45 and 4▓▓▓▓
symbolizes the duke's *provide*▓▓▓▓
brimming with fruit alludes t▓▓▓▓
is its outcome. Needless to say▓▓▓▓
tively, the means and the end▓▓▓▓
government aspired, in *otium*▓▓▓▓

Finally, the duke's *imprese*▓▓▓▓
ary decorations, and device▓▓▓▓
band that runs between the ▓▓▓▓
nets, recalling his presence th▓▓▓▓
erences. His *imprese* include▓▓▓▓
Federico had inherited fro▓▓▓▓
Antonio da Montefeltro, of ▓▓▓▓
arrow in its beak and a scroll▓▓▓▓
"Ich kann verdauen ein grosse▓▓▓▓
low a large iron), indicating▓▓▓▓
versity. Also represented are▓▓▓▓
according to Pliny, alludes to▓▓▓▓
nade, indicating shrewd rule▓▓▓▓
only when activated); and th▓▓▓▓
izing purity, which Federico▓▓▓▓
with a desire to clear himsel▓▓▓▓
of having killed his half-bro▓▓▓▓
The bridle bit and brush we▓▓▓▓
by the duke of Milan, France▓▓▓▓
Federico's wife, Battista), su▓▓▓▓
power over the state, and the▓▓▓▓
idea of just peace. As for the d▓▓▓▓
fices to mention the Garter an▓▓▓▓
Ermine, while his devices inc▓▓▓▓
love" worn by the Accesi (An▓▓▓▓
Venice's Compagnie della Calz▓▓▓▓

Stocking, or groups of noblemen who organized theatrical performances), which would have reminded the duke of the years he spent in that city and the knightly ideals of the *compagnia*.[10]

Thus these symbols of alliances, honors, and family traditions reinforce the panegyric of the intarsia, though here again a complementary message of moral exhortation is hidden within the grammar of the heraldic signs. Federico could pause to meditate on these references when, his efforts concluded and his arms put aside, he finally sat down with a book in hand, as in the portrait by Joos van Gent and Pedro Berruguete in Urbino's Galleria Nazionale delle Marche. In these moments, one might add, he became the toga-wearing humanist with a lance and the collar of the Ermine who appears on the north wall of the studiolo (plate 40). The chiastic relationship with the painting becomes even more apparent when one notes that, while in the painting the warrior-in-arms devotes himself to meditation, in the intarsia the lettered prince lowers his lance, not out of inertia, but because he has already won the peace.[11]

It should be noted that the studiolo was not the only room in the palace with intarsia work. Very similar motifs (the duke's weapons, musical instruments, an armillary sphere, an aspergillum, books) appear on the door that leads from the Sala degli Angeli to the Sala delle Udienze. And there is no lack of other themes, such as the Triumph of Chastity, on the exterior side of the main door to the Sala della Jole, and the Theological and Cardinal Virtues with Hercules, on a second door in the same room. In the Sala degli Angeli, the antechamber of Federico's apartments, the entrance door is adorned with the Liberal Arts; the door leading to the duke's bedchamber, with Mars and Hercules; and the door leading to the Sala del Trono, with Apolla and Minerva above two ideal city views. Recent iconographic analyses have enabled us to perceive the constant pursuit of an encomiastic and moral framework in these compositions as well, which all contribute to the creation of an orderly microcosm over which Federico reigned supreme.[12]

Given the spiritual, iconographic, and formal similarities, mention should also be made of the

OPPOSITE PAGE
45. Benedetto da Maiano, 1442–1497
Perspectival View with Fruit Basket and Squirrel, 1474–76
Studiolo of Federico da Montefeltro, Palazzo Ducale, Urbino

PAGES 62–63
46. Benedetto da Maiano, 1442–1497
Perspectival View with Fruit Basket and Squirrel (detail), 1474–76
Studiolo of Federico da Montefeltro, Palazzo Ducale, Urbino

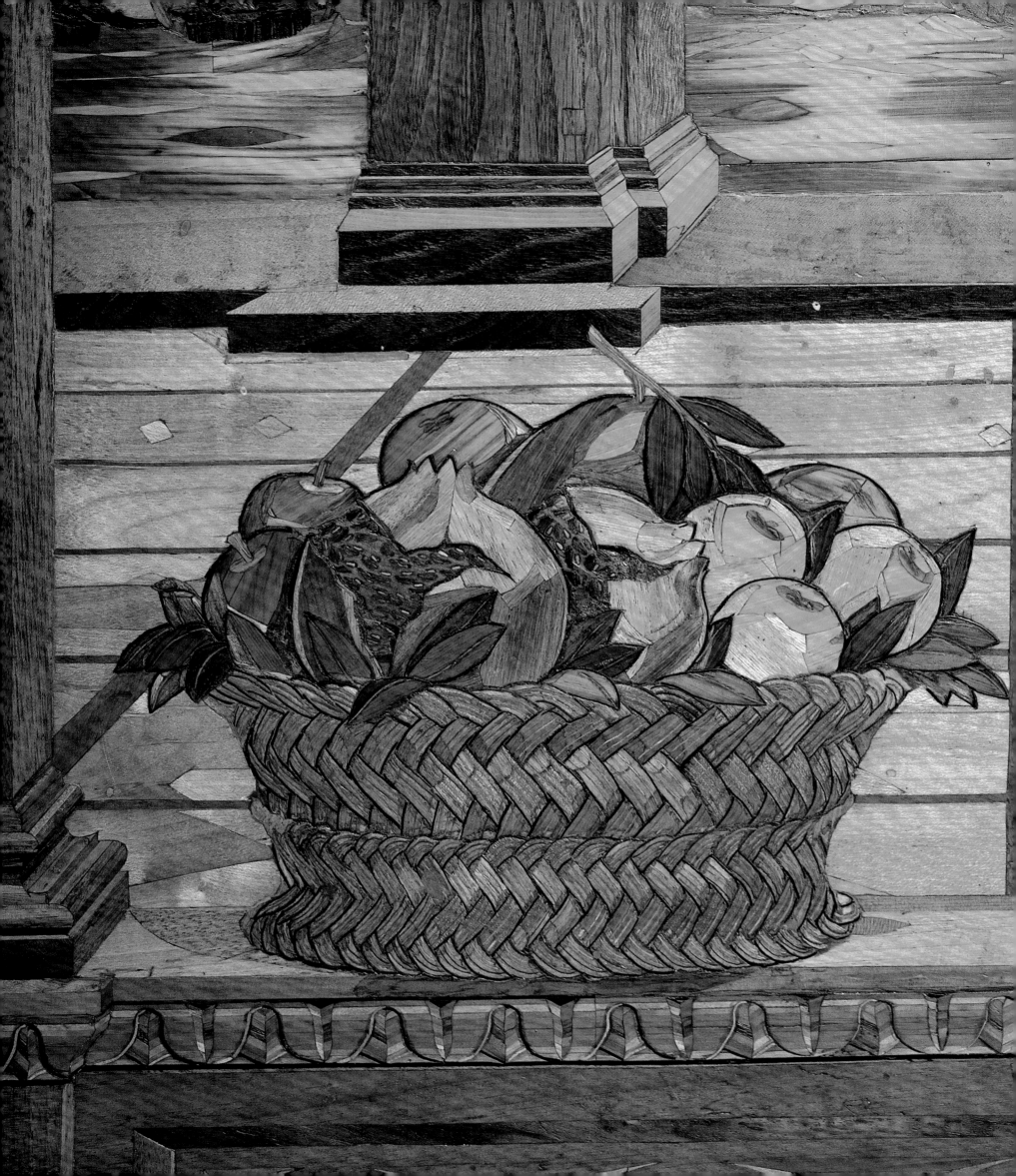

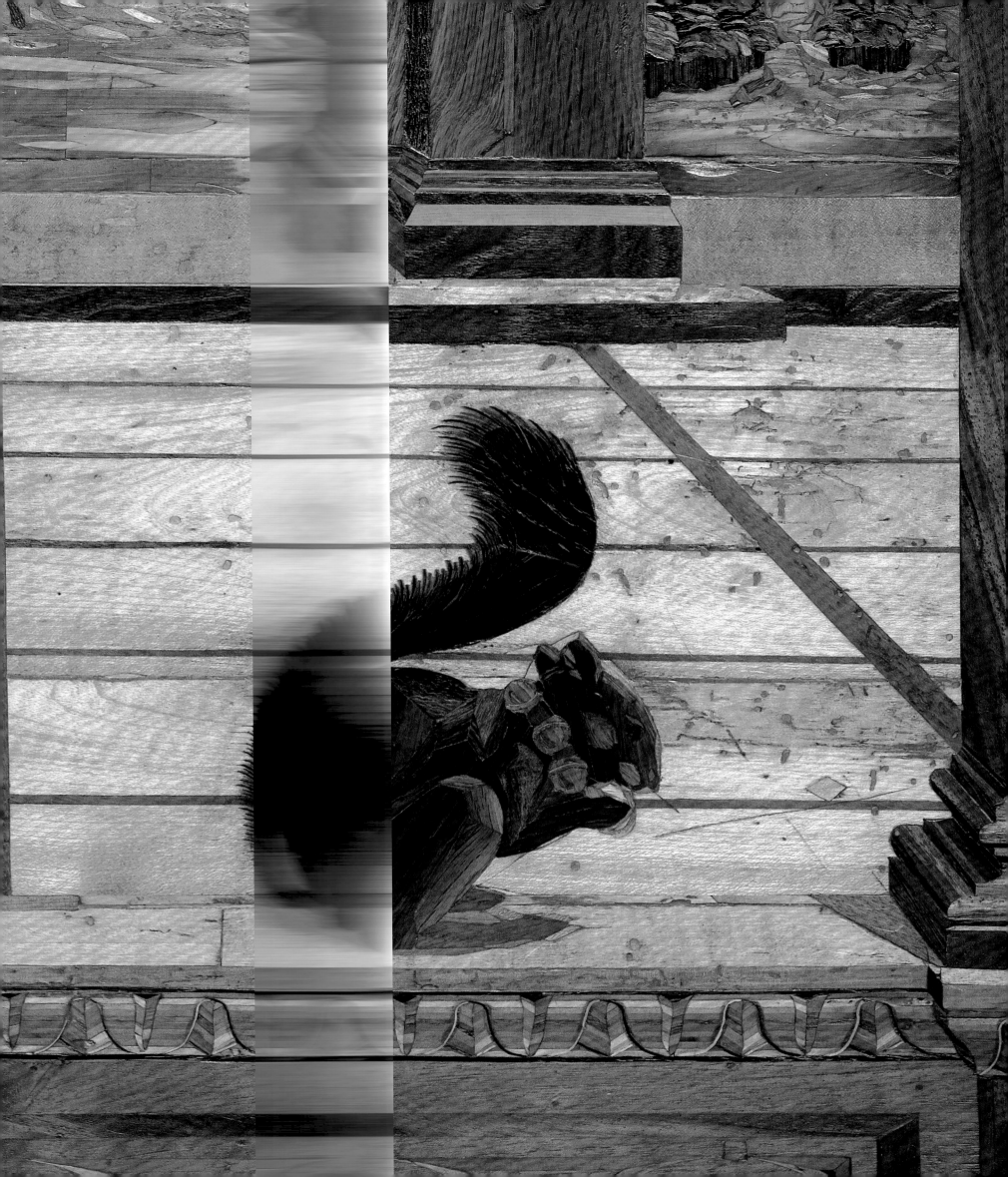

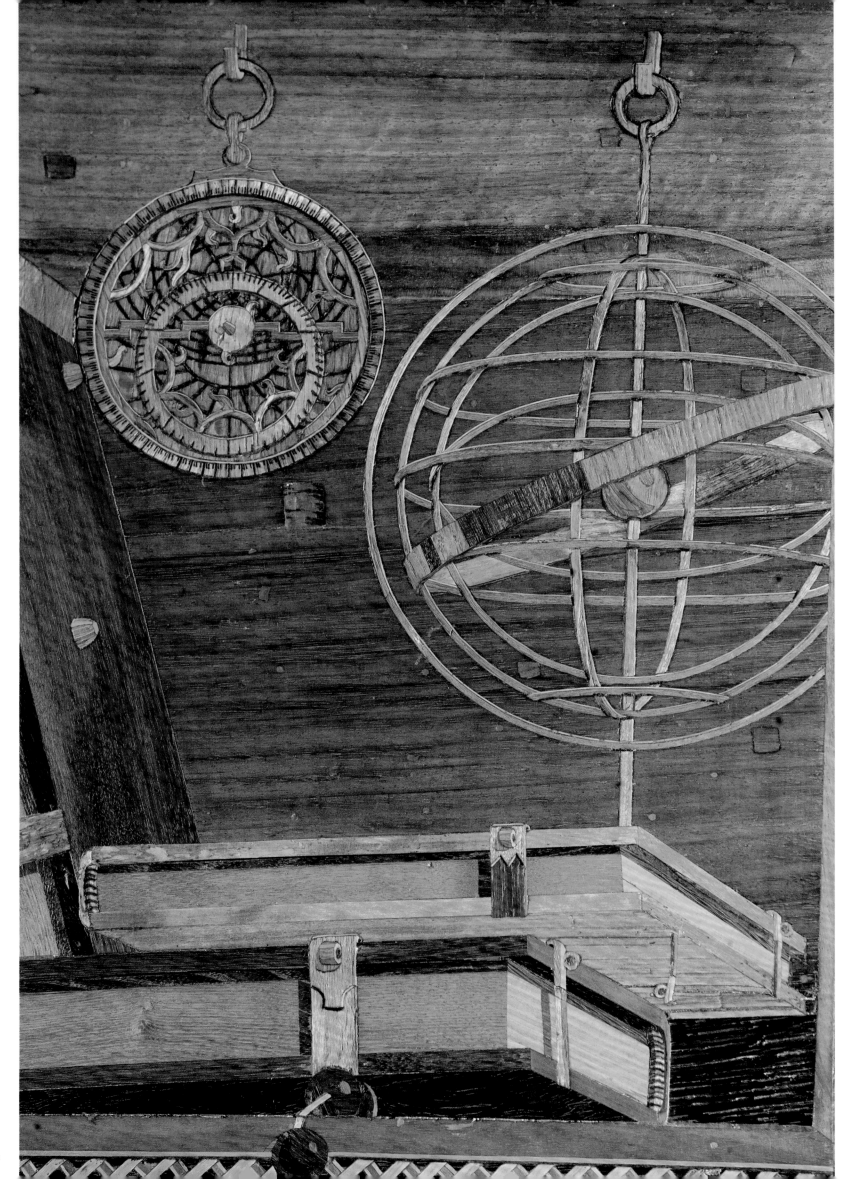

intarsiated studiolo created f[...] bio, the second city of the M[...] installed at the Metropolita[...] New York, the Gubbio studio[...] with certain variations, the same concepts that inform the one in Urbino, confirming the indispensability of this message to the "virtual self-portrait" of Duke Federico da Montefeltro.[13]

OPPOSITE PAGE

47. Benedetto da Maiano, 1442–1497
Cabinet with Astrolabe and Armillary Sphere (detail), 1474–76
Studiolo of Federico da Montefeltro, Palazzo Ducale, Urbino

1. On biographical, cultural, and political events pertinent to Federico da Montefeltro, refer to essays collected in *Federico di Montefeltro,* Cerbeni Baiardi, Chittolini, and Floriani, eds., 1986 (with earlier bibliography), as well as the more recent contribution by Mallet 2004. For more on Federico's dukedom, see Clough 1981. For Federico's relationship with the church, see Miglio 2004. For the political situation in central Italy, see Isaacs 1986.

2. It is likely that work on the palazzo began in the 1450s, but it was not until 1468 that Francesco Laurana received the *patente* to direct the work and bring it to completion; see Westfall 1978; Polichetti, eds., 1985; Fiore 1996; Frommel 2004; Höfler 2006.

3. The expression "virtual self-portrait" comes from Arasse 2006, p. 55. For the significance of the specific location of the studiolo in the palace, see Liebenwein 1988, pp. 25–28; Ciardi Duprè Dal Poggetto 1996, p. 51. Regarding the studiolo itself, for which the bibliography is quite substantial, see the principal contributions by Chastel 1964, pp. 367–80; Heyden-

[...]chi 1971, pp.
[...]1974, pp. 332–56;
[...]i 1982, pp. 517–24;
[...]pp. 25–28; Bagatin
[...]Bagatin 2005; Kirk-
[...]
[...]tudiolo's attribu-
[...]ith references
[...]ohy, by Ferretti
[...]or suggestions that
[...]della Francesca's
[...]verall design, see
[...]; Ciardi Duprè Dal
[...]51–56. But on the
[...]ect's execution,
[...]by Benzi 1996.
[...]l trickery" in
[...]the studiolo is
[...]l its implications
[...]om the concept
[...]ana (Albertian
[...]i 1982, p. 524.
[...]uprè Dal Poggetto
[...]the tripartite
[...]the intarsia work,
[...]retti 1982, pp.
[...]
[...]significance
[...]s relation to
[...]ations by Cheles

1981; Cheles 1982; Limido 1987; Cheles 1991; Arasse 2006. For the origins and meaning of the motif of the caged bird, understood as a symbol of the soul enclosed by material shackles, see Grabar 1966; Hjort 1968; Mihályi 1999. The symbolic value of the musical instruments is addressed by Winternitz 1982. Regarding Federico's marked interest in astronomy and astronomical instruments, see Cieri Via 1986, pp. 52–53. The bit of paper noted in the text reads, in the original Latin, "Virtutibus itur ad astra" (*Aeneid* 9.641). For the Neoplatonism of the decorative programs in the palace, also see Pernis 1993.

7. Cheles 1983; Cheles 1986, pp. 271–73. For the series at the Louvre, see Reynaud, Ressort 1991. For certain technical aspects, see Martin 1998.

8. On this subject, see Clough 1984. For development of the iconography and for riddles in the studiolo, see Cheles 1986, pp. 274–75, 277, 281–82; Arasse 2006, pp. 29–33.

9. The reference to the active and the contemplative life in these two panels is identified by Cheles 1986, p. 272,

who also insists on the presence, among the Illustrious Men, of the pairings of Cicero/Seneca and Moses/Solomon, corresponding to the armor, and Homer/Virgil and Thomas Aquinas/Duns Scotus, corresponding to the lectern. The landscape with the basket of fruit is interpreted in the same manner as well (pp. 279–80). On *providentia*, see Ciardi Duprè Dal Poggetto 1996, pp. 51, 54. On the symbolic tradition of the squirrel, see Gentili 2000.

10. Nardini 1931; Cieri Via 1992, pp. 137–40.

11. The political and encomiastic significance of the painting, in this context, is analyzed by Rosenberg 1986. In the intarsia, however, Federico appears with the lowered lance attributed to the *Mars paciferus* seen on Roman coins; see Cheles 1986, pp. 278–79.

12. Cieri Via 1986. On the ideal views in the intarsia, see Trionfi Honorati 1983.

13. The Gubbio studiolo has been exhaustively analyzed in its totality by Raggio 1999.

3

PA███████████████AND RELIQUARY CABINET
O1███████████████L SANTO, 1462–69, 1475–77

███████████████zo Canozi da Lendinara

███████ica Molteni

On the night of March 28–29 ████████████
which began in a confession████████████
pel of Saint Joseph, irreparabl████████████
bytery of the Basilica del Sar████████████
Basilica) in Padua. All the w████████████
furnishings were reduced to ████████████
paneling of the ambulatory, t████████████
organs near the high altar, the████████████
choir, with its sumptuous in████████████
by Cristoforo and Lorenzo C████████████
between 1462 and 1469.[1] Th████████████
choir to be spared were two sta████████████
perspectival city view giving████████████
scape (plate 51), the other with████████████
ica from the nearby Cloister of████████████
52). However, their survival ████████████
entirely positive fortunes of th████████████
structure in the century prior t████████████

Between 1651 and 1654, L████████████
painter and architect from Re████████████
drawn up a plan to modernize████████████
the church, at the request of t████████████
the commission in charge of th████████████
commodate the redesign, the████████████
Canozi—originally aligned in ████████████
central bay of the crossing, f████████████
in front of Donatello's altar, i1████████████
Catholic doctrine prior to the C████████████
had been moved behind the h████████████
semicircle defined by piers of████████████
This change had been forcefu████████████
because of the inevitable corru████████████
nal plan and because of the m████████████
cern that the choir would not s████████████
since its wood was, according to████████████
counts, so "ancient, decayed, ████████████
throughout" that it might crum████████████
ters and dust."[3]

Nonetheless, the operation tu1████████████
invasive than feared, and when████████████
located, only two seats were sacr████████████

light of the tragedy that later befell this part of the basilica, the changes could be seen as providential, since they were responsible for the preservation of the city views that decorated the backs of the two seats removed from the choir. These seats were initially mounted into the confessionals that Bedogni designed for the Chapel of the Black Madonna in 1652, and finally transferred to the Chapel of Saint Rose of Lima in the nineteenth century.[5]

While the perspectival skill, clarity of design, and chromatic richness of this intarsia cycle may still be appreciated from the two surviving panels, the magnitude of the loss would seem to prevent an adequate reconstruction of the whole. But there is a sound body of documentary evidence attesting to the Canozi's work in the basilica, and the eloquence of these sources compensates in large part for the material losses and enables us to understand the construction of the choir from a broader viewpoint, encompassing the historical development of the presbytery and the professional careers of its authors.

The Canozi's commission was part of a project to redefine and update the decoration of the main chapel, initiated by the Arca del Santo in the 1440s and partially completed with the installation of Donatello's altar in 1450.[6] At this point, however, there still remained the problem of resolving the jarring contrast between the bold and sensational theatricality of this Renaissance creation and the ancient mass of the fourteenth-century choir. In 1462, it was finally decided that the old choir would be replaced, and Cristoforo and Lorenzo Canozi were engaged to create the new one.

The original scope of this commission can be fairly approximated from a contract dated April 27, 1462, and signed by both artists, committing them to build the choir according to plans they had presented and within a maximum time of eight years (to be measured from the following July). It was to be constructed of good-quality

OPPOSITE PAGE
48. Lorenzo Canozi, 1425–1477
Saint Louis of Toulouse (detail), 1475–77
Basilica del Santo, Padua; sacristy,
reliquary cabinet

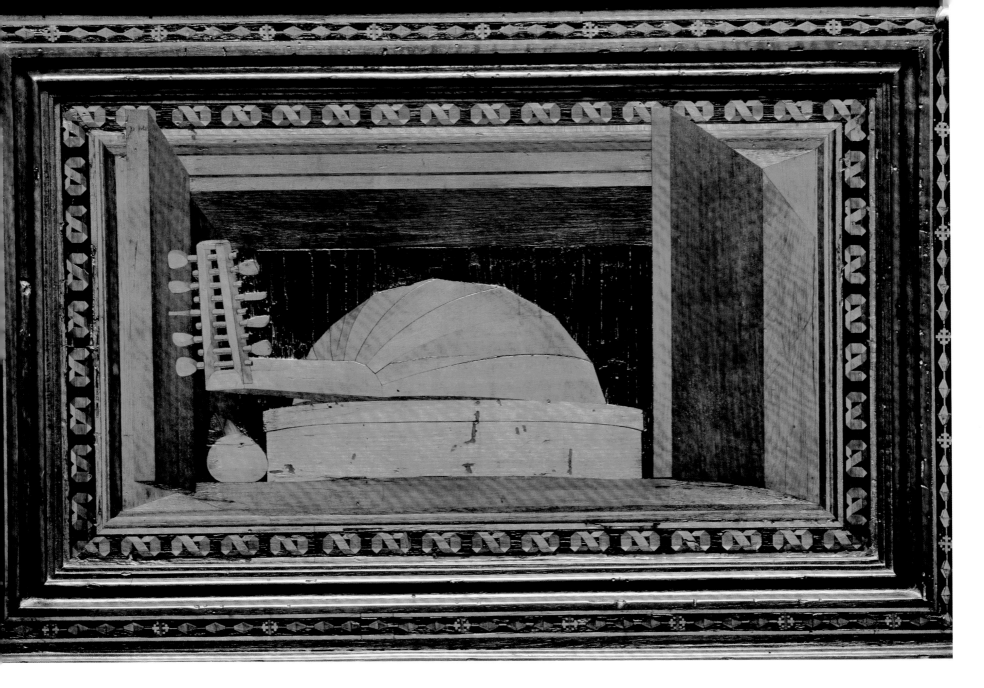

49. Cristoforo Canozi, c. 1426–1491,
and Lorenzo Canozi, 1425–1477
Still Life with Musical Instruments,
1461–65
Duomo, Modena; choir, panel from
eighth upper stall on the left

wood, with fifty-two large stalls, crowned by baldachins with gilded stars, and thirty-eight smaller ones.[7] The stalls were to be decorated with capitals, foliage, and fretwork, as well as one intarsia panel each. The brothers would also create four small lecterns and one large one, likewise suitably decorated with intarsia, to be placed at the center of the space.[8]

Completed in the middle of 1469, the work immediately aroused the admiration of contemporary witnesses, and it is precisely this unexpected success that makes it possible to reconstruct, if only generally, the iconographic scheme of this *clarissimum opus* in intarsia. It should be noted that the monks of the Arca del Santo placed no particular constraints on the commission, limiting their requests to the inclusion of ten panels with half-length figures of saints, whose identities they would have decided themselves. We may assume that the compositions were constructed ac-

cording to the rules of perspective, and featured enough different themes for each intarsia panel to be unique.

On this subject, an essential source is the "Laus perspectivae" (printed in Venice in 1486), an epistolary essay by the Sicilian monk Matteo Colazio, addressed to Cristoforo, Lorenzo, and the latter's son-in-law, Pier Antonio degli Abati. Colazio endorses the supreme skill of the three artists by comparing them to the renowned Greek masters Parrhasius, Phidias, and Apelles. He also provides an accurate description of the now-lost intarsia work of the Paduan choir, attesting that it had excited much admiration in observers for the perspectival knowledge and mimetic skill displayed, which were such that everything depicted seemed real, indeed *veris veriores* (realer than real), and not an artistic fiction.[9]

Reading through Colazio's epistle, one encounters many of the canonical subjects of the

Lendinarese artists' repertoi[...]
in their choir stalls of a sim[...]
and Parma),[10] subjects whos[...]
(achieved by the alternation c[...]
precision and accuracy of rer[...]
tion, and refined inlay tech[...]
produce the superior illusioni[...]
ities that so enchanted Colazi[...]
lievable than authentic ones,[...]
closed or half-closed, arrangec[...]
ways; wax candles, some strai[...]
or greatly inclined" or place[...]
laden fruit bowl, from which [...]
instruments; a cage with a mu[...]
that leaves the viewer in dou[...]
is alive or not"; and the usual [...]
jars, a plane, a chalice covere[...]
a censer—arranged with pers[...]
There are also city views with[...]
and churches, "where one see[...]

arches and windows that cast shadows, half-closed doors that offer glimpses of the space inside." Finally, there are the figures of saints, among which the writer particularly admires the Saint Prosdocimus (the first bishop of Padua), rendered with "white curls beneath his chin, like a collar," and an Annunciation, with the archangel Gabriel and the Virgin surrounded by leafy branches whose shape and "luxuriance of fronds and fruit" would not easily be equaled in nature.

That long list, in addition to a mention by the sixteenth-century writer Valerio Polidoro of a Saint Louis and a view of the basilica itself,[12] as well as the two surviving intarsia panels in the Chapel of Saint Rose of Lima, provide a quite satisfactory overall impression of what the Canozi depicted on the backs of the choir stalls in Padua. An even clearer picture emerges if one considers that the aforementioned use of standard themes as a basis for the iconographic program makes it

ABOVE
50. Cristoforo Canozi, c. 1426–1491, and Lorenzo Canozi, 1425–1477
Open Book, 1461–65
Duomo, Modena; choir, panel from third upper stall on the left

PAGE 70
51. Cristoforo Canozi, c. 1426–1491, and Lorenzo Canozi, 1425–1477
Gate to the City and Hilly Landscape, 1462–69
Basilica del Santo, Padua; Chapel of Saint Rose of Lima

PAGE 71
52. Cristoforo Canozi, c. 1426–1491, and Lorenzo Canozi, 1425–1477
View of the Basilica del Santo from the Cloister of the Magnolia, 1462–69
Basilica del Santo, Padua; Chapel of Saint Rose of Lima

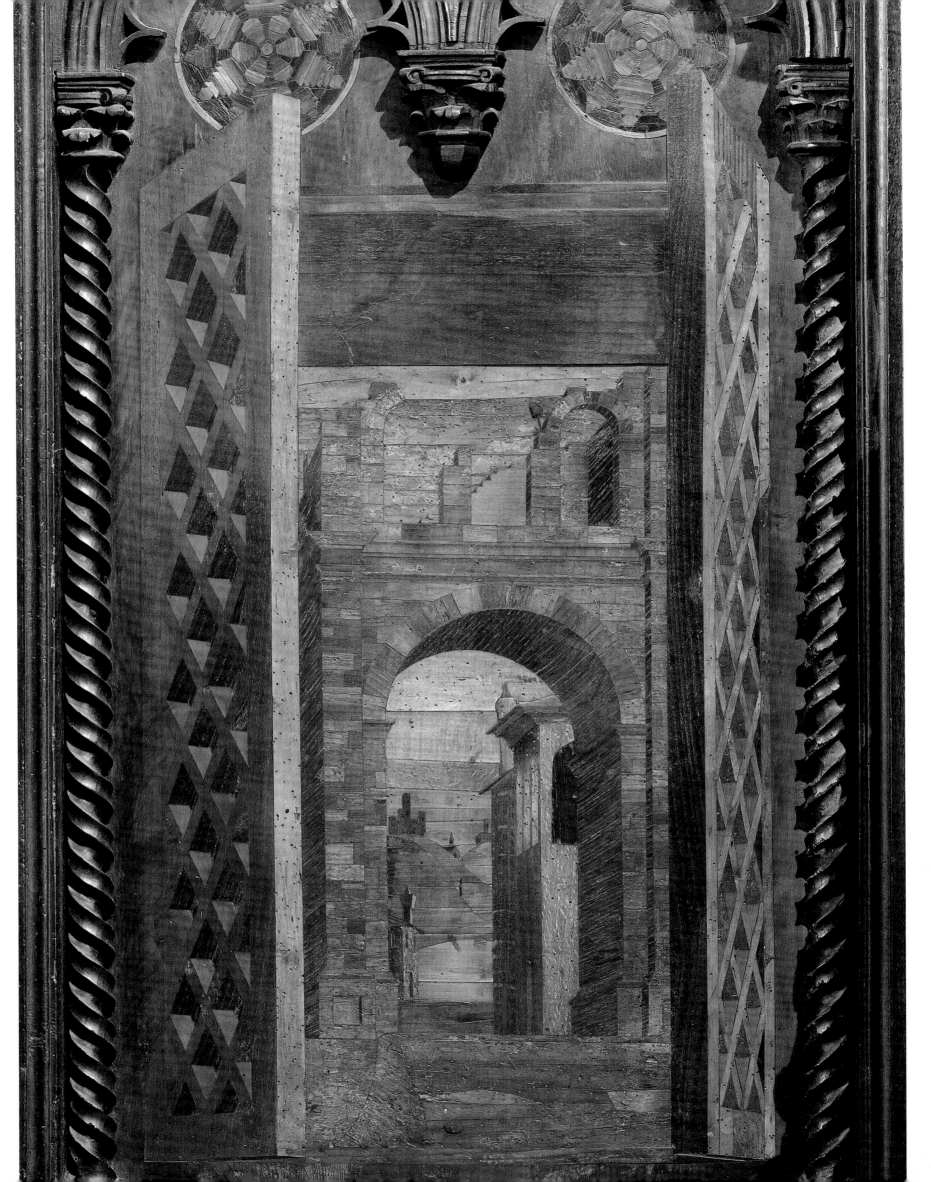

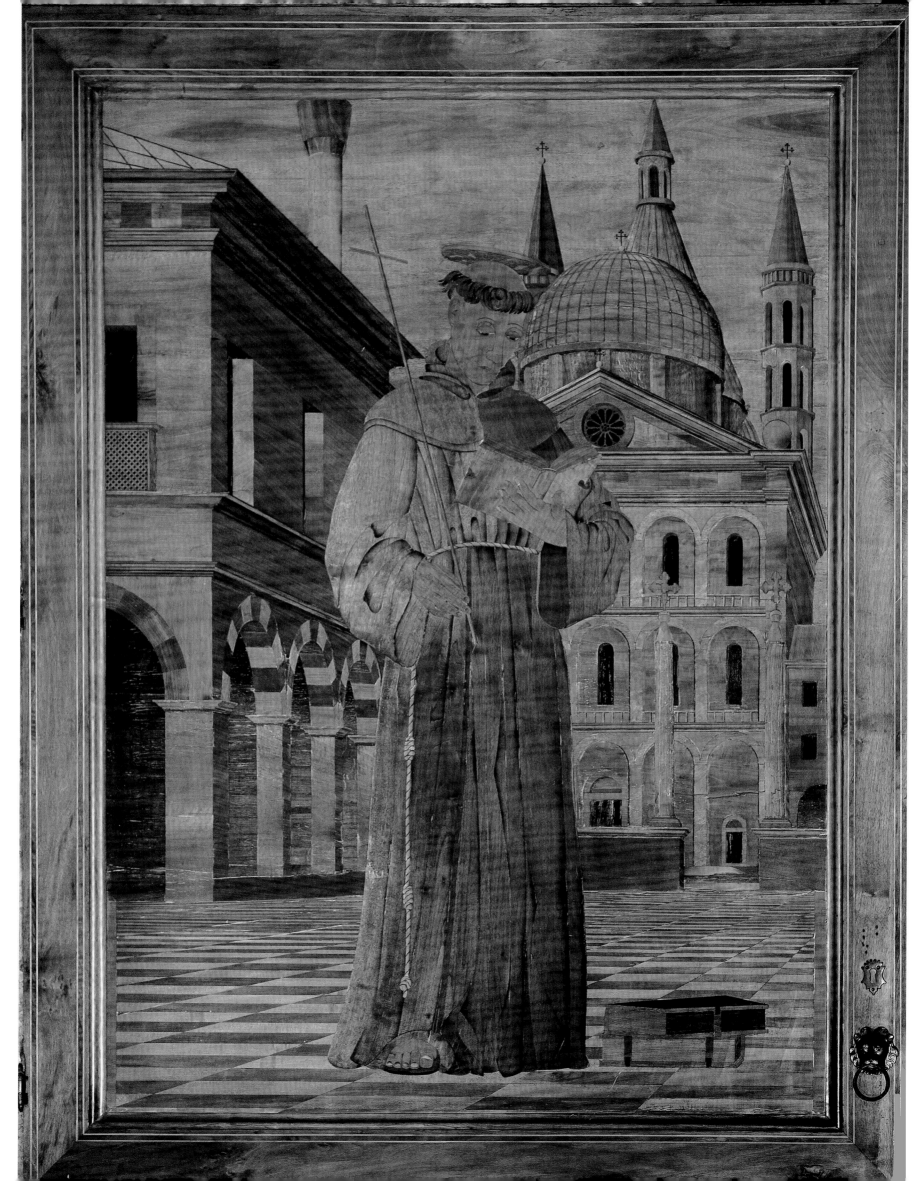

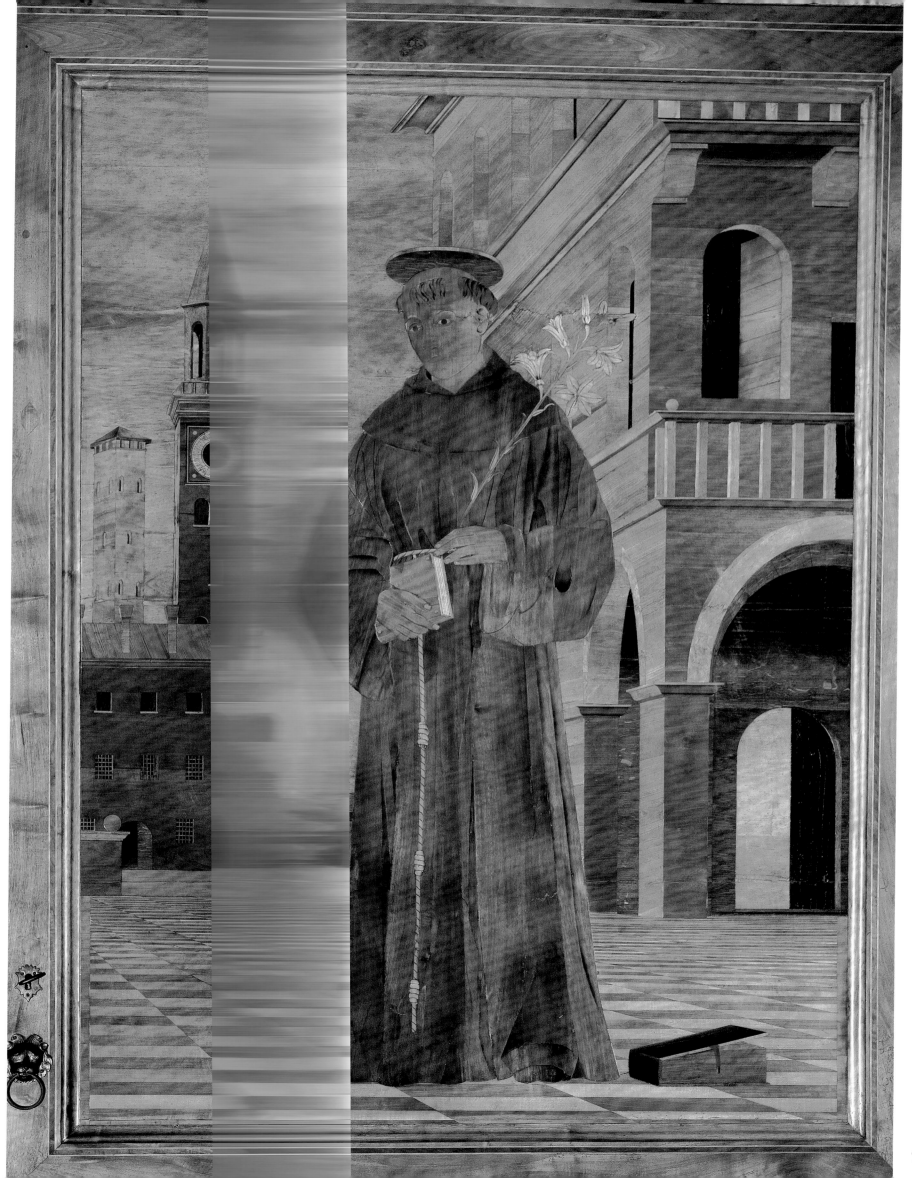

PAGE 72
53. Lorenzo Canozi, 1425–1477
Saint Francis, 1475–77
Basilica del Santo, Padua; sacristy,
reliquary cabinet

PAGE 73
54. Lorenzo Canozi, 1425–1477
Saint Anthony, 1475–77
Basilica del Santo, Padua; sacristy,
reliquary cabinet

ABOVE
55. Lorenzo Canozi, 1425–1477
Reliquary cabinet intarsias, 1475–77
Basilica del Santo, Padua; sacristy

possible to identify, within the Canozi workshop's body of surviving work, other renditions of the subjects described by Colazio. This repetition also points more generally to the existence of a shared repertory of motifs intended specifically for the decoration of choir stalls. Within this repertory, *varietas* was achieved through the three principal genres of the still life, the urban landscape, and the representation of the human figure, which in turn became vehicles for the allegorical implications residing in the images and, even more, in their possible combinations. While the common premise of this iconography remained the celebration of universal harmony, symbolized by objects such as books, clocks, and musical instruments,[13] it is also true that the individual motifs referred more specifically to themes of meditation that were more intimately connected to the daily experiences and the moral and spiritual aspirations of the client,[14]

whose devotional inclinations would also have determined the selection of the figures of saints that normally completed intarsia cycles. We have already observed the latter in the Paduan cycle, and Colazio's partial account also reveals an emphasis on the theme of the transience of existence, represented by the depictions of candles, and that of the soul imprisoned in matter, represented by the bird in the cage,[15] while the musical instruments were an allusion to spiritual perfection, attainable only through the practice of faith—in turn symbolized by the liturgical objects.

Yet many other iconographic details of the project still cannot be recovered, nor can its presumed perspectival subtleties, mentioned in a specific contractual clause, not to mention the specific order and distribution of the individual motifs, which must have revealed many thematic, perspectival, and structural connections.

The possibility of evaluatin
cifics of the intarsia work a
stylistic code underlying its
equally elusive. The two su
backs obviously give only a
picture of the project, preven
of the apparent preeminence a
whom the documents freque
as the "maestro del choro."[16]
apparently substantiated by
clusive—and continuous—p
in the choir of the Modena c
50) in 1464 and 1465, has so
to indicate a division of resp
in the family workshop. Th
anteed that Lorenzo had nea
over the project in Padua,
presents characteristics both
cized sky—blue with gol
the upper stalls) and iconog
probably based on actual vie
inconsistent with other wo
the other hand, it is import
the principal source related
Colazio's "Laus perspectivae
ers, adding the name of Lor
Antonio degli Abati, as t
connoisseur Marcantonio
shortly thereafter in his no
present state of knowledg
therefore remain open, if i
persist in trying to identify
ality that would not really
work of an acknowledged
fellowship such as this one

In any case, the success o
del Santo led the monks to
ship with the Canozi in the
deed, in 1469 the brothers
preparation of six wooden
around Donatello's altar, a
same period, also delivere
thony to be placed in fro
to him.[20] But the Canozi
cant new commission fr
until 1474, when Lorenz
had moved on to the art o

success[21]—was engaged to decorate the doors of the new cabinets in the sacristy of the relics.[22]

Completed in 1472 by the Paduan sculptor Bartolomeo Bellano, the monumental structure of these cabinets occupied the entire west wall of the sacristy. Beginning work in the spring of 1475, Lorenzo was thus confronted by a preexisting marble facade, in which it remained to fill, with decorated doors, the three large apertures between the piers of the upper register and the four smaller ones at the sides of the lower register (plate 55).[23]

The solution he adopted for the doors of the lower register clearly recalls the conventional motifs of intarsia work, with an illusionistic play of half-open cabinet doors that reveal shelves supporting chalices, books, and wooden boxes. Pier Luigi Bagatin has rightly noted that these motifs, "in their fiction, refer to the reality of the furniture to which they are applied,"[24] and probably also indicate the actual contents of the cabinet's lower shelves. However, the power of invention evident in the arrangement of the principal register is of another order entirely. Here the unusual dimensions of the space to be covered in intarsia create in themselves a notable scenographic impact, which is further heightened by the decision to develop, in the central panels, an urban perspective of great breadth, against which the figures of Saint Francis (plate 53) and Saint Anthony (plate 54) stand out, silent and monumental, accompanied by four other saints inscribed within the shadowy depth of the niches delineated on the side shutters: Saint Bernardine (plates 56 and 57) and Saint Jerome (plate 56) on the left, Saint Louis of Toulouse (plates 48 and 58) and Saint Bonaventure (plate 58) on the right.[25]

Leaving aside the matter of the division of responsibilities—once again difficult to discern—on a project that was clearly headed by Lorenzo, but which was brought to completion after his death in 1477 by Pier Antonio degli Abati,[26] there is no doubt that these iconographic innovations can be ascribed to Lorenzo.[27] Yet once again the present condition of the work precludes the possibility of understanding the artist's stylistic approach. The devastating cleaning and subsequent

PAGE 76
56. Lorenzo Canozi, 1425–1477
Saint Bernardine and *Saint Jerome*, 1475–77
Basilica del Santo, Padua;
sacristy, reliquary cabinet

PAGE 77
57. Lorenzo Canozi, 1425–1477
Saint Bernardine (detail), 1475–77
Basilica del Santo, Padua;
sacristy, reliquary cabinet

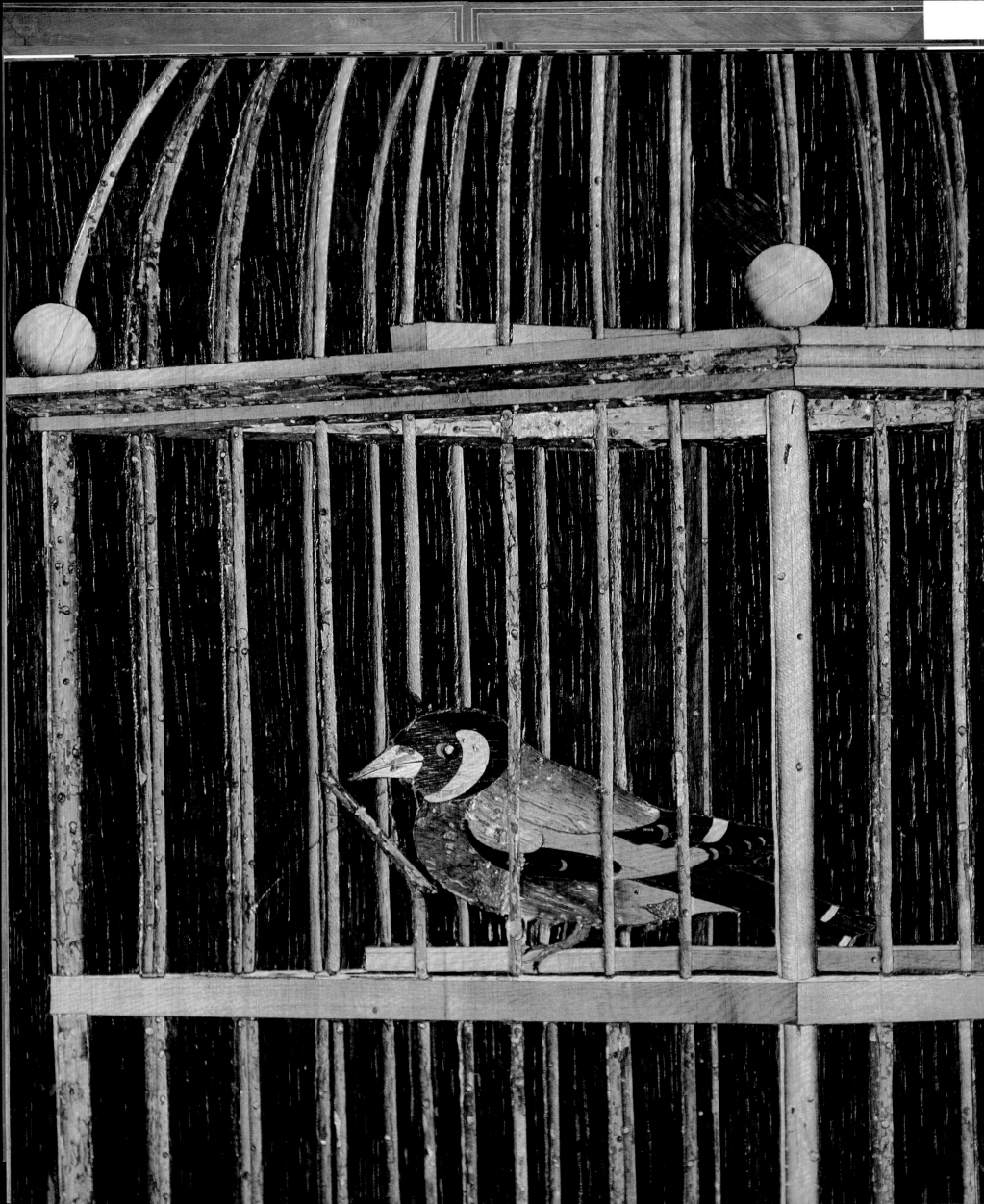

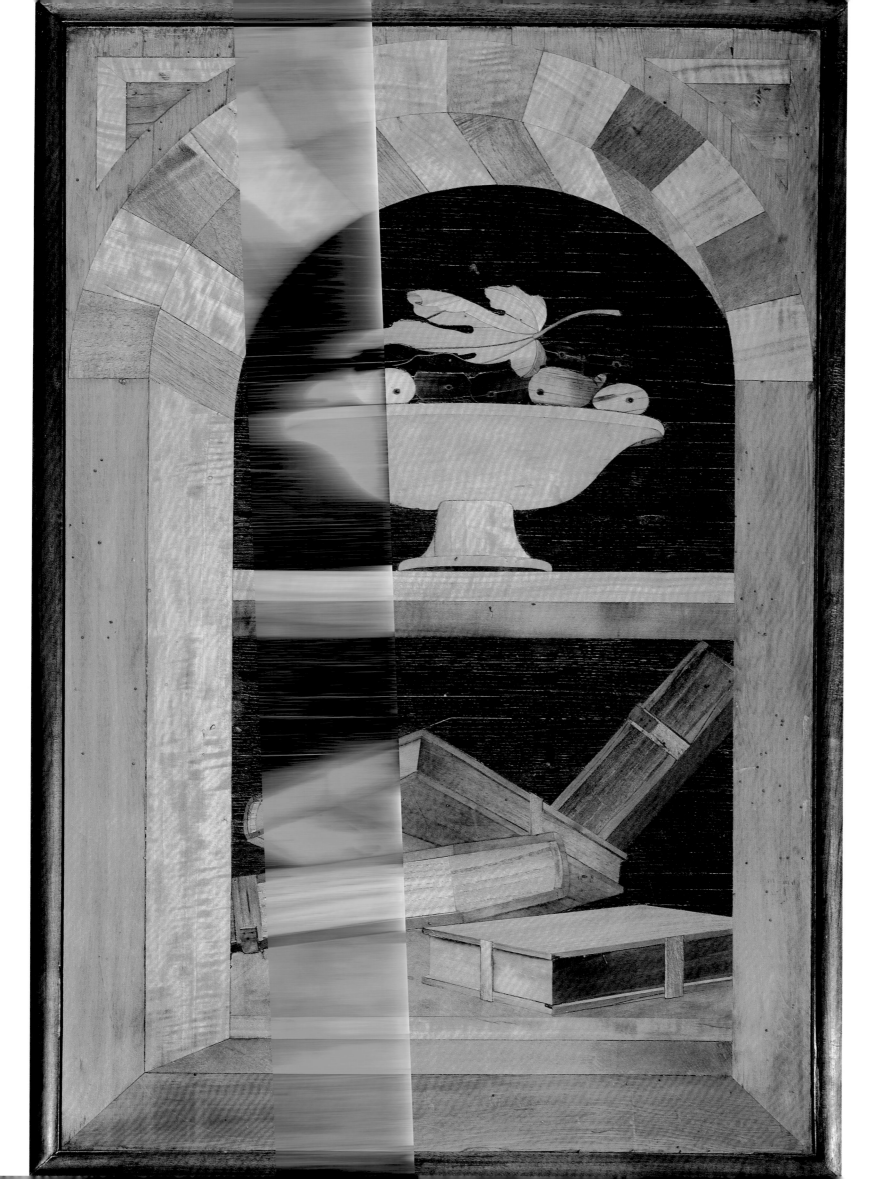

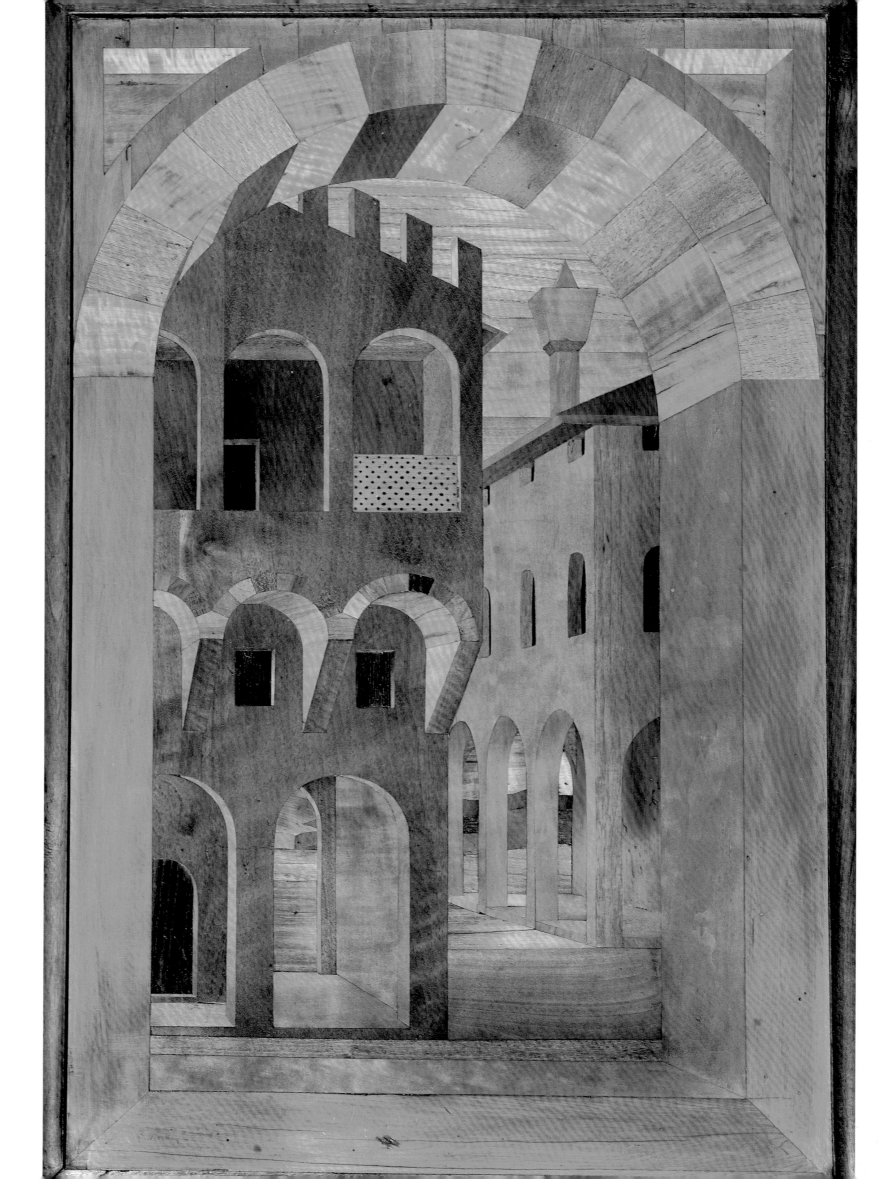

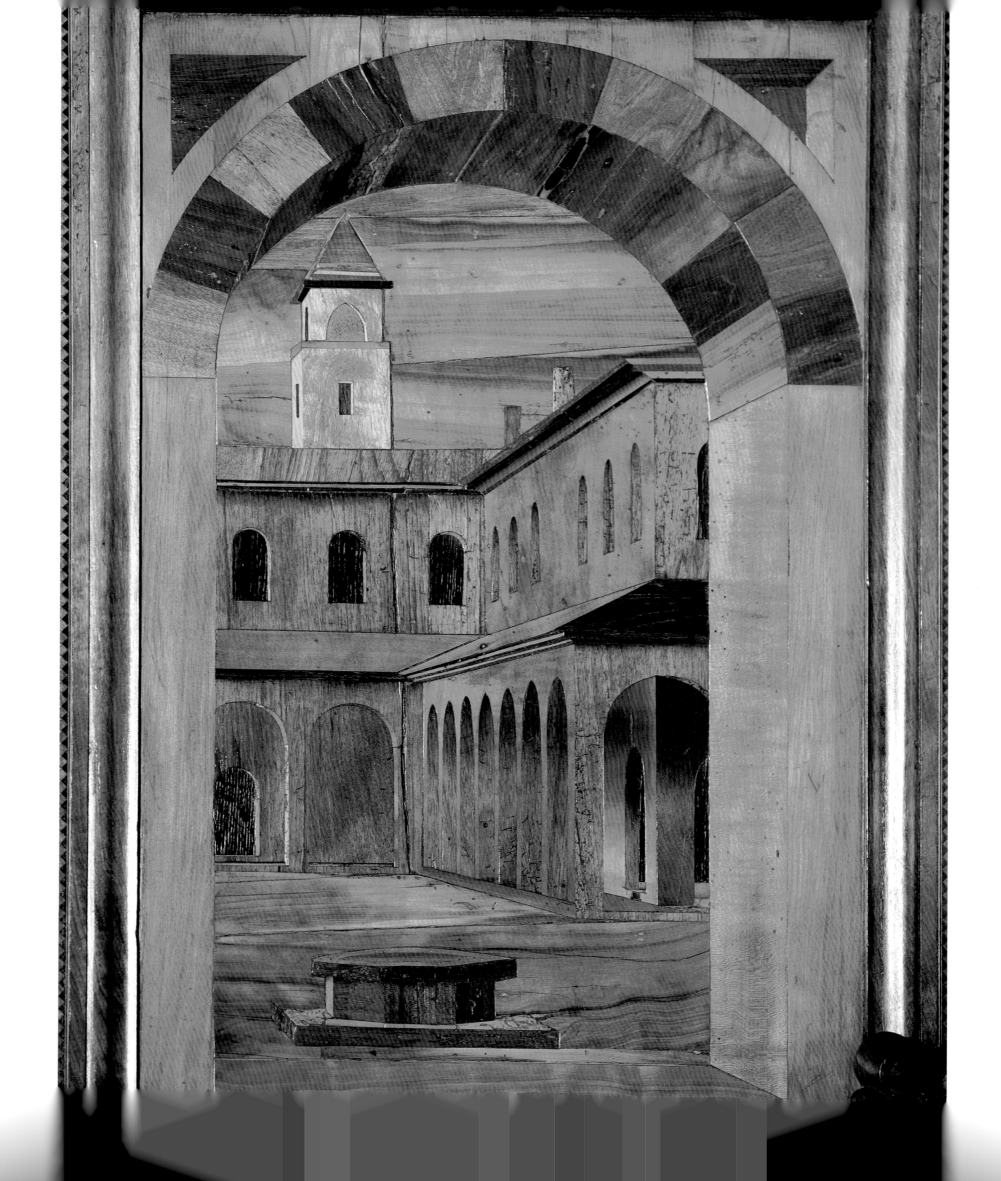

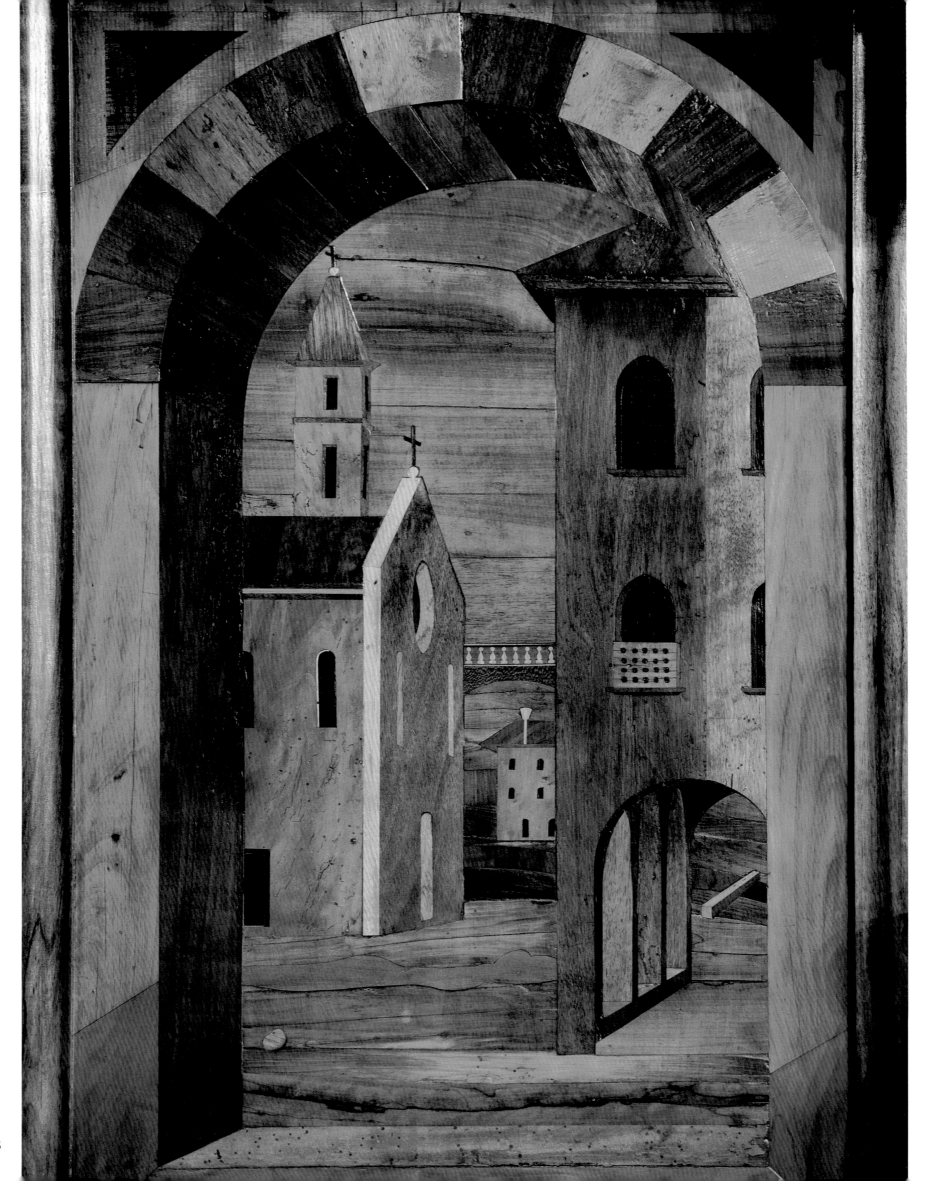

for perspective.[26] This was a tale [...] his encounter, mediated by the [...] language of Piero della Francesca [...] fectly understood and assimilated [...]

Pier Antonio degli Abati, *magis[...]* thus gives an account of "his" cit[...] its buildings: real houses that he m[...] upon or ideal palaces rendered [...] verisimilitude. The particular con[...] recognizable in some of these scen[...] seemed all the more vivid, concrete[...] with significance to those who had [...] time—down to even its minor arch[...] fore their eyes.

In intarsia after intarsia, the st[...] one another, and a story unfurls, m[...] chanted moments, of ecstatic stage se[...] almost outside of time. There are h[...] notations—the evolution from a m[...]

proto-Renaissance architecture is clear—and yet the feeling is eternal. Crystalline rhythms regulate the geometry of these city views, which a motionless zenithal light helps turn into enchantingly abstract, almost "metaphysical" inventions.[28]

Just when a real attempt was being made to renew the urban fabric of Vicenza, contingent obstacles to this transformation emerged, and with them fears that the enterprise might remain confined to paper or be only partially completed, and thus essentially fail. The best response to this apprehension was the ideal city, informed by the architectural revival of the early Renaissance, that Pier Antonio degli Abati constructed at Santa Corona, as well as at San Bartolomeo and, perhaps, Monte Berico: a city within the city that presents us with an image, albeit stereotyped and incomplete, of what the *renovatio urbis* would have signified for Vicenza.

OPPOSITE PAGE
77. Pier Antonio degli Abati, c. 1430–1504
City View with Religious Building,
c. 1487–89
Sanctuary of Monte Berico, Vicenza; choir
(formerly in the San Bartolomeo choir)

BELOW
78. Andrea Mantegna, 1431–1506
Martyrdom of Saint Christopher and the Transport of His Body, 1453–57
Church of the Eremitani, Padua;
Ovetari Chapel
Pier Antonio would have encountered the new architecture of his time not only on the city streets, but also through paintings such as this one. Mantegna's work in the Ovetari Chapel must have been known to the Modenese intarsist, who was in close contact with Paduan circles before his arrival in Vicenza. Like Mantegna's frescoes, Pier Antonio's intarsia panels reveal a careful study of the most recent formal developments in architecture, as well as an interest in the representation of perspectival spaces that give way to more distant vistas, glimpsed through arcades.

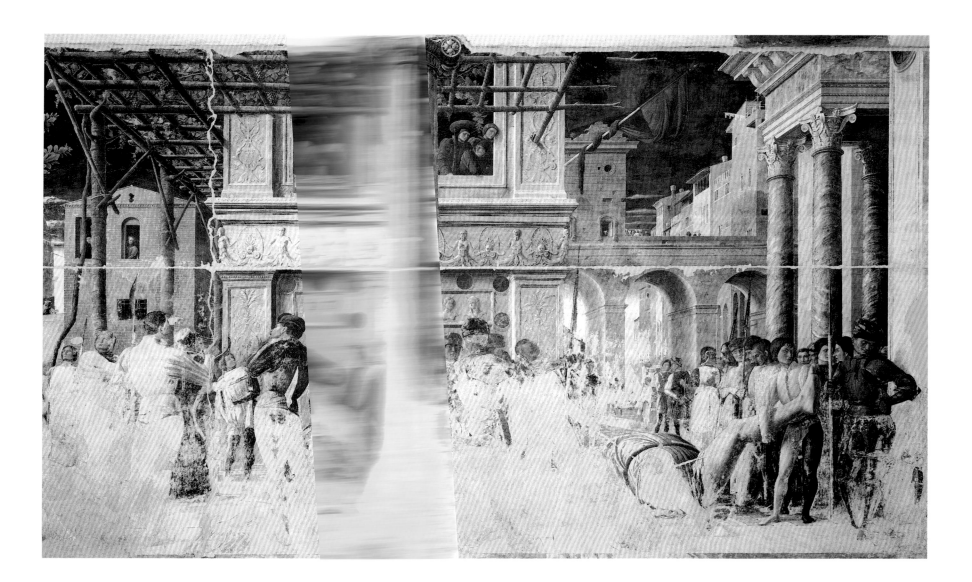

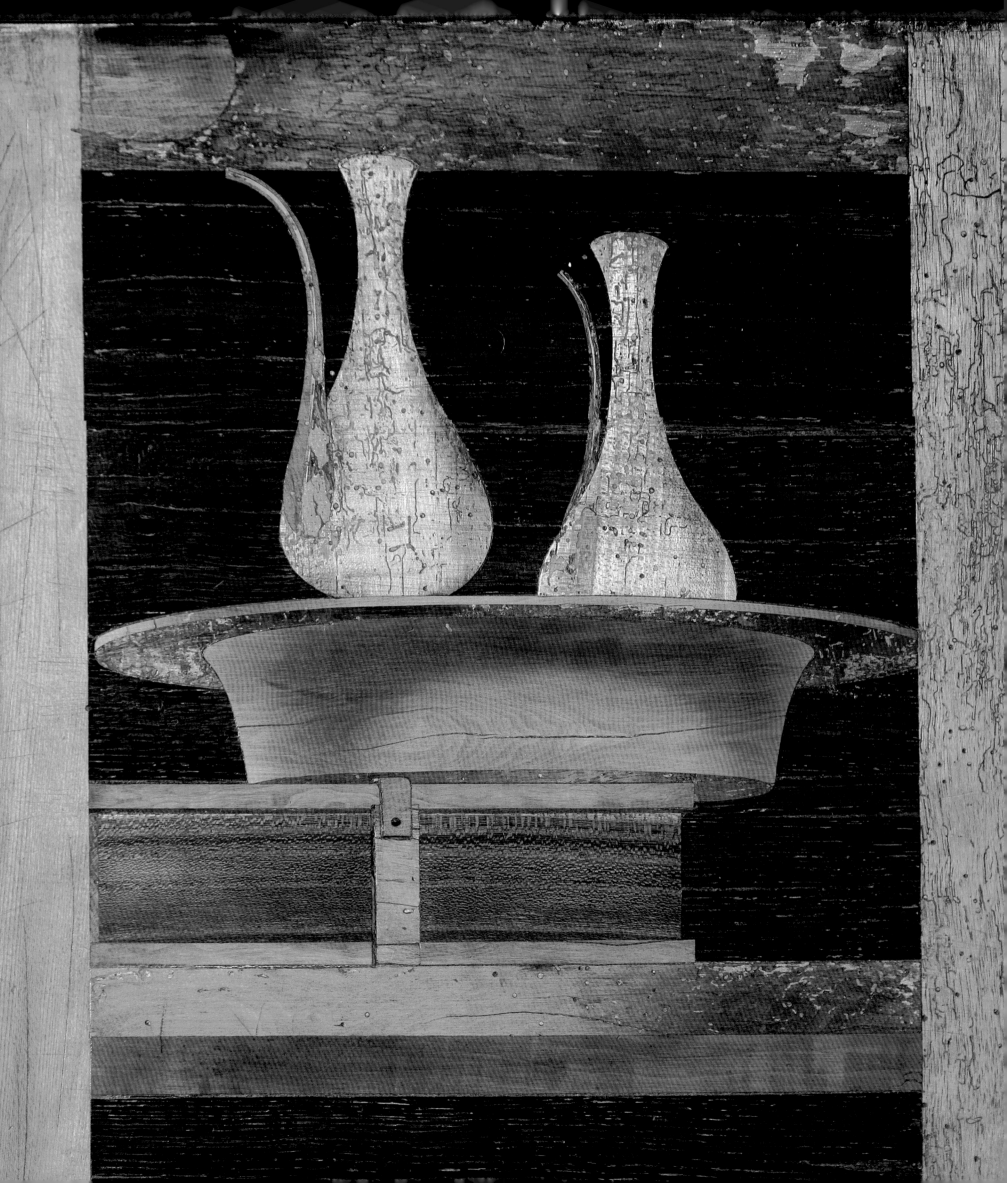

OPPOSITE PAGE
79. Pier Antonio degli Abati, c. 1430–1504
Liturgical Objects (Jugs, Basin, Book), detail,
c. 1484–85
Sanctuary of Monte Berico, Vicenza;
sacristy, cabinet (formerly in the stalls
of the old choir)

1. See Barbieri 1987, pp. 34–49; Zaupa
 1998.

2. *Nobilità di Vicenza*, Dragonzino 1525,
 c. 3r (stanzas 10–11); for these lines,
 given below in Italian, see also
 Dragonzino 1981, eds., F. Barbieri and
 F. Fiorese, p. 24:

 Giunti a la porta et ambi dentro intrati,
 vidi ample strade e genti pellegrine,
 li superbi palazzi istoriati,
 con fondamenti a punte adamantine,
 portici, archi, colonne e tempii ornati
 di porfiri e di pietre serpentine,
 d'intagli, di rilievi e di pitture,
 in varie fogge, a compassi e misure.

 Le larghe facce d'ogni alto edifizio
 d'intorno fiammeggiavan di fino oro,
 che con ragione e con miro artifizio
 mirabilmente adorna ogni lavoro.
 A comprender non basta uman giudizio
 tanto valor ne lo speso tesoro;
 e chi non crede quel ch'io vo scrivendo,
 vi vada, e più vedràch'io non distendo.

3. Rattin, 1993, p. 6.

4. Fiocco 1956, pp. 240, 242, 253–54;
 Menegazzo 1964–65, pp. 505–7. The
 latter publishes a notarial deed drawn
 up in Rovigo on December 17, 1504,
 in which the brothers Sigismondo
 and Bartolomeo, sons of "quondam
 Petriantonii a Coro de Abbatibus de
 Mutina," their father having died
 "his elapsis diebus," full of debts and
 without having dictated a will, ap-

5. Fio

6. See ni in
 thi

7. Fio uinta-
 val . 43
 n. 4

8. Sart

9. Bag

10. Bag
 Can

11. The
 by Z
 print ed
 by D

12. For m ee
 the d
 Loren
 suppl u-
 larly r

 formally
 state.
 nterpret
 tigoni
 ld seem
 ween
 t, the
 renzo
 d with
 projects
 n of the
 at Pier
 central
 tus
 ierit
 a").

13. Initial support for the hypothesis in
 Zorzi 1916, pp. 165–66, is followed
 by more cautious judgments in Dani
 2008, pp. 108–9; Bagatin 1990, p. 186;
 Barbieri 2008, p. 95. This theory may
 be true, but it is another question
 how, from their contact (and perhaps
 collaboration) at Monte Berico, Bar-
 tolomeo Montagna would have begun
 an enduring association with Pier An-
 tonio based on a shared "interest in
 the perspectival problems connected"
 with virtuosic "illusionistic experi-
 mentalism"; Tanzi 1990, p. 612.

14. Rumor 1929, p. 157.

15. Dani 2008, p. 104.

16. Ferretti 1982, pp. 508–9.

17. This was still the case midway
 through the twentieth century: see
 Barbieri, Cevese, Magagnato 1953,
 p. 378; Arslan 1956, pp. 184–85.

18. Ferretti 1982, p. 509; Bagatin 1990,
 p. 189.

19. Rattin 1993, pp. 47–49, indicates that
 in the years 1487–89, the Modenese
 intarsist lived in the Pusterla district
 of Vicenza, on the farm of the monas-
 tery of San Bartolomeo. His presence
 there as a guest of the Lateran canons,
 as well as certain of the monastery's
 documents from that period, would

 in Vicenza, by Barbieri 1987 (chapt.
 related to the early Renaissance, pp.
 34–49) and Zaupa 1998 (with earlier
 bibliography).

 seem to confirm that he was engaged
 as a *magister perspectivae* on the choir.

20. Faccioli, "Miscellanea," ms., c. 104r.

21. See Fioretto 1994 for a valuable dis-
 sertation on the intarsia cycle for the
 choir of Santa Corona.

22. Arslan 1956, p. 70; Barbieri, Cevese
 2004, p. 509.

23. See Saccardo 1976, pp. 169–71 (based
 on evidence by Faccioli).

24. On the iconography of the caged bird,
 see Grabar 1966; Hjort 1968; Mihályi
 1999.

25. Rigoni 1933–34; Bagatin 1990, pp.
 198–99.

26. De Seta 1987, p. 88, focuses on this
 question, recognizing in the Santa
 Corona panels "evidence of an ab-
 stract symbolization of architectural
 elements and urban views, where
 the problem of topographic verisi-
 militude surely should be absolutely
 excluded." I am convinced, however,
 that some of these panels invite a less
 categorical judgment. Moreover,
 De Seta himself admits that in the
 work of the Canozi da Lendinara,
 who closely influenced Pier Antonio,
 there is "a latent tension between
 abstraction and realism" (p. 92),
 which we are sometimes persuaded
 to identify, upon careful analysis,
 in Pier Antonio's work as well.

27. Dani 2008, p. 113.

28. Barbieri 2008, p. 93.

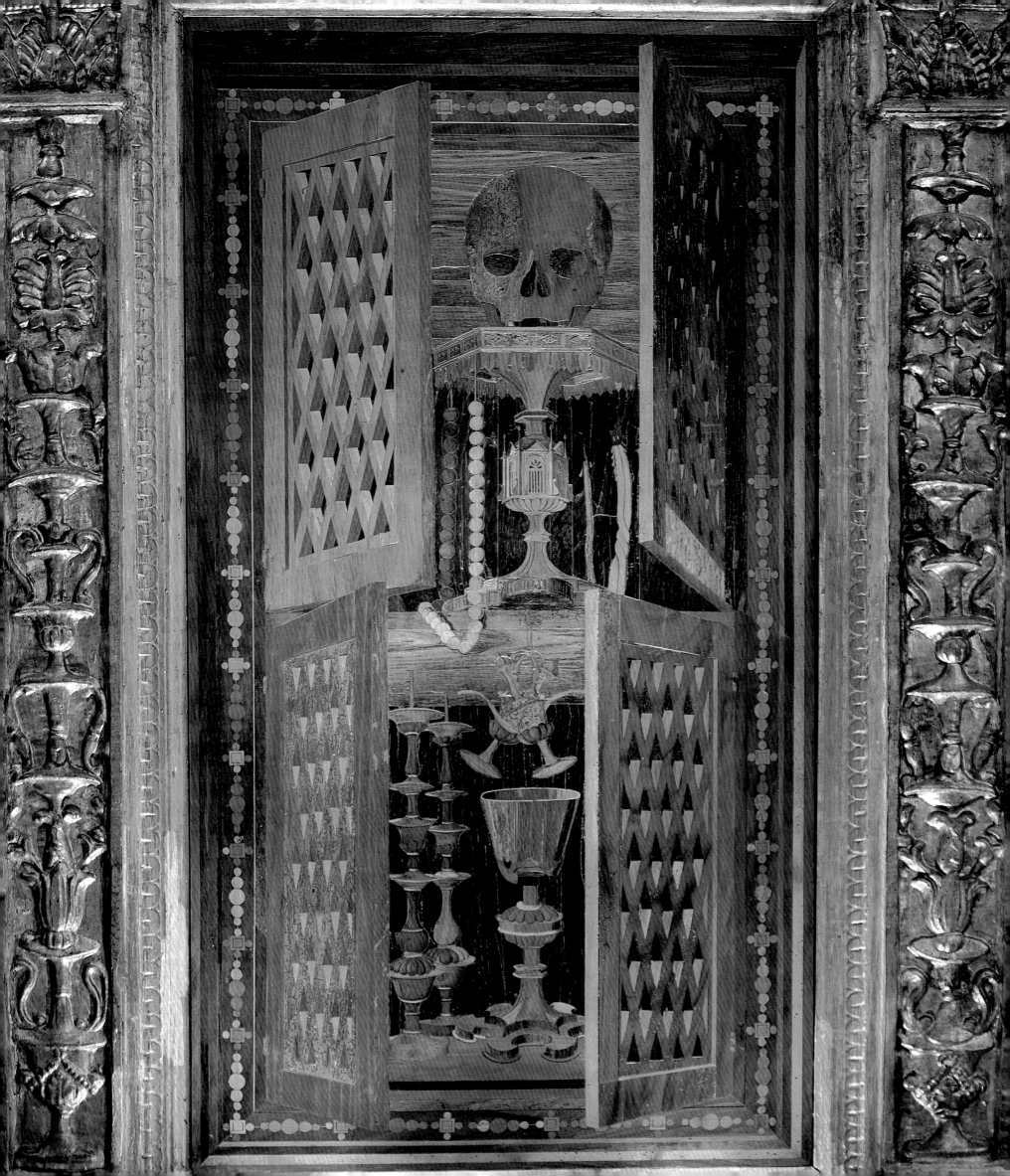

Part II

✳

THE TRIUMPH OF PERSPECTIVE

Intarsia at the Dawn of the Cinquecento

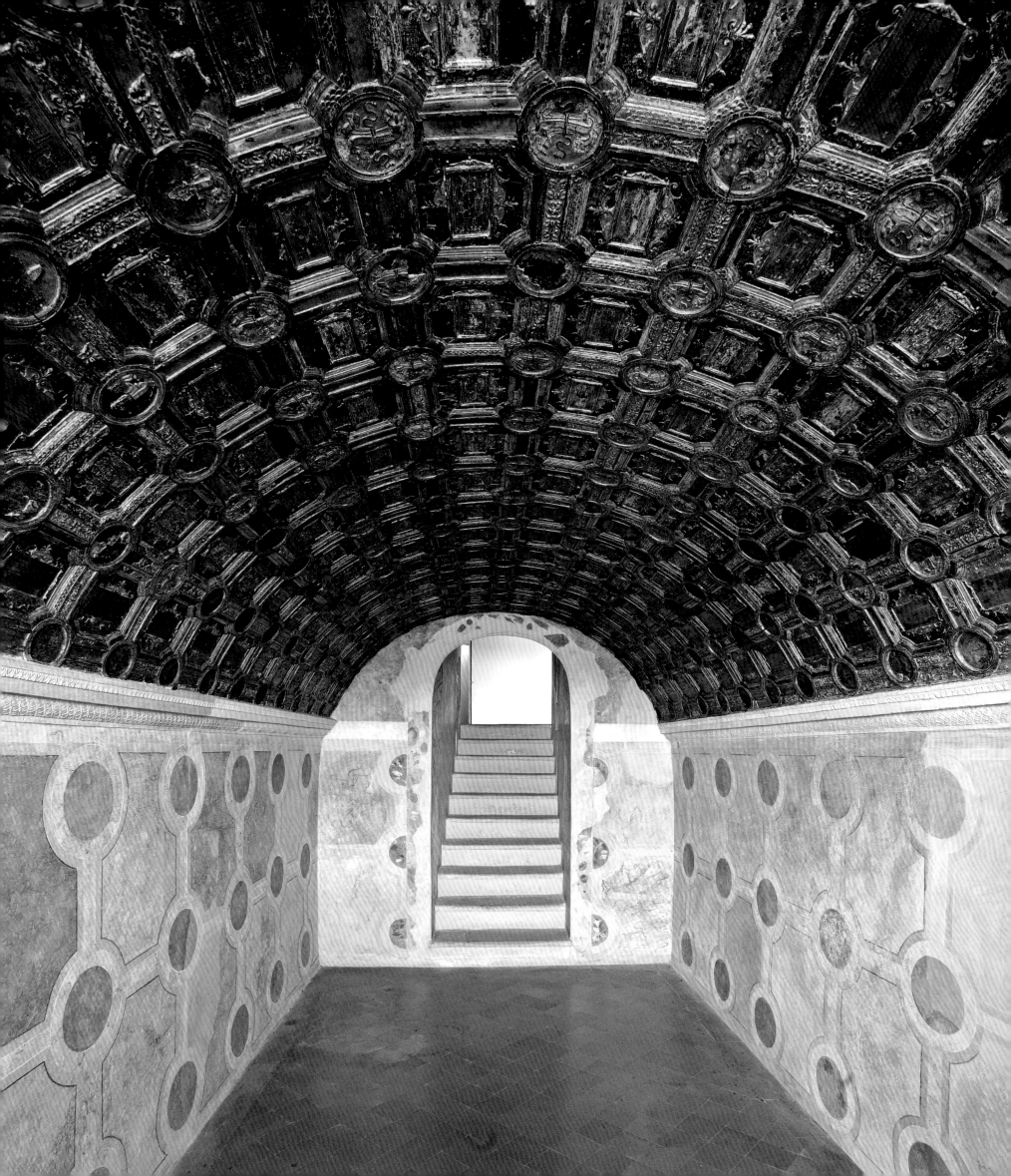

MANT[...] OF ISABELLA D'ESTE
[...]UCALE, C. 1506
[...]aolo Mola

[...]ertelli

Amid the labyrinthine glory of the[...] in Mantua, two rooms in particula[...] to become "a symbol of dynast[...] and to remain even today, despit[...] and transplantation, a temple of c[...] arts. Many were the vicissitudes t[...] present installation of the Grotta a[...] Isabella d'Este (1474–1539), which[...] ning probably interpreted, or were[...] a preexisting space that served a sim[...] dating back to the time of Ludovic[...] (marchese of Mantua from 1444 to 14[...] private rooms were in fact first locat[...] ducal complex from their current lo[...] Castello di San Giorgio, on two adja[...] the Torretta di San Nicolò. Some vest[...] apartments still survive, as we shall s[...] of which is the gilded vault with mo[...] reliefs (plate 81) that depict her perso[...] or emblems, of the lottery ticket and[...] pause. After the death in 1519 of her h[...] marchese Francesco II Gonzaga, "vinci[...] Battle of Fornovo, Isabella decided to[...] "secret" quarters to the complex on t[...] floor of the Corte Vecchia that woul[...] known as the Appartamento Vedovile, o[...] quarters. The inventory taken by the[...] notary Odoardo Stivini after Isabella's[...] 1539 presents a vivid image of an extra[...] place whose collections represented the[...] fined expression of the culture of the t[...] tiquities, works of the great masters, a[...] other rare and unusual objects. These co[...] became a touchstone of artistic taste, an[...] source of pride for the Gonzagas. Consi[...] example, that Isabella's garden, adjacen[...] grotta, was chosen as the site for the w[...] banquet of Guglielmo, duke of Mantua, i[...] and that in 1569 Guglielmo's brother Lu[...] (who founded the French branch of the[...] thanks to a bequest from his grandmother[...]

[...]'Alençon) attempted to make off with some of the [...]ollection. And then there was the idiosyncrasy of [...]at most splendid of Mantuan dukes, Vincenzo [...] who wore, hanging from his belt, the keys to [...]abella's rooms, an evident sign of his jealous [...]ncern for the collections of his cultivated great-[...]andmother. It was probably in the third decade [...] the seventeenth century, under the dukedom [...] Ferdinando, that the rooms were disassembled [...]l relocated to the fifteenth-century Domus [...]va, where they were soon integrated with new [...]ntings and woodwork, the result of a modern-[...]ion desired by the Gonzaga-Nevers branch of [...]family that ruled over Mantua and Monferrato [...] the war of succession, sack, and plagues that [...]ommemorated in Alessandro Manzoni's great [...]l *I Promessi Sposi* (1827). There the rooms re-[...]ed until the First World War, when (in 1917, [...]various military events), it being feared that [...]oorly led Italian forces would have to retreat [...] as the Mincio River, both were disassembled [...]heltered in a secure location. At the end of [...]nflict, they were restored and reassembled, [...]s with less than perfect scrupulosity, in the [...] in the Corte Vecchia that they had occu-[...]om about 1519/22 to 1630. It is worth not-[...]a point of curiosity, that a life-size model of [...]tta and studiolo, constructed for the 1911 [...]s Fair in Rome, still sits in the storerooms [...]onzaga Palace, awaiting a suitable home.[1] [...] insatiable desire for things ancient,"[2] is [...]bella d'Este, in a letter sent to a merchant [...] described her yearning for antiquities, [...]ced alongside works commissioned from [...]est artists of her time. If the studiolo was [...] library-study, with canvases by Man-[...]orenzo Costa, Perugino, and Correggio [...]lls, the grotta was more of a private gal-[...]sing the major part of her art collection.
[...]1. Brown notes: "The term *grotta*, used [...] a cloakroom, a small study, a writing

PAGE 102
80. Fra Giovanni da Verona, 1457/58–1525
Cabinet with Skull and Liturgical Objects, 1506–10
Sant'Anna dei Lombardi, Naples; Oratory of San Carlo Borromeo

OPPOSITE PAGE
81. Original Grotta of Isabella d'Este in the Castello di San Giorgio, Palazzo Ducale, Mantua.

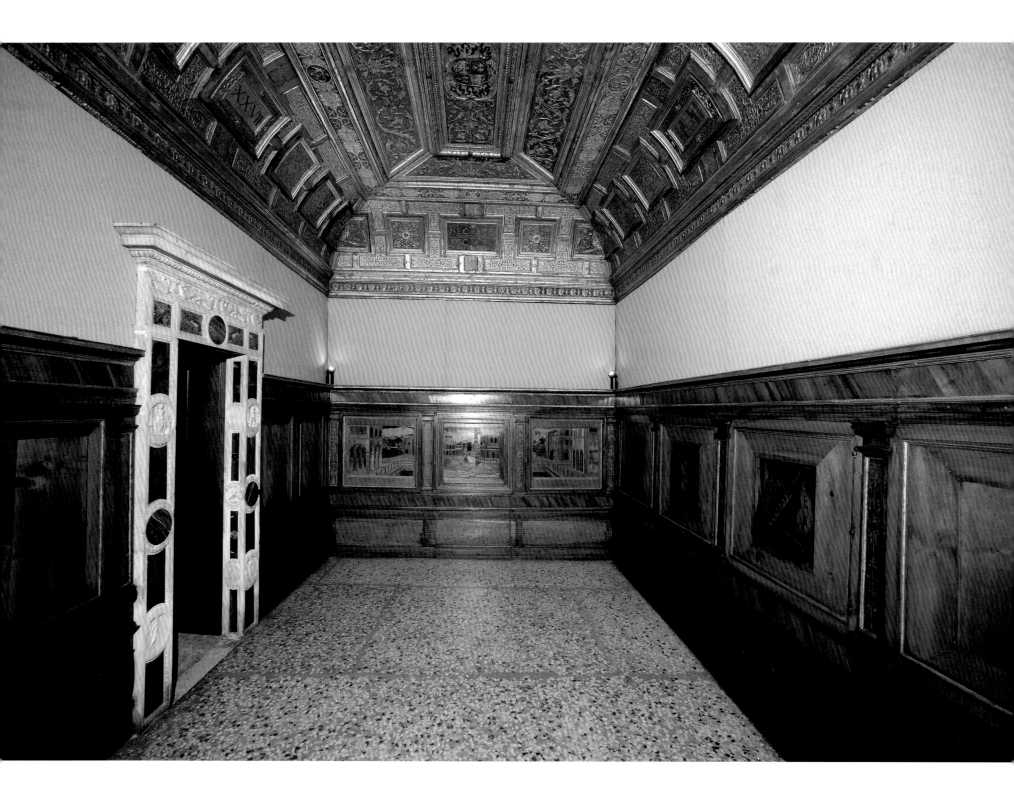

82. Grotta of Isabella d'Este, overall
view, in the Corte Vecchia, Palazzo
Ducale, Mantua.

OPPOSITE PAGE
83. Aron Johansson, 1860–1936
Grotta of Isabella d'Este, 1886?
Soprintendenza per il Patrimonio
Storico, Artistico ed Etnoantropoligico
for the Provinces of Mantua, Brescia
and Cremona, Mantua

room, or a gallery, in Mantua could only refer to
that sole space. It had been introduced into the
Mantuan vocabulary by Isabella d'Este in 1498 to
describe the secret room with a vaulted ceiling,
beneath her studiolo, in the Torretta di San Nicolò
in the Castello."[3] That vaulted ceiling, of wood
decorated in gilded stucco (plate 81), is the only
surviving relic of the original grotta, predating
Isabella's move to the Corte Vecchia after 1519. It
was probably created in 1506–8 by the brother
intarsists Antonio and Paolo Mola, covering a cu-
rious zodiacal decoration attributed to the painter

Bernardo Parentino, which had constituted the
"sky" of the space.[4]

By the end of Isabella's life, the rooms, then in-
stalled in the Corte Vecchia, contained more than
sixteen hundred items, including coins, medals,
bronzes, musical instruments, a unicorn's horn, a
cameo of Augustus and Livia, an onyx vase from
Braunschweig, a Cupid by Michelangelo, and an
equally celebrated one by Praxiteles. In the Corte
Vecchia, the grotta was divided longitudinally
into three bands (plate 82), unifying the space and
providing for the small cabinets that held much

of the collection. Uppermost is the barrel vault of carved, painted, and gilded wood;[5] then there is a middle portion that was hung with paintings, in front of which stood bronzes, statuettes, and other objects, resting on the cornice of the woodwork beneath; and finally there is the woodwork itself, its shutters rhythmically punctuating the walls. Today the room is entered from the studiolo, through a small doorway probably created by Gian Cristoforo Romano in the early sixteenth century. This formally spectacular portal is surmounted by a frieze of vases and fantastic beasts, while on the faces and inner surfaces of the jambs, tondis of polychrome *pietre dure* from Sicily alternate with others containing mythological and allegorical images of rare refinement. The entrance is located halfway down the long side of the grotta, so that, upon entering, the visitor is faced by the uninterrupted series of intarsia scenes, while the large window looking onto the garden of the Piazza Pallone is to the right.

A more careful observation of the space reveals, at the center of the vault (executed in 1522 by a "maestro Sebastiano"), the Este coat of arms, placed within an exultation of delicate gilded plant volutes, which also appear in the various other compartments of the ceiling, sometimes against a blue background (plate 84). Around the sides of the vault, rhythmically juxtaposed coffers display references to the marchesa's elevated status. At the center of the longer sides are two *imprese*: above the entrance, the number XXVII, and on the opposite side, the *impresa delle pause*, depicting the musical signs for pauses or rests. Midway along the shorter sides are two inscriptions: on the side opposite the window, NEC SPE / NEC METU (with neither hope nor fear), and on the side above the window, ISAB[ELA] ESTEN[SIS] / MAR[CHIONISSA] MAN[TUAE].[6]

The band below, now empty, was occupied by paintings (plate 83); the last series placed there, probably executed by Francesco van den Dijk and still in the Palazzo Ducale, depicts a succession of deities in various postures. It is reported that there were earlier installations of paintings by Domenico Fetti and Lorenzo Costa.[7]

Wooden panels, some with intarsia work, com-

plete the decorative scheme of the walls. There are six intarsiated panels in all: three of them occupy the entire width of the short wall opposite the window, and the other three adjoin them on the left side of the long wall opposite the entrance. The intarsia work is attributed to the Mola brothers, Mantuan craftsmen who, after various experiences, settled permanently in their home city in late 1505 or early 1506, precisely when Isabella was planning the renovation of her chambers. They had executed some well-received intarsia work for the sacristy of San Marco in Venice, a city with which Isabella was developing closer contacts in this period, thanks in part to certain key figures (one thinks of her attempt to acquire Giorgione's nocturne through her agent Taddeo Albano); moreover, after the death of Giovanni Maria Platina in 1500, the two brothers were considered the most successful local intarsists. In any case, the first document regarding their work for Isabella's rooms dates to this period: a letter in which the marchesa threatened to "make them suffer privation in the depths of the tower" if they did not finish the *quadri* on which they had been working before they fled the city for fear of the plague.[8] Isabella's correspondence reveals that there were already eight intarsia panels in the palace at that time; within a few months the brothers—who humbly identified themselves as "Antonius et Paulus Mola Lignorum Incisores" (wood-carvers) and no longer with the courtly description of "artis emblematariae ac perspectivae peritissimi" (most skilled in the art of inlay and perspective)—would deliver a second group of works. The arrangement of the intarsia panels must have changed when, within a few years after the death of Francesco II, Isabella d'Este withdrew to the Corte Vecchia and reinstalled her *gabinetti* there. The intarsia panels were used to decorate the doors of the cabinets built into the walls of the new grotta, while, due to the changed dimensions, the gilded ceiling was entirely re-created, as noted above. Likewise, a doorway by Tullio Lombardo was installed (alongside the older one by Gian Cristoforo Romano), and it is very probable that the carved panels that make up the wainscoting and frame the intarsia were also created at this time.

OPPOSITE PAGE
84. Master Sebastiano
Vault, 1522
Grotta of Isabella d'Este,
Corte Vecchia, Palazzo Ducale,
Mantua

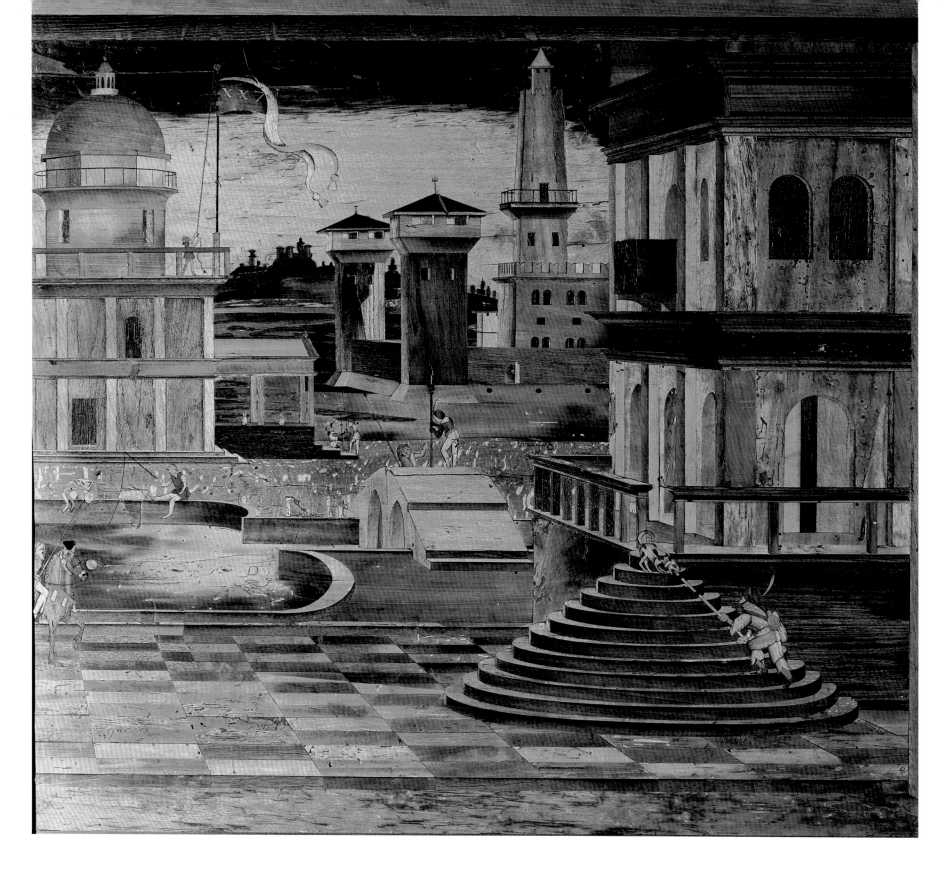

ABOVE
85. Antonio and Paolo Mola,
act. by 1498
Intarsia B, c. 1506
Grotta of Isabella d'Este, Corte
Vecchia, Palazzo Ducale, Mantua

OPPOSITE PAGE
86. Antonio and Paolo Mola,
act. by 1498
Intarsia B (detail), c. 1506
Grotta of Isabella d'Este, Corte
Vecchia, Palazzo Ducale, Mantua

The six surviving intarsia panels—which obviously represent only a fraction of those that the Mola brothers originally executed—depict the following subjects, starting from the left corner of the short wall and moving rightward:[9]

A. The portico of a building at the left borders a pool of water, protected by a balustrade, to the right. In the middle ground is a tower surmounted by a fluttering banner with the *impresa* XX7. The background features a lake landscape with buildings, hills, and distant mountains.

B. On the left, a horseman enters a checkerboard-paved piazza, and on the right, a cone-shaped flight of circular steps accesses an imposing three-story building; on the steps, a pilgrim tries to tear his stick free from a dog that has bitten down on it. A canal, traversed by a humpbacked bridge, typical of Venice and perhaps of Mantua at the time (and on which two figures stand, one holding a halberd, the second a pike), occupies the middle ground; along the canal on the left, a tall building terminates in a domed turret, beside which a figure

raises a flag bearing the *impresa* XX7. Farther back, in the center, is a structure fortified with two towers, reminiscent of Mantua's castle, and within its walls stands another building with a very tall tower. An expanse of countryside with hills and villages fills the background. (Plates 85 and 86.)

C. To the right stand at least three buildings with porticoes on their lower floors; in the foreground to the left is a pool of water, separated by a balustrade. In the middle ground, marked by a flag with the motto "ISAB/ELLA," is a lake landscape that terminates in some buildings and a view of hills.

D. A piazza with checkerboard paving is delimited by a balustrade, against which some figures stand; on the left is a series of monumental buildings, looking out over a lower piazza. Behind them one glimpses a facade surmounted by an arched tympanum (reminiscent of certain Venetian buildings); part of a bell tower, probably belonging to a church; and, farther back, a gate with an octagonal tower. On the right side, a canal leads to a port with various vessels; in the background are the defensive towers that mark the entrance to the port and, finally, a hilly landscape. Across the bottom of the panel is reproduced the musical notation of Johannes Ockeghem's canon "Prenez sur moi."[10] (Plate 87.)

A half-open cabinet reveals, at the left, a *viterna* (the so-called Latin guitar), with a fretted neck, a pegbox terminating in a monstrous head, and four single strings. Resting against it is a *bombarda sopranino* (an ancestor of the oboe); to the right, beneath a *lira da braccio* (an early bowed string instrument), is a tenor flute. At the center, curiously, are an ocarina and two small, connected reed flutes.[11] (Plate 89.)

A cabinet without shutters contains a spinet, closed up against a dark background on its open case, on the right part of which there also is a small closed book and a lute. On the opposite side, behind the spinet, one glimpses a triangular harp.[12] (Plate 88.)

Panels A and C reveal, on the inside, a complex rather rigid geometric decoration; in fact, these intarsia panels on the short wall conceal niches suitable for cabinets. The other walls,

OPPOSITE
87. Antonio and Paolo Mola,
act. by 1498
Intarsia D, c. 1506
Grotta of Isabella d'Este, Corte
Vecchia, Palazzo Ducale, Mantua

however, do not contain any such recesses, complicating any interpretation of the original disposition of Isabella's cabinets. A structural reading of the six intarsia panels, the surviving members of a decidedly larger group, discloses that the three panels on the short wall share the same horizon line; the vanishing point is always to the side, falling beyond the decorated surface of the two outer panels and on the left border of the central one (though it once must have been well inside the composition, whose dimensions have clearly been reduced).[13] Panels A and C display a similar use of light, and their symmetrical structure relates them to each other. Panel B, however, reveals a more diffuse light source, and its dimensions also differ from those of panels A and C, as well as the three on the long wall. This all contributes to the recovery of a "memory" of the original arrangement of the intarsia panels in the older grotta at the Castello di San Giorgio.

In the Mantuan intarsia panels, the architecture is employed in the description of a horizontal space, taking on a massive appearance; it bears many similarities to that in the Mola brothers' intarsia in the sacristy of San Marco in Venice, although here it is less attenuated and more solid. The little figures in panels B and D (plates 86 and 87) are created with tiny rounded pieces of colored wood, as in the Venetian cycle, with an effect that recalls watercolor, and an overall "genre" appearance.[14] A typical motif of the Mola brothers, pleasing to the eye and conferring a greater lightness on the whole, is the punctuation of the buildings with fluttering banners, which here bear the Isabellian *impresa* XXVII (curiously, written in at least two different ways).

The intarsia panels with musical instruments reveal a relationship between those instruments connected to the popular music of the time and those typical of the courtly, if not humanist, tradition. This is not only an indication of the meeting of these two modes of expression (think, moreover, of the canon "Prenez sur moi," faithfully reproduced in panel D), but also a reference to Arcadia, which in this period was becoming a pregnant motif for an entire body of literature, painting, and music.

OPPOSITE
88. Antonio and Paolo Mola,
act. by 1498
Intarsia F, c. 1506
Grotta of Isabella d'Este, Corte
Vecchia, Palazzo Ducale, Mantua

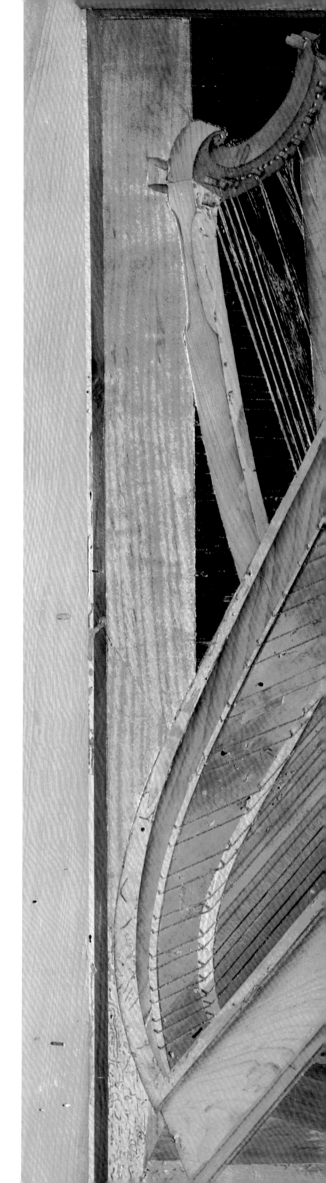

114

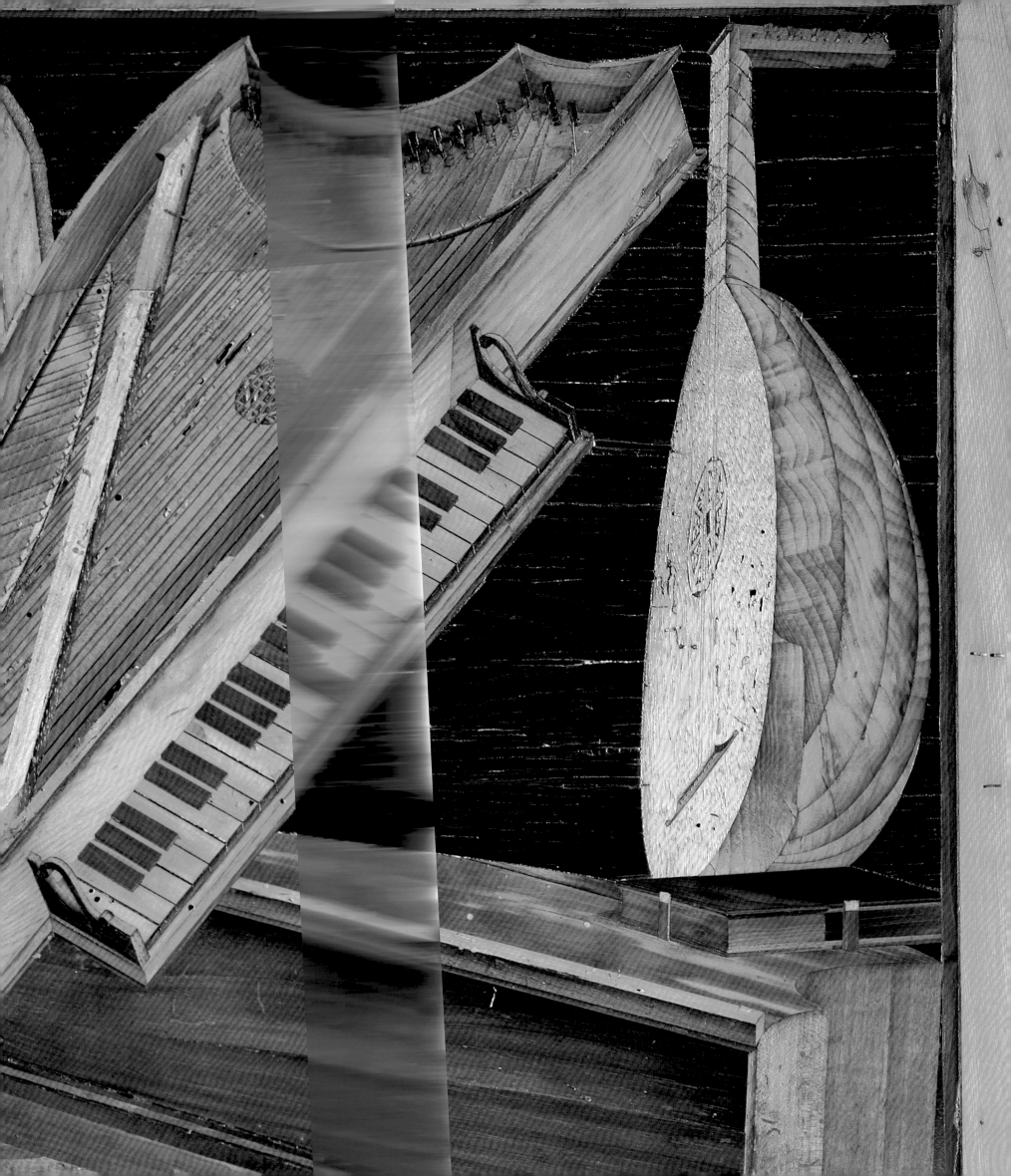

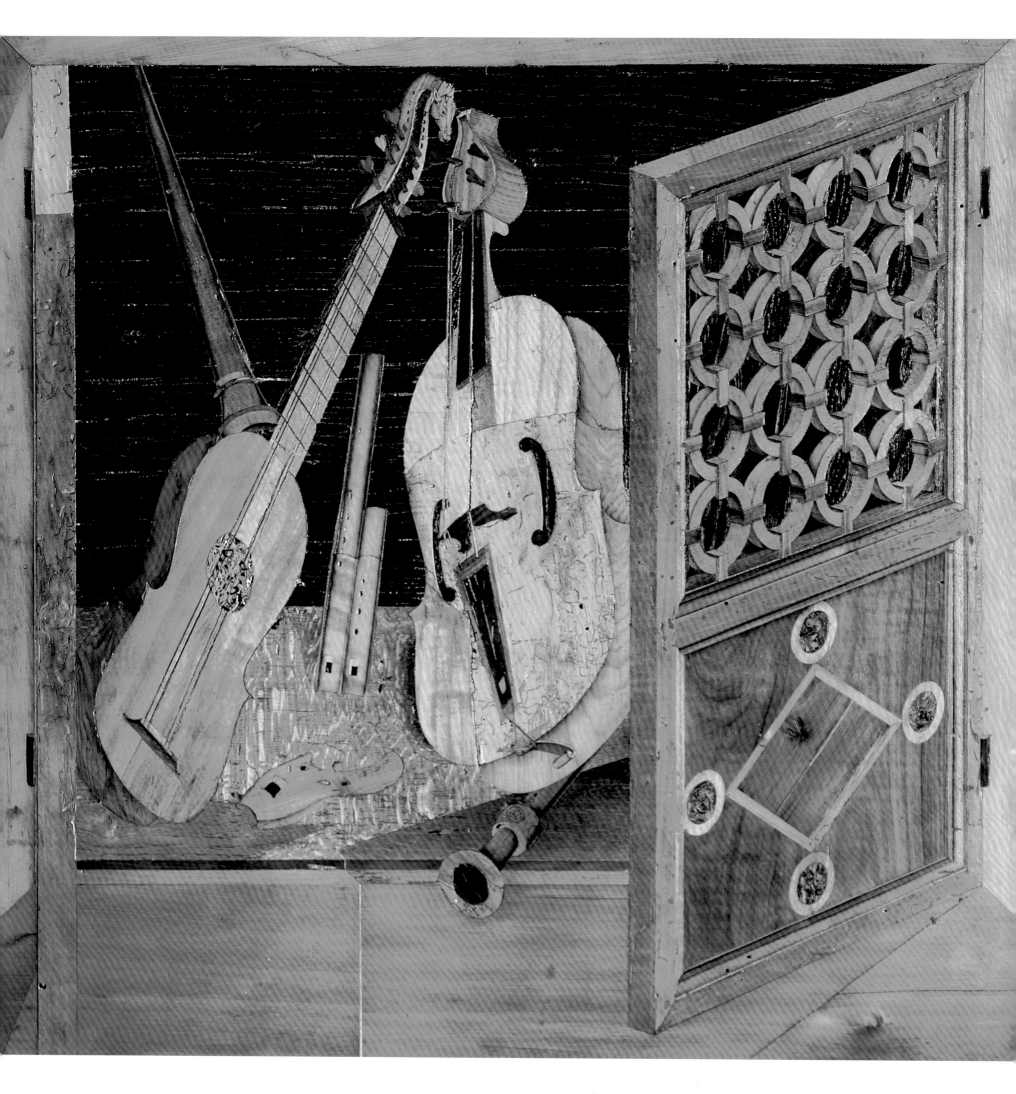

From a technical standpoint, th[...] sia panels do not employ a subst[...] range of woods than those in V[...] the use of the wood grain for p[...] poses tends to disappear, allow[...] emphasis on the pictorial qualiti[...] als, which are also heightened b[...] application of the woodburning i[...]

Other elements help to finish t[...] the grotta: the pilasters placed betv[...] panels (depicting candelabra wit[...] foliage, terminating in a flaming [...] with a scroll bearing the word *Fe*[...] panels of the wainscoting (with the[...] musical pause, the flaming *A*, and[...] with a lyre, a candelabrum, or the Is[...] and the corner pieces adorned with[...]

Regarding the grotta's current sta[...] tion,[15] it should be remembered that[...]

tion of 1933, some new panels were added to the woodwork, replacing the lost originals. The reinstallation of the room in its present space has allowed some of the shutters to be made functional once again (specifically, the ones on the short wall opposite the window, as noted above), but neither the woodwork nor the configuration of the walls has permitted the restoration of the niches near the window, which, according to the sources, once held the Cupids of Michelangelo and Praxiteles. The lower wainscoting also reveals the insertion of some incongruous elements. Moreover, the modifications to the containing structure of the grotta over time deserve to be more closely examined, as do the corresponding changes in the interpretation of this Isabellian space, one of the most exclusive and refined interiors of the entire Renaissance.

OPPOSITE PAGE
89. Antonio and Paolo Mola, act. by 1498
Intarsia E, c. 1506
Grotta of Isabella d'Este, Corte Vecchia, Palazzo Ducale, Mantua

1. For a bibliography of the grotta, including the collections once held there, see *Le Studiolo d'Isabelle d'Este* 1975; Brown 1977; Brown 1978; *Gli studioli di Isabella d'Este* 1978; Lorenzoni 1979; Brown 1985; Brown 1986; *Isabella d'Este: Fürstin und Mäzenatin der Renaissance* 1994, pp. 145–98; L'Occaso 2003; Brown 2005 (a sort of summa of Isabella's rooms, extensively illustrated and including earlier bibliography); Brown 2008; Grassi 2011. Although it is dated, the dissertation on the Mola brothers by Daniele 1980–81 (for which Massimo Ferretti was the advisor) is always interesting. Ferretti edited the proceedings of the important conference Intagli e Tarsie fra Gotico e Rinascimento, held at the Scuola Normale Superiore in Pisa (October 30–31, 2009), publication forthcoming, which will be a point of reference for this material and to which one

2. [...] isio, Janu- [...] Gonzaga [...] chivio di

3. [...]

4. [...] ding the [...] e Società [...] ll'Ara

5. [...] are about [...] ches [...] it 2 feet

6. [...] XXVII [...] novesi [...] y).

7. R[...] e grotta, s[...]; Bertelli 2[...] bibli- o[...] d to van d[...] ond h[...] y was

[...]pth

probably readapted to this location. The series of parables by Fetti date to around 1620, while in 1665 there were "eight pieces of paintings with work from the Old Testament, by the hand of Costa Vecchio." (Meroni, ed., 1976, p. 41.

8. See Luzio 1909, pp. 867–68.

9. The classification employed here is that of Daniele 1980–81, which will also be referred to on certain technical points.

10. Exhibited in Paris in 1975; see *Le Studiolo d'Isabelle d'Este* 1975, p. 29 n. 90.

11. Exhibited in Paris in 1975; see *Le Studiolo d'Isabelle d'Este* 1975, p. 29 n. 91.

12. All the intarsia panels were exhibited in Vienna in 1994; see *Isabella d'Este: Fürstin und Mäzenatin der Renaissance* 1994, pp. 191–98.

13. A precise clarification appears in Daniele 1980–81, p. 12. Note also that

in intarsia B the figure of the horseman at the left edge is cut off, and that there are four circular blocks that perhaps cover the holes for a handle; all evidence indicates that the intarsia was cut down on this side sometime after its creation.

14. See Daniele 1980–81, pp. 13–14.

15. In addition to the 1933 restoration, which remains to be addressed (but see at least Cottafavi 1934), there are records of another that took place at an indeterminate date (but probably in the 1960s) and one by Anselmo Baraldi in 1978; see Daniele 1980–81, p. 17. There have been more recent interventions as well, particularly on the vault, including the cleanings and disinfestations carried out by the firm Coffani Restauri in the mid-1980s; see Marti 1988.

MANTUA ✳ PALAZZO DUCALE 117

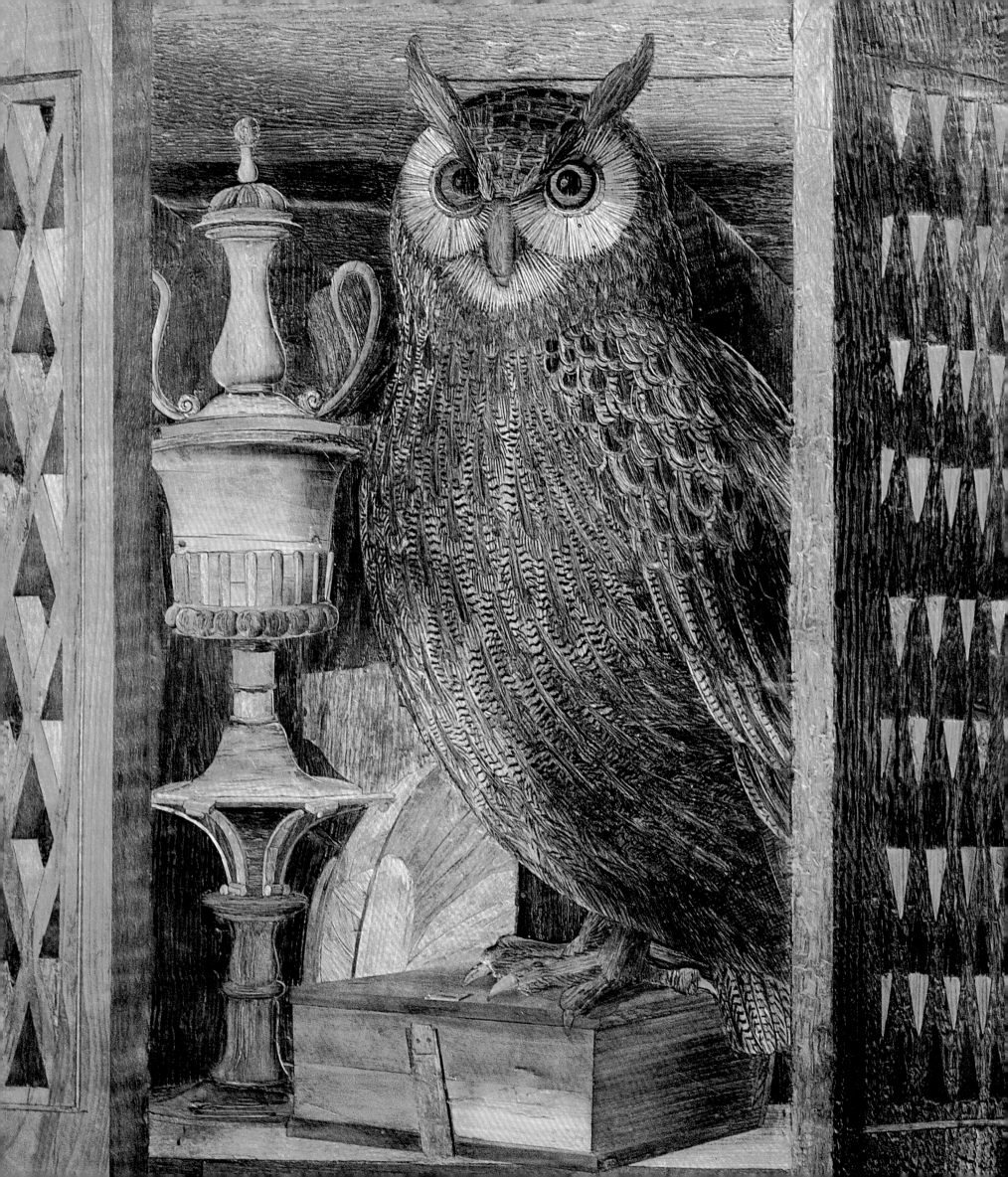

6

Fra Giovanni da Verona

By Alessandra Zamperini

At the church of Santa Maria in▒▒▒▒▒▒▒▒▒▒
had been governed by the Oliv▒▒▒▒▒▒▒▒
1444, an ambitious renovation of▒▒▒▒▒▒▒
Romanesque structure was begur▒▒▒▒▒▒
in this context that, in 1494, Gio▒▒▒▒▒
began his work on the furnishin▒▒▒▒▒▒
Himself a member of the Olivetan▒▒▒▒▒
ably had learned carving and in▒▒▒▒▒
Ferrara, where he had spent his yo▒▒▒▒
astery of San Giorgio. Fra Giovan▒▒▒
considerable interest among art hi▒▒▒
because of the renown he achieved▒▒▒▒
for his mastery of wood carving▒▒▒▒▒
him a commission from Pope Juliu▒▒▒
the wainscoting of the Stanza del▒▒▒▒
the Vatican, unfortunately destroy▒▒▒
of Rome in 1527.[1]

In any case, Giovanni's experie▒▒▒▒
left their mark, particularly in th▒▒▒▒
ward sophisticated material effect▒▒▒▒
working, though he always exe▒▒▒▒▒▒
control over any expressive exce▒▒▒▒▒
tion of his study of classical cultur▒▒▒
his intarsias for the choir of Santa▒▒▒
gano—which were finished in 15▒▒▒▒
created for the monks an environr▒▒▒▒
above all elegant (and which, it sho▒▒▒
bered, was originally positioned l▒▒▒▒
with respect to the high altar), with▒▒
appearance that was perfectly integ▒▒
altarpiece that Andrea Mantegna h▒▒▒
1497, depicting the Madonna in Glo▒▒
John the Baptist, Gregory the Gre▒▒▒
and Jerome (now in the museum o▒▒▒
Sforzesco in Milan).[2]

It is true that this was not the first ▒▒
intarsia in Verona; a few years earlie▒▒
Dominicans of Sant'Anastasia had c▒▒▒
inlay work from Lorenzo da Salò fo▒▒▒
of that church.[3] However, in its bala▒▒▒
orous approach, the work in the O▒▒▒

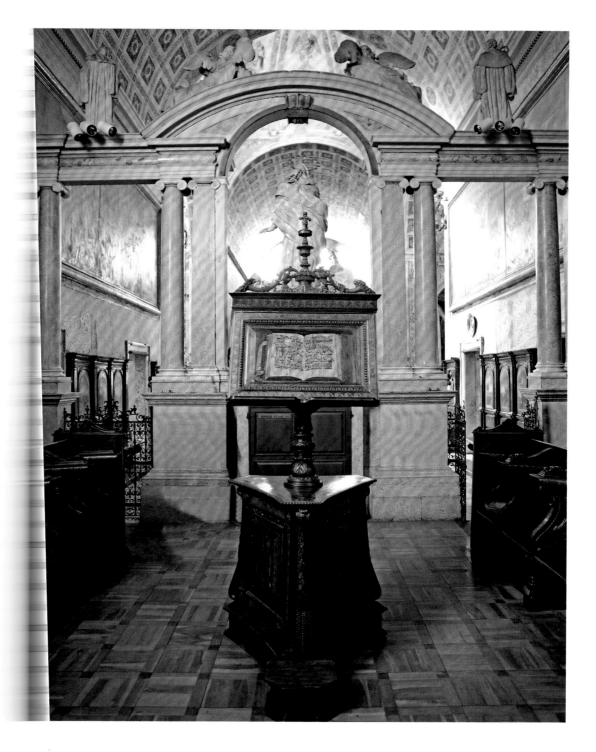

OPPOSITE PAGE
90. Fra Giovanni da Verona, 1457/58–1525
Owl, 1518–23
Santa Maria in Organo, Verona; sacristy

ABOVE
91. Fra Giovanni da Verona, 1457/58–1525
Wooden lectern, c. 1500
Santa Maria in Organo, Verona; choir

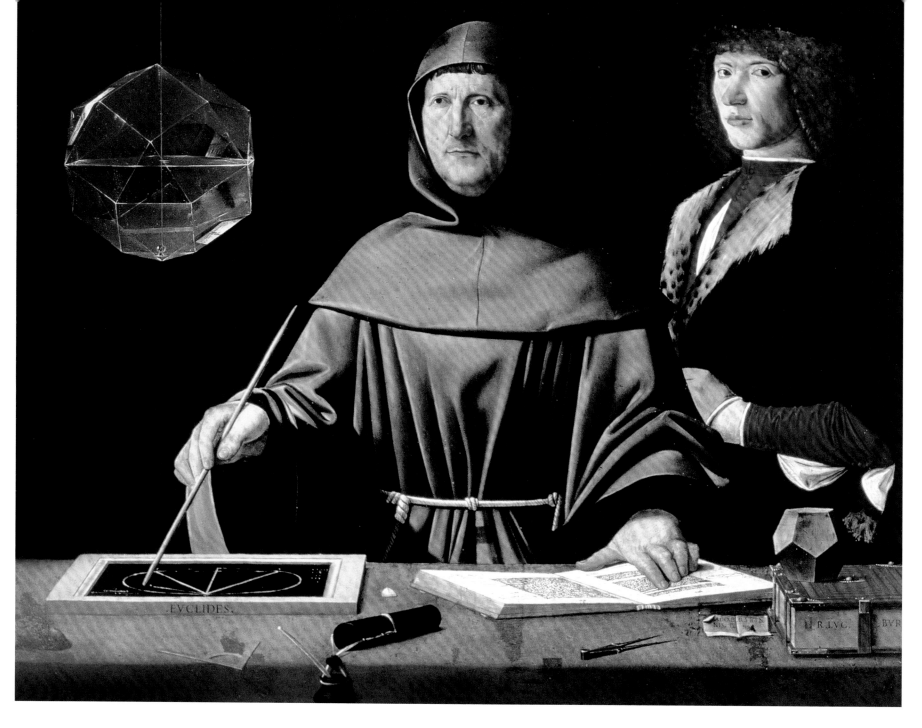

ABOVE
92. Jacopo de' Barbari (attr.),
c. 1460/70–c. 1515
*Luca Pacioli and Guidobaldo da
Montefeltro*, c. 1500
Museo di Capodimonte, Naples

OPPOSITE PAGE
93. Fra Giovanni da Verona,
1457/58–1525
*Cabinet with Liturgical Objects, Books,
and Polyhedrons*, 1518–23
Santa Maria in Organo, Verona;
sacristy

PAGES 122–23
94. Fra Giovanni da Verona,
1457/58–1525
Liturgical Book, c. 1500
Santa Maria in Organo, Verona; choir
(detail of lectern)

represented a monument to the serene repertory of the antique, as well as a highly intelligent interpretation of the traditional iconography of intarsia work, which was based on the human figure, and, even more congenially, on ideal architecture and enigmatic trompe-l'oeil still lifes.[4]

To complete the *opus tarsiatum* in the church, Giovanni executed another cycle for the sacristy (plate 97), planned after his return to Verona in 1518 and completed in 1523.[5] The technical mastery and inventive powers that he had acquired in the interval preceding this second project are expressed in the carvings of the pillars between the panels, which include surprising "still lifes" combining classical panoplies and domestic implements. But his skill is displayed most especially in the intarsia panels themselves (plates 90, 93, 96, 98, 99, and 101), which in some ways can even be

described as luministic. This term may seem incongruous when speaking of work in a medium as "opaque" as wood, but it is well enough applied to Giovanni's achievements here, which stand out not only for the complexity of his motifs (including polyhedrons recalling those of Piero della Francesca and Leonardo, probably taken from the studies of Luca Pacioli; plate 92) but also for the brilliance with which he renders such effects as the liveliness of plumage (for example, in the depiction of the rooster; plate 2), the softness of draperies (in the description of open curtains on the monstrance), and the weight of stone (in the view of an amphitheater, a last tribute to what was by now a well-established antiquarian passion).

These are all elements that—to take a small step back—were already present in the intarsia of the choir (plates 94, 95, 100, and 102). Here

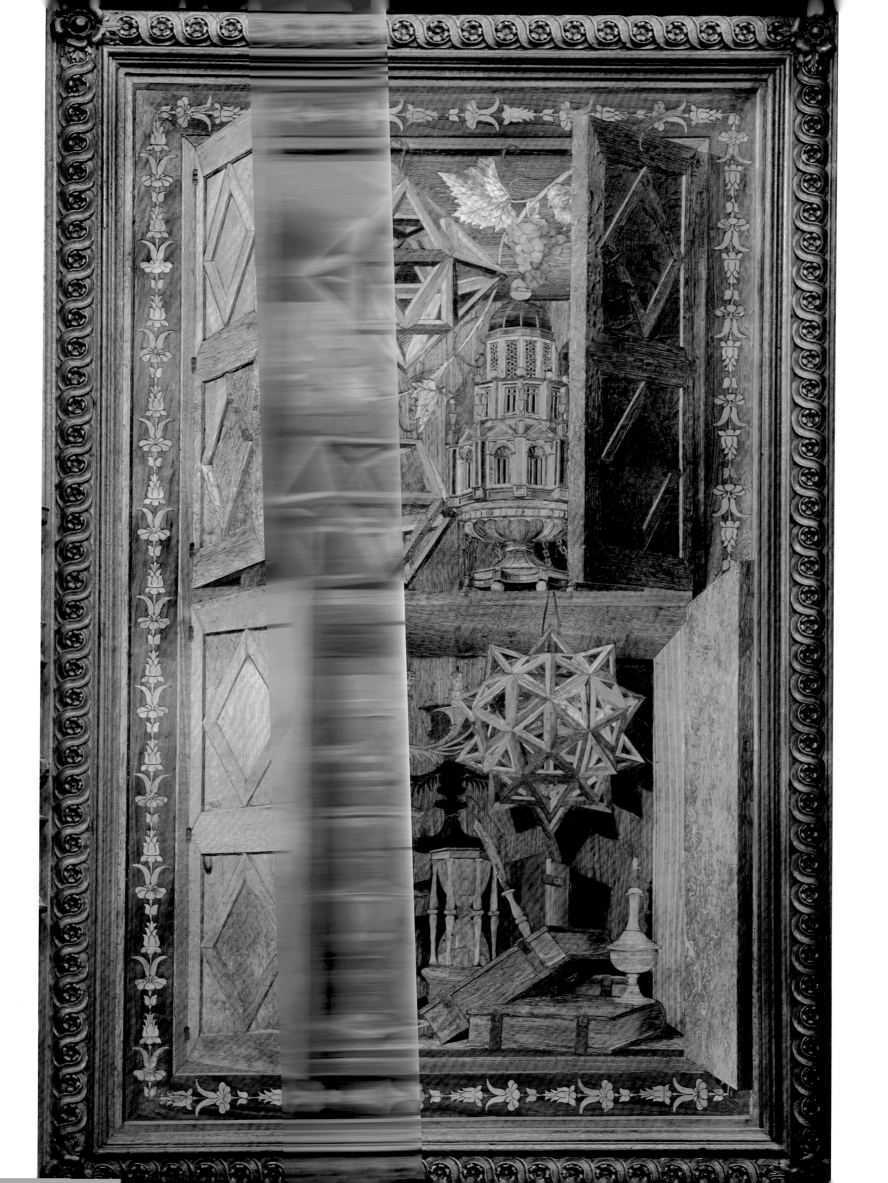

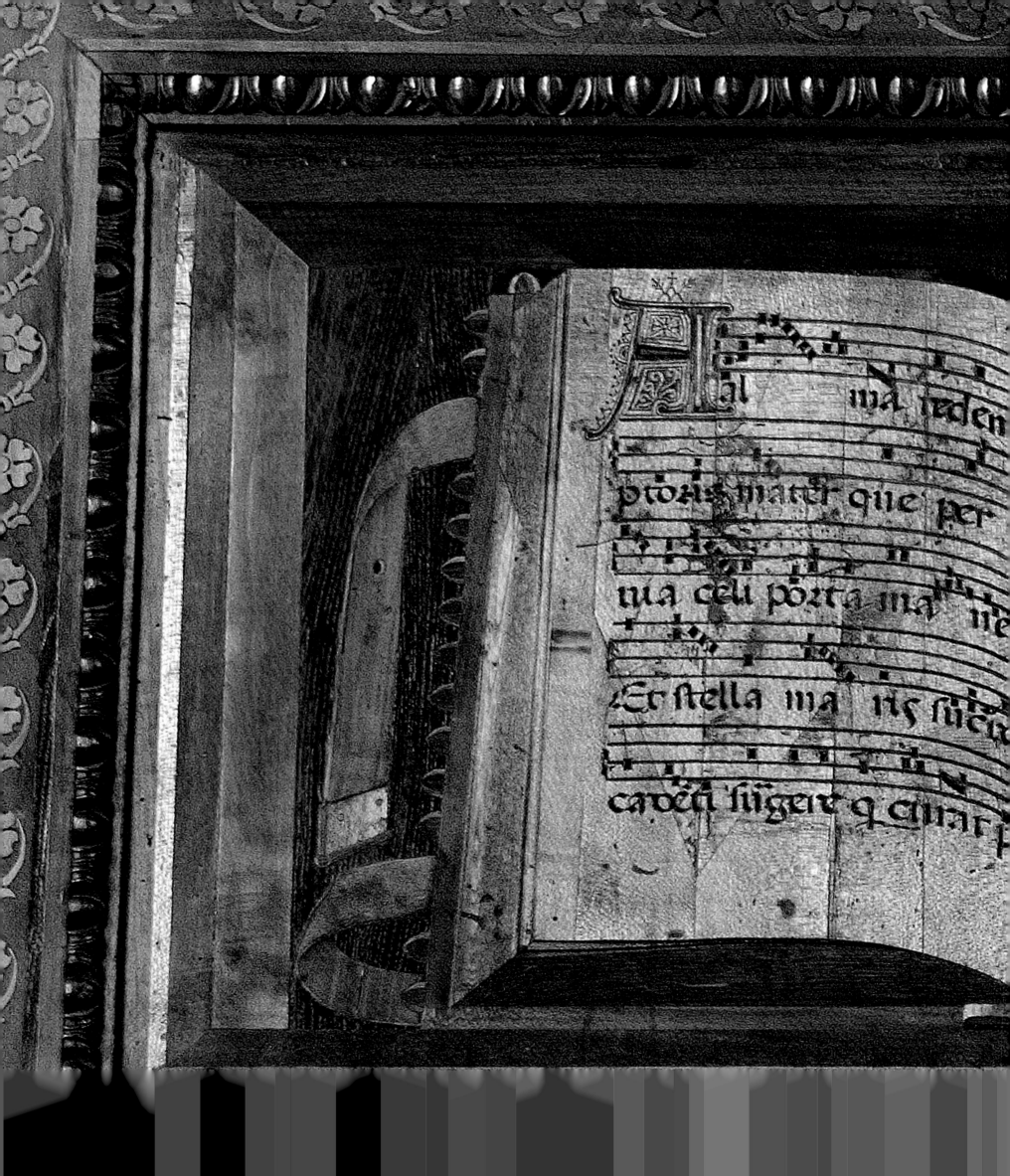

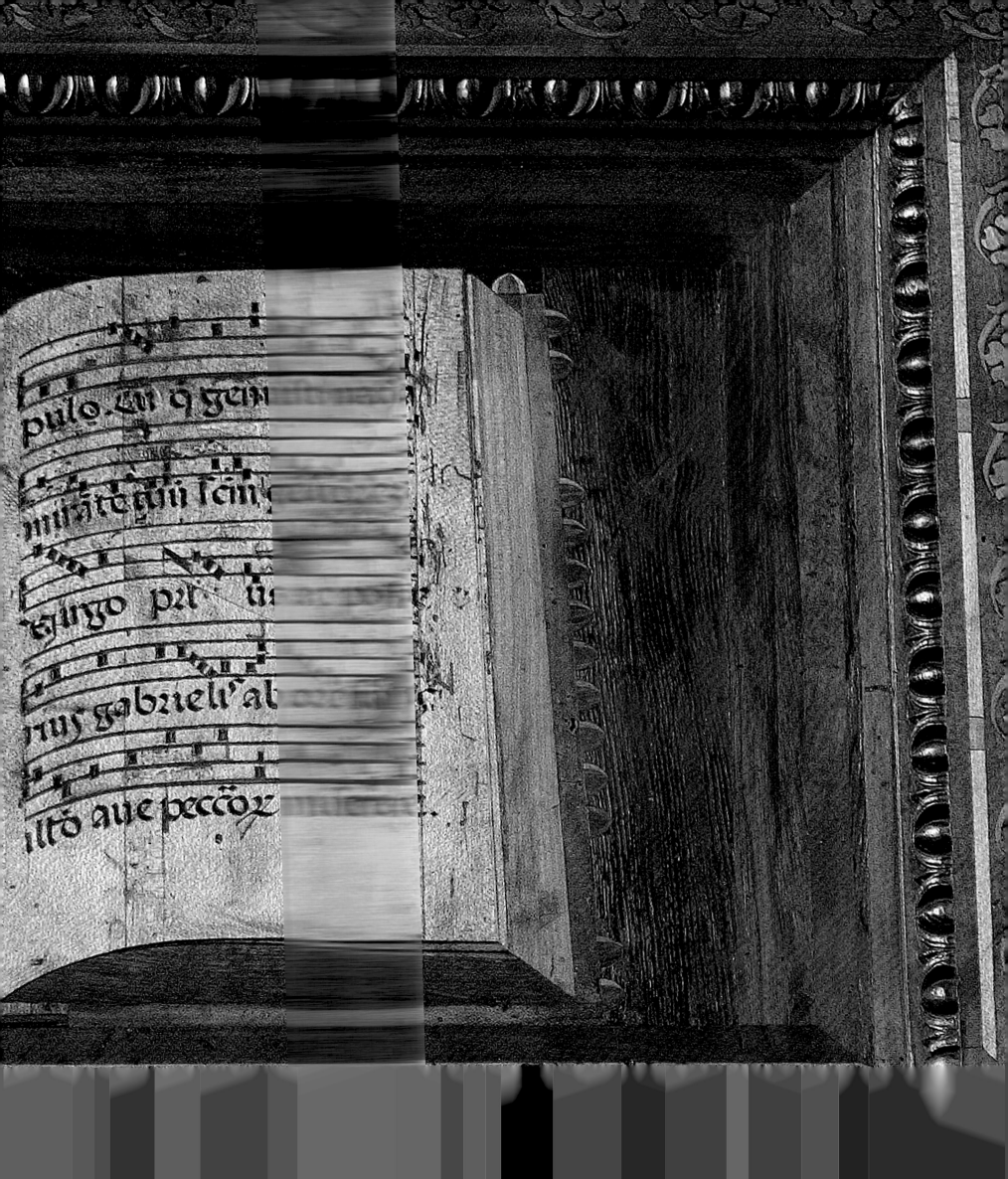

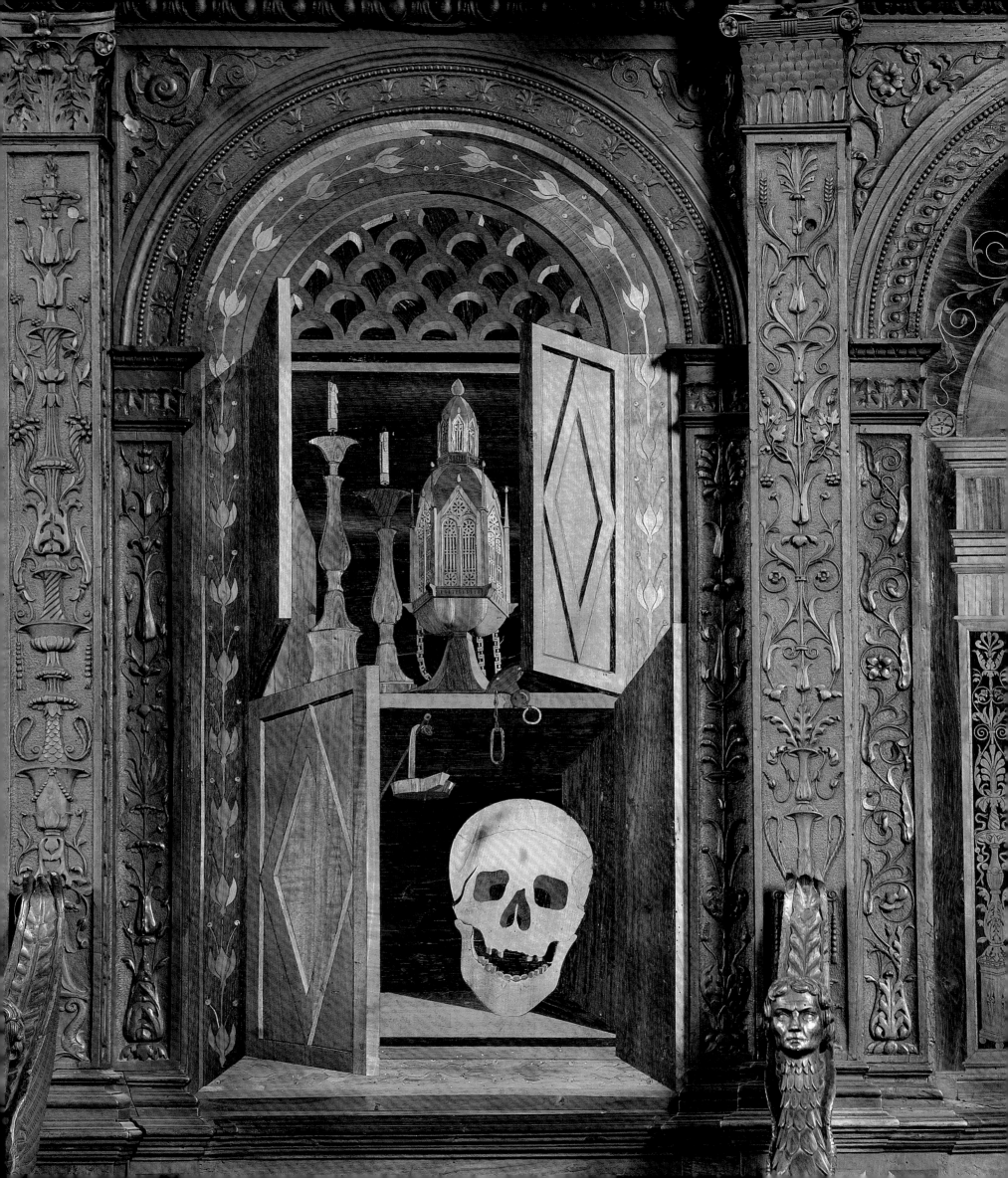

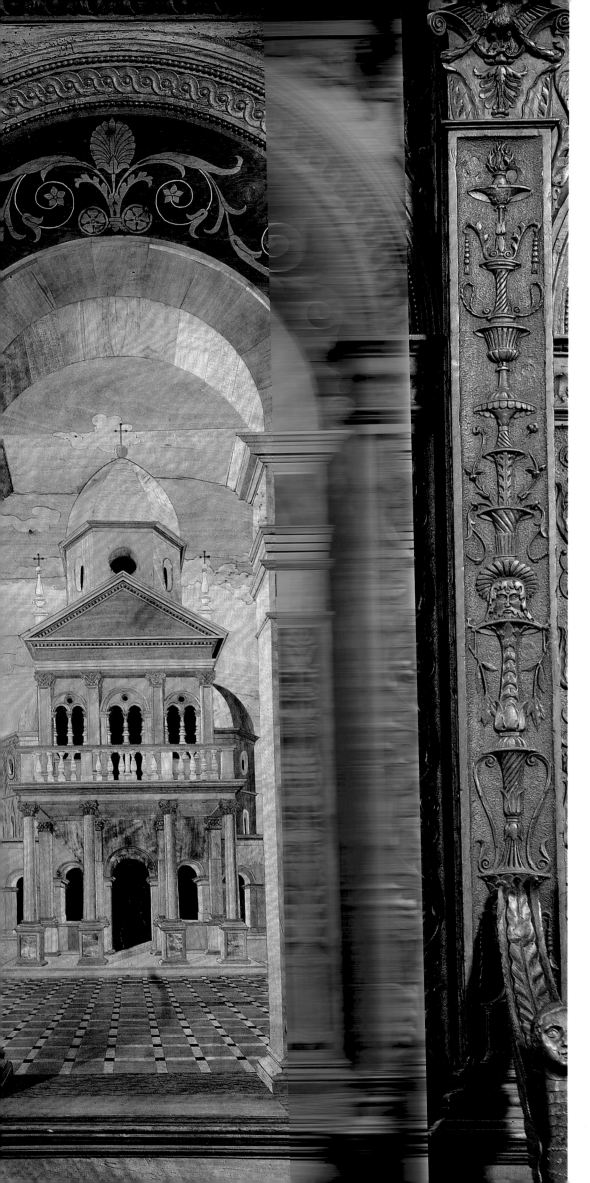

urban landscapes, liturgical objects, musical instruments, clocks, and candles appear in rigorous perspective alongside rhythmically measured ornamental motifs, and within frames that were inspired by the Porta Borsari, a local Roman monument that had become an important point of reference in this period. This allusion to Verona's classical origins may be understood as an expression of the Olivetans' desire to be fully integrated into the historical and cultural fabric of their host city.

But these are not the only subjects, and there are numerous variations. The panels on the lower level, in fact, are decorated with plant motifs, sphinxes, and other fanciful beasts, while the armrests of the upper stalls feature sculpted sphinxes and griffins.

While all the themes are treated with equal dignity, particularly notable—both for their technique and their underlying values—are the architectural views, in which the intarsist was able to draw his inspiration more fully from the antique. He presents so-called ideal cities, in which regularly cadenced loggias are combined with modern motifs from Alberti and Codussi (such as the oculi in the windows; plate 95), creating, together with the deliberate repetition of arches and facades, a meticulous and severe organization of space.[6] Clearly, antiquity is evoked here not through precise archaeological references, but implicitly, in the spirit that animates the measures and proportions, which all ultimately lead back to the laws of perspective. In other words, the reference to ancient architecture is based on the inspiration it would have provided—through its recodification in the Renaissance—to the regularization of the urban fabric.[7]

This is not to say that there are no outright quotations of the antique, for the imaginary palace flanked by two perspectival wings may be considered a reinterpretation of the residence of Diocletian in Split, Croatia. Likewise, there is the gateway leading into a city whose construction is ordered by the grid of the paving stones and the symmetry of the window frames; some have suggested that this may be identified as the Porta Organa, located near the church and still partly

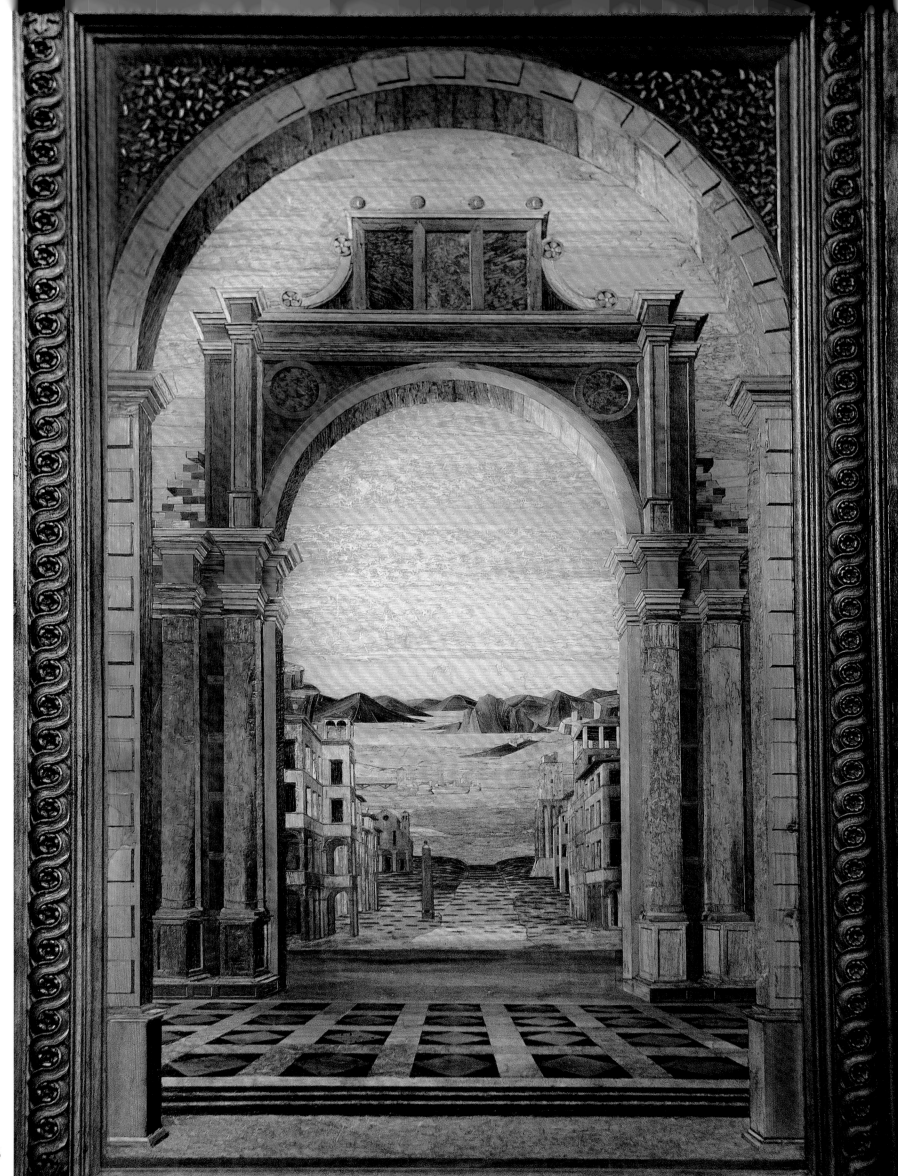

intact, and it does in any case l[...]
cast to the ancient entrances to th[...]

At the same time, these are not [...]
workings of classical architectur[...]
ization of forms forbids any p[...]
pastiche; all ornamentation is exc[...]
if at times the sensibility of the ru[...]
in the depiction of the gateway, [...]
rel plant, clearly symbolic, grow[...]
in its upper part—there predomi[...]
forward interest in complete str[...]
with reassuring geometric prop[...]
cantly, this reveals a more critical[...]
the classical heritage, which stil[...]
important object of study and sc[...]
tion, but with an understanding [...]
and difference, from the present. [...]
the attempt to improve on reality,[...]
of abstract and regular forms, and[...]
focus on buildings with contemp[...]
larized features, in which there [...]
discerned a deepening of the archi[...]
based on readings of the ancient [...]
flections on the reuse of classical e[...]

The monks' very decision to e[...]
with the intarsia work should also[...]
in this context; indeed, the artist[...]
not only a mastery of wood carvi[...]
but also a substantial understandi[...]
ture, thanks to which he designe[...]
new bell tower as well (begun in [...]
pleted in the following century).

Along with the attention give[...]
qualities, we may assume that the[...]
of the choir, as well as that of the s[...]
bued with an iconographic signific[...]
be read on multiple levels. This rea[...]
implies the possibility that there w[...]
ing program for all the images, an[...]
still awaits verification; in this reg[...]
arship is cautious, though it doe[...]
the idea. No one denies that, in ger[...]
only in Verona—the subjects of int[...]
itive, mostly falling within the trip[...]
structure alluded to earlier (of the fi[...]
landscape, and the still life) and r[...]
models, if not the same cartoons. M[...]

contracts that have come to light for other intarsia cycles, the client often makes only vague suggestions regarding the urban landscapes, leaving room for these to be generic scenes. Then there is the fact that the nature of the medium, with its extraordinary suitability to the demands of perspective, lends itself to an idealized treatment. An examination of the architecture in most intarsia work reveals that it is composed of the most regular features, without any purely descriptive passages, for even if a realistic detail does appear, it is never enough to give the scene a tone of quotidian verisimilitude.[8]

Nonetheless, this generalization can be scrutinized more closely and somewhat modified. In fact, there are some cases, albeit rather few, that refer to a clearly identifiable view.[9] Of course, it should be recognized that in these instances the outlines of the landscape, while recognizable, still retain something of the abstract. At the same time, however, such solutions create a bridge between the entirely ideal and the entirely real view, suggesting that there is, at least sometimes, the possibility of a concrete proposition, of a portrait of the city: the transfigured vision of reality is thus assimilated to the theoretical project, and they converge toward a common goal of excellence.[10]

Otherwise—to return to the intarsias of Santa Maria in Organo—it would be difficult to explain the introduction of certain scenes that, even if they have rarely been considered in this regard, were obviously inspired by actual corners of the city, easily recognizable to the friars themselves. There is, for example, the panel that portrays what must be the renovated interior of this very church in Verona: the course of the basilica is articulated by Renaissance bays, a checkerboard pavement, and a grid of columns (whose shafts are adorned with modern candelabra), with an impeccable rhythm that invites one to admire the level of perfection potentially achievable by modern science, namely perspective. This is not an image of the church as it was actually renovated, but of what might have been desired, and what might have been possible, if theoretical principles could have been followed without restriction; in expressing this hope, it suggests an ideal discourse of which Giovanni's

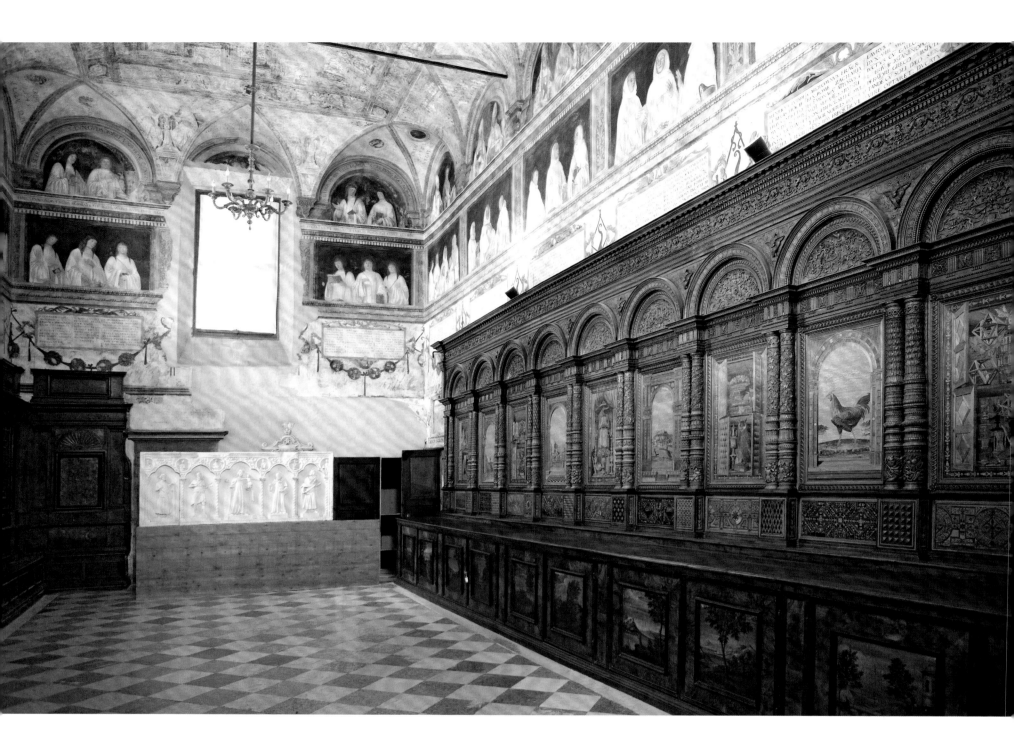

intarsias, even despite the limits imposed by real-
ity, make themselves the bearers.

The exterior views may be placed within the
same discourse. It is true that, at Santa Maria in
Organo, they consist mostly of unknown palaces
of impeccable symmetry, harmonious propor-
tions, and strict measure. But the fact remains
that a number of them also include, in the back-
ground, a hilly area that, to anyone familiar with
the Veronese landscape, would surely be reminis-
cent of the hill of San Pietro that rises behind the
church. Verona is recalled even more explicitly in
another panel, in which two travelers observe a
walled city: in addition to the myriad of bell tow-
ers that studded the urban landscape at that time,

one clearly recognizes the church of San Zeno and
the arena, respectively the sanctuary of the city's
patron saint and the symbol par excellence of its
Roman tradition.

Thus it seems likely that the "ideal cities" de-
picted in this choir were not merely vague con-
ceptions, but presented—in the form of "real"
views transfigured by the perfection of perspec-
tive—models for a desired modern restoration of
Verona, whose beginnings lay, obviously, with
the power of the Olivetan order.

This intention, moreover, was very likely sup-
ported and shared by the culture of the order
itself, and the *forma urbis* of Venice, too, prob-
ably underwent its own important renewal in the

intarsias that Sebastiano da Rovig[...]
for the Olivetan church of Sant'El[...]
that city.[11] The power of the Oliv[...]
was founded on various factors [...]
on Venetian ecclesiastic hierarch[...]
other cases in the region, but rat[...]
archate of Aquileia; the possessi[...]
relics of Aquileian martyrs; and t[...]
erudite vocabulary),[12] but it found[...]
tural and decorative lexicon of ant[...]
means of expressing a view of th[...]
fundamental role was played by [...]
Organo, whose depiction in the [...]
panel was by no means accidenta[...]
to be an *altera Hierusalem* (secon[...]
and indeed, in the Deposition tha[...]
Libri painted for this very churc[...]
city features prominently in the [...]
the shadow of the Cross—it wou[...]
classical guise, which the Oliv[...]
ing to the inscription proudly d[...]
church's exterior (QUOD INCURIA[...]
DILIGENTIA RESTITUIT / MCCCC[...]
"What had been lost through negl[...]
by diligence / 1497"), had laborio[...]
from medieval neglect (*incuria*).[13]

But this renewal was not limite[...]
tistic activity; the new look mus[...]
tended as the linchpin of a spirit[...]
would go to the very heart of Vero[...]
be assumed that the still lifes in [...]
cabinets, like the city views, wer[...]
vey a particular message and wer[...]
on purely decorative grounds. Thi[...]
does not require any exaggeration[...]
is not difficult to identify the spec[...]
the most common motifs—and to [...]
would not do justice to the comp[...]
images. And if there were a progr[...]
iconography of studioli, why wou[...]
be true for church choirs? After a[...]
vironments sometimes fulfilled the[...]
as a place of retreat and meditati[...]
then, hypothesize that their dec[...]
both cases intended to be instructi[...]

The significance of the objects [...]
of the choir might in fact be read [...]

ent levels. The first pertained to the daily medita-
tion of the monks, in which the motifs, perhaps
through mnemonic devices we cannot fully recon-
struct, must have served as an aid. A second level
reaffirmed the crucial points of the moral ascent of
which the monks were the interpreters: the tran-
sience of life (to which the clocks and burned-out
candles allude), the fragility of existence (evoked
by the glass with a flower), *memento mori* (brought
to mind by the skull; plate 102), and the soul's im-
prisonment in the material world (asserted by the
little bird in a cage) would have been counterbal-
anced by the hope offered by faith (symbolized by
the liturgical objects) and spiritual perfection (to
which the instruments and musical scores refer).[15]
In the lectern placed at the center of the choir, the
dialogue continued with the presence of animals
(an owl, a rabbit; plates 90 and 100) that reiterated
the invitation to temperance and contemplation.[16]
Finally, a third level of interpretation referred to
more abstract principles with wider implications,
whereby the entire iconography, through the
variety and rhythmic disposition of the motifs,
would have represented that universal harmony
for which books, clocks, and musical instru-
ments were recognized symbols in the humanist
imagination.[17]

Likewise, in the explication of the overall pro-
gram, the presence of Saints Benedict, Scholastica,
Gregory, and Zeno in the central part of the choir
should not be considered accidental or merely cel-
ebratory. The founders of the monastic rule that
had been adopted by the Olivetans, as well as the
pontiff who had encouraged that rule's dissemi-
nation through his *Dialogues*, were placed along-
side the patron saint of the city, which would be
given a new face under the constant guidance of
Santa Maria in Organo, in full accordance with the
values of which the convent proclaimed itself a
repository.

Thus the creations of Giovanni da Verona satis-
fied the expectations of his clients. However, in
the interest of truth, it should be added that the
monk did not work alone on these projects, which
included the lectern in the choir (c. 1500; plates
91 and 94) and a magnificent candelabrum, men-
tioned with admiration by Vasari. Surely Giovanni

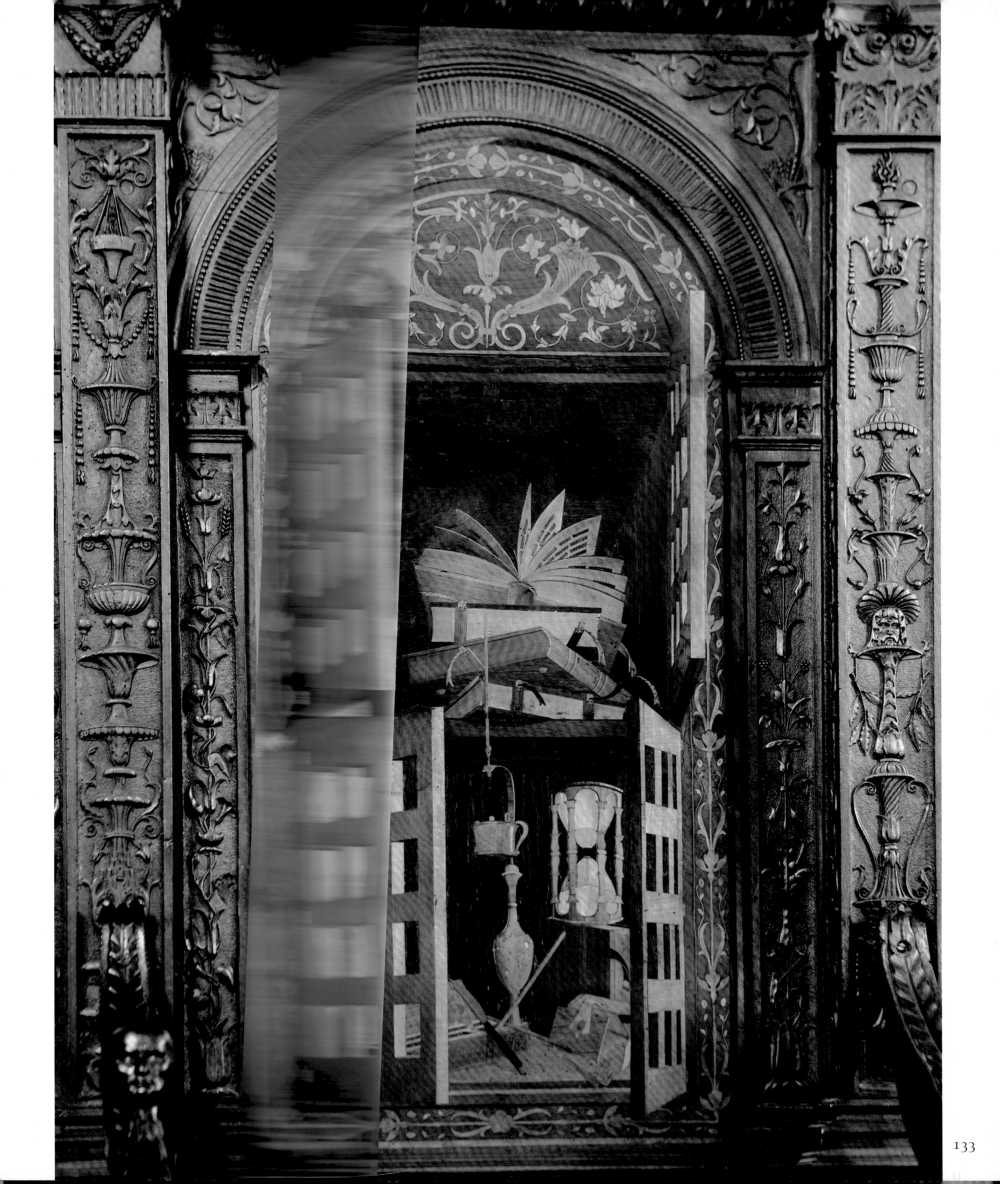

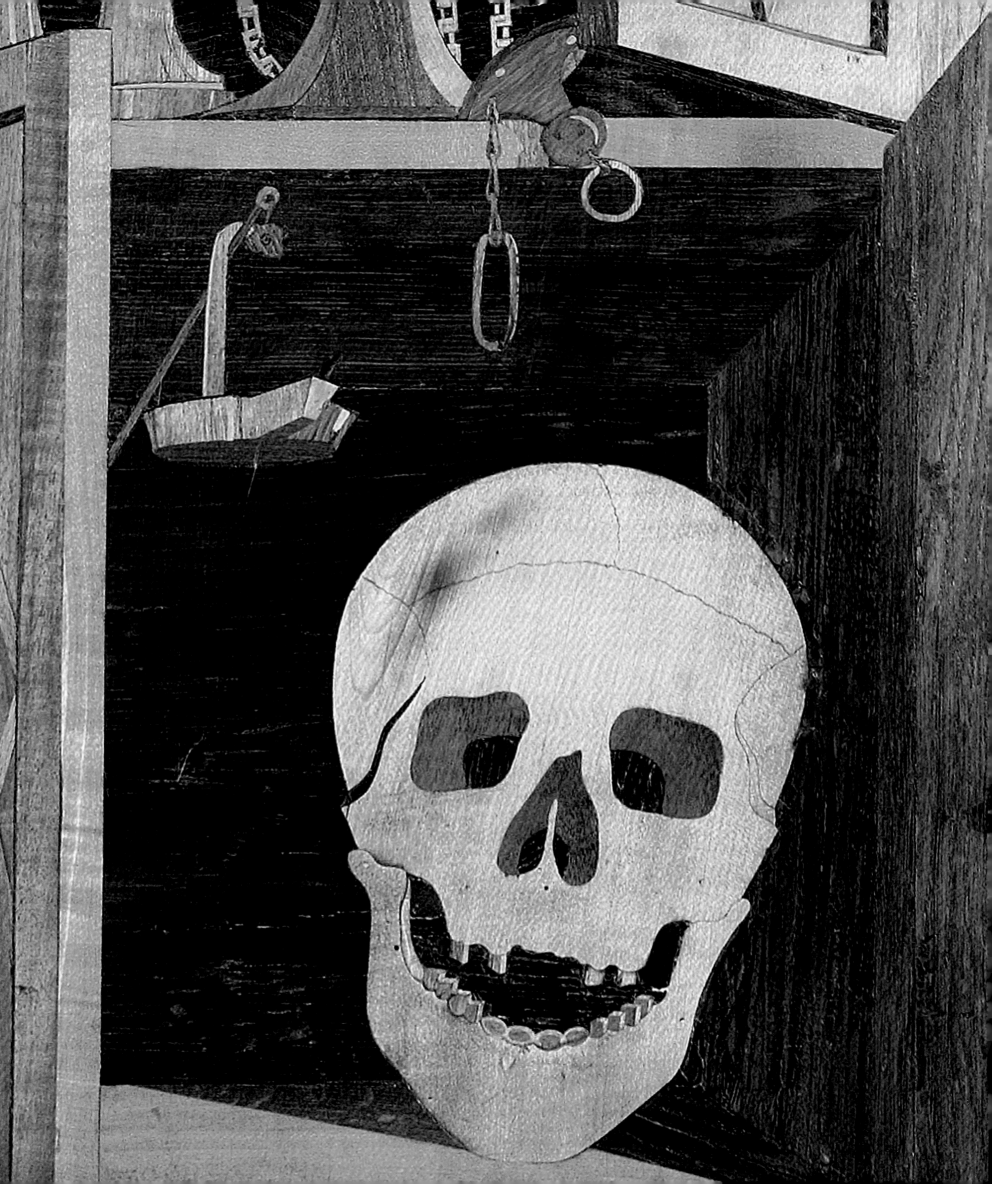

supervised and was responsible fo[...] it is known that he was assisted in[...] cution by other woodworkers, am[...] at least two Olivetans from Verona[...] Vacche and Francesco Orlandi. [...] less familiar, though their skill at[...] in the superb panel (today in th[...] Museum of Art in New York) tha[...]

[...]ne decorations executed by the latter in 1547 [...]or Bastia d'Urfé, near Saint-Etienne, in France.[18] [...]n any case, the use of assistants was a common, [...]ndeed necessary, artistic practice, which by no [...]neans diminishes the value, or the fascination, of [...]he ideas that Fra Giovanni was able to translate [...]nto wood in his church in Verona.

OPPOSITE PAGE
102. Fra Giovanni da Verona, 1457/58–1525
Cabinet with Liturgical Objects, Candles, and Skull (detail), 1494–99
Santa Maria in Organo, Verona; choir

1. Regarding Santa Maria in Organo, s[...] Rognini 1988; Rognini 2002. Regard[...] ing Giovanni da Verona, it suffices t[...] cite Rognini 1978; Ferretti 1982, pp[...] 533–39; Rognini 1985; Bagatin 200[...] and Felicetti 2005, with their addi-[...] tional bibliography.

2. For the altarpiece, here it suffices to cite Lightbown 1986, pp. 211–12; a[...] Marinelli in *Mantegna e le arti* 200[...] pp. 218–22.

3. Rognini 1994, p. 18.

4. Chastel 1953; Ferretti 1982, pp. 562–85.

5. On the sacristy, it suffices to cite Cuppini 1971, pp. 115–17; Baldiss[...] Molli 1998; Rognini 2002, p. 63; Rognini 2007.

6. On the Codussian motif, see Pupp[...] Olivato 1977, pp. 161–62.

7. The underlying tone and theoreti[...] implications of the intarsia views[...] examined in depth in Ferretti 198[...] pp. 562–74.

8. Regarding the idealizing quality [...]

[...], see in particular [...]retti 1986.
[...] pp. 40–46, is cred-[...] important contribu-[...] retation of intarsias [...]ctual views (how-[...]eris). Opinion to the [...]er, is expressed by [...]. 780; Ciati 1980. For [...]sion of the subject, [...]s collected in *Imago* [...]erretti, and Tenenti, [...]documented cases of [...]dscapes are summa-[...] 1982, p. 564. [...] intarsia toward this [...], as a "hinge with [...]ms of illusion" in the [...] emphasized in Ferretti [...]niele 1997. [...] p. 16–17 (and for the [...]–38). [...]a Maria in Organo's [...] the patriarchate of [...]ntini 1953–54, coll.

122–35. Regarding the relics, an inscription of 1496 in the Chapel of the Cross refers to the remains of Saints Canzio, Canziano, Canzianilla, Crisogono, Proto, and Anastasia, figures whose importance is examined in Cuscito 1992; Cuscito 2000.

13. Franzoni 1984, pp. 353–54; Franzoni 1997, p. 40; most recently, M. Bolla, in *Mantegna e le arti* 2006, p. 440.

14. For the parallel between choirs and studioli, see Ferretti 1982, p. 576; Liebenwein 1988, pp. 17–20; Liebenwein 1991, pp. 135–36.

15. On the glass, see B. Aikema in *Il Rinascimento a Venezia* 1999, pp. 234–35. For the skull, which is connected to the *contemptus mundi*, it suffices to cite Seznec 1938; Janson 1973. The theme of the caged bird, often understood as a symbol of the soul enclosed in the shackles of the material, has ancient origins; see Grabar 1966; Hjort 1968; Mihályi 1999. On the meaning of the musical instruments, refer to

Winternitz 1982; and for examples in Verona, see Bugini 2004, particularly p. 53.

16. Although traditionally interpreted negatively, the owl, in all its types, also had positive connotations; see Charbonneau Lassay 1940, pp. 463–67. On the symbolic meanings of another animal represented in these intarsias, namely, the squirrel, see Gentili 2000.

17. This "third level" is the interpretation that Ferretti 1982, pp. 578–85, proposes for the intarsias. The need to add other interpretive levels stems from the observation that such universal concepts may indeed be present, but must coexist with other meanings, as the symbolism of the animals or certain other motifs reveals. This sort of interpretation for the programs of intarsia cycles is also suggested in Daniele 1998, pp. 42–48.

18. Rognini 2008.

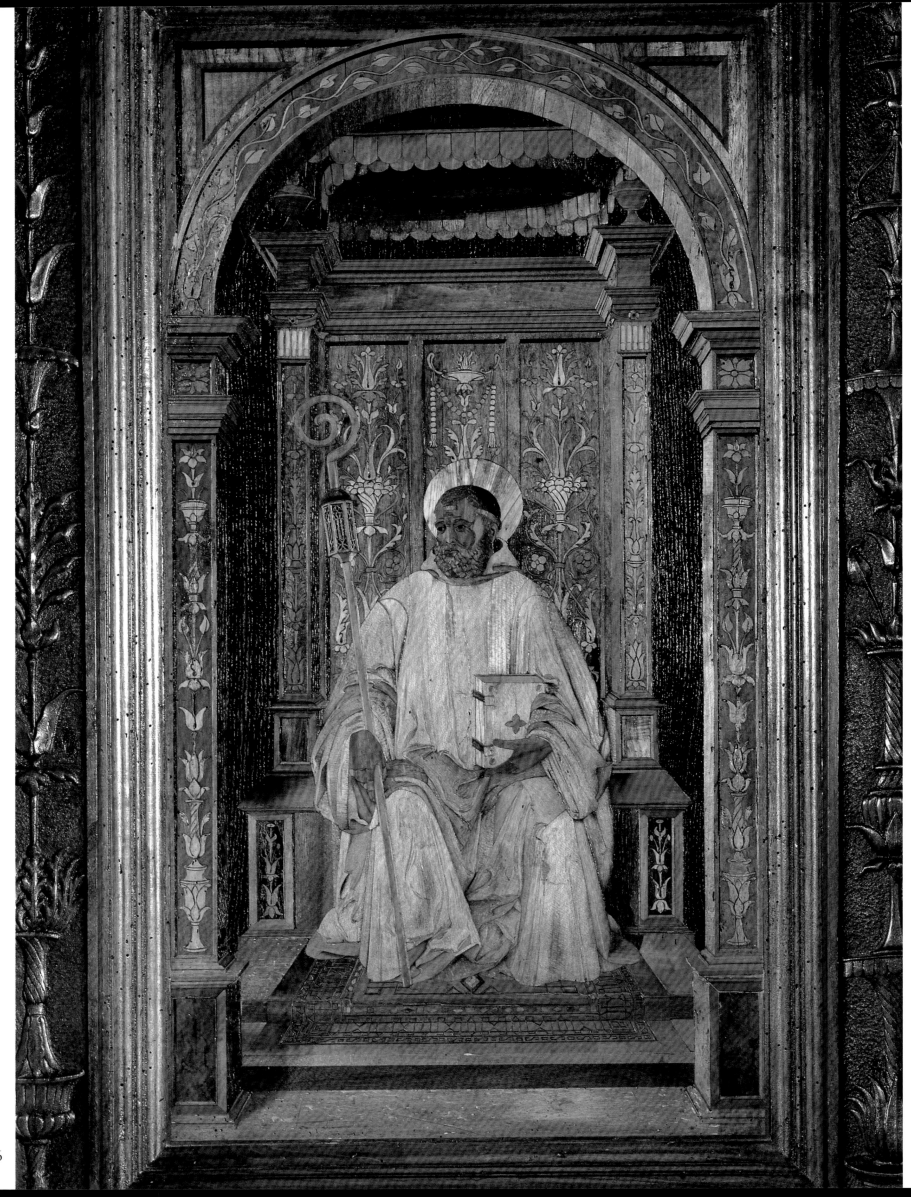

7

THE CHOI███████████TO MAGGIORE, 1504–5

████████ı Verona

███████ ?ltrami

At the height of the zeal for asceti███████ teenth century, three young Sie███████ Giovanni Tolomei, Ambrogio P███████ Patrizio Patrizi, abandoned the ███████ families to devote themselves to ███████ way of life. The harsh lands of th███████ near Siena, between Buonconvei███████ became the appointed site for th███████ mitage, and after six years, on ███████ the new order was recognized u███████ Saint Benedict. Tolomei, who wa███████ running the new monastery, ac███████ Bernardo, after Saint Bernard o███████ had been his source of inspirati███████ ous terrain of Accona became ███████ a toponym that lends itself to ?███████ tion, referring both to the olive ███████ monks planted in the arid Sier███████ symbolic site of Catholicism, the███████ passed his last, difficult night b███████ Dressed in white, a sign of thei███████ the monks took vows *in primis*███████ soon attracted numerous acolyt███████ drawn to the intense spirituali███████ emanate from the surroundin███████ and almost lunar.

Within some fifty years, ███████ Giovanni Tolomei, now near███████ number, had established th███████ teries, a number that, with t███████ pope and the nobility, grew to███████ the mid-1400s. In the establish███████ nastic poverty, the order imp███████ ment from all worldly ties: b███████ disciplined by severe schedul███████ mum sobriety in dress, acts ███████ ity toward the poor and dere███████ powerful. Every activity wa███████ most rigorous silence: in silenc███████ their gardens, vines, and olive███████ their meals; and in silence th███████

ıssigned tasks. The sole exception was the recita-
.ion of the daily prayers.

At this point, the Olivetans must have desired a seat worthy of the role their order had assumed. At Monte Oliveto, the cloister had first priority in terms of decoration, and in 1497 the monks en-trusted this work to Luca Signorelli. The choice of this artist from Cortona, who had already com-pleted his *Annunciation* for the church of San Francesco in Arezzo, as well as his *Testament and Death of Moses* in the Sistine Chapel, guaranteed a work that would reflect the elevated position of the order.[1] Here Signorelli executed a cycle of fres-coes depicting events from the life of Saint Bene-dict, following an iconographic scheme provided by Domenico Airoldi di Lecco, a monk within the community. By 1498, the artist had already com-pleted his eleven scenes of the saint's life, in which, according to Adolfo Venturi, he developed "the idea of sudden inspiration from within."[2] The re-maining decoration of the cloister was entrusted, in 1505, to Giovanni Antonio, better known as Il Sodoma, whose painting had a more lighthearted aspect.[3]

Even before the frescoes of the cloister were completed, the monks turned their attention to the choir, where they required the services of a "sculptor" in wood. The name of Giovanni da Verona must have immediately presented itself as the most obvious choice. Indeed, he had already given proof of excellence in his work at Santa Maria in Organo in Verona[4] and at Sant'Elena in Venice; Giorgio Vasari would describe him as a "great master . . . of perspective-views in inlaid woodwork," who was unrivaled "in design or in workmanship."[5]

The monks' plans, however, came up against the harsh economic reality of Siena at the begin-ning of the sixteenth century: not only had a ter-rible famine destroyed the harvest, but there were also the incursions of Cesare Borgia, which did not

OPPOSITE PAGE
103. Fra Giovanni da Verona, 1457/58–1525
Saint Bernard of Clairvaux, 1504–5
Monte Oliveto Maggiore, Siena; church choir

137

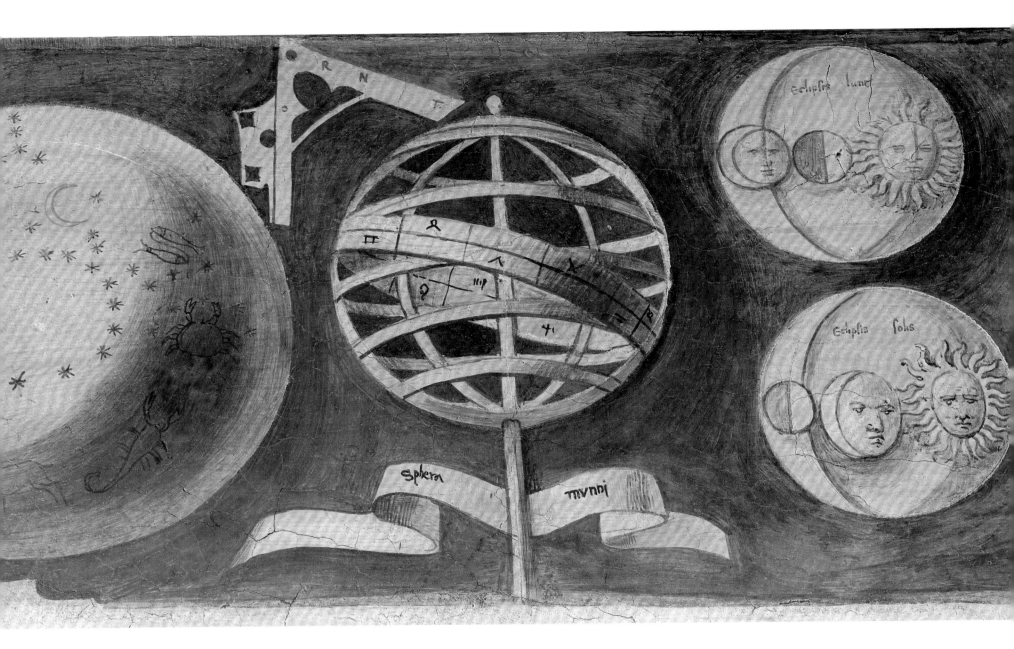

ABOVE
104. Giorgione, 1477/78–1510
Instruments of the Liberal Arts
(detail), 1500–1505
Museo Casa Giorgione, Castelfranco
Veneto

OPPOSITE PAGE
105. Fra Giovanni da Verona,
1457/58–1525
Astronomical Instruments, 1504–5
Monte Oliveto Maggiore, Siena;
church choir

spare even the Olivetan monastery. While some preliminary work was done on the choir between 1502 and 1503, the entire intarsia cycle was not completed until 1504–5. The plan of the cycle follows that of the choir of Santa Maria in Organo in Verona, but with the important difference that at Monte Oliveto, which did not have a similarly deep nave, the artist accentuated the decorative details. The candelabra, volutes of foliage, bowls of fruit, vases of flowers, musical instruments, measuring tools, liturgical objects, and animals display a technical and intellectual virtuosity that, in certain passages, is even superior to the Veronese precedent.

The decorative program of the choir opens with two large figures of saints that face each other, forming a matching pair. On one side is a saint identified as Bernard of Clairvaux, clad in the white garments of the Olivetan order, which

Giovanni da Verona conveys so skillfully that the material seems almost tangible (plate 103). On the other side is Saint Benedict, author of the eponymous rule, holding a shepherd's staff with a gem-studded crook—a seeming reprise of the episode of Aaron's rod, which blossomed and yielded almonds, just as Saint Benedict had seen a flowering of the followers of his rule, even prior to his death. Both panels share the same composition: the figures are surrounded by a perfect architectural frame, and sit upon thrones decorated with plant motifs that also appear on the piers of the rounded arch. Both figures hold the book of the rule, richly bound and elegantly closed by gilded clasps. The illusion of gilding and of the reflection of light on metal are proof of the highly refined technique of Giovanni da Verona, who bends his material to the representational needs of the cycle, seeming to go even beyond the innate possibilities

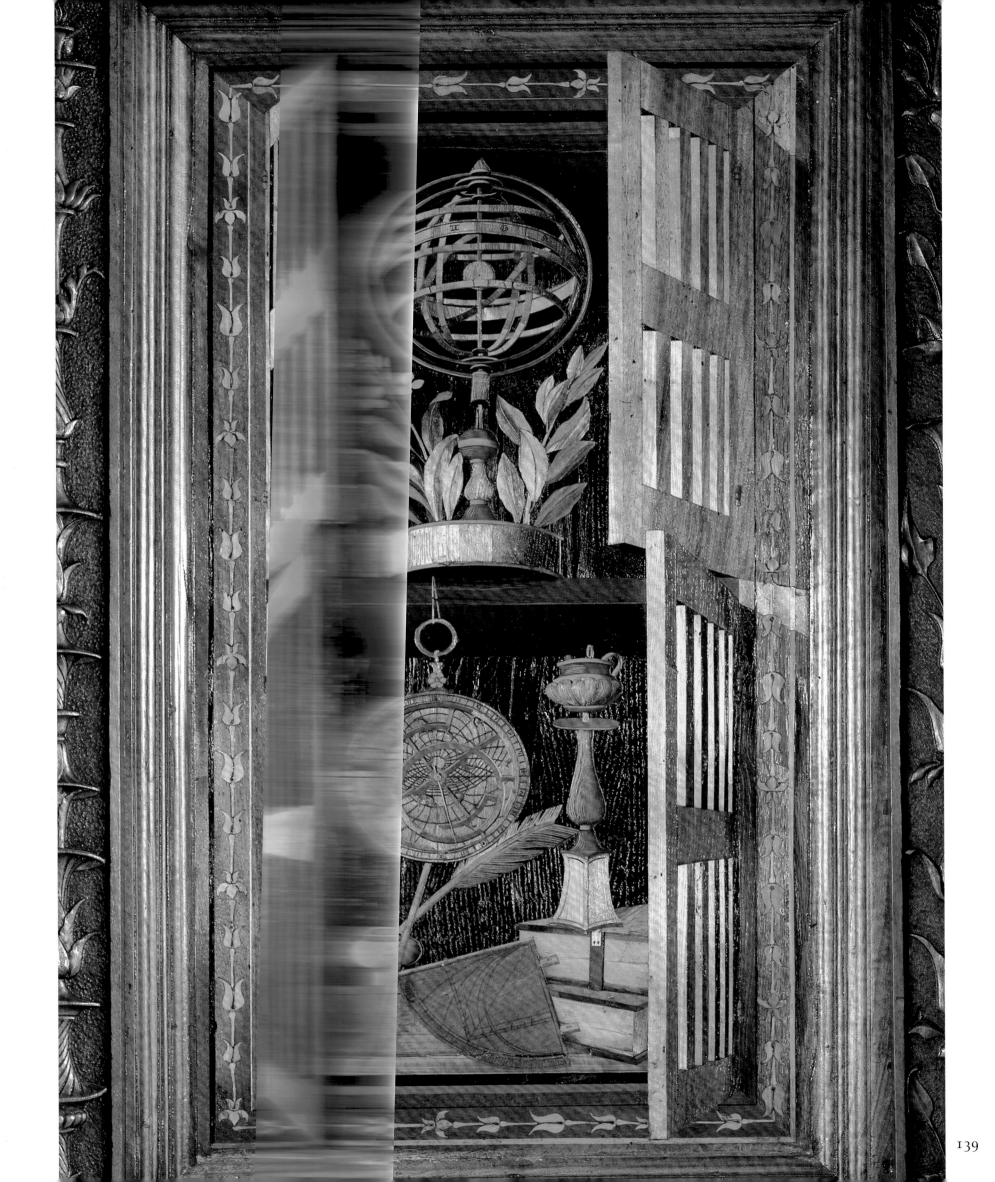

106. Paolo Uccello, 1397–1475
Battle of San Romano: Unhorsing of Bernardino della Ciarda (detail), c. 1438
Galleria degli Uffizi, Florence
Certain of the knights wear the circular *mazzocchio* on their heads.

OPPOSITE PAGE
107. Fra Giovanni da Verona, 1457/58–1525
Polyhedron and Tools of Intarsia, 1504–5
Monte Oliveto Maggiore, Siena; church choir

of wood. The depiction of metals reaches its highest point in the staff held by the saint on the left, which is embellished with a sort of ciborium in the form of a hexagonal Gothic temple, complete with windows and a small dome. Much of the previous scholarship has identified this saint as Bernardo Tolomei, but when the iconographic program was planned and the intarsias created, he had only been beatified and was not yet a saint.[6] Thus, with all likelihood, the saint depicted is Bernard of Clairvaux, who was a source of inspiration to Tolomei and the entire Olivetan order.[7]

The two saints are the only figures represented in the Monte Oliveto cycle, which instead focuses on cabinets with half-closed shutters and windows that open onto ravines and impassable hills, faithfully reflecting the actual landscape that

surrounds the monastery. Each element helps to narrate the daily life of the monastery: a life devoted to prayer and the liturgy, but also to reading, writing, and the observation of the world in both its scientific and Christological aspects. While many objects refer to the inevitable impermanence of life, and are thereby imbued with a Christian significance, others reflect the humanist culture in which the artist was strongly rooted. Indeed, the second pair of intarsia presents, on the one side, two empty candlesticks and a crucifix with three-lobed arms, and on the other side, two shelves filled with scholarly objects: books closed with clasps, an inkstand still in use, an astrolabe, and two complex astronomical instruments (plate 105). These iconographic choices belong to the tradition of intarsia, but Giovanni da Verona

also reveals a profound knowledge ███████████
Francesca and Leonardo da Vinci, ███████████
study of the Mantuan mathematicia█████████
In fact, in his *Libellus de quinque cor*████
ibus (Short Book on the Five Regula███████
della Francesca had devoted much ███████████
septuaginta duarum basium vacuum█████████
polyhedron with seventy-two face█████████████
depicts in the sixth intarsia on the ███████████
choir (plate 107). In terms of its ███████
plexity and chromatic liveliness, t███████████
has clear precedents in certain in█████████████
the fifteenth century, such as the u█████████████
the north wall of the Sacrestia del███████████
Florence duomo, executed by Ag███████████
between 1436 and 1440, as well as ███████████
created for Federico da Montefeltr████████████
Gubbio. The intarsia of the Urbi████████████
depicts a *mazzocchio* (a circular ███████████
the one that Giovanni da Verona r███████████
below his polyhedron, and like th███████████
so frequently as a geometric devi████████████
ings of Paolo Uccello. (In fact, in h█████████
of San Romano, the Tuscan painte███████████
as a sort of anomalous headgear ███████████
who in this way acquire a physica███████████
106.) The intarsia panel with the ███████████
of the most complex at Monte ███████████
cluded with a bold trompe-l'oeil████████████
as a kind of artist's signature: the███████████
cord a group of measuring and █████████████
ments, through which twines a s███████████
Greek motto "tà tòn emblematòn███████████
may be translated as "the tools of ███████████

Giovanni da Verona alternate████████████
filled with objects and laden wit███████████
erences, with illusionistic openin███████████
side world. He carves and chise████████████
to feign rounded arches that op███████████
perspectival flights: the long pav████████████
with both religious buildings an████████████
ings reveal an urban fabric that i███████████
lar and, at the same time, marked████████████
codification, based on calculatio███████████
pretation of ancient models.[8] The███████████
sion that had taken hold in the███████████
Veneto, reaching such high poi███████████

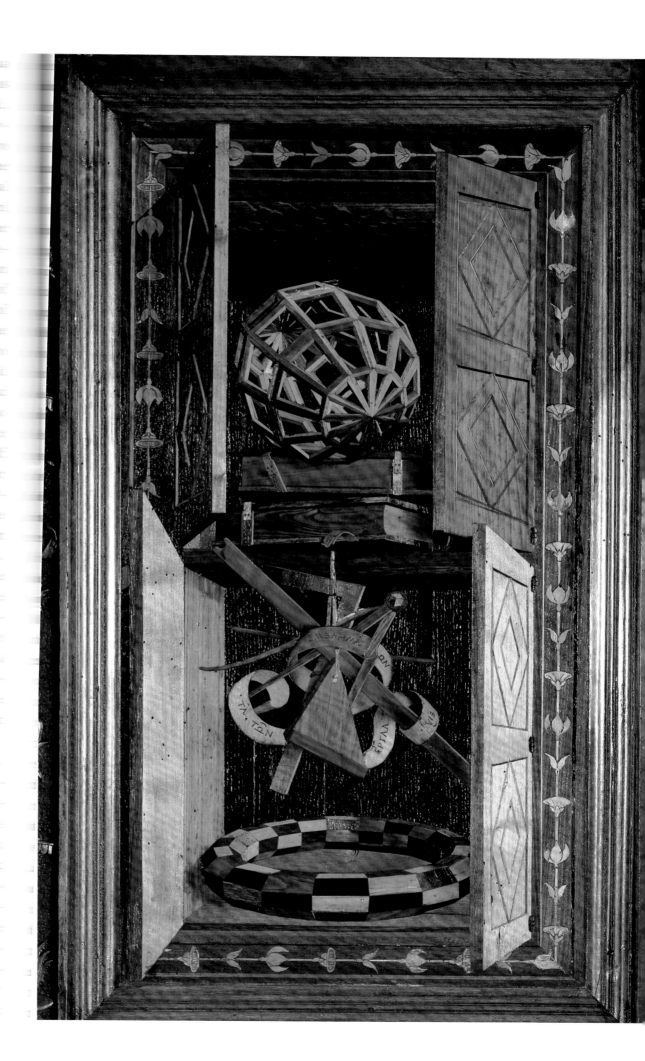

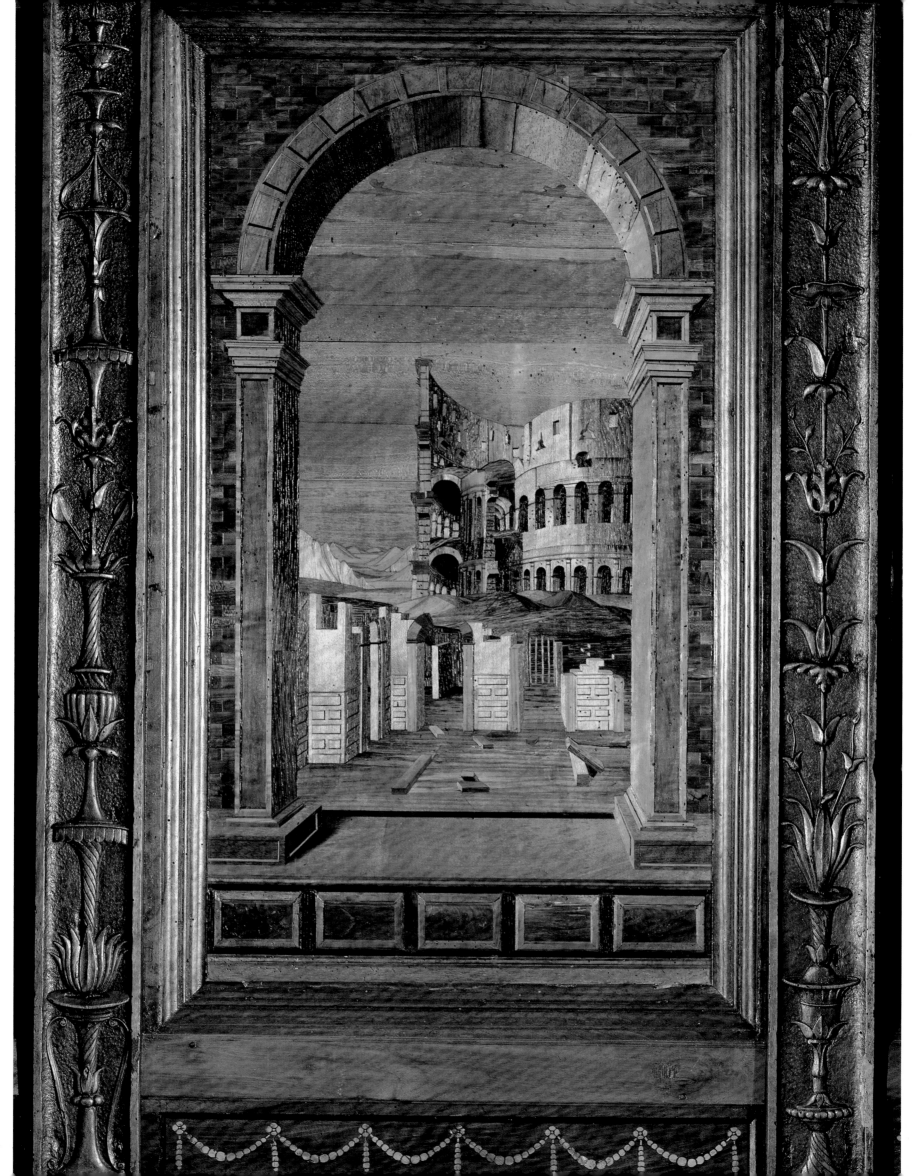

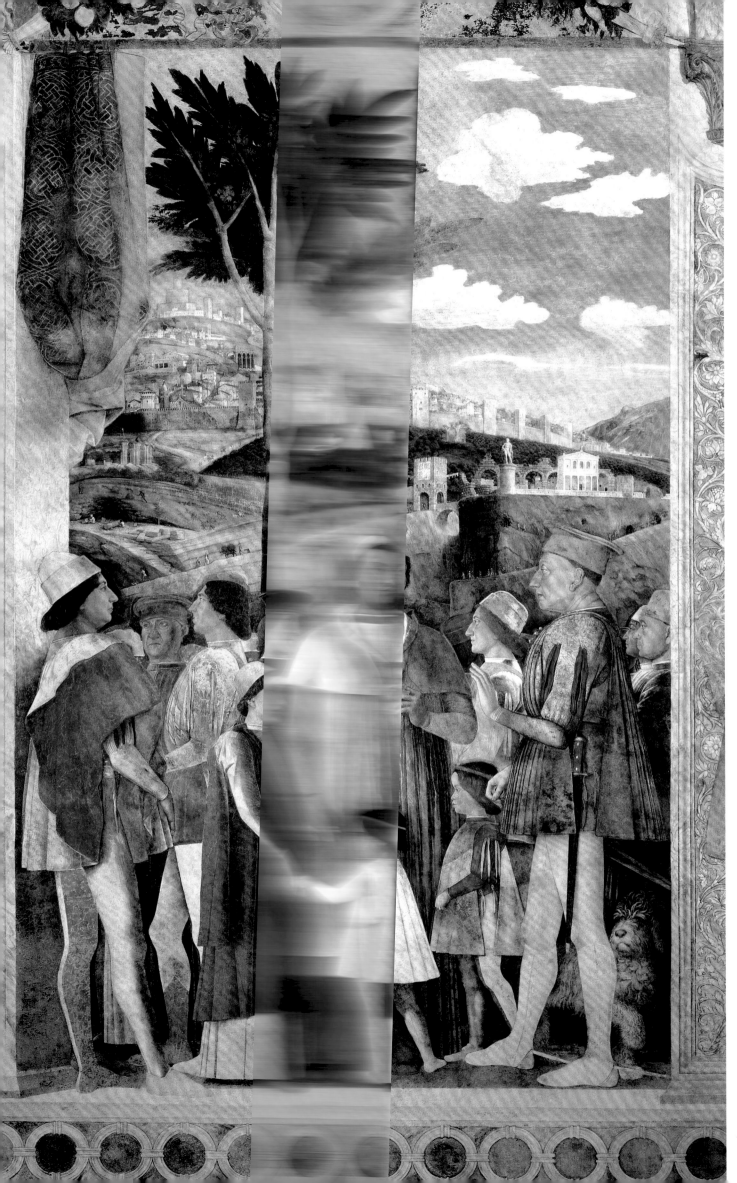

OPPOSITE PAGE
108. Fra Giovanni da Verona, 1457/58–1525
Landscape with Ancient Ruins, 1504–5
Monte Oliveto Maggiore, Siena; church choir

THIS PAGE
109. Andrea Mantegna, 1431–1506
Camera degli Sposi (detail), 1465–74
Palazzo Ducale, Mantua
The architecture in the background evinces
a classically inspired humanistic culture that
also underlies the intarsias with similar
subjects at Monte Oliveto Maggiore.

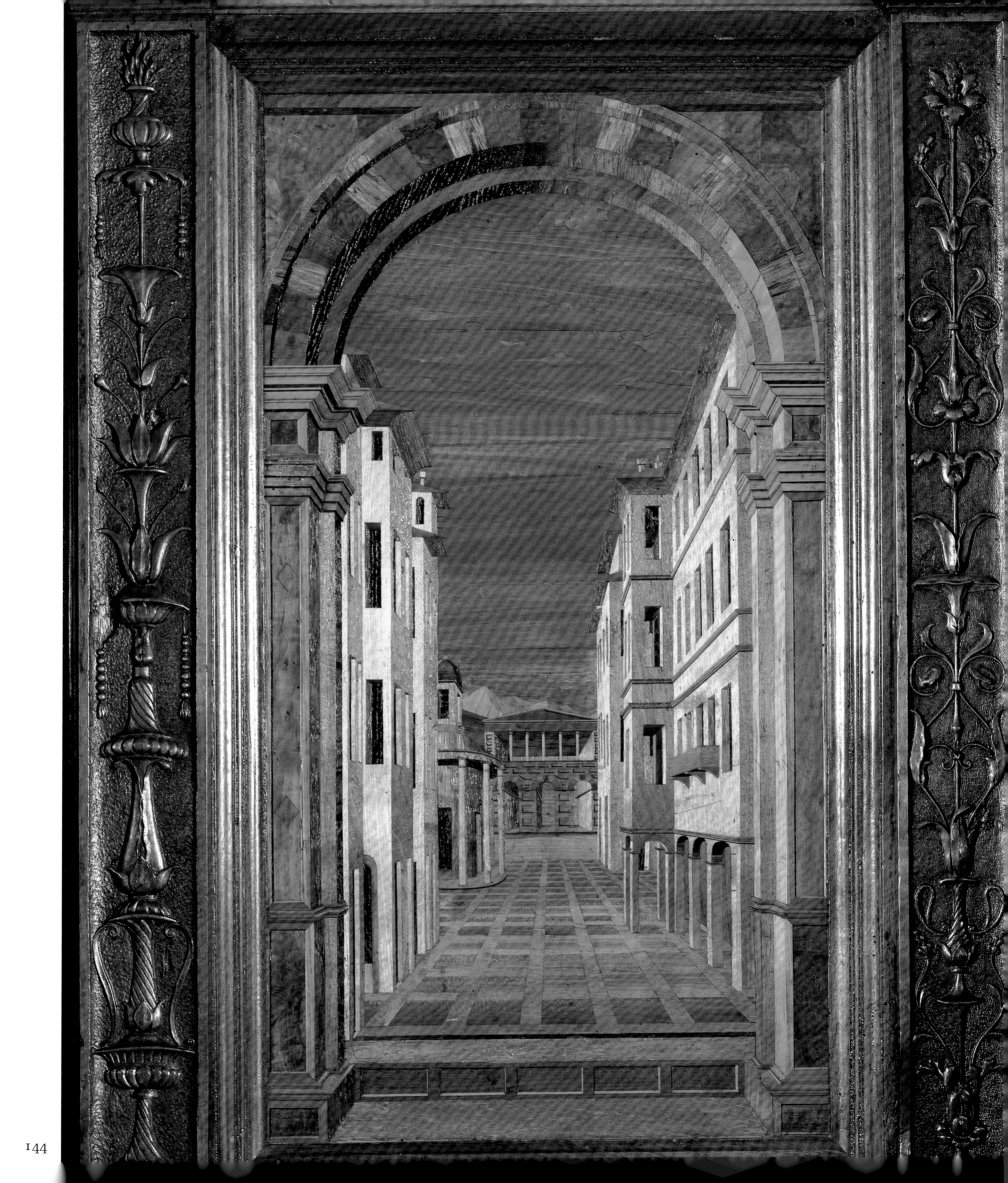

Andrea Mantegna's frescoes in the Camera degli Sposi in the Palazzo Ducale of Mantua (plate 109), reappears in Fra Giovanni's obvious evocation of the Colosseum, in front of which stand classical ruins (plate 108). At Monte Oliveto, however, the ruins are never exaggerated, but instead are the product of a mental vision in which formal rule prevails over reality. The way in which the artist concretizes this vision in wood is well exemplified by both the amphitheater and, perhaps even more, the array of remains located in front of it. In the balance he strikes between intellectual suspension and representational fidelity, including in his depiction of the urbanistic and architectural changes that the city underwent during the Renaissance, Giovanni da Verona shows that he has assimilated the example of Masaccio, who, in the Brancacci Chapel in Santa Maria del Carmine in Florence, sets episodes from the life of Saint Peter in a very similar urban context (plates 110 and 111).

Passing from Giovanni's urban views to his landscapes, the latter, framed by large rusticated entryways (plate 114), present bird's-eye views of a terrain that is faithful to the arid Olivetan setting yet cannot help but recall the formal severity of the rocks in Mantegna's work. The eye wanders freely through mountainous scenery that sometimes records the area around the monastery and other times offers glimpses of small villages, or cedes the stage to splendid winged creatures. The hoopoe, pheasant, magpie, titmouse, and goldfinch, as animals, are gifts from God, but they are also symbols of the fraternal company of those who follow the rule of silence. The rendering of the plumage exceeds the chromatic limitations of the medium, capturing the "pictorial" liveliness and softness of actual feathers. The magnificent pheasant, displaying an extremely abundant and richly shaded plumage, that occupies the entire foreground of one panel (plates 113 and 115) is a symbol of simplicity of spirit and thus an embodiment of the foremost principle of the Olivetan order.

In keeping with the iconographic tradition of the masters of intarsia, based on the human figure and, even more fittingly, on ideal architecture and trompe-l'oeil still lifes, Monte Oliveto has realized

enigmatic *nature morte*, inevitably linked to a concept of life's transience.[9] They include fresh fruit piled in an elegant decorated bowl, or a long white lily on the verge of flowering, as the more informal clusters of violets have already done. And there are even more explicit *memento mori*, such as the hourglass, the just-spent candle, and the skull.

The sense of temporal suspension that envelops the views extends even to the liturgical objects, which are not depicted as they were actually

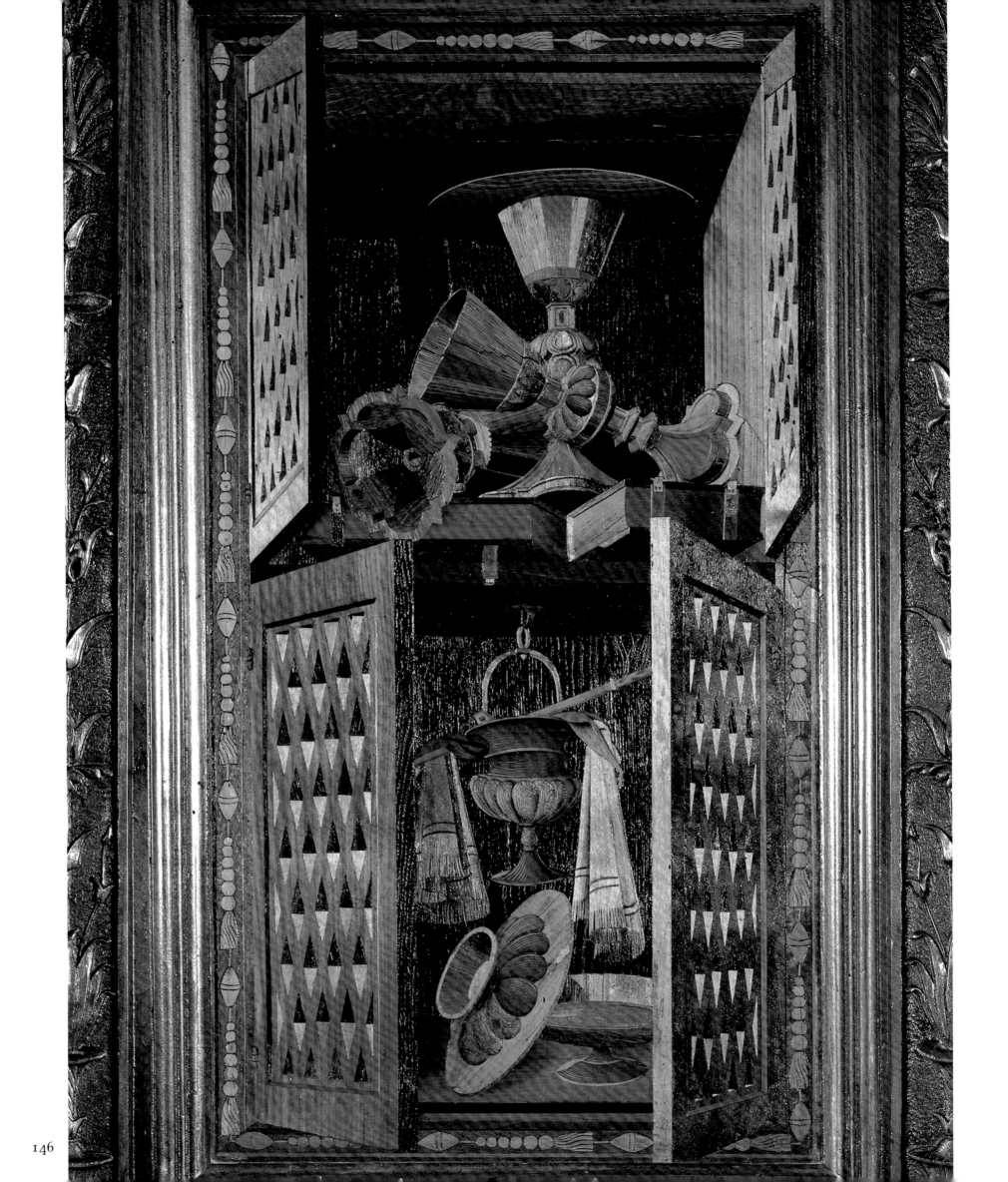

stored but deliberately summoned to a celebration of perspectival vision. Thus in an image of Eucharistic chalices (plate 112), one is radically foreshortened so as to emphasize the perspectival effects, and all three serve to demonstrate the potential of the intarsist's technique, which was capable of transcending the physical limitation of its material—namely, its opacity—to achieve an imitation of metal. An analogous discourse applies to the musical instruments and scores, metaphors for spiritual perfection.[10] In the tenth intarsia at Monte Oliveto (plate 116), Giovanni da Verona rests two flutes—one a three-holed *gamurra*, the other a six-holed *flageolet*—against a larger stringed instrument on the upper shelf, from which there hangs, in a display of considerable perspectival virtuosity, a sheet of paper with a score that musicologists have recognized as the melody of "Verbum caro factum est" (The Word became Flesh), a popular medieval hymn of praise. On the lower shelf, the strings of a boldly foreshortened lute loop around in curls against the dark background of the cabinet, playing affectedly about the edges of the score. The profound classical culture of the artist and the very setting of the series suggest the possibility of multiple levels of interpretation. The choice of objects can be connected, first of all, with the monks' daily meditation, which involved complex mnemonic procedures. The same objects also present a second level of meaning tied to the path of moral ascent undertaken by the monks and based on the fragility of life, a concept emphasized by the numerous *memento mori*. Finally, a third level of interpretation pertains to the concept of *varietas*, a rhythm created by the images themselves and a reflection of a universal equilibrium.[12]

It should be noted that the present-day choir at Monte Oliveto differs from the one created by Giovanni da Verona in the early sixteenth century; it is the result of successive interventions that began in the seventeenth century and concluded with a final adjustment of the intarsias in 1820 by the cabinetmaker Venanzio Baroni, who remounted the sequence without, however, distorting the iconographic program.

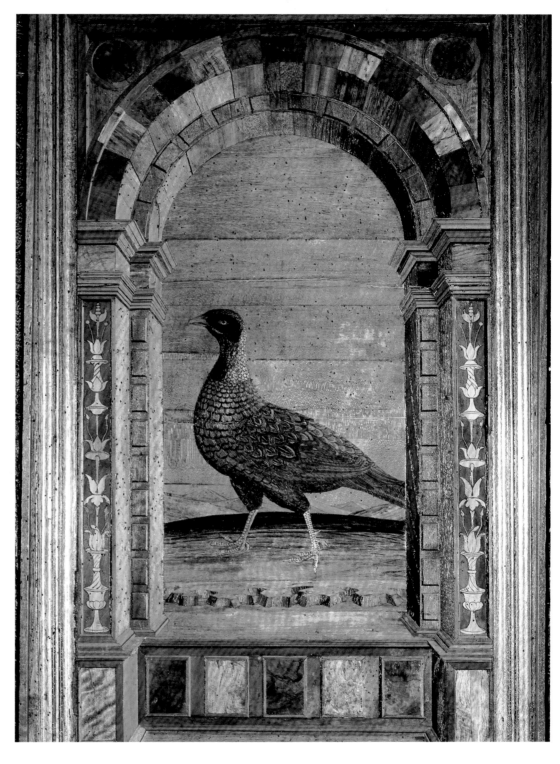

OPPOSITE PAGE
112. Fra Giovanni da Verona, 1457/58–1525
Implements of the Eucharist, 1504–5
Monte Oliveto Maggiore, Siena; church choir

ABOVE
113. Fra Giovanni da Verona, 1457/58–1525
Landscape with Pheasant in Foreground, 1504–5
Monte Oliveto Maggiore, Siena; church choir

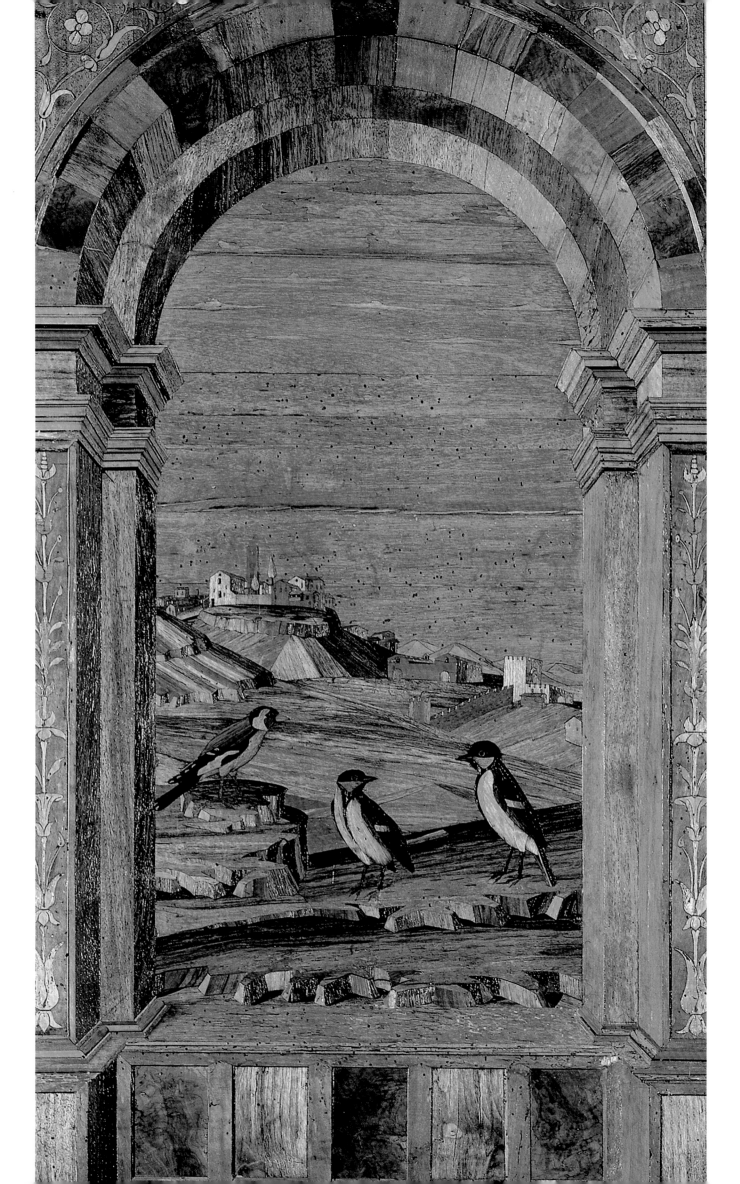

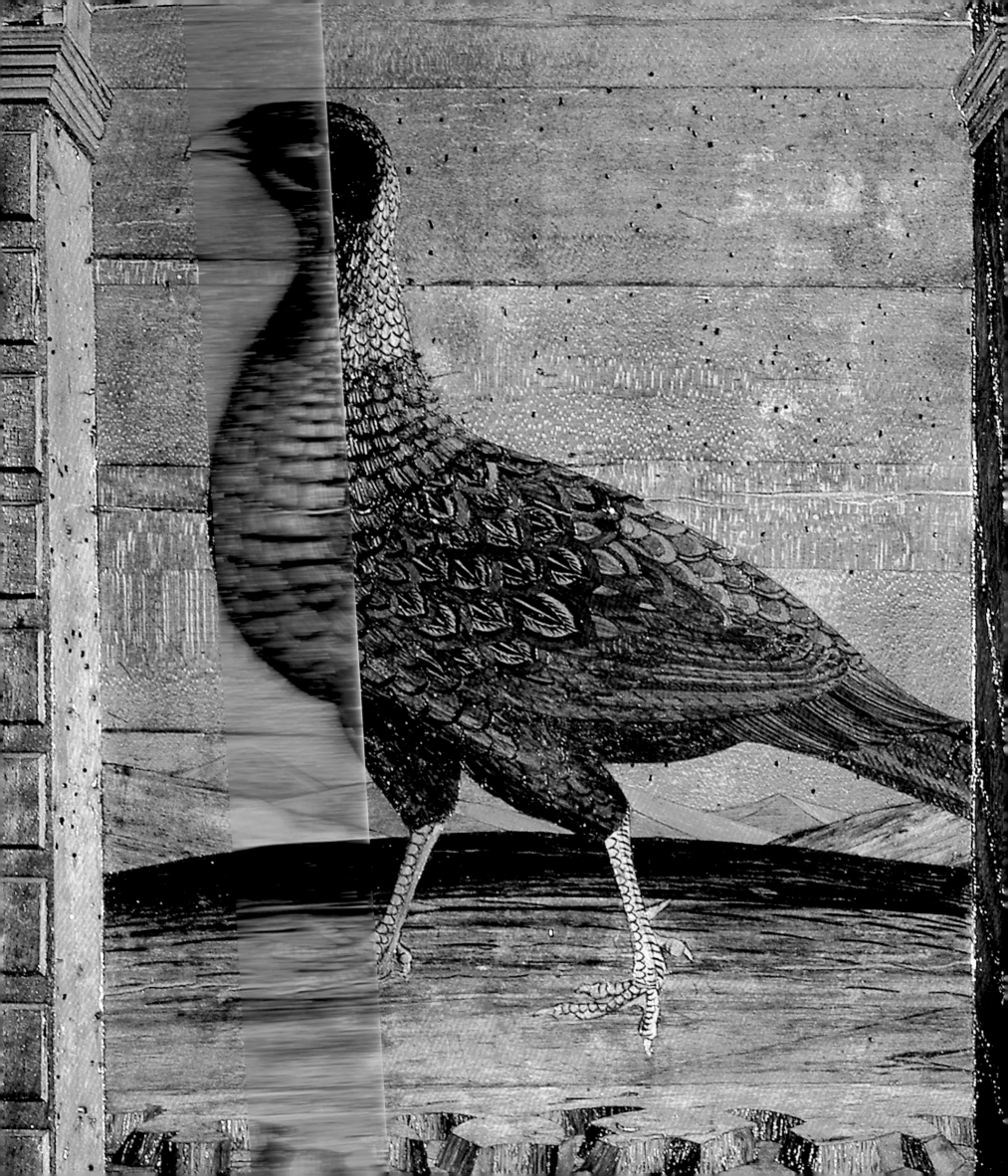

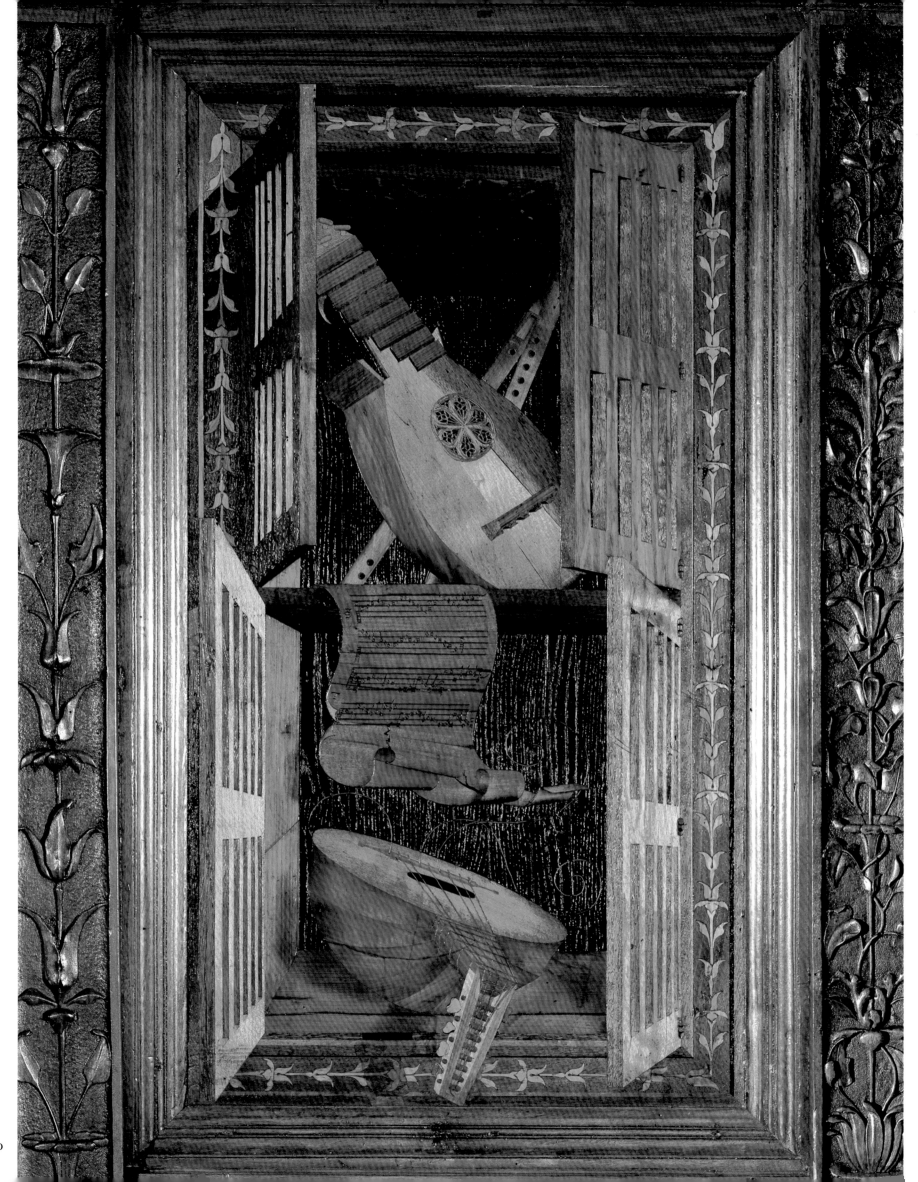

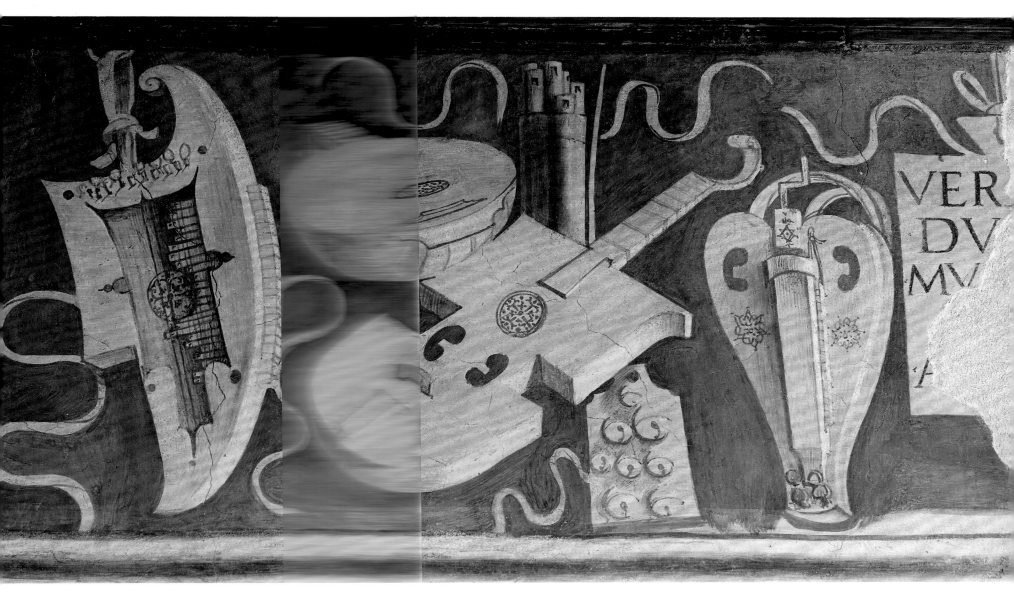

ABOVE
117. Giorgione, 1477/78–1510
Instruments of the Liberal Arts
(detail), 1500–1505
Museo Casa Giorgione,
Castelfranco Veneto

1. The most up-to-date monograph on the artist is *Luca Signorelli*, Kanter, Henry, and Testa, the last of whom contributes an entire chapter on the decoration of the cloister at Monte Oliveto (pp. 39–45).

2. Venturi 1922, p. 30.

3. Regarding Sodoma's presence at Monte Oliveto, refer to Bartalini 1996, pp. 87–89, with extensive bibliographic analysis; however, the account given by Sapori, in his critical edition of Vasari's life of the artist, remains valuable: "In 1503 Sodoma was summoned to Sant'Anna in Camprena, near Pienza, where, with little knowledge and much feeling, he frescoed the refectory of a small convent of Olivetans. From there his art began to take an ascendant direction. The artist worked to correct some of the flaws

school, leaps out dressed in the sumptuous robes of the Renaissance. . . . From the silence of the cloister, where he had led the life of an eccentric artist and successful horseman, amidst a swarm of bizarre beasts that he depicted in his painting and which amused the monks, we see that on the last day of August in the year 1508, Sodoma departed in the direction of Rome." Sapori, 1914, pp. 10–12.

4. Regarding the history of Santa Maria in Organo, see Rognini 1988; Rognini 2002. Regarding Giovanni da Verona, see, with additional bibliography, Rognini 1978; Ferretti 1982, pp. 533–39; Rognini 1985; Bagatin 2000; and, of course, the essay by Alessandra Zamperini in this publication (p. 119).

5. The passage from Vasari was published

in Bagatin, ed., 2002, p. 8. (Translation by De Vere, 1912, IV, p. 222.)

6. Bernardo Tolomei would not be canonized until 1644; see Bagatin, ed., 2002, p. 19.

7. The identification with Bernard of Clairvaux was recently confirmed in Bagatin, ed., 2002, p. 19.

8. The underlying tone and theoretical implications in the intarsia views are examined in depth by Ferretti 1982, pp. 562–74.

9. See Chastel 1953; Ferretti 1982, pp. 562–85.

10. Regarding the significance of the musical instruments, see Winternitz 1982.

11. See Bagatin, ed., 2002, p. 30.

12. See Ferretti 1982, pp. 578–85.

13. See Bagatin, ed., 2002, p. 51.

8

NAPLES ✳ THE INTARSIAS OF SANT'ANNA DEI LOMBARDI, 1506–10,
AND THE CERTOSA DI SAN MARTINO, C. 1514
Fra Giovanni da Verona and Giovan Francesco d'Arezzo

By Piermario Leonardelli

In a well-known letter of 1524 addressed to the Venetian connoisseur Marcantonio Michiel, the Neapolitan humanist Pietro Summonte, describing the salient advances of the Renaissance in his city, does not neglect to devote some lines to the intarsia work there, beginning with that in the church then dedicated to Santa Maria dell'Annunziata di Monte Oliveto, and now known as Sant'Anna dei Lombardi.[1]

Giovanni da Verona—whom Summonte describes as "a monk from the same white-robed order as Saint Benedict" and "an illustrious artist"—was responsible for two of the cycles of "wood inlay and perspective" that adorned the Olivetan church. On the occasion of his stay in Naples, which lasted from about 1506 to 1510, Fra Giovanni had worked on both the old sacristy and, at the request of Paolo di Tolosa, the choir in the Tolosa family chapel.[2]

Unfortunately, these works did not long remain in their original form or location. In 1595, the intarsias in the Tolosa chapel were transferred to the new sacristy (which would become the present-day Oratory of San Carlo Borromeo; plate 119), where, during the seventeenth century, they were equipped with Baroque frames and, along with the other works by Giovanni, were then rearranged in their current configuration.[3]

But to return to the early years of the sixteenth century, Fra Giovanni could by this time claim a decade of impressive experience in the field of wood inlay. After executing the intarsias for the choir of Santa Maria in Organo in Verona between 1494 and 1500, he was summoned to his order's motherhouse at Monte Oliveto Maggiore (near Siena), where he worked on the choir in 1505. His reputation strengthened by this commission, Giovanni traveled on to carry out other commissions from members of his order, and thus arrived in Naples, where—as was usual for projects of

this scope—he was assisted by at least two collaborators. Pietro Summonte mentions "Geminiano, a Tuscan from Colle, or a Florentine" and "Imperiale from Naples," stressing that both, while in subordinate positions, could undeniably be considered both master wood-carvers and consummate professionals, in a situation in which it was essential to follow the directives of their colleague from Verona with consistency and finesse.[4]

Giovanni's project was not in fact anomalous within the Neapolitan sphere, since intarsia work had already been introduced by the start of the sixteenth century, in the sacristy of Sant'Angelo a Nilo and the choir of San Pietro a Maiella. The value of these projects, even despite the stylistic limitations sometimes noted by critics, lay in their adoption of the many ideas offered by the local school of painting, which were capably translated—particularly at Sant'Angelo a Nilo—into the more graphic, but not for that less subtle, language of wood.[5] Giovanni Gallo's work in the choirs of the monks and the lay brothers in the Certosa (Charterhouse) di San Lorenzo in Padula, completed in 1503 and 1507, respectively, also reveals varied techniques and iconographies that attest to the autonomous development of intarsia in Campania.[6]

Nonetheless, Fra Giovanni's expressive and conceptual mechanisms surpassed anything that had been accomplished up to that time, carrying all the "mathematical" and perspectival potential of intarsia to the highest possible level. It is again Pietro Summonte who reserves some words of praise for Giovanni's *Saint Benedict* (noting that it is just one of the "figures of great value" executed by the Olivetan, which may be taken as an eloquent summation of his treatment of the human figure in his intarsias. But the city views deserve the same regard: they are veritable stage sets where the rigorous checkerboard pavement of the foreground

119. Oratory of San Carlo Borromeo, with intarsias by Fra Giovanni da Verona, Sant'Anna dei Lombardi, Naples.

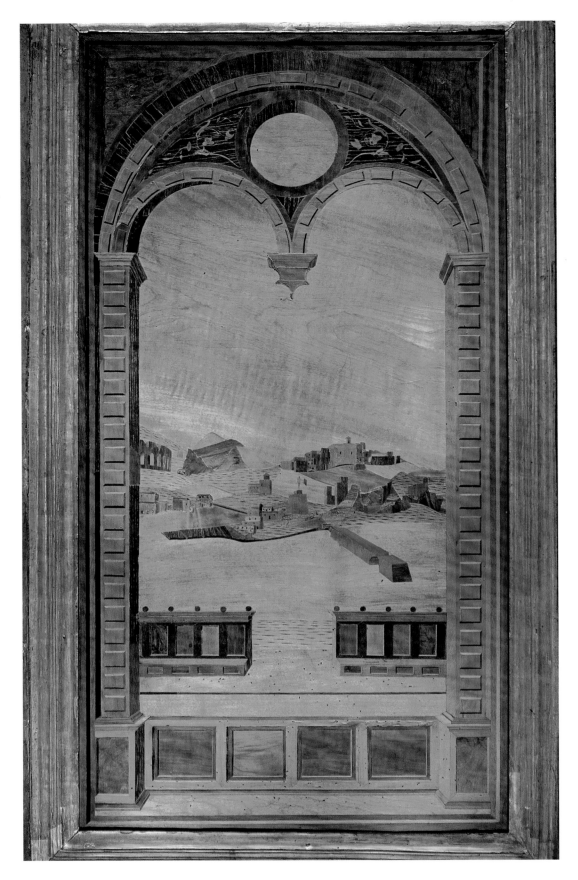

120. Fra Giovanni da Verona,
1457/58–1525
View with the Castel Nuovo, 1506–10
Sant'Anna dei Lombardi, Naples;
Oratory of San Carlo Borromeo

it, for example, at Verona and Monte Oliveto Maggiore): they linger sometimes on the frame of the panel (plate 122), and sometimes in the foreground of the image (plates 118 and 125), representing, in their virtuosic naturalistic detail, the only form of life in a panorama that is crystallized in its immobility. And finally, the viewer's admiration is sustained by the illusionistic cabinets (plates 80 and 124), on whose shelves liturgical implements are placed in an apparently disorganized (but in fact carefully considered) fashion alongside clocks, candles, papers, books, and baskets brimming with fruit, in accordance with a consistent semantic system intended to suggest both universal harmonies and more concrete cues for the meditations appropriate to the setting.[7]

Just as Fra Giovanni's works did not spring forth in a desert, they were not destined to remain an isolated case. At the same Olivetan church they were joined by the panels in the choir of the main chapel attributed (again in the 1524 letter) to Giovan Francesco d'Arezzo and his colleague Prospero.[8] It should be noted that while this work is of good quality, many of its subjects, which are focused on antiquarian themes such as cornucopias, vases, and candelabra (plate 126), seem to correspond only partially to the "trifle[s] of perspective" mentioned by Summonte, given that they look rather flat against the uniform background of the stalls, without much articulation of depth.

Nonetheless, the same source also ascribes to this pair of craftsmen the intarsias of the twenty-five stalls once located in the main chapel of the Certosa di San Martino (and now incorporated into the lay brothers' choir, in the right part of the presbytery; plate 127), as well as the so-called prior's stall (the original configuration of which is rather problematic). The seat back of the latter depicts the Crucifixion, a Christological theme that is foreign to the figurative practice of Giovanni da Verona, who generally does not venture into the field of *historia*, but consistent with certain iconographic schemes in Campania, such as that of the aforementioned monks' choir of the Certosa di Padula.[9]

In any case, the intarsia cycle at San Martino has raised other questions. For example, the former apsidal choir's date of creation has only recently

may transition into the gentler surfaces of the background, or where ideal views, with programmatically perfect architecture, may alternate with actual scenery, as in the scene representing the Castel Nuovo (plate 120). No less masterly is the rendering of the animals, which include winged creatures (among them an owl) and a rabbit (a favorite subject of the intarsist, who also depicted

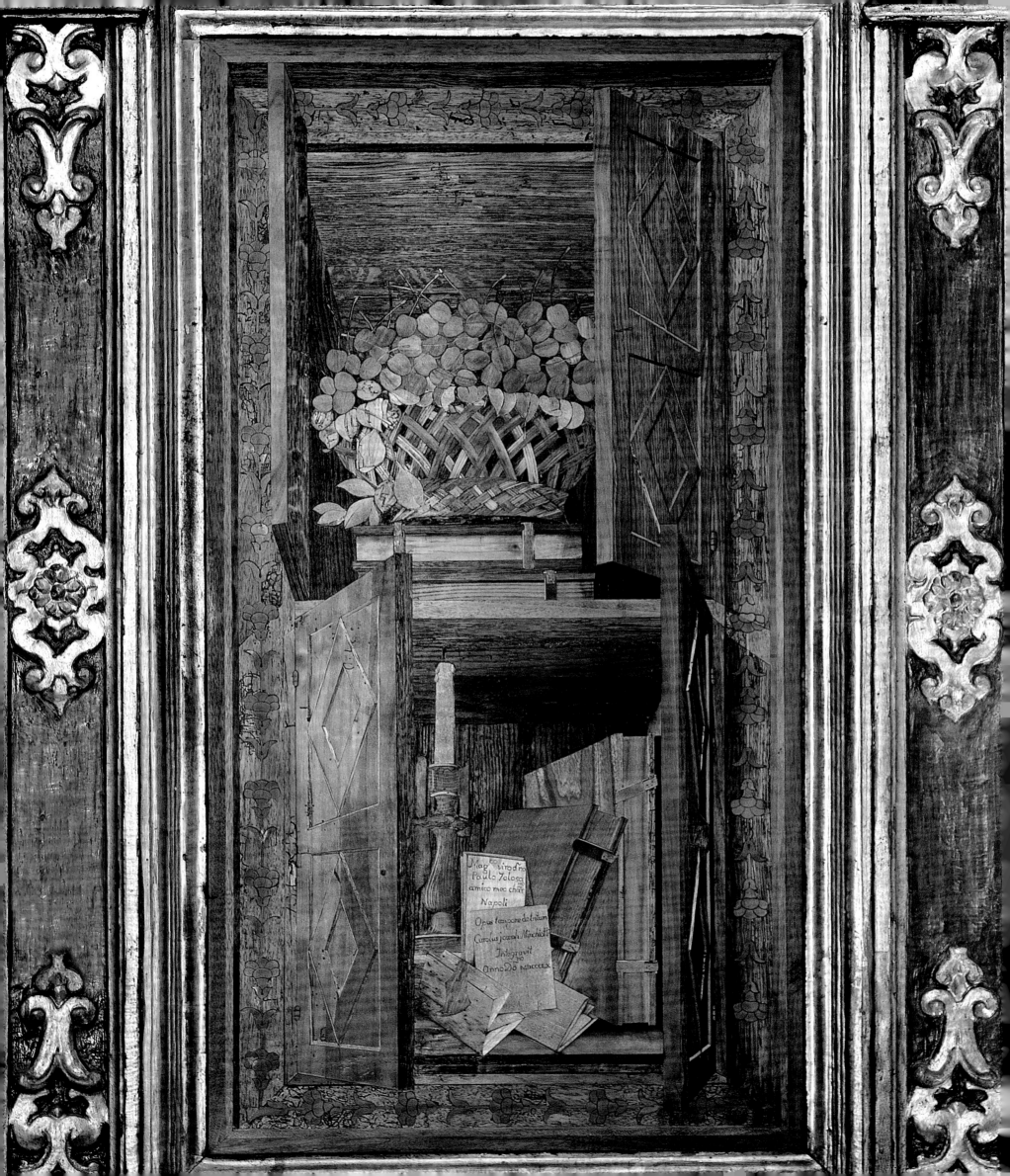

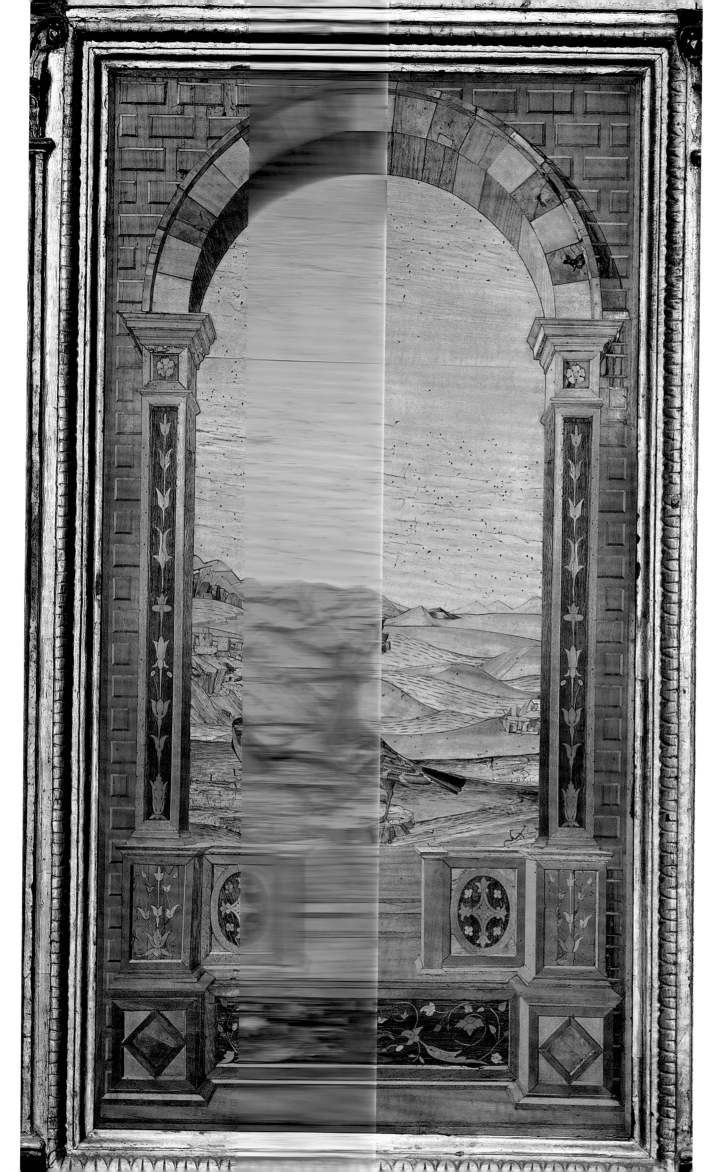

OPPOSITE PAGE
124. Fra Giovanni da Verona,
1457/58–1525
*Cabinet with Basket, Books, Candle,
and Papers*, 1506–10
Sant'Anna dei Lombardi, Naples;
Oratory of San Carlo Borromeo

THIS PAGE
125. Fra Giovanni da Verona,
1457/58–1525
Landscape with Hoopoe, 1506–10
Sant'Anna dei Lombardi, Naples;
Oratory of San Carlo Borromeo

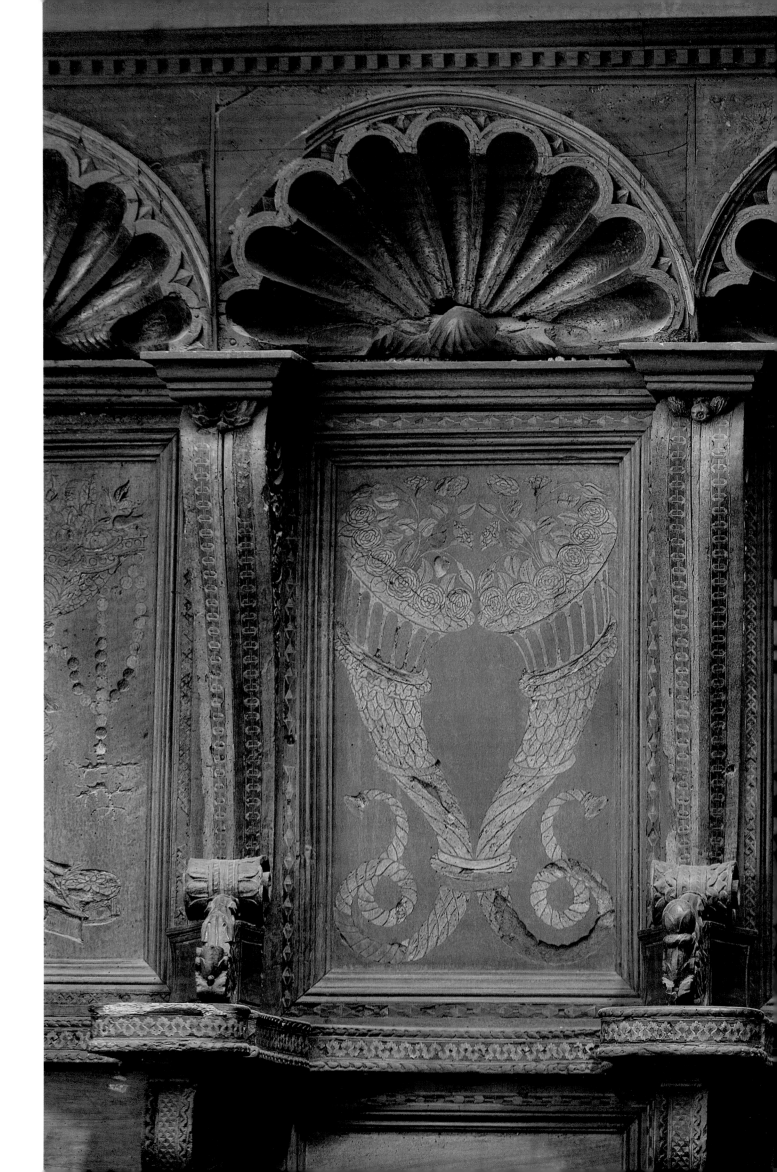

126. Giovan Francesco d'Arezzo
and Master Prospero
Intarsiated panels, c. 1510
Sant'Anna dei Lombardi, Naples;
choir

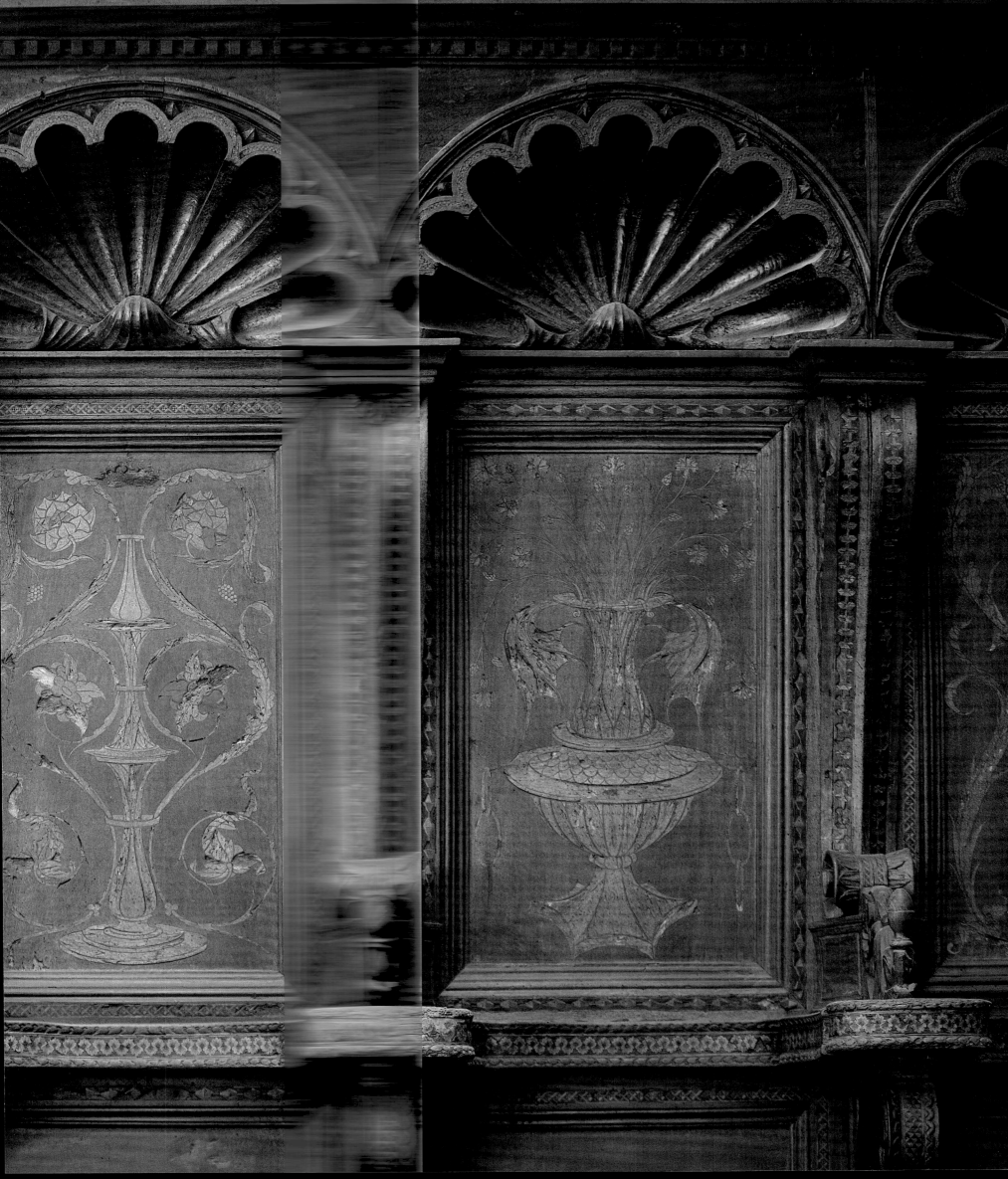

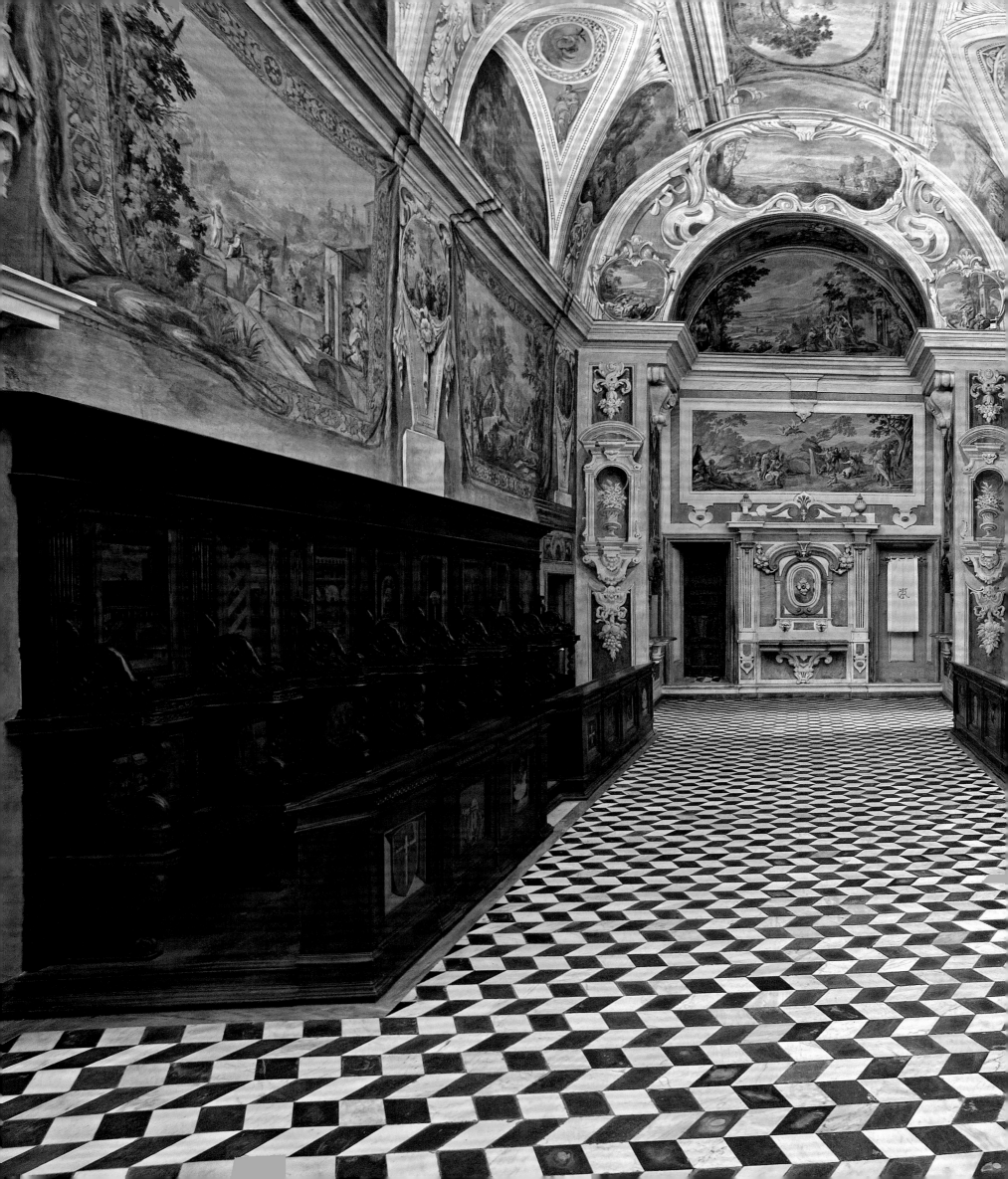

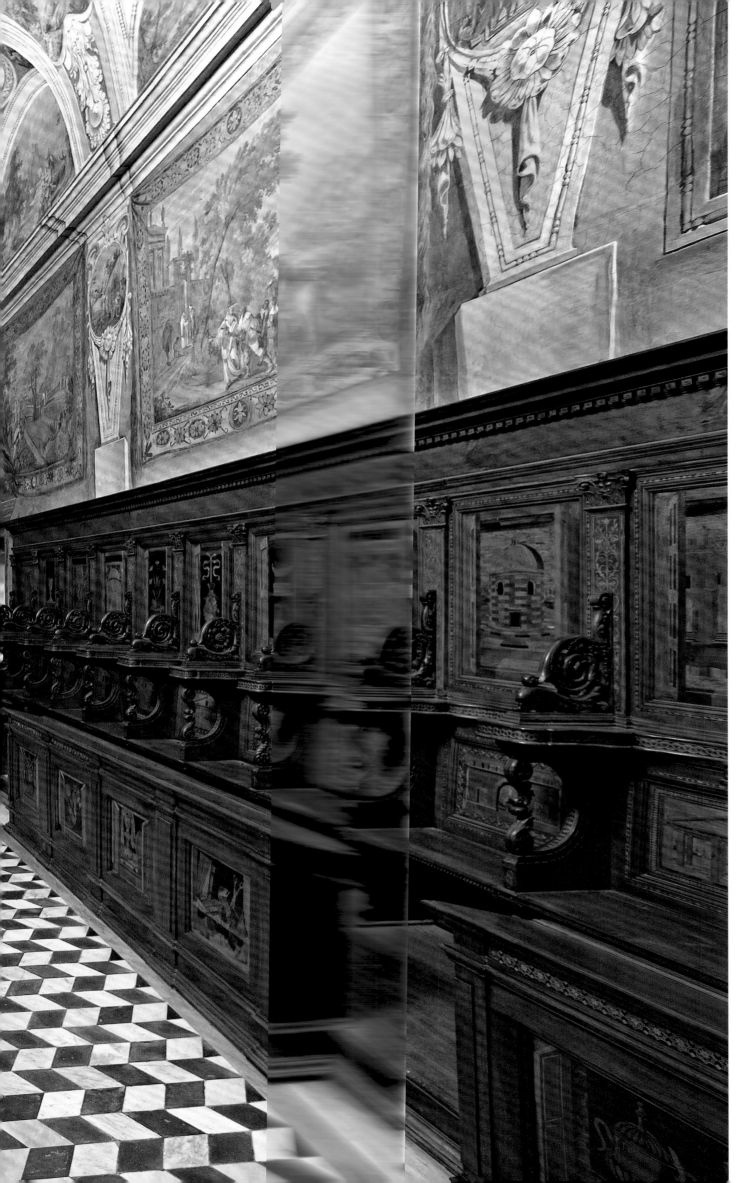

127. The lay brothers' choir, with
intarsias by Giovan Francesco d'Arezzo
and Master Prospero, in the Certosa
di San Martino, Naples.

been deduced, on the basis of a detail whose significance had not been fully appreciated in the past—namely, the depiction of Bruno of Cologne, founder of the Carthusian order. The importance accorded this figure—the subject of his own individual panel, in which he is represented with the radiant halo of the beatified—may be connected with the veneration granted to him by Leo X in 1514. This would place the rest of the intarsias in the same period as well, and thus at a temporal remove from the orbit of Giovanni da Verona.[10]

Indeed, however much the intarsias of San Martino may fall under the influence of Fra Giovanni (as Summonte's letter would seem to imply), they do not reveal the same perspectival fascination or clarity of design. Certainly they represent an advance in quality over Giovan Francesco's simpler inlays in the choir of the Olivetan church, but this advance—it has been suggested—might be connected to the expectations of the Carthusians, which would have included, among other things, the use of a wider variety of woods. And it may also be that the pictorial precedents of the San Martino cycle are best sought not in external sources but in the ideas presented by local models, such as those that informed the choir of the lay brothers in the Certosa di Padula, which dates, as we have noted, to 1507.[11]

These local connections are of no small consequence. Leaving aside those differences that may be attributed to the respective abilities of the workshop hands, the distance between the Olivetan and Carthusian cycles makes it possible to enumerate the iconographic and formal ideas available to the intarsists working in the Neapolitan sphere. Their work, which is particularly admirable for its versatility of invention and its accommodation of the wood medium, must be viewed in light of the distinctive artistic experience of the region, as well as the needs and tastes of their clients. Seen in this framework, then, the intarsias of San Martino reveal a limit to the pervasiveness of Fra Giovanni's admittedly outstanding lingua franca (which certainly benefited from the later compliments of Giorgio Vasari), counterbalancing it with evidence of a local tradition and of the specific influence of a rival religious order.[12]

OPPOSITE
128. Giovan Francesco d'Arezzo and Master Prospero
Aedicula with Annunciation, Saint Jerome, and *Ciborium,* c. 1514
Certosa di San Martino, Naples; lay brothers' choir

PAGES 168–69
129. Giovan Francesco d'Arezzo and Master Prospero
City Views and *Vase of Fruit,* c. 1514
Certosa di San Martino, Naples; lay brothers' choir

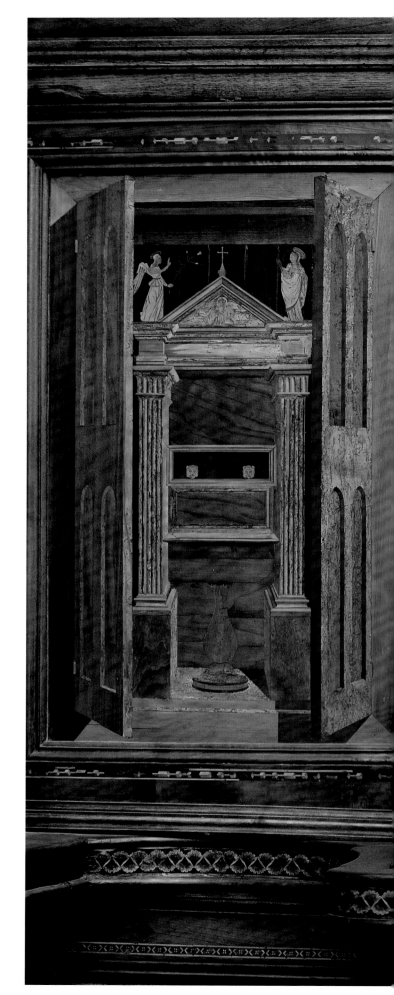

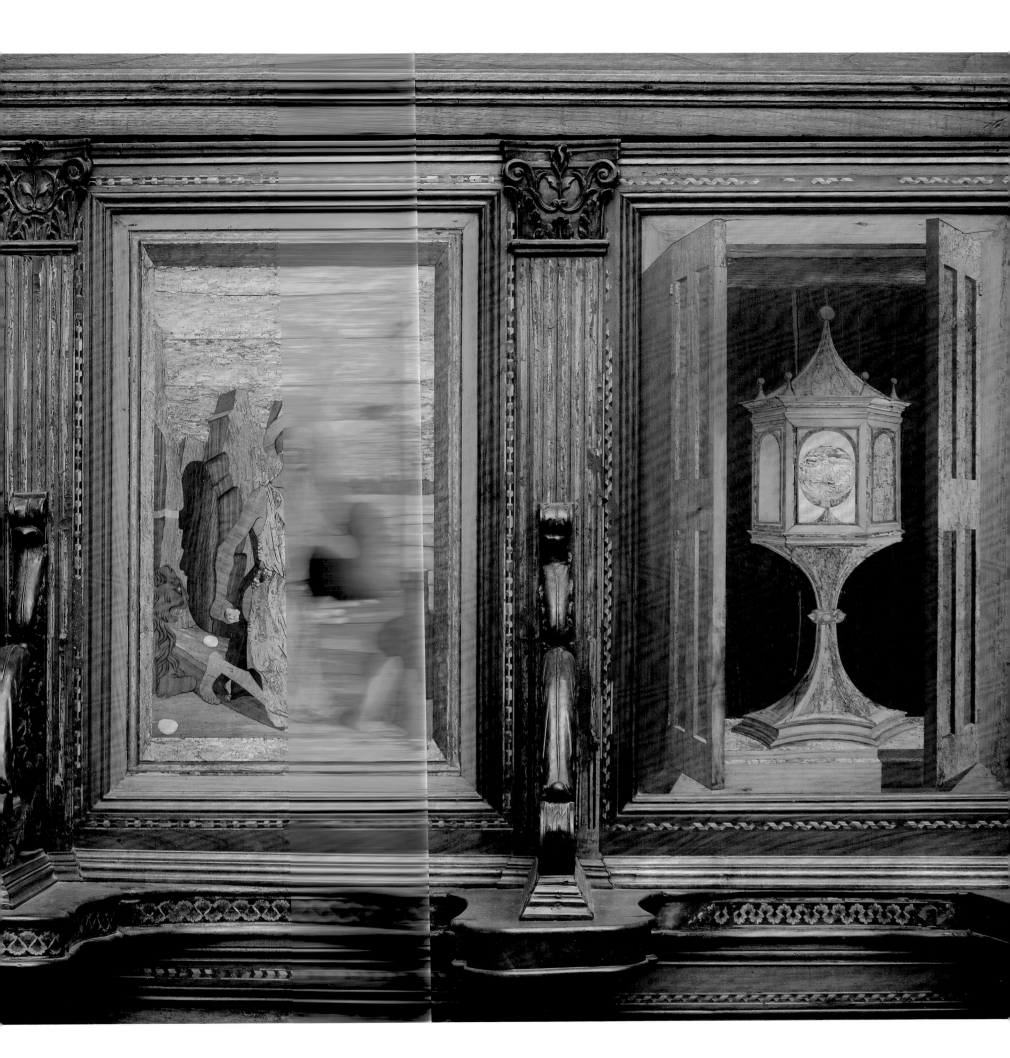

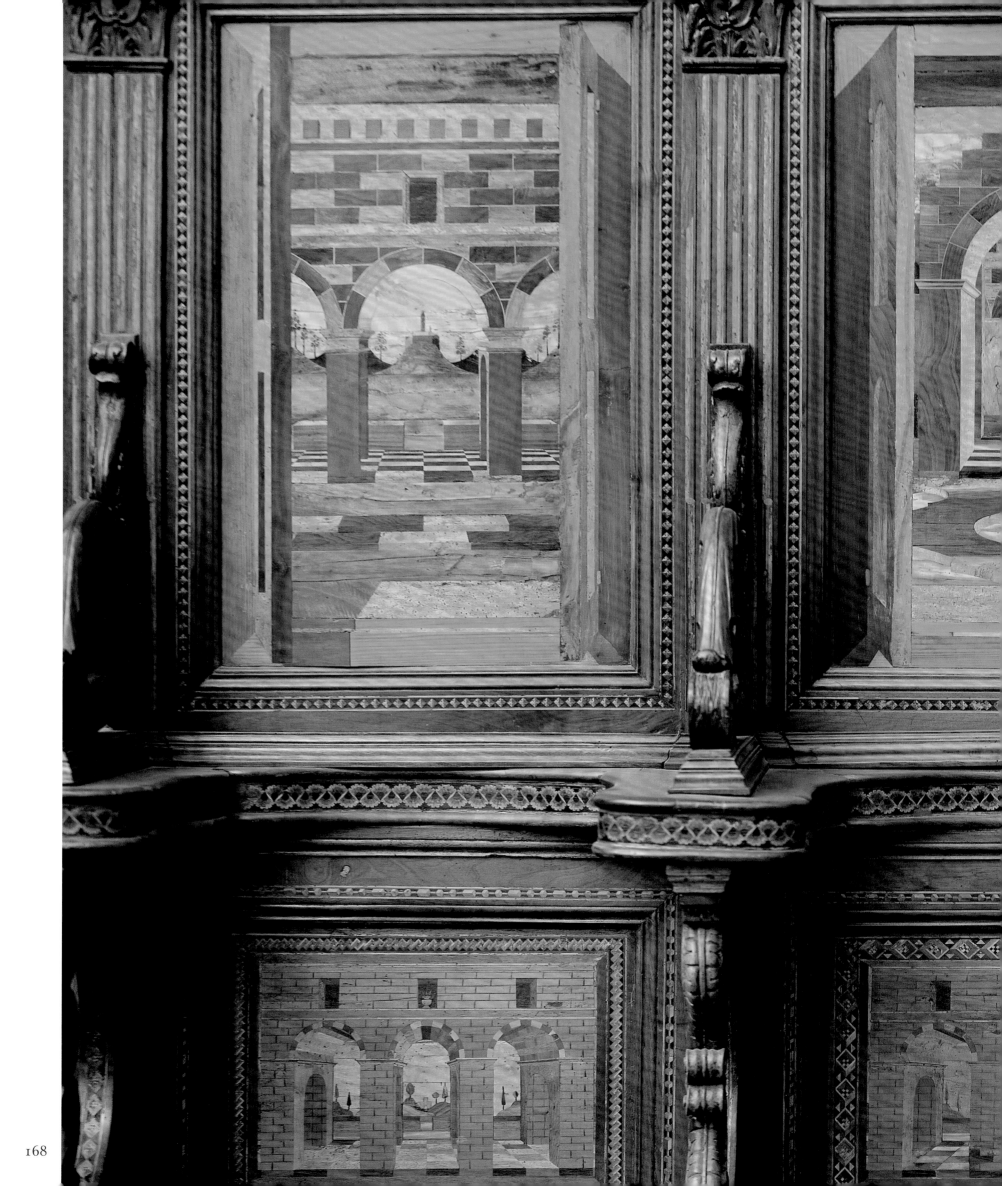

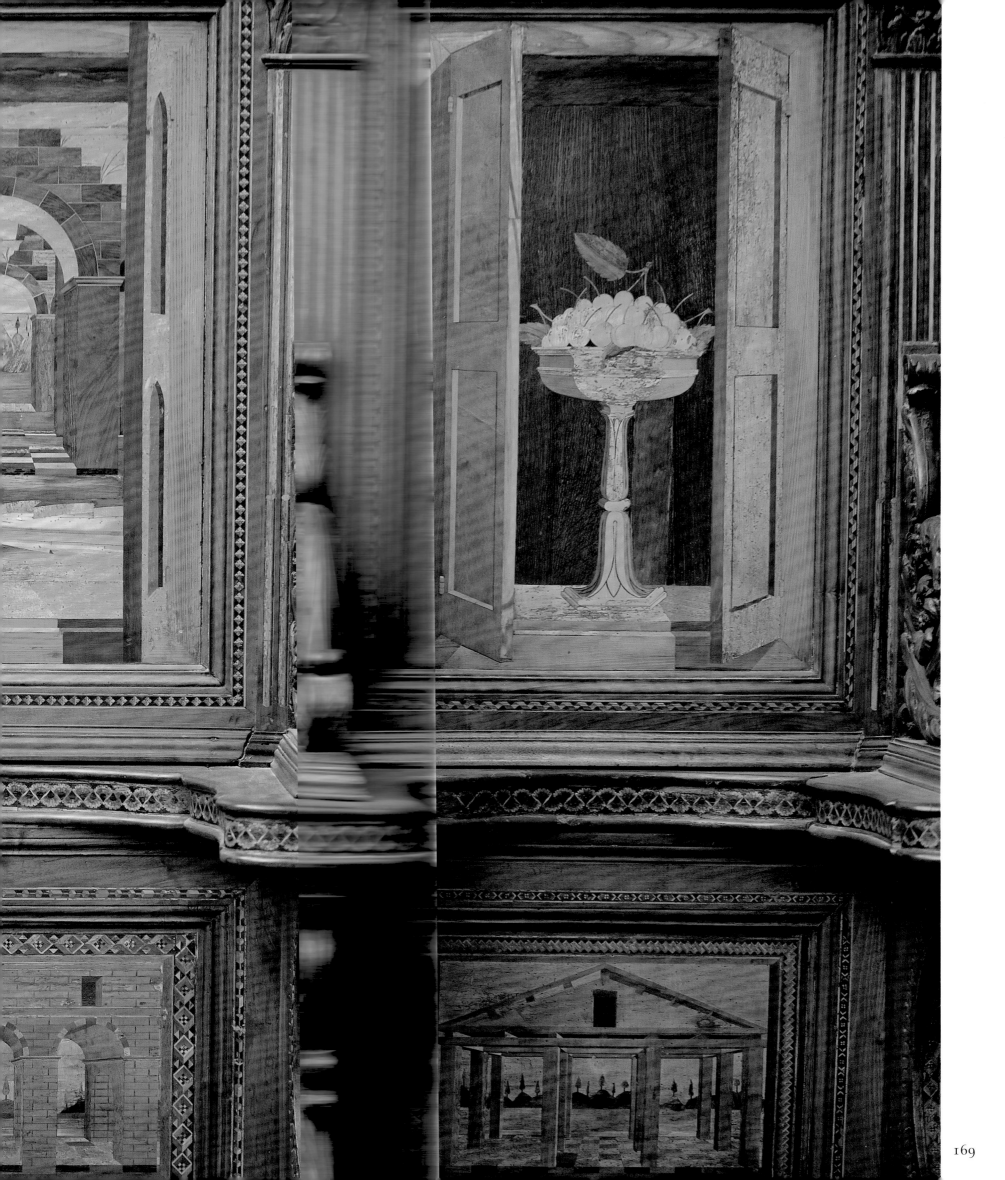

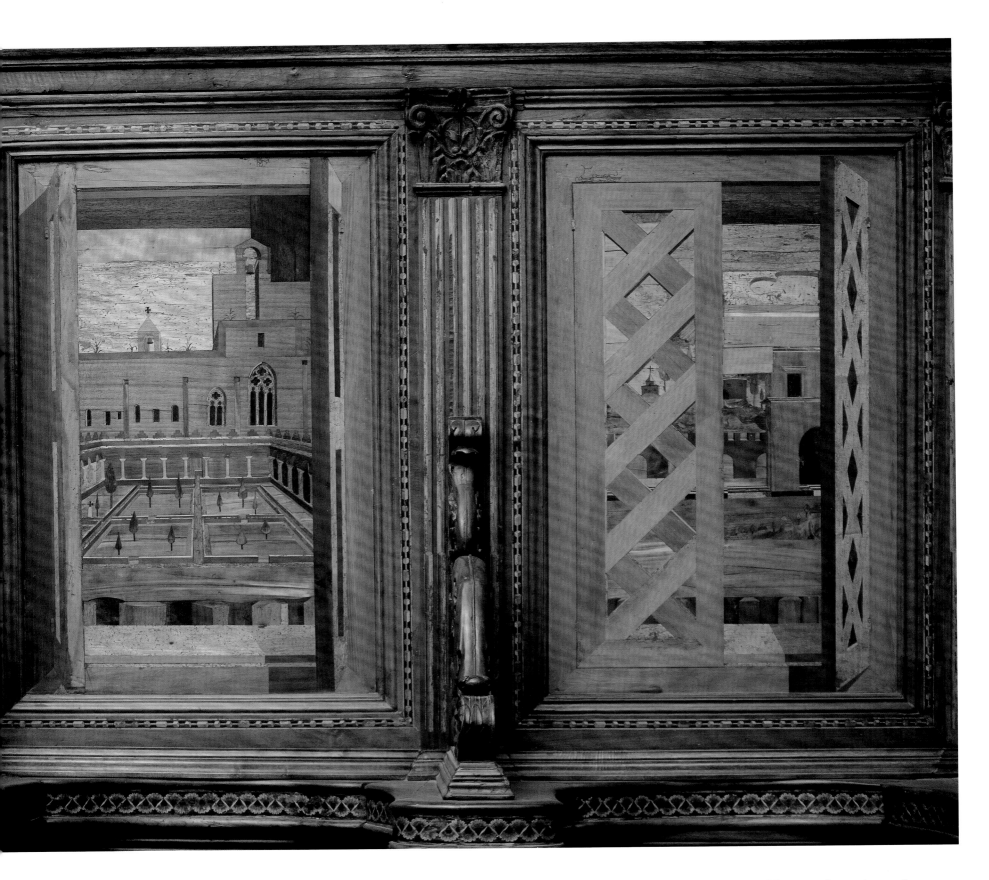

130. Giovan Francesco d'Arezzo and
Master Prospero
Cloister of the Certosa di San Martino
and *City View*, c. 1514
Certosa di San Martino, Naples; lay
brothers' choir

At the same time, the changes, often insuffi-
ciently documented, to the arrangement of the
panels over the centuries (beginning with the ex-
pansion of the apsidal section in 1590–91) pose
inevitable problems to the reconstruction of a uni-
fied iconographic program for the San Martino
cycle. However, in addition to noting the repeated
presence of the canonical themes of intarsia work
(namely, the landscape, still life, and human fig-

ure), it is still possible to infer at least the over-
all tenor of the old choir, as well as something of
its original message. Particularly relevant in this
regard are the four panels depicting Saints Bruno
of Cologne and Hugo of Châteauneuf, founders of
the Carthusian order; Saint Jerome (plate 128); and
Saint John the Baptist. The latter two figures are
dressed as hermits, symbolizing the importance of
meditation to the rule of the order.[13]

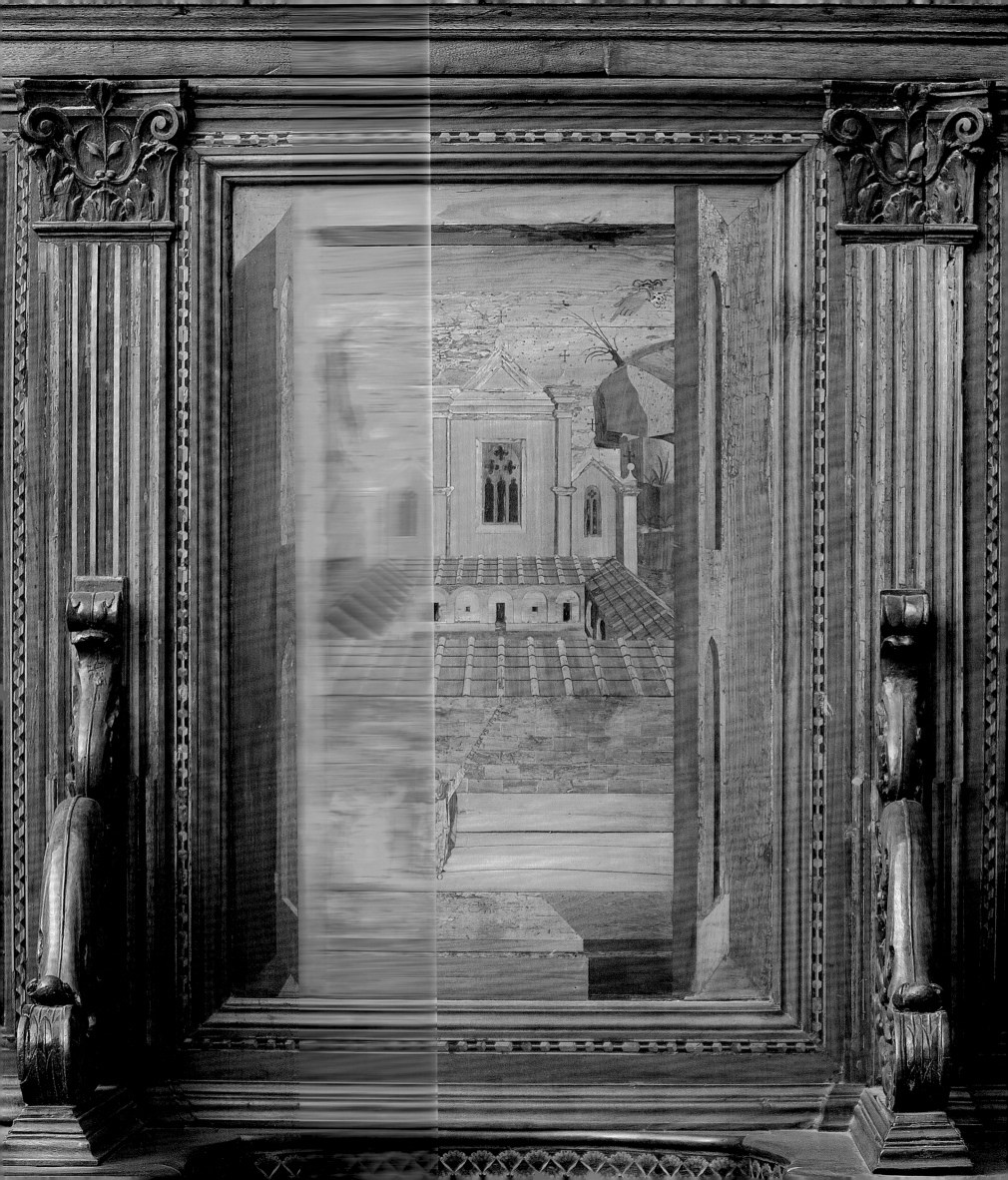

In any case, the intarsias are now arranged on three levels, beginning with the fronts of the prie-dieux, continuing in an intermediate band on the benches, and then concluding in the upper paneling of the stalls. While it is true that some of the fortified cities that appear on the benches (plate 129) are rendered in the linear perspective typical of intarsia work, complicated by multiple vanishing points, what emerges overall is a representational framework based on the original expressive capacities of the artists. And while the general themes may be the accustomed ones, the aedicula with acroteria depicting the Annunciation merits notice for the way in which the wood inlay imitates sculpture (plate 128). There also appears, among the landscapes, an image of the garden of the Carthusian cloister as it was prior to the modifications of the seventeenth century (plate 130); aside from its undoubted documentary value, this scene is noteworthy for being observed from a balcony, the edge of which is visible in the panel.

However, in order not to deny the debts that do exist—and which, in fact, also bring into play the dynamic of exchange among workshops—it must be admitted that there are certain repetitions, if not of the actual cartoons, at least of the

ideas of Giovanni da Verona: at San Martino, as at the Olivetan church in Naples, a skull and tapers appear together, suggesting the transience of existence, and there is the same device of a chalice overturned so as to offer a foreshortened view of its base. It has even been pointed out that the crumbling ruins depicted on one of the benches at San Martino reveal a direct resemblance to a particular intarsia at Santa Maria in Organo in Verona.[14]

Nonetheless, it is equally incontestable that the masters of San Martino always stop short of attaining the extreme idealization of Fra Giovanni's intarsias. It is enough to examine the *Arrival at the Great Certosa* (plate 131), which includes not only Gothic architecture that seems to foretell the Baroque (with a taste of all that is foreign to the "Renaissance" outlook of Giovanni da Verona) but also some passages of the everyday, such as the gestures of the protagonists, which introduce a sense of vital movement unknown to the Olivetan. There is also the panel with a building on a central plan, a theme frequently addressed by Fra Giovanni; here, however, it is placed within a landscape of more gently sloping planes, thus anticipating, with its naturalistic notes, the pictorial visions of the mid-Cinquecento.

PAGE 171
131. Giovan Francesco d'Arezzo and Master Prospero
Arrival at the Great Certosa, c. 1514
Certosa di San Martino, Naples; lay brothers' choir

1. The relevant passage from Pietro Summonte's letter, which will be referred to elsewhere in the text, reads as follows: "At Monte Oliveto the sacristy has designs, all worked in wood inlay and perspective, by the hand of an illustrious artist, Fra Giovanni da Verona, a monk from the same white-robed order as Saint Benedict, where, among other fine things, there are some figures of great value, and especially the figure of Saint Benedict. In this work Fra Giovanni was assisted by a Master Geminiano, a Tuscan from Colle, or a Florentine, and by Master Imperiale from Naples, who, in addition to working and helping him on this project, on their own were significant masters. In said church of Monte Oliveto there is a chapel with the same work, also by the hand of Fra Giovanni. The choir in this church, worked in wooden inlay with some trifle of perspective, is by the hand of Master Giovan Francesco and Master Prospero, monk and disciple of said Giovan Francesco d'Arezzo. The beautiful choir of the church of the Certosa di San Martino is also by their hand and the same

2. ████████████████████, pp.

2. ███████████████████ y in ████████████████████ orma- ████████████████████ phy in ███████████████ 5–36; ████████████ 999, pp. ████████████████████.

3. █████████████████ 925, pp. █████████████ Bagatin █████████████████

4. S████████████████ no and I████████████████ o," a t████████████████ ation, s████████████████ es- t████████████ erretti I██████████ s the m██████████ io 2006, p██████████ ntioned t██████████ llabora- t██████████ n as Il P██████████ cia, also w██████████ lated in F████████████

5. T████████████ Nilo, in fa████████████ ircle of Fr██████████ 1982, p.██████████ 97, p.██████████ , 57 n.████████████ etro

a Maiella, it has been suggested that they relate to the painting of Riccardo Quartararo in Ferretti 1982, p. 536 n. 7, or to Umbrian models in Porzio 2006, p. 57 n. 2.

6. Regarding the execution of these intarsias and the problems of their attribution to Giovanni Gallo, see Restaino 2010, pp. 268–73; Fatigati 2010, pp. 373, 379–82.

7. Regarding choirs' function of prayer and meditation, see the observations and comparisons in Ferretti 1982, p. 576; Liebenwein 1988, pp. 17–20; Liebenwein 1991, pp. 135–36.

8. It has never been possible to reconstruct the personalities of these artists. There is even some doubt as to whether Giovan Francesco came from Arezzo, or whether his toponym has been misinterpreted. The name of his colleague Prospero is thought to be a descriptive pseudonym, since one word for a choir stall was *prospera*; see Porzio 2006, pp. 62–63 nn. 10–11.

9. On the San Martino intarsias, refer to the essential contributions of Causa 1961–62 and Causa 1962, recently discussed and expanded by Porzio 2006. The intarsias in the Certosa di Padula

have been exhaustively studied by Restaino 2010 (see in particular pp. 273–82 for an analysis of the scenes from the life of Christ) and Fatigati 2010, both of which have extensive earlier bibliography.

10. This hypothesis is by Porzio 2006, pp. 47–48.

11. Regarding this theme, refer to the observations of Porzio 2006, pp. 44–45; with some repetitions, concerning the formal significance of the comparisons, but not the confirmation of conclusive technical similarities, in Fatigati 2010, pp. 369–70.

12. But there are in fact some singular connections between the Olivetans and the Carthusians, attested to, in the Neapolitan instance, by the presence of Giovan Francesco d'Arezzo and Prospero at both the Olivetan church and San Martino; see Porzio 2006, pp. 44–45; Fatigati 2010, p. 403.

13. In this regard, for a term of comparison, see the observations in Restaino 2010, pp. 293–300.

14. See Porzio 2006, pp. 56–57, figs. 22–25.

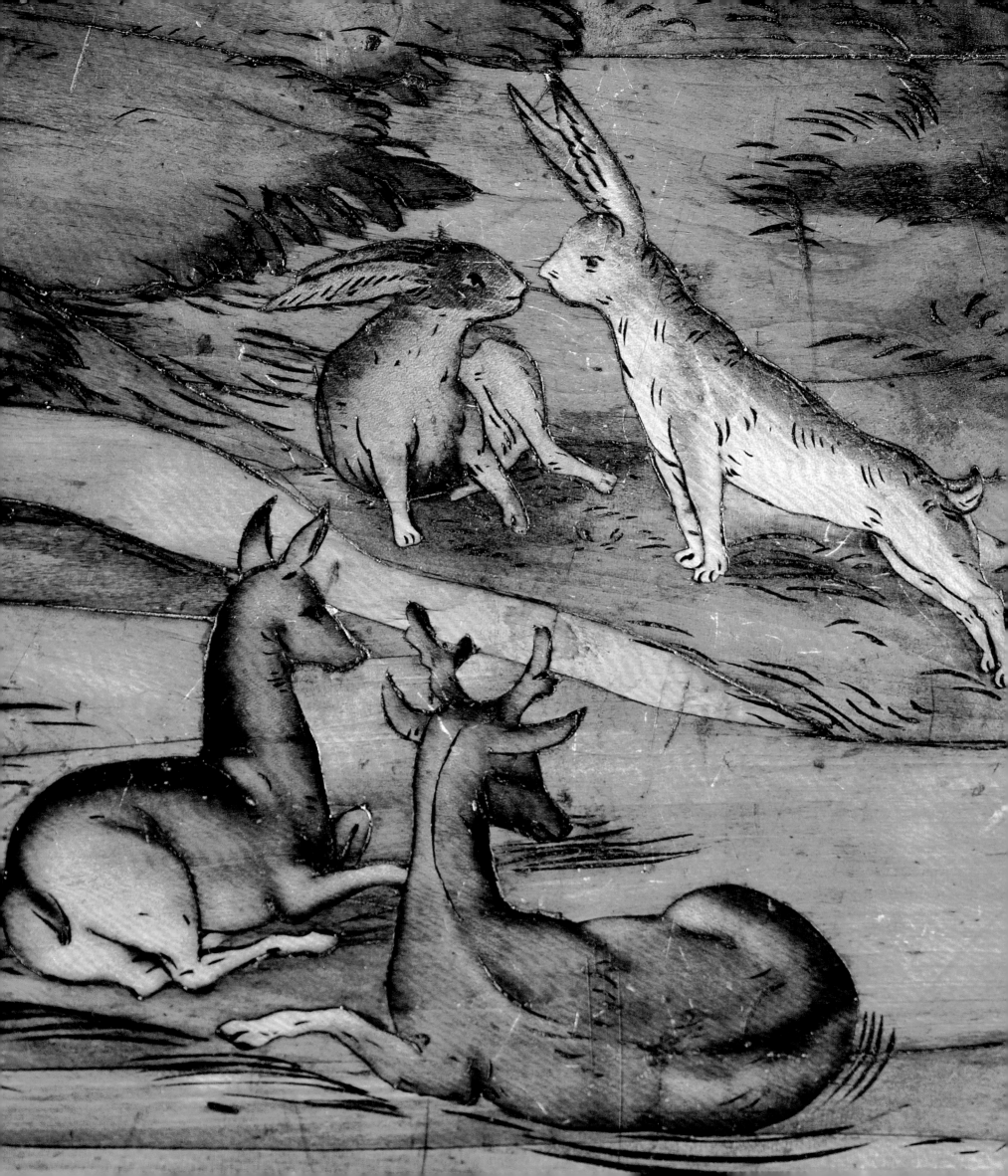

Part III

✳

LIGHT, SHADOW &

DISEGNO

The Evolution of Intarsia

in the Cinquecento

9

The creation of the intarsias in the choir of Santa Maria Maggiore in Bergamo is amply documented in both archival records and an extensive series of letters written by Lorenzo Lotto, the artist who, in 1524, was entrusted with the execution of the preparatory cartoons for this cycle, one of the most significant of the entire Italian Cinquecento, a masterpiece of woodworking and of graphic, compositional, and illusionistic design.

Built on the initiative of the citizenry in the twelfth century, when the free municipality of Bergamo was growing stronger, Santa Maria Maggiore was located opposite the Palazzo della Ragione, facing onto the small piazza that, for centuries, was the center of political, economic, and military life in the city. The basilica was thus a significant point of reference for Bergamo's inhabitants. Its inclination toward autonomy became quite evident in 1449, when it was placed under the sole administration of the confraternity of the Misericordia Maggiore, an important charitable institution in the city.

The process of creating the intarsias, which has been meticulously reconstructed by Francesca Cortesi Bosco,[1] began in the autumn of 1522, when the confraternity decided to entrust the project to Giovan Francesco Capoferri, a young wood-carver from the nearby town of Lovere, who, on October 23 committed himself to "work on and build and have executed and completed a beautiful, dignified, and praiseworthy choir, presbytery, benches and ornamentations for the large chapel."

In the initial phases, however, there was some uncertainty about how to handle the decorative program for the new choir. The choice of the twenty-five-year-old Capoferri[2] over Fra Damiano Zambelli—an experienced intarsist and Capoferri's instructor in the art, with whom the younger man had collaborated only one year earlier at the convent of Santo Stefano in Bergamo[3]—had created considerable discontent and resentment, mainly

toward Lorenzo Lotto, who had championed the decision.[4] Indeed, Lotto, who had intuited the talents of the young master and, above all, his great openness to experimenting with new directions and new languages, had given Capoferri a drawing of the Annunciation to render in intarsia so that he might demonstrate his abilities to the Reggenti della Misericordia (the confraternity's governing body), who, the painter knew, intended to renovate the choir.

The original pictorial program—which Lotto had, in all likelihood, aspired to carry out from the beginning—was to consist of episodes from the Old Testament, whose "invention" had been entrusted to the Franciscan theologian Gerolamo Terzi. However, this concept for the program must

135. Front part of the choir, with intarsias (1524–33) by Giovan Francesco Capoferri, Basilica di Santa Maria Maggiore, Bergamo.

not have been shared unanimously, for in October 1523 the Reggenti did not go to the illustrious foreigner Lotto—who was one of the most prominent artists in Bergamo and had worked for the confraternity since 1516,[5] the year of his Martinengo Altarpiece (plate 134)[6]—but inexplicably entrusted the execution of the cartoons to a local painter, Nicolino Cabrini. The choice of this unknown Bergamesque artist seems to indicate a move in a more conservative direction, and the guidelines of the contract do in fact reveal a return to a cohesive decorative structure, which was to include images "finely colored in perspective." Thus the idea of a great narrative cycle relating a series of biblical stories was abandoned in favor of an already familiar and accepted tradition and practice.[7] However, the death of Cabrini in January 1524 gave the confraternity an opportunity to rethink the program and consider going back to the original idea. The new Reggenti della Misericordia summoned Lotto, who had been working on the Suardi Oratory in Trescore,[8] not far from Bergamo, and gave exclusive charge of the cartoons to this most versatile and complex artist.

The contract specified that once the intarsias were made, the drawings would be returned to the painter, and that he would be excused from assisting Capoferri and his artisans in the execution of the work. In practice, however, Lotto proved at least initially to be very open to collaborating with the workshop of his young intarsist friend, particularly in the final outlining of the forms,

where the intervention of a skilled art[ist helped to] ensure a successful outcome.

The panels illustrating the scenes f[rom the Old] Testament suggested by Terzi were [to adorn the] seats of the front part of the choir. [However, a] few months after Lotto signed the co[ntract for the] cartoons, it was decided that the valu[able hand-] work should be protected by mova[ble wooden] covers decorated with symbolic com[positions in] "chiaro et scuro." These inventions [were also to] be supplied by Lotto, who was to ens[ure that the] meaning of each one corresponded wit[h the under-] lying scene.

We do not know whether Lotto [hesitated to] take on this new assignment, which [would keep] him engaged for eight years, but it se[ems that he] sought and desired it from the outs[et. Indeed,] enough to secure to the enterprise th[e master of] woodworking and perspective (as int[arsia was] then called) most open to experimen[tation —] most as a challenge to himself, as a p[ainter who] was accustomed to using vivid reds, [blues, and] greens and strong tonal contrasts. In [his encoun-] ter with this new art form, in whic[h light and] color were rendered in subtle tonal [variation,] Lotto transformed the tradition of in[tarsia, leav-] ing behind the accustomed perspect[ival and ar-] chitectural approach of the Quattroce[nto. He not] only surpassed the existing narrativ[e models in] the variety and novelty of his inventi[on, but also] imbued his intarsias with a freely pic[torial char-] acter. The young Capoferri, for his p[art, proved] to be a willing collaborator in this u[ndertaking,] using his great technical sensibility an[d profound] familiarity with the medium of wood [to interpret] the unifying poetic principle of Lott[o's imagina-] tion. Through the subtle manipulation [of different] woods and varnishes, Capoferri succe[eded in cap-] turing the painter's colors, lights, sha[dows, shad-] ing, aerial perspective, stormy skies, [landscapes,] and dramatic dynamism of action.

Once contracted, Lotto promptly [prepared a] certain number of designs: in 1524, h[e provided] nine of the Old Testament episodes (*T[he Death of] Abel*, *Amasa Killed by Joab*, *Susanna*, *[The Sacri-] fice of Abraham*, *The Drunkenness of N[oah, Joseph] Sold by His Brothers*, *Tubal*, *Enos*, an[d The Sacrifice]

[...] *of Cain and Abel*), as well as eight composi[tion]s for the cover panels. The following year he [deli]vered, in addition to various "chiaro-scuri," [seve]n further biblical cartoons, including one [of l]arger dimensions (*Noah's Ark*) for one of the [four] intarsia panels to be placed on the outer side [of t]he iconostasis—the only ones that would be [visi]ble to the faithful during solemn services. It [was] specifically this first of the four larger draw[ing]s that convinced Lotto that the agreed-upon [com]pensation for the project was inadequate; he [then] asked for an increase, which was denied. [Thus] began an interminable controversy with the [Mis]ericordia; the artist ceased all collaboration [with] Capoferri's workshop and in December of [1525] moved to Venice, from where he continued, [in th]e years that followed (1526 to 1532), to honor [his] commitments, sending drawings, along with [writt]en instructions, although he would not re[turn] to Bergamo. The deterioration of relations [and t]he increasingly harsh tone assumed by Lotto [are] documented in an extraordinary series of au[togr]aph letters that he addressed to the confra[tern]ity between 1524 and 1532, and which were [disc]overed in the association's archives at the mu[nicip]al library.[9] On January 25, 1531, Lotto sent [the] last six cartoons, and in 1532, his drawings [were] returned to him (with the exception of two). [His] stubborn refusal to go to Bergamo to help with [the fi]nishing touches to the intarsia panels proba[bly a]lso ruined his friendship with Capoferri, who [died] in early 1534, at the age of thirty-seven. Thus [neith]er of its two principal creators ever saw the [finis]hed choir, which was not completed, with the [mou]nting of the last intarsiated panels, until 1555. [And] to think—as Francesca Cortesi Bosco sug[gests]—that on the cover panel for *Joseph Sold by [His] Brothers*, the Venetian painter placed his own [port]rait next to that of the young Bergamesque [mast]er, to mark a bond of fraternal friendship.

[Lo]tto prepared more than seventy drawings [and] cartoons for the choir, following a program [that] for all its complexities of meaning, followed [a chr]onological scheme, beginning with the Cre[ation] and proceeding through the Old Testament, [in a] constant juxtaposition of good and evil, dam[natio]n and salvation. Every narrative intarsia had

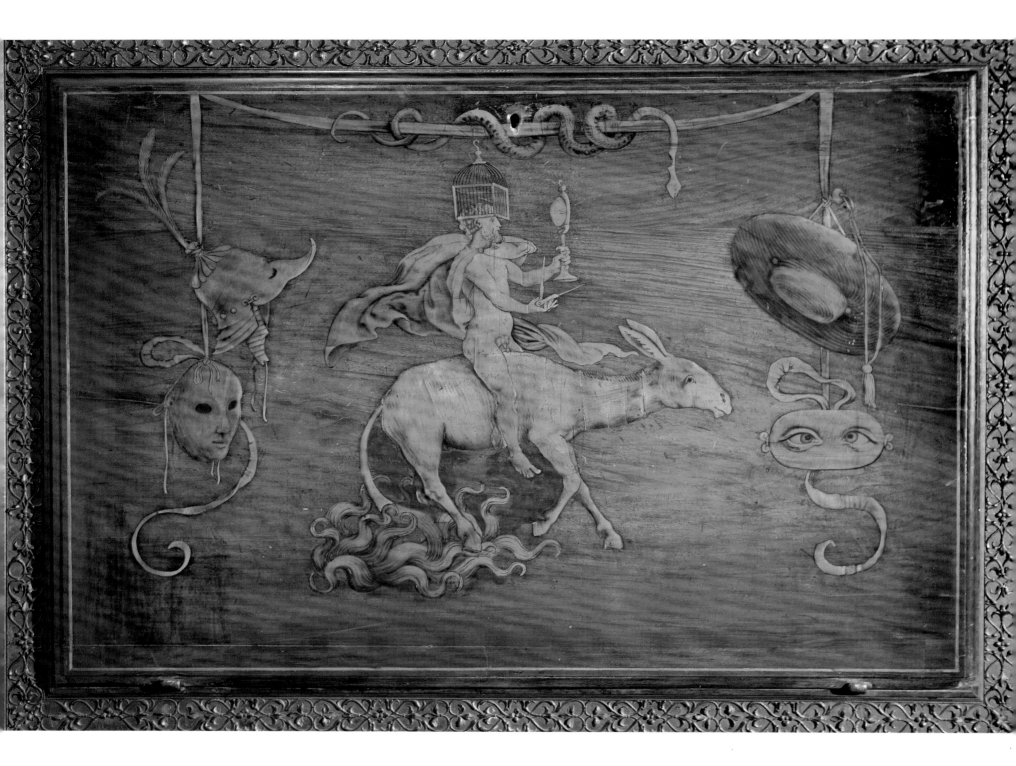

136. Giovan Francesco Capoferri, 1497–1534, after a drawing by Lorenzo Lotto, c. 1480–1556/57 Cover panel for *Drowning of Pharaoh's Army*, c. 1526–27 Basilica di Santa Maria Maggiore, Bergamo; choir, outer side of the iconostasis

a corresponding cover panel that commented on it symbolically and served to protect it. But the chapter of the confraternity of the Misericordia decided to put most of these symbolic panels (save for the ones on the iconostasis) to a different use, to decorate the choir of the lay brothers, permanently breaking up the artist's intended sequence. Generally speaking, Lotto's biblical scenes demonstrate an inexhaustible theatrical imagination, with a loose narrative whose numerous popular references form a contrast with the erudite and sometimes cryptic compositions on the cover panels, which are composed in the manner of emblems, with symbolic objects accompanied by

brief mottoes clarifying their significance.[10] This was a means of creating strongly suggestive and easily memorized images, a sort of theater of the memory that helped the monks to meditate on the significance of the biblical episodes.[11]

In the intarsias of the Old Testament, the narrative unfolds in all its power, with tumultuous crowd scenes, and with multiple episodes and moments of time represented in the same space, amid architecture, palaces, wonderful gardens, and romantic and dramatic landscapes. These characteristics are especially visible in the four large panels, which are still installed on the iconostasis, the position for which they were originally conceived

VIDVITA
TIS
GLORIA

(plate 133); along with their correspo[nding cover] panels, they may be considered a sum[mation of all] the themes that are addressed, and all [the allusions] that are developed, in the panels pla[ced around] the inner perimeter of the choir (plate [133]).

In the *Drowning of Pharaoh's Army* [plates 138-] 41), the very title emphasizes the div[ine punish-] ment that strikes the wicked Pharaoh [rather than] the miraculous parting of the water[s before the] Israelites. In the cover panel, too, th[e sovereign,] or rather his pitiless moral caricature [is the pro-] tagonist in negative (plate 136). At t[he center of] the panel, a donkey, lapped by flame[s, carries on] its back a naked man who holds a m[irror and a]

[com]pass and whose head is in a cage. Framing this [mai]n group is a ribbon around which curls a snake [with] its head nearly cut off, and from which hang, [on] the left, a helmet and a mask and, on the right, [a car]dinal's hat and a plaque with crossed eyes. Al-[thou]gh Pharaoh bears the attributes of prudence [the] mirror and compass), he is ridiculously naked, [ride]s a recalcitrant beast moved only by the fire lit [ben]eath its tail, and wears on his head, instead of a [cro]wn, a symbol of lunacy (the cage). The snake is [also] a symbol of prudence, but it is depicted with [its h]ead almost severed, while the helmet and the [car]dinal's hat—temporal and spiritual power— [are] corrupted by their association with the mask

137. Giovan Francesco Capoferri, 1497–1534, after a drawing by Lorenzo Lotto, c. 1480–1556/57 *Viduitatis gloria* (*The Glory of Widowhood*), cover panel for *Judith*, c. 1527 Basilica di Santa Maria Maggiore, Bergamo; choir, outer side of the iconostasis

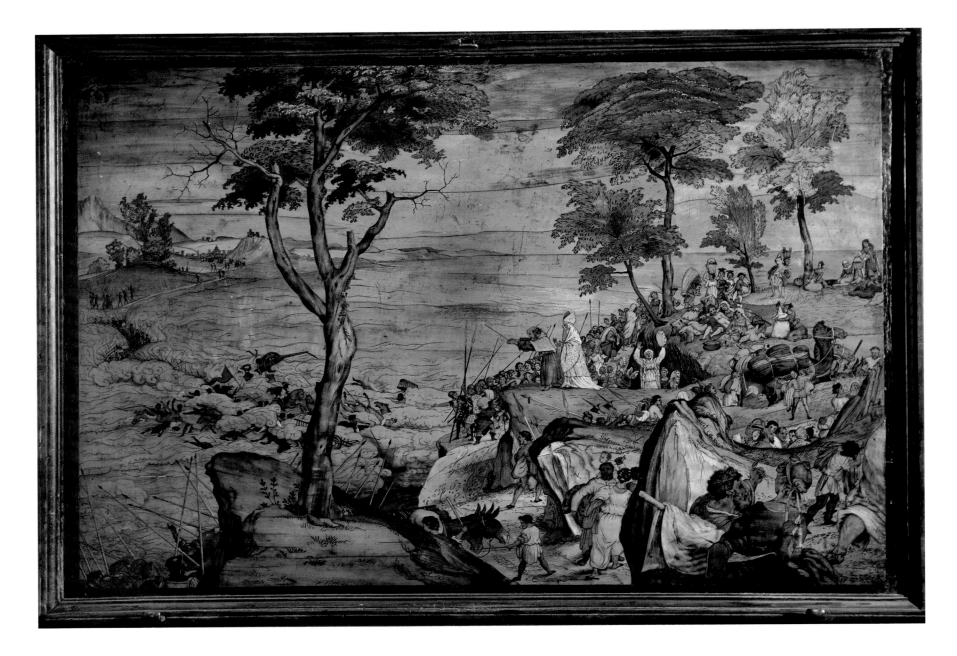

ABOVE
138. Giovan Francesco Capoferri,
1497–1534, after a drawing by
Lorenzo Lotto, c. 1480–1556/57
Drowning of Pharaoh's Army, c. 1526–27
Basilica di Santa Maria Maggiore,
Bergamo; choir, outer side of the
iconostasis

OPPOSITE PAGE
139. Giovan Francesco Capoferri,
1497–1534, after a drawing by
Lorenzo Lotto, c. 1480–1556/57
Drowning of Pharaoh's Army (detail),
c. 1526–27
Basilica di Santa Maria Maggiore,
Bergamo; choir, outer side of the
iconostasis
A couple in sixteenth-century
Venetian dress enters the scene at
lower right, while another figure
exits from the visual field, giving this
episode of the Exodus a strong sense
of contemporaneity.

(falsehood) and the cross-eyed gaze (folly, error).[12] Thus, once the key to reading this singular symbolic code has been acquired, it becomes apparent that its outlandish images are intended not merely to be cryptic but rather to intrigue the viewer and thereby fix themselves in the mind, according to the rules of mnemonics.

But it is within the narrative episode of the drowning of Pharaoh's army that we find a linguistic register of extreme modernity. At the lower right, a couple dressed in contemporary Venetian style intrude upon the biblical story (plate 139). Another figure, conversely, seems to escape beyond the edge of the frame (leaving only one leg visible), almost as if the virtual space were an extension of the real one, a sort of expansion of consciousness, capable of uniting past, present, and future in a single contemporaneity. The cropping, almost like a snapshot, makes the Exodus

to the promised land seem real and present, here and now: the journey to salvation cannot be interrupted, but must continue in the mind and memory of the viewer.

In the intarsia that depicts Judith beheading Holofernes (plates 142–45, 147, and 148), another characteristic of Lotto's language presents itself in a disruptive manner: the use of different registers in the same scene. Elements of a more refined and erudite lexicon—such as, for example, the marvelous profile of the head of Holofernes (plate 143; see also plate 137), almost like an antique cameo—are juxtaposed with episodes of a strongly realistic, if not vernacular, flavor. In the encampment in the background, some solders from the Assyro-Babylonian army are shown urinating and defecating, in a scene halfway between a Dutch genre painting and a lewd burlesque (plate 145; see also plate 146). Certainly one cannot help but think

RIGHT
140. Giovan Francesco Capoferri,
1497–1534, after a drawing by
Lorenzo Lotto, c. 1480–1556/57
Drowning of Pharaoh's Army (detail,
caravan of camels), c. 1526–27
Basilica di Santa Maria Maggiore,
Bergamo; choir, outer side of the
iconostasis

PAGES 186–87
141. Giovan Francesco Capoferri,
1497–1534, after a drawing by
Lorenzo Lotto, c. 1480–1556/57
Drowning of Pharaoh's Army (detail,
men with donkeys), c. 1526–27
Basilica di Santa Maria Maggiore,
Bergamo; choir, outer side of the
iconostasis

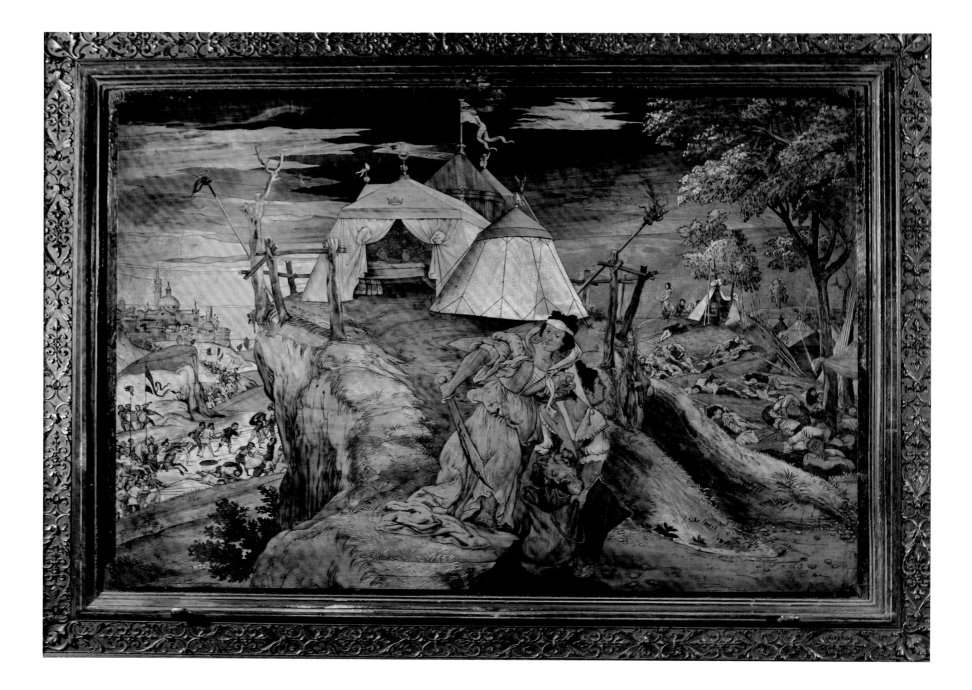

ABOVE
142. Giovan Francesco Capoferri,
1497–1534, after a drawing by
Lorenzo Lotto, c. 1480–1556/57
Judith, c. 1527
Basilica di Santa Maria Maggiore,
Bergamo; choir, outer side of the
iconostasis
The refined garments of the biblical
heroine contrast with the prosaic nature
of the enemy encampment with the
sleeping soldiers.

OPPOSITE PAGE
143. Giovan Francesco Capoferri,
1497–1534, after a drawing by
Lorenzo Lotto, c. 1480–1556/57
Judith (detail, head of Holofernes),
c. 1527
Basilica di Santa Maria Maggiore,
Bergamo; choir, outer side of the
iconostasis

of the contemporary comic plays of the Paduan Angelo Beolco, known as Il Ruzzante (after his most famous character), but also of the ongoing debates on the value and dignity of the vernacular language, the most illustrious supporter of which was the scholar and cardinal Pietro Bembo. It is the quotidian that breaks into the sacred scene; around the biblical protagonists in their exalted moments, there throng a multitude of figures captured in moments of everyday life. The two registers are used simultaneously: a plebeian "dialect" to represent these more prosaic tales, and a polished literary tongue, the Latin of the intellectuals, to relate the deeds of a heroine such as Judith, with her superbly classical face (plate 144). In the panel *David and Goliath* (plates 19, 20, 149, and 150), a particular stroke of genius in the popular

register may be seen at the far left, namely, Lotto's depiction of the divine messenger who comes to the young shepherd David as a breathless "postman" with the bag of his profession slung over his shoulder, self-consciously and proudly flourishing an envelope (plate 149). Nothing could be further from the intellectualisms and the alchemical, cabalistic, and Neoplatonic overtones of the encoded emblems on the cover panels.

The narrative in the intarsia of David and Goliath is imagined almost in four dimensions, with successive episodes being presented together simultaneously. They are depicted in some six iconographic units, distributed across a composition that tends to bring the most significant moment to the foreground. The third iconographic unit (plate 150) shows the shepherd boy in the great council

144. Giovan Francesco Capoferri, 1497–1534, after a drawing by Lorenzo Lotto, c. 1480–1556/57
Judith (detail, figure of Judith), c. 1527
Basilica di Santa Maria Maggiore, Bergamo; choir, outer side of the iconostasis

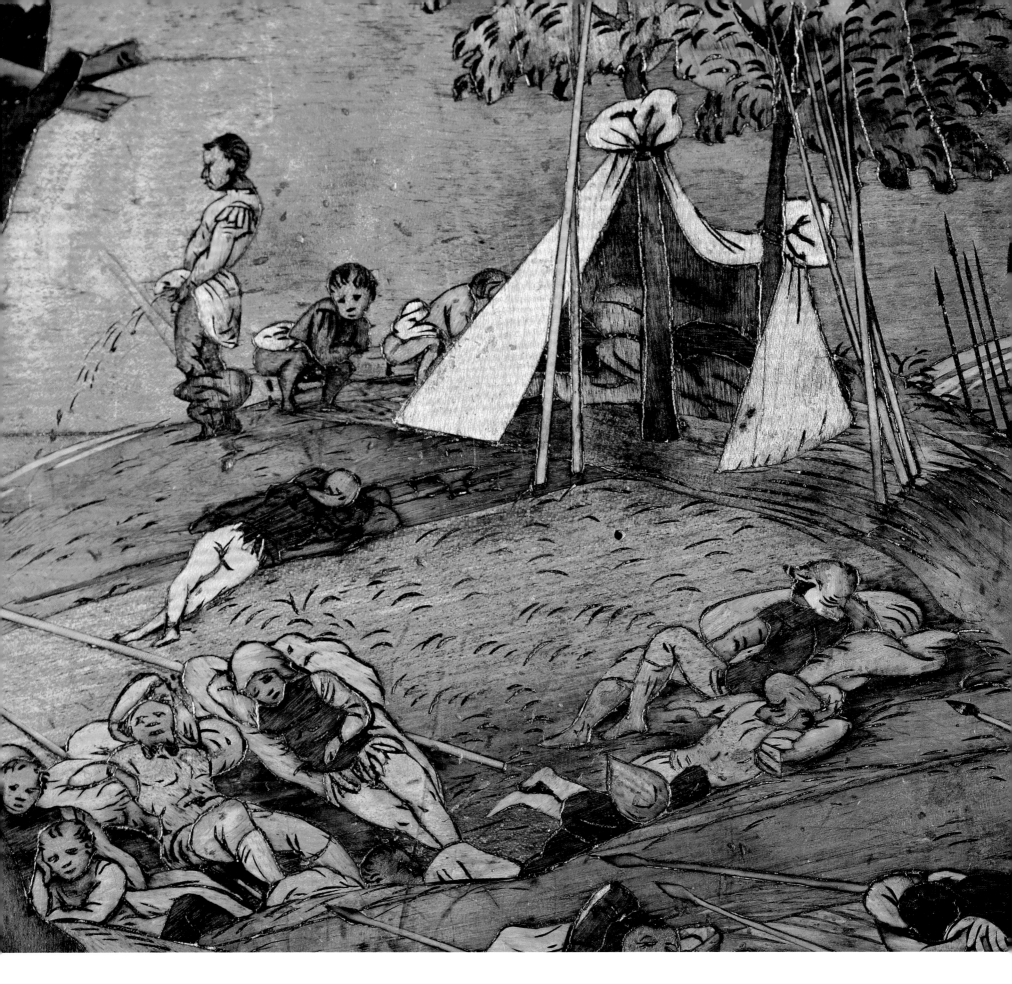

145. Giovan Francesco Capoferri,
1497–1534, after a drawing by
Lorenzo Lotto, c. 1480–1556/57
Judith (detail, soldiers urinating and
defecating), c. 1527
Basilica di Santa Maria Maggiore,
Bergamo; choir, outer side of the
iconostasis

146. Lorenzo Lotto, c. 1480–1556/57
Venus and Cupid, 1540–41
The Metropolitan Museum of Art,
New York
This work, relaying an amusing tale
with exquisite humor, reveals the
painter's propensity for irony and for
the use of a complex web of symbols
drawn from literature and mythology,
but also alchemy and religion. In
the urination of the cheerfully
impertinent Eros, there is an obvious
allusion to the sexual act, sanctified,
however, by the passage of the urine/
semen through the bridal garland.
Nonetheless, it is the playful aspect of
the amorous interaction that stands
out, and to which the iconography
clearly refers.

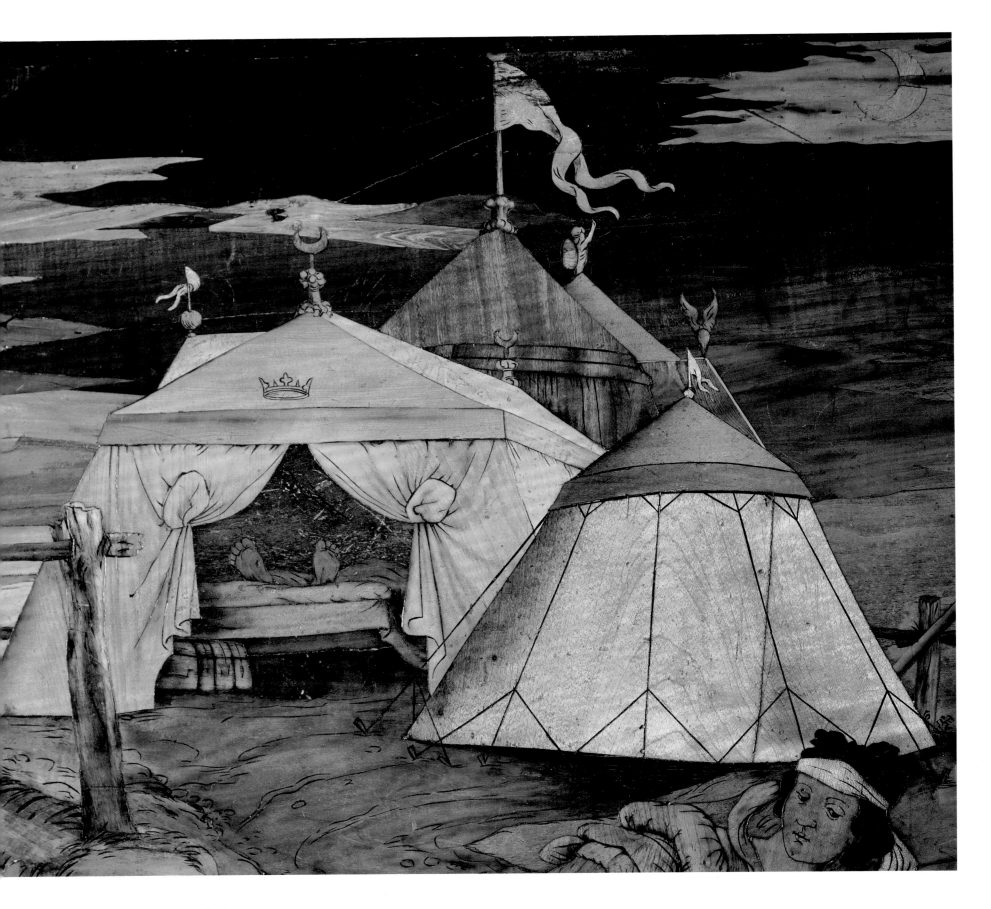

147. Giovan Francesco Capoferri,
1497–1534, after a drawing by
Lorenzo Lotto, c. 1480–1556/57
Judith (detail, Assyro-Babylonian
encampment), c. 1527
Basilica di Santa Maria Maggiore,
Bergamo; choir, outer side of the
iconostasis

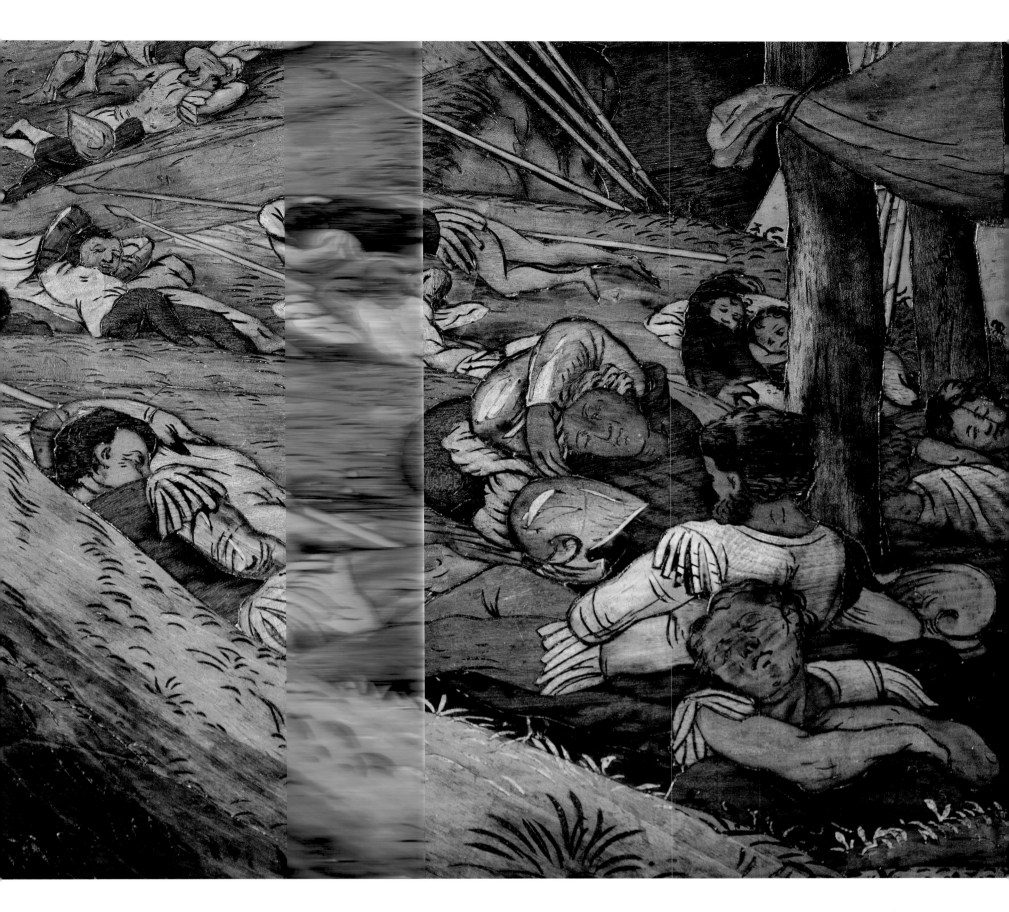

148. Giovan Francesco Capoferri,
1497–1534, after a drawing by
Lorenzo Lotto, c. 1480–1556/57
Judith (detail, sleeping soldiers), c. 1527
Basilica di Santa Maria Maggiore,
Bergamo; choir, outer side of the
iconostasis

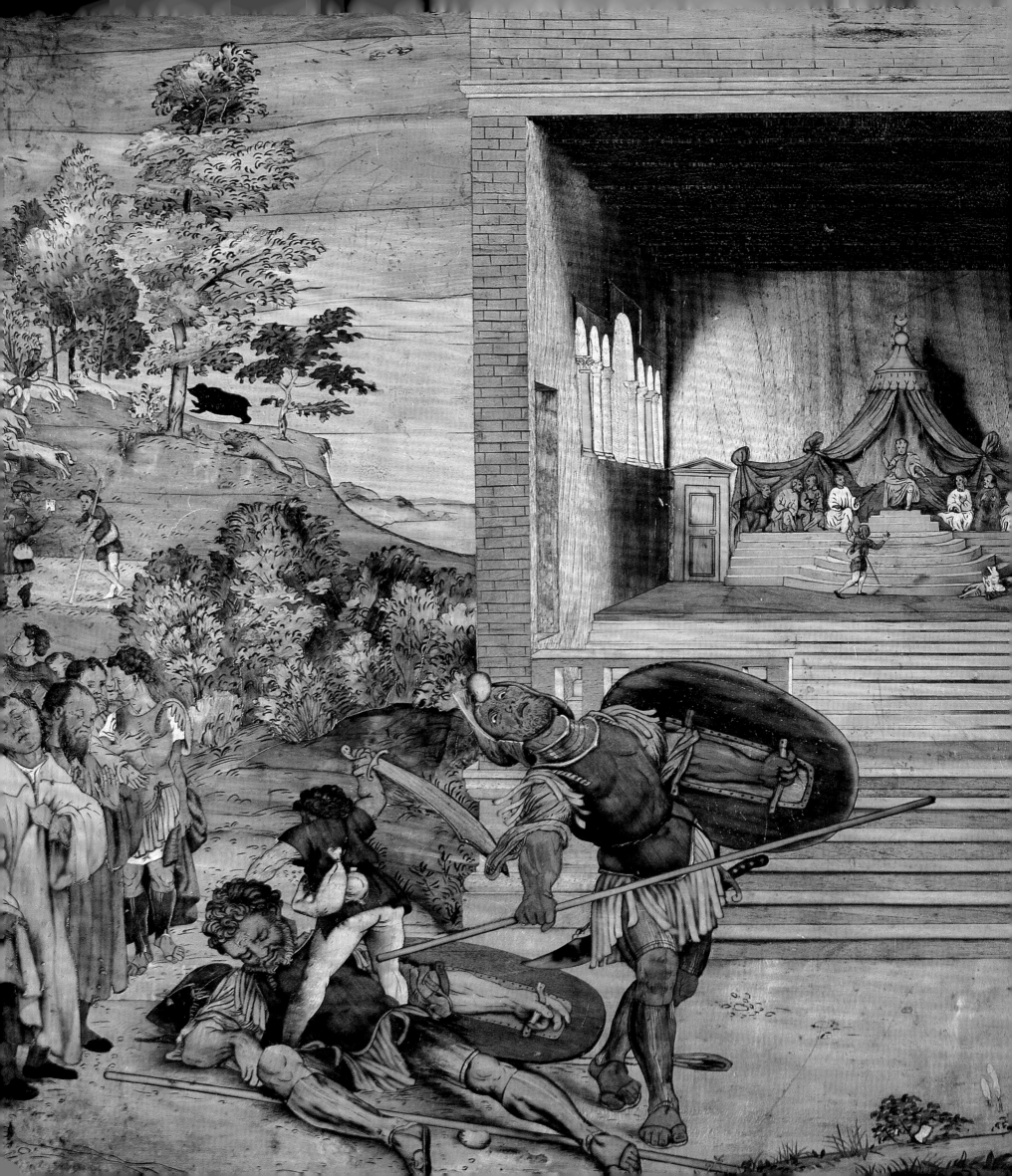

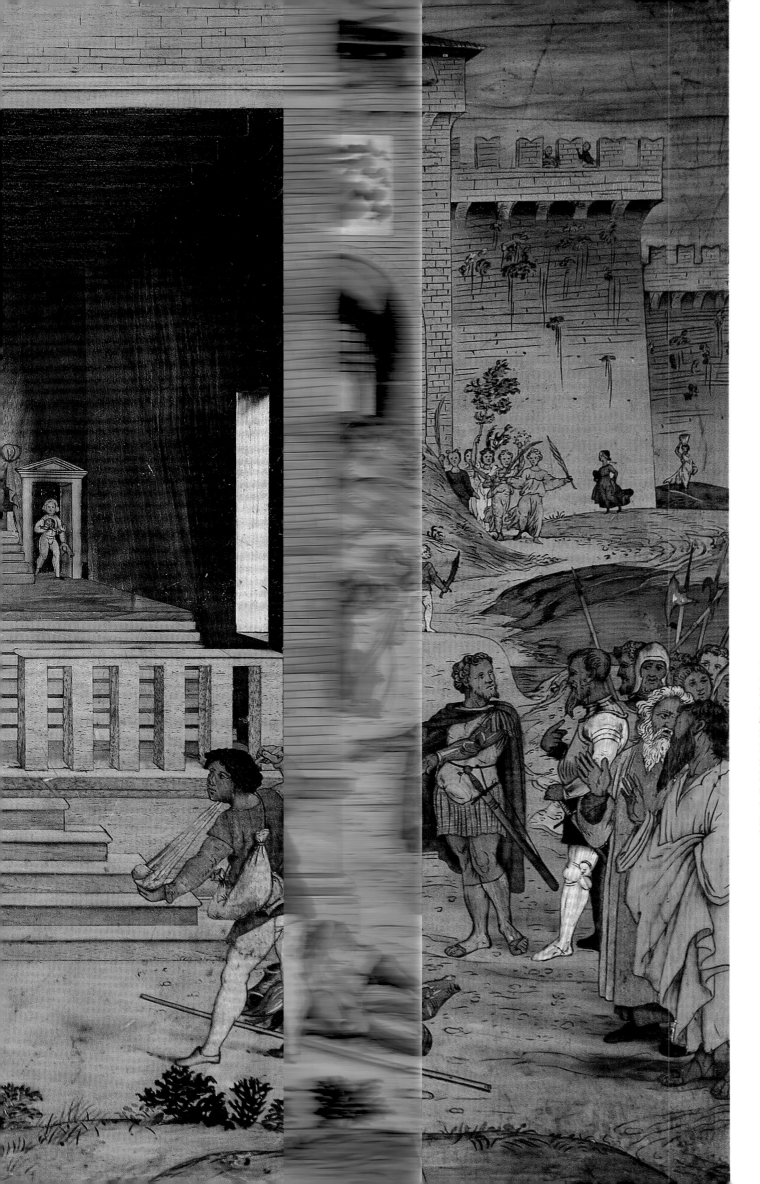

149. Giovan Francesco Capoferri,
1497–1534, after a drawing by
Lorenzo Lotto, c. 1480–1556/57
David and Goliath (detail, toppling
and beheading of Goliath), c. 1525–26
Basilica di Santa Maria Maggiore,
Bergamo; choir, outer side of the
iconostasis
Note, at the far left edge, the divine
messenger in the guise of a "postman,"
who even carries the sack of his
profession, delivering an envelope
to the shepherd David.

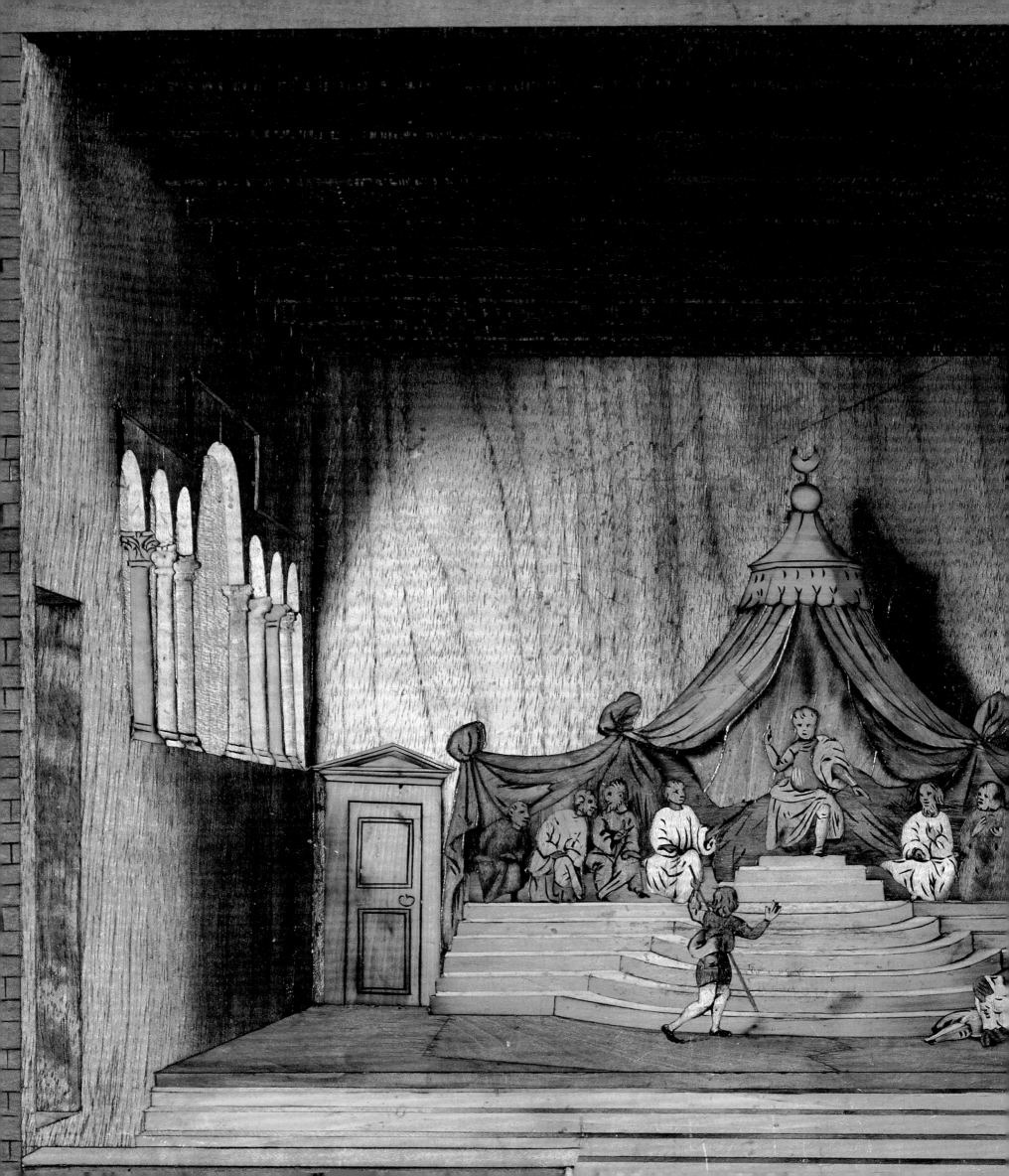

150. Giovan Francesco Capoferri, 1497–1534, after a drawing by Lorenzo Lotto, c. 1480–1556/57
David and Goliath (detail, David before King Saul in the great council hall), c. 1525–26
Basilica di Santa Maria Maggiore, Bergamo; choir, outer side of the iconostasis

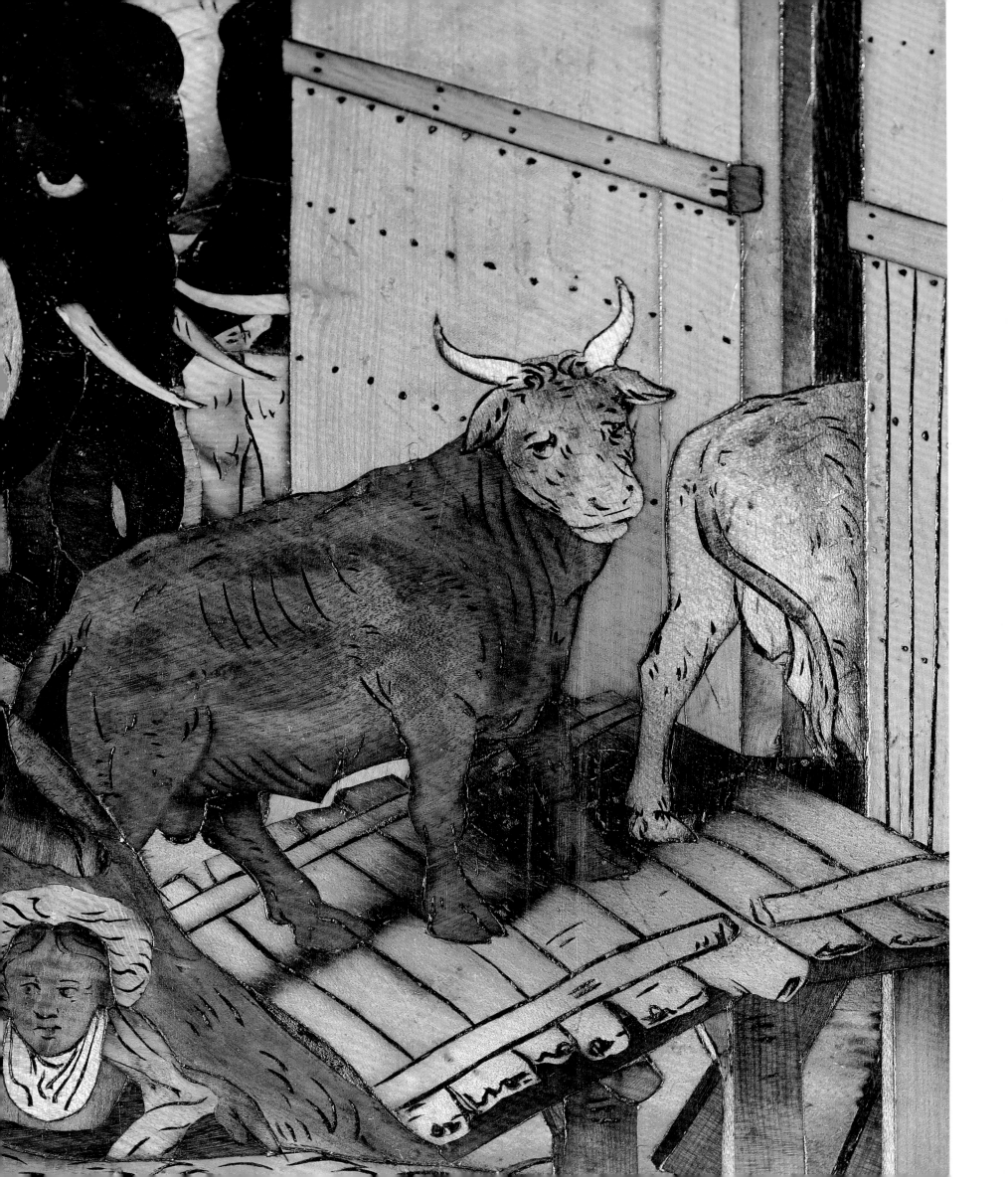

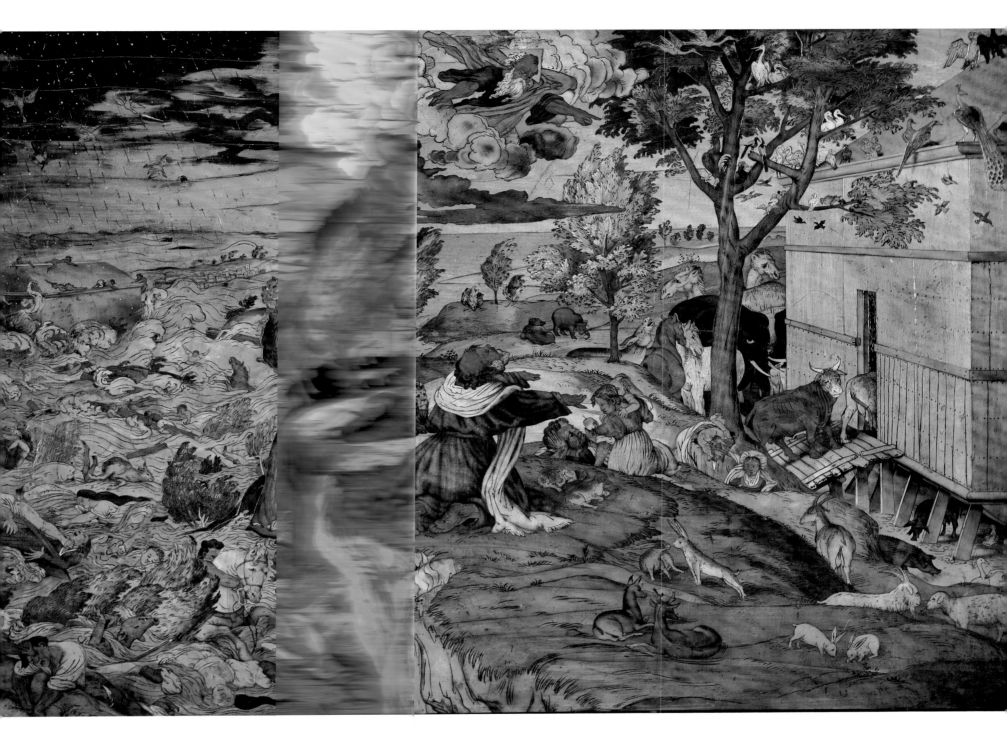

hall, before King Saul, who sits am[...] isters beneath a broad canopy su[...] sphere and a half-moon. This cou[...] doubtedly the pivot around whic[...] volves, and yet, as Francesca Co[...] observed,[13] it serves as a theatrica[...] emphasizes the main action un[...] stage: David toppling and cutting [...] the giant Goliath (plates 19, 20).

In the fourth large panel, *Noah's* [...] and 151–54), it is significant tha[...] once again to represent simultan[...] tinct moments that are usually i[...] rately: the entrance into the ark a[...] flood. Kneeling with his arms o[...]

[...]is palms turned skyward, the just Noah seems [...]o make one last plea for protection as pairs of [...]nimals surround the ark, waiting to enter (plates [...]32, 151, and 154). On the left side of the scene, [...]he deluge has already begun to cover the land; [...]nly a few trees and a group of buildings remain [...]bove the waters, and men and animals struggle [...]n vain to keep from being submerged (plate 153). [...]s in the *Drowning of Pharaoh's Army*, the opposi-[...]ion between good and evil, virtue and vice, the [...]ust and the sinners, salvation and damnation, and [...]ow between the ark and the flood, represents the [...]oundation of the religious message. There is no [...]oubt that the composition of the scene, with the [...]lear division created by the precipitous break in

153. Giovan Francesco Capoferri,
1497–1534; after a drawing by
Lorenzo Lotto, c. 1480–1556/57
Noah's Ark (detail, men and animals
struggling against the rising waters),
c. 1525
Basilica di Santa Maria Maggiore,
Bergamo; choir, outer side of the
iconostasis

the terrain, serves a precise communicative func-
tion: to counterpose the damnation of the flood
and the path of redemption open to sinners.

The ultimate goal of the sacred images placed on

the iconostasis, in a direct and close relation to the
liturgical rites, was thus to render visible and in-
dicate to the faithful the path of inner purification
necessary to the attainment of eternal salvation.

154. Giovan Francesco Capoferri, 1497–1534,
after drawing by Lorenzo Lotto, c. 1480–1556/57
Noah's Ark (detail, pairs of animals waiting to enter the ark), c. 1525
Basilica di Santa Maria Maggiore, Bergamo; choir, outer side of the iconostasis

1. Cortesi Bosco 1987; but also see Cap-
uani 1975, pp. 617–21. Cortesi Bosco's
monograph remains an essential point
of reference both for reconstructing
the choir's history and for the inter-
pretation of its decorative program.
2. On Giovan Francesco Capoferri, see
Cortesi Bosco 1987.
3. The Santo Stefano intarsias, like
Lotto's Martinengo Altarpiece, were
moved to San Bartolomeo following
the demolition of Santo Stefano in the
late sixteenth century to allow the
construction of the new city walls.
See Polli 1995; Alce 1995; and, most
recently, Colalucchi 2000, pp. 73–94.
4. For an overview of Lorenzo Lotto's
stay and activity in Bergamo, see

 2001.
 p. 201.
 he altarpiece,
 pp. 213–49;
 Pala Mar-
 Centro Cul-
 987; Tardito
 ; Lucco 1998,
 bibliogra-
 p. 248–49;
 i 1982, pp.
 the mono-
 1987 remains
 recently,
 cco 1997;
 57.

9. There have been preserved thirty-
nine letters that accompanied the car-
toons sent from Venice to Bergamo;
see Lotto 1968. This correspondence
was published first in 1964 and then
in a second edition, edited by Chiodi,
in 1968; now it also appears in Cortesi
Bosco 1987, II.
10. For the iconographic interpretation
of the intarsias, Cortesi Bosco 1987
remains a fundamental point of refer-
ence, in which earlier interpretations
are also discussed. See also Zanchi
1997 and 2003.
11. Zanchi 2009 and Zanchi 2011, pp.
43–45, have recently focused on the
connections between the *imprese* on
the cover panels for the choir of Santa

Maria Maggiore and contemporary
theories of the art of memory, which
were earlier discussed in Cortesi Bosco
1987, pp. 165–80. In this regard,
moreover, there are documented links
between Lorenzo Lotto and Giulio
Camillo Delminio, the theoretician of
the "theater of memory" (see Olivato
1971, pp. 284–91). For an in-depth
examination of the art of memory,
see Yates 1966; Bolzoni 1984; Bolzoni
1995.
12. For the interpretation of this intarsia
(as with all the others), refer to Cortesi
Bosco 1987, pp. 466–69.
13. Cortesi Bosco 1987, pp. 430–34.

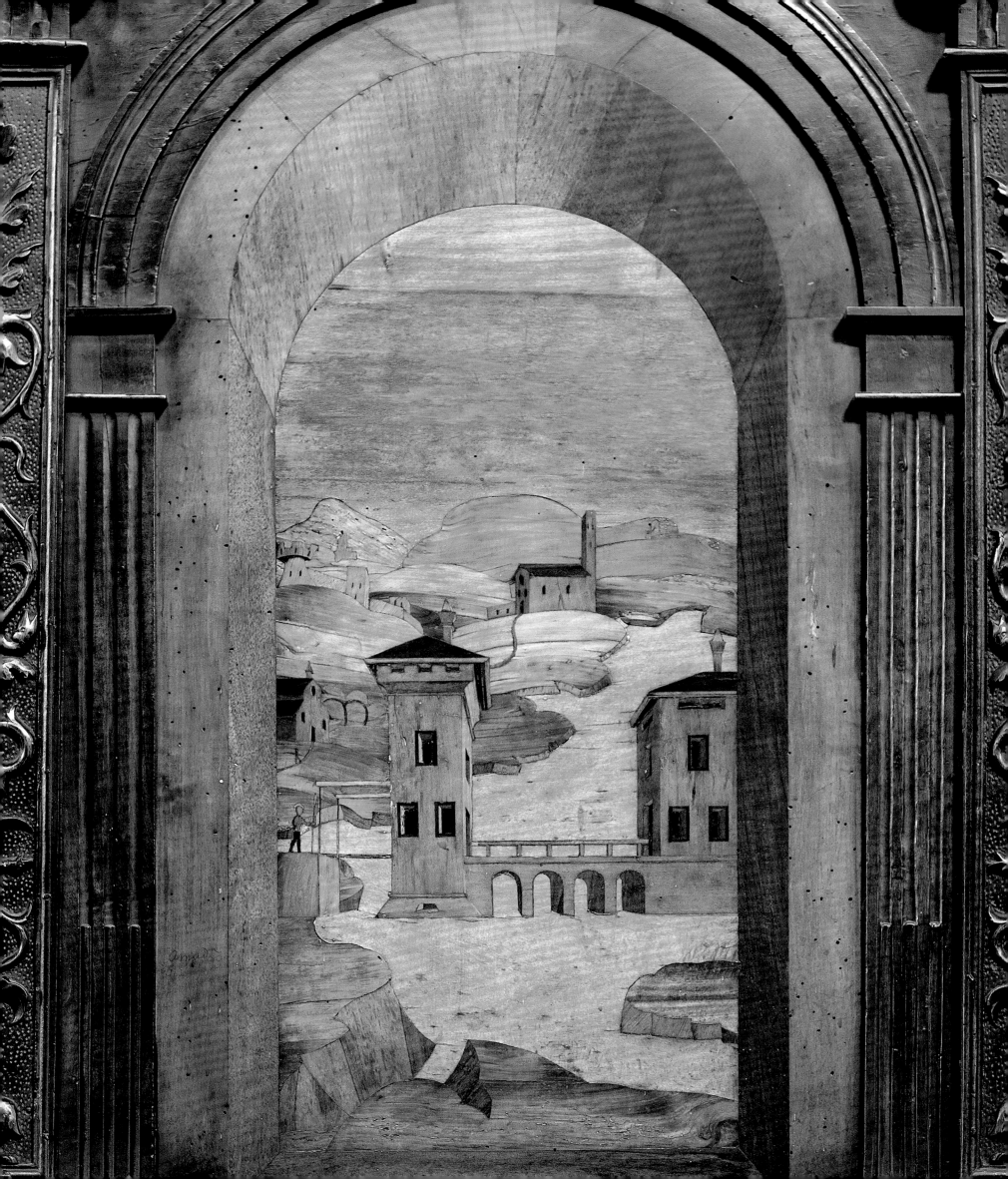

10

Cristoforo and Lore▨▨▨ ▨▨▨▨▨ ▨▨ ▨▨▨▨▨▨ara, and Cristoforo de Venetiis

▨▨ ▨▨▨▨▨ ▨▨▨atta

While the wooden choir of the B▨▨▨▨▨ ▨▨ ▨▨▨ Prospero in Reggio Emilia, already ▨▨▨ ▨▨▨▨▨▨ ▨▨ a valuable study by Massimo Ferr▨▨▨ ▨▨▨▨▨ ▨▨▨ Monducci),[1] has notable intarsias, ▨▨ ▨▨▨▨ ▨▨▨ ▨ first glance display those signs of e▨▨▨▨▨▨▨ ▨▨▨ would mark it as a "truly significar▨ ▨▨▨▨▨▨▨ ▨▨ the mature Cinquecento. However, ▨ ▨▨▨▨▨▨ ▨▨ amination of the historical context ▨▨ ▨▨▨ ▨▨▨▨ which fortunately was documented ▨▨ ▨▨▨▨▨▨▨▨ and detailed archival records,[3] has ▨▨▨▨ ▨▨ ▨▨▨ sible to reconstruct its developme▨▨ ▨▨▨▨▨▨▨▨ the phases of its removal from its or▨▨▨▨▨ ▨▨▨▨▨▨▨ to the apse. While many other Itali▨▨ ▨▨▨▨▨▨ ▨▨ derwent a similar transplantation, th▨▨ ▨▨▨▨▨▨▨ because of its early date, the com▨▨▨▨▨▨ ▨▨ ▨▨▨ undertaking, the reuse of older inta▨▨▨▨▨ ▨▨▨ ▨▨▨ involvement of a painter—may be ▨▨▨▨ ▨▨ ▨▨▨ exemplary and in many ways surpri▨▨▨▨

Up through the fifteenth century, ▨▨▨▨▨▨ ▨▨▨▨▨ were located before the altar—a▨▨ ▨▨▨▨ ▨▨ the front part of the body of the na▨▨ ▨▨▨▨▨▨▨▨ screen between the faithful and the ▨▨ ▨ ▨▨▨▨ ble dividing wall erected between th▨ ▨▨▨▨▨▨▨▨ and the nave of the church."[4] Later, ▨▨ ▨▨▨▨▨▨▨ with the reforms promoted by the Co▨▨▨▨ ▨▨ ▨▨▨▨▨ (1545–63), fifteenth-century choirs ▨▨▨▨ ▨▨▨▨▨▨ tled or, more often, moved into the ▨▨▨▨ ▨▨▨▨▨▨ and to the side of the main altar, in ▨▨▨▨▨ ▨▨ ▨▨▨▨ the altar more visible.

This is what happened at San Pro▨▨▨▨▨ ▨▨▨▨▨ the reconstruction of the choir in its ▨▨▨▨▨▨▨ ▨▨▨ figuration (plates 156, 157) began in 1▨▨▨ ▨▨▨ ▨▨▨▨ before the Council of Trent was co▨▨▨▨▨▨ ▨▨▨ thus represents one of the first exa▨▨▨▨▨ ▨▨ ▨▨▨ type of modification. But in fact, as E▨▨▨ ▨▨▨▨▨▨ has documented, the old choir had ▨▨▨▨▨▨ ▨▨▨▨ moved behind the altar in 1504 ("opu▨ ▨▨▨▨▨ ▨▨▨▨ ferre chorum de corpore ecclesiae pr▨▨▨▨▨ ▨▨ ▨ pellam maiorem"),[5] when the new ap▨▨ ▨▨▨▨▨▨ designed by the architect Biagio R▨▨▨▨▨ ▨▨▨ built to replace an earlier one that h▨▨ ▨▨▨▨▨▨▨

▨▨d some restoration work had already been done ▨▨ 1514 and 1537, in the first case on the entire ▨▨urch and in the second, only on the choir.[7] The ▨▨mplexity of this history has led Ferretti, in his ▨▨▨ent study, to begin specifically with the activi-▨▨▨s of 1544–46 and work backward toward the ▨▨igins of the older choir in the fifteenth century, ▨▨ approach that enabled him to clarify the events ▨▨▨ shall revisit here.

On July 7, 1544, the canons of San Prospero en-▨▨▨sted Cristoforo de Venetiis, a woodworker from ▨▨emona, with the task of reinstalling the choir.[8] ▨▨▨ey probably settled upon de Venetiis because of ▨▨▨ proven ability in this type of project; indeed, ▨▨▨t a few years earlier, he had moved the choir by ▨▨ovanni Maria Platina in the Cremona cathedral ▨▨▨m the *ante aram* position to the apse,[9] an opera-▨▨▨n similar to that required in Reggio Emilia. In ▨▨▨t, the canons of San Prospero not only chose the ▨▨▨e woodworker, but also procured a copy of the ▨▨▨tract between de Venetiis and the Cremona ca-▨▨▨dral, which they used as the basis of their own ▨▨reement with him. The latter document, which ▨▨onducci has published,[10] stipulated that the ▨▨▨ir was to be "reformed" within thirty months, ▨▨▨ a fee of 250 ducats, which was a considerable ▨▨▨m. De Venetiis was specifically required to reuse ▨▨▨ intarsias from the old fifteenth-century choir, "▨▨conzandoli perhò di tarsia, cornisamenti et in-▨▨▨li che stiano bene," that is, adjusting their ▨▨▨mes (which were executed in *tarsia a toppo*) to ▨▨▨ new settings and standardizing their differ-▨▨t formats. He was also instructed to move them ▨▨▨m the upper row of the old choir to the lower ▨▨w of the new one, "doe seduto se apogiano cum ▨▨ spalle li signori canonici" (where the canons sit ▨▨▨ rest their backs). In their place, on the upper ▨▨w, de Venetiis was to insert new intarsias of his ▨▨▨n creation. For these, he presented a drawing ▨▨▨t, following a common practice, was divided in ▨▨▨f, presenting two possible decorative schemes.

OPPOSITE PAGE
155. Cristoforo de Venetiis, 1490s–1550
Fortified Bridge, 1544–46
Basilica di San Prospero, Reggio Emilia

PAGES 206–7
156. The choir of the Basilica di San Prospero in Reggio Emilia, overall view.

157. The choir of the Basilica di San Prospero in Reggio Emilia, view looking toward the nave.

OPPOSITE PAGE
158. Cristoforo de Venetiis, 1490s–1550 (after a drawing by Prospero Patarazzi?) *Resurrection of Christ*, 1546 Basilica di San Prospero, Reggio Emilia

This project drawing has not survived, but, according to the contract, the canons chose the option "that is on the left side . . . on said drawing," which called for the architectural "perspectives" and the landscapes that may still be seen today (plates 155 and 159–62).

De Venetiis was also to reuse all the carved armrests, cornices, and footrests (*brazali*, *cornisamenti*, and *pedi*) that he could salvage from the old choir, "in the manner in which he reworked those of the Cremona cathedral," carving the new ones on the model of the old ones, and generally taking care that the old parts would "seem all one thing with the new." The contract required, moreover, some iconographic changes to the presented design, placing a *Resurrection of Christ* (plate 158) in the central stall instead of the previously specified image of Saint Prosper, which would end up on the side, by Saint Venerius. De Venetiis was

subsequently asked to add the figures of Saints Chrysanthus and Daria, for which he received a drawing by the painter Prospero Patarazzi. This is an interesting instance of a documented relationship between an intarsist and a painter, albeit a minor one, known only as the brother of the more celebrated Niccolò who created an altarpiece for a side altar.[11] On June 12, 1546, Alfonso Visdomini reported in his chronicle of Reggio Emilia that "the stalls of San Prospero, that is, the Choir, which have been made anew, were unveiled"[12]— ahead of the schedule specified in the contract.

The stylistic interpretation of de Venetiis's intarsias recently put forth by Ferretti hinges on the artist's proximity to certain exponents of the genre in Cremona, in particular Paolo Sacca, with whom he had collaborated in 1531, on the choir of San Francesco in Cremona, now lost. It is not difficult to find points of comparison, even exact

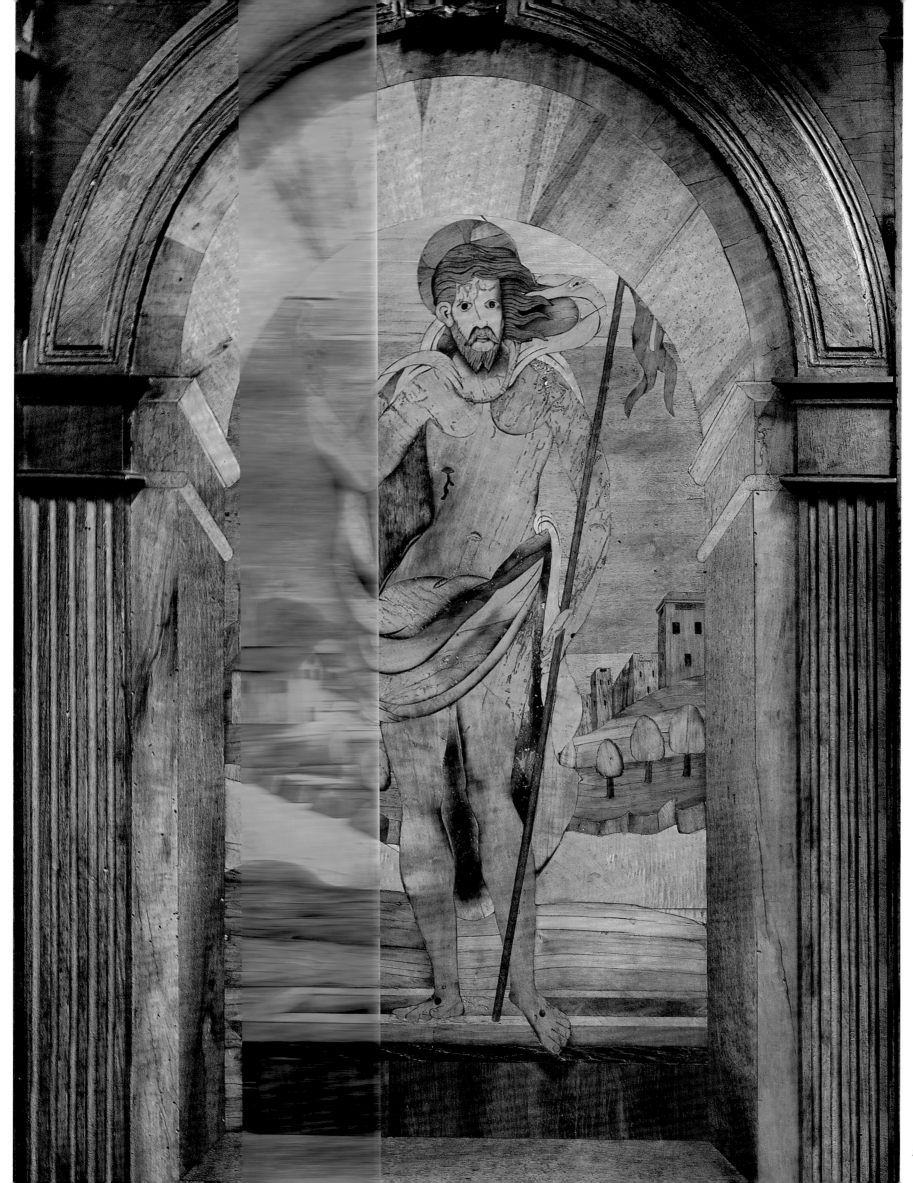

ABOVE
159. Stalls beneath the organ, with intarsias executed by Cristoforo de Venetiis in 1544–46, Basilica di San Prospero, Reggio Emilia.

OPPOSITE PAGE
160. Cristoforo de Venetiis, 1490s–1550
Idealized View of the Pantheon in Ruins, 1544–46
Basilica di San Prospero, Reggio Emilia

PAGE 212
161. Cristoforo de Venetiis, 1490s–1550
Perspectival View of Church with Lantern (formerly thought to be a view of the Reggio Emilia cathedral), 1544–46
Basilica di San Prospero, Reggio Emilia

ones, between de Venetiis's intarsias in Reggio Emilia and those by Sacca, especially the cycle at San Giovanni in Monte in Bologna.[13] Likewise, it is easy to identify repetitions and borrowings from the intarsias by Platina in the choir of the Cremona cathedral, which de Venetiis had renovated before coming to Reggio Emilia. The art of de Venetiis, however, remains more abstract and geometric than that of his colleagues and predecessors; moreover, his "palette" of woods is less broad, he almost never resorts to the use of bog oak, and his intarsias "expand across the surface,"[14] without seeking a deep structure or relying on an insistent perspectival grid. The overall effect is thus one of

manifest and solid simplicity. De Venetiis's "perspectives" may be compared with those by the brothers Cristoforo and Lorenzo Canozi da Lendinara, as in an interesting view of the Pantheon (plate 160), in which Ferretti, noting a *rovinismo* (taste for ruins) before the fact, also detected a possible familiarity with Sebastiano Serlio's treatise on architecture.[15] In fact, there may also be seen in these images a reflection of the "cutaway" technique frequently used by the Florentine architect Giuliano da Sangallo in his much-copied studies of the sections of classical monuments. The interest in the architecture of the time, through which attempts are made to update the models that had

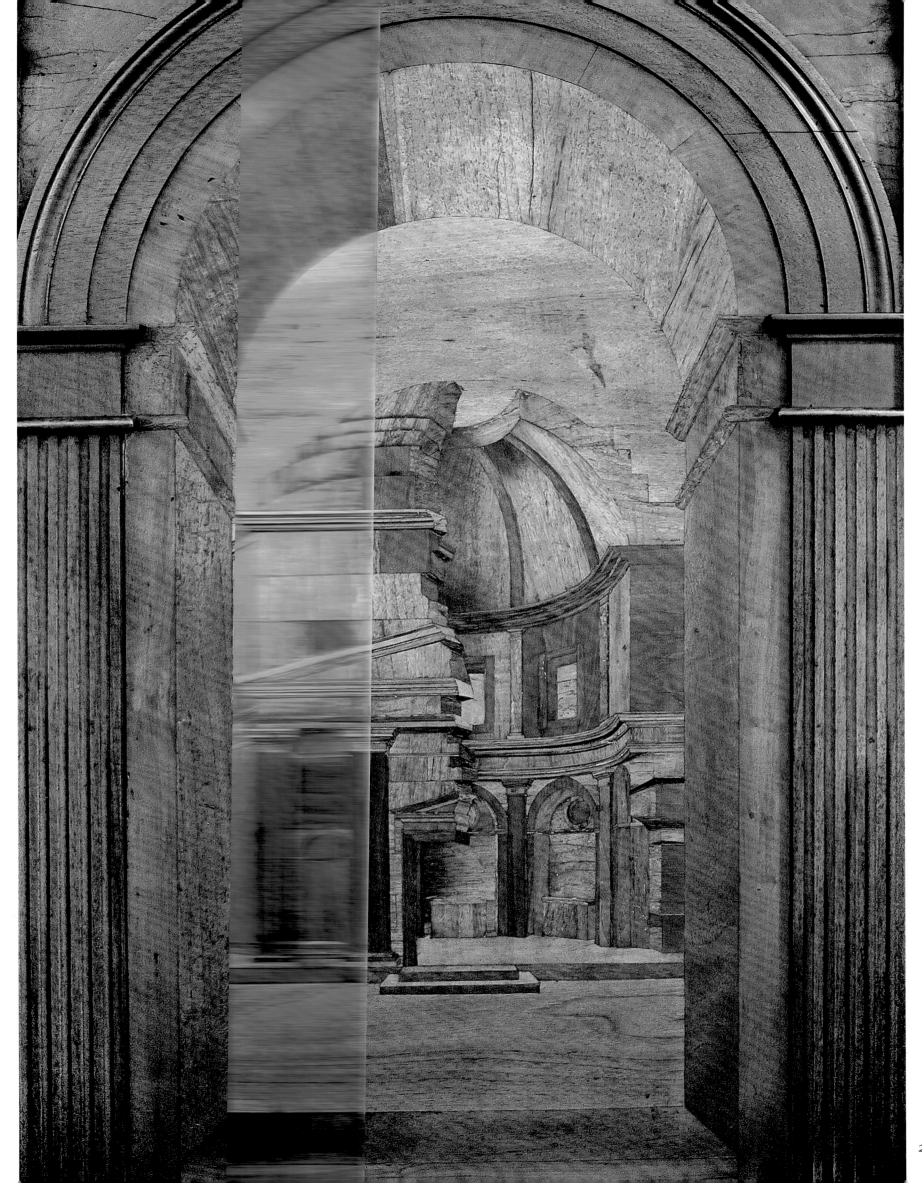

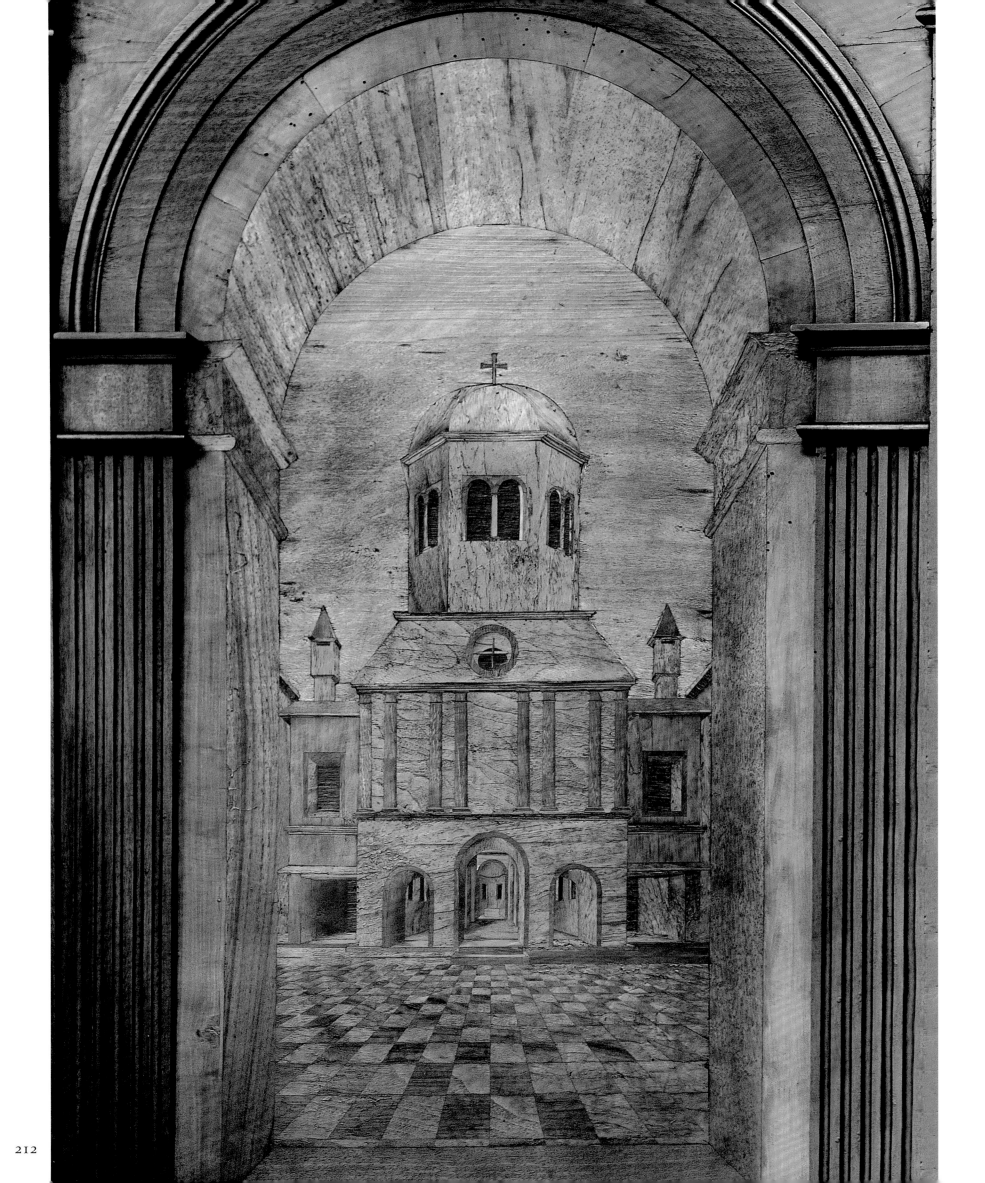

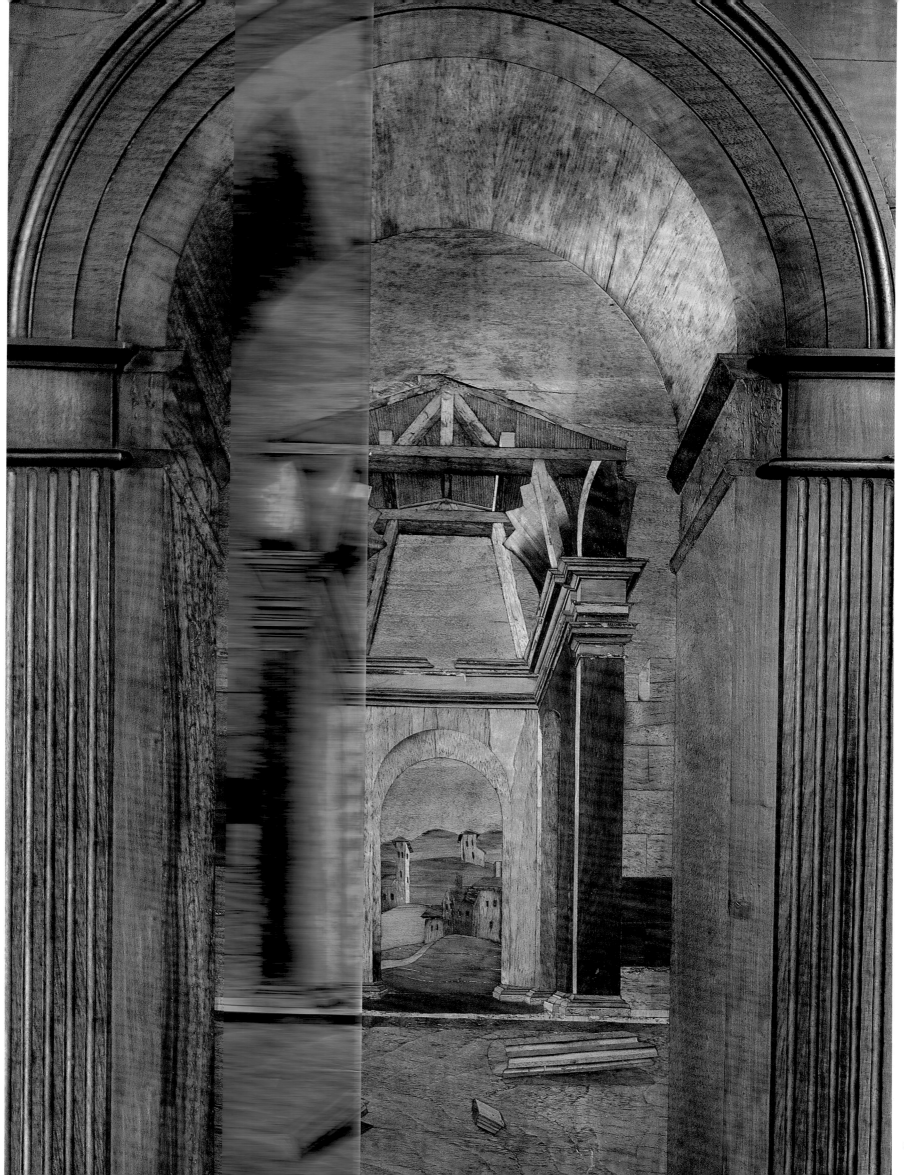

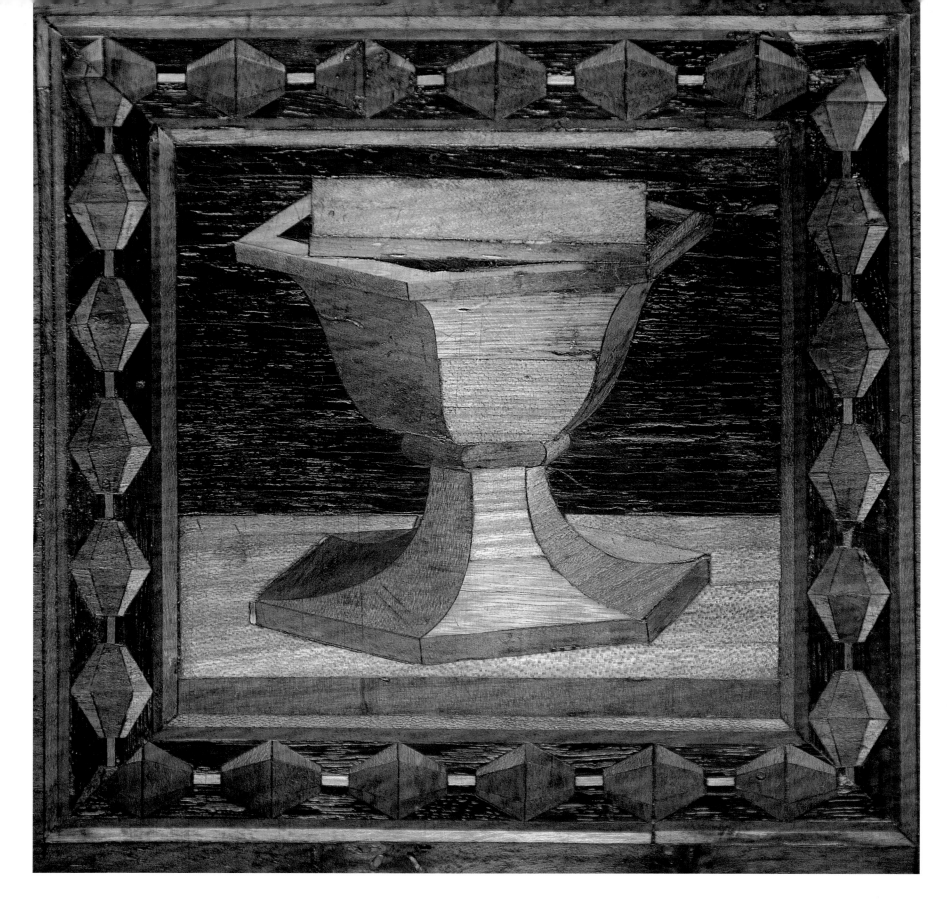

162. Cristoforo de Venetiis, 1490s–1550
Ruins, 1544–46
Basilica di San Prospero, Reggio Emilia

ABOVE
163. Cristoforo Canozi, c. 1426–1491,
and Lorenzo Canozi, 1425–1477
Chalice, 1457–58
Basilica di San Prospero, Reggio Emilia

been passed down from the Quattrocento, finds full expression in the tenth intarsia from the right in the upper row (plate 161), depicting what Ferretti describes as an "almost utopian building form that reveals a memory of the lantern-campanile of the cathedral" of Reggio Emilia.[16] This would be the sole concession to the actual architecture of the region—a proposition that, however interesting, remains to be studied in depth. The first plan

for the cathedral—which dates to 1544, the same year as de Venetiis's contract—did in fact call for a three-arched portico, which is also represented in the intarsia. But how can this suggestive coincidence be reconciled with the ill-concealed rivalry between the canons of San Prospero, the church of the lay community, and those of the cathedral, the church of the religious oligarchy? And why would de Venetiis not have received instead the design

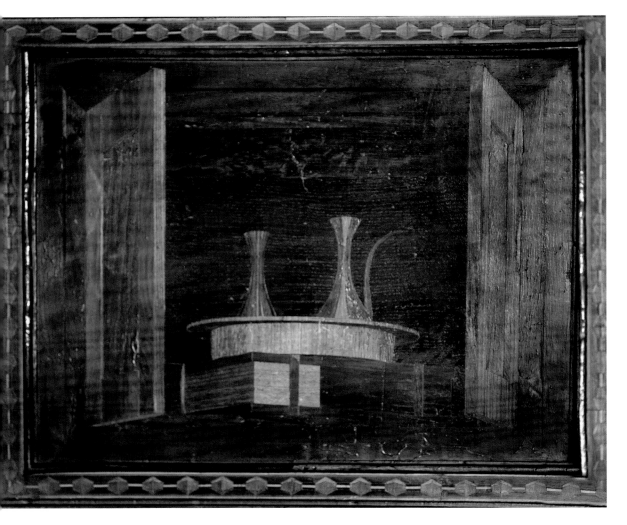

for the tower of San Prospero itself, already in an advanced state of construction in 1544, based on a model by Giulio Romano? It is apparent that a choir as complex as this one can give rise to many speculations, reflecting as it does the demands of the client, the repetition of traditional motifs, the need to incorporate preexisting material, and all the impulses toward modernization arising from the time, place, and context.

No less interesting, and no less debated, is the matter of the Quattrocento choir "reformed" by de Venetiis in the lower row of the present one. Monducci,[17] on the basis of certain archival documents, attributed the older choir (executed 1457–58) to the brothers Cristoforo and Lorenzo Canozi da Lendinara. If one accepts Monducci's interpretation, the fragments of the fifteenth-century choir of San Prospero that were reused by de Venetiis would, significantly, be the oldest extant works by the Canozi. According to the documents in question, on April 12, 1457, Borso d'Este, the duke of Ferrara, Modena, and Reggio, denied a request from the provost of San Prospero to have the "intarsia masters work on his choir" since they had not completed "our work." Monducci identified the masters active in Ferrara as the two Canozi brothers, and this would seem to be confirmed by a later document: in 1461, one of the first expenses incurred for the choir of the Modena duomo, executed by the Canozi, was "for going to see the choir in Rezo," which the artists presumably suggested as a model. Some reservations, both historical and stylistic, were later expressed about this documentary evidence and the attribution to Cristoforo and Lorenzo Canozi. Pier Luigi Bagatin in particular questions why the "choir in Rezo" would have to be the one in San Prospero, and not the one in the cathedral, which is dated to 1459.[18] However, Ferretti, who argues that the choir in the cathedral should be assigned a later date, has revived the attribution of the San Prospero choir to the Canozi.[19] Granting certain premises, such as the difficulty of evaluating parts of the choir that have been extensively modified over the centuries, and also reporting the opinion of Monducci (who did at any rate admit that the intarsias in Reggio Emilia had less merit than

those in Modena), Ferretti has focu... the lower stalls reassembled by de... 163–66), in particular the panels ... a book (plate 166) or a well and a... taining that these at least "oblig... the name of the Canozi."[20] He con... clusion because of the unequivo... simulated window, the choice of ... perspectival synthesis. More justif... that some of the *toppi* that fram... century images, while altered, seem... same rule of geometry and artisa... as those in Modena."[21] According ... iconographic choices, including, n... presence of animals, would also be... the dates of the Quattrocento choi... thus with the initial phase of the C...

Finally, Ferretti's study has the merit of identifying in the lower stalls four panels, previously assigned to the Canozi, that can be credited to Platina instead, further complicating the issues of attribution discussed above.[23] As Ferretti has convincingly demonstrated, these four intarsias—placed at the bottom of the end stalls of the main row and representing a stool with a bowl of fruit (plate 168), a candlestick on an oval box (plate 167), and two decorative friezes—do not fit with either the late perspectival style of de Venetiis or the panels by the Canozi, which they clearly post-date. Once again it is a document that resolves a complicated question: on May 22, 1546, customs fees were paid for "four panels that Master Cristoforo [de Venetiis] brought from Cremona." And indeed, comparison with Platina's intarsias in the

167. Giovanni Maria Platina, c. 1450–1500
Candlestick on an Oval Box, 1483–89
Basilica di San Prospero, Reggio Emilia
(from the Cremona cathedral)

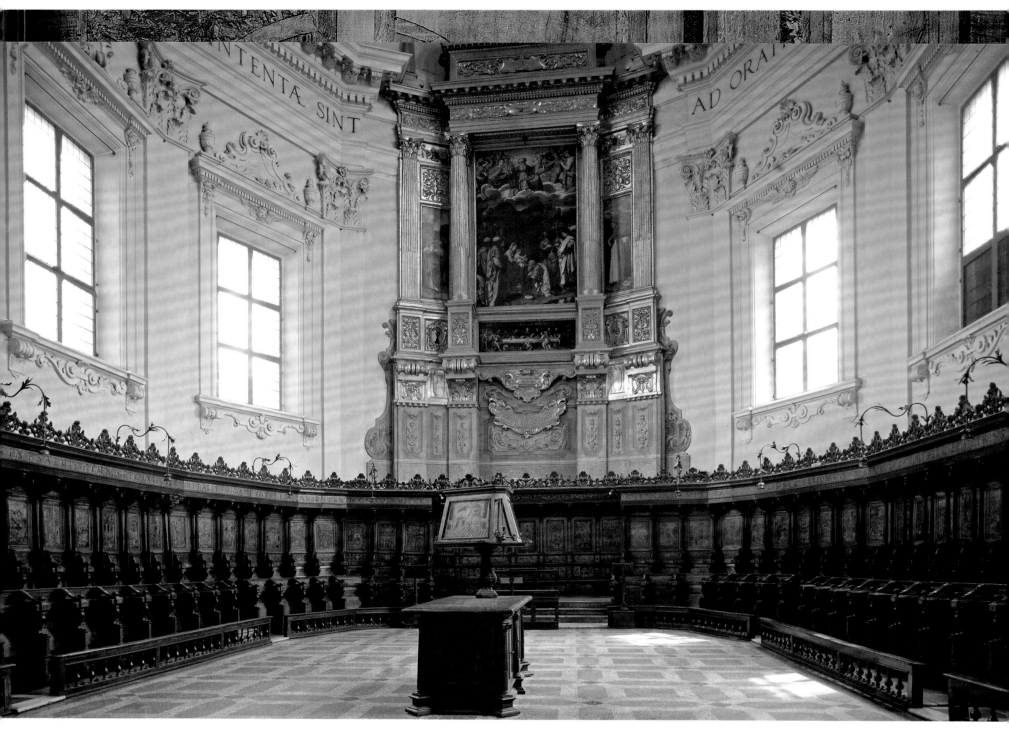

170. View of the choir of the Basilica di San Domenico, Bologna, with intarsias by Fra Damiano Zambelli and collaborators, 1528–51.

along not only the tools of his trade, but also these cartoons for his intarsias at Santo Stefano, which he would reuse, with revisions and elaborations, in the Bolognese choir.

In 1526, the basilica of San Domenico in Bologna still retained its original structure, with a three-aisled nave divided into two sections by the *pontile*, or raised walkway, that ran across it perpendicularly from the elevated Chapel of the Arca di San Domenico, the saint's tomb. The part of the nave between the facade and the *pontile*, with an open-beamed roof supported by columns, was called the "lay" or "exterior" church and intended for the faithful. The part between the *pontile* and the apse, covered with cruciform vaults, was called the "interior church" or simply the "choir" and reserved for the Dominicans. In the right aisle were two flights of stairs, one on the

lay side and the other on the brothers' side, both leading to the entrance of the Chapel of the Arca di San Domenico.

On October 24, 1528, Fra Damiano was officially transferred to the Dominican convent in Bologna at the request of its prior, Fra Stefano Foscarari, and that same year began work on the new choir. While there are few documents concerning the beginning of the project, the importance of Prior Foscarari is still apparent. A native of Bologna with exceptional human, religious, and civic virtues, he overcame numerous difficulties to make this undertaking possible, as Father Alce relates.

After obtaining the ample storeroom over the fourteenth-century sacristy for use as a workshop, Fra Damiano executed his first documented work at San Domenico: two intarsiated seats that were used as models and then installed in the

choir some years later. Fra Damiano [?]
creation is in fact made up of nume[rous parts that]
he executed between 1528 and his [death in 1549]
(with the project finally being com[pleted by his]
collaborators in 1551). He first carri[?]
sale (1528–30; plate 172), originall[y placed along]
the right wall of the presbytery, op[posite the high]
altar, and later, following the litu[rgical reform]
of the Council of Trent (1545–63), [moved to the]
back of the new Baroque choir, be[hind the high]
altar (1625). Between 1530 and 153[? he executed]
and installed the so-called *spalliera*[, or seat backs]
of the Chapel of the Arca di San D[omenico; with]
the seventeenth-century renovatio[n of the chapel,]
sixteen intarsias from this *spalliera* [would be re-]
used as shutters for the cabinets in t[he sacristy. He]
began the large lectern, still locate[d at the center]
of the choir (plate 171), in 1537, and[? the door as-]

[openin]g to the choir, originally installed in the center
[of] the *pontile*, in 1538. Finally, between 1541 and
[1]549, Fra Damiano was able to bring the great
[ch]oir, with its double row of stalls (plate 170),
[n]early to completion. It too would be transferred
[an]d adapted, in 1625, to the new polygonal plan
[of] the apse.

The *dossale* of the choir is a furnishing used in
[th]e Dominican rite as a seat for the clergy who
[c]elebrate Mass at the high altar. The seven large
[in]tarsias in Fra Damiano's *dossale* (plates 172–79)
[ha]ve, over the centuries, inspired greater admira-
[ti]on in visitors than any other part of the choir.
[In] fact, along with the *spalliera* of the Chapel of
[th]e Arca di San Domenico, it marks the highest
[an]d most consistent point in the artistic produc-
[ti]on of Fra Damiano—who here signed his initials
["]F.D." some four times—thanks to its technical

ABOVE
171. View of the lectern and choir stalls,
Basilica di San Domenico, Bologna.

PAGES 224–25
172. Fra Damiano Zambelli, c. 1480–1549
Dossale of the choir, 1528–30
Basilica di San Domenico, Bologna

PAGE 226
173. Fra Damiano Zambelli, c. 1480–1549
*Commemoration of the Coronation of
Charles V in Bologna* (detail), 1530
Basilica di San Domenico, Bologna;
dossale

PAGE 227
174. Fra Damiano Zambelli, c. 1480–1549
Stoning of Saint Stephen, 1528–30
Basilica di San Domenico, Bologna;
dossale

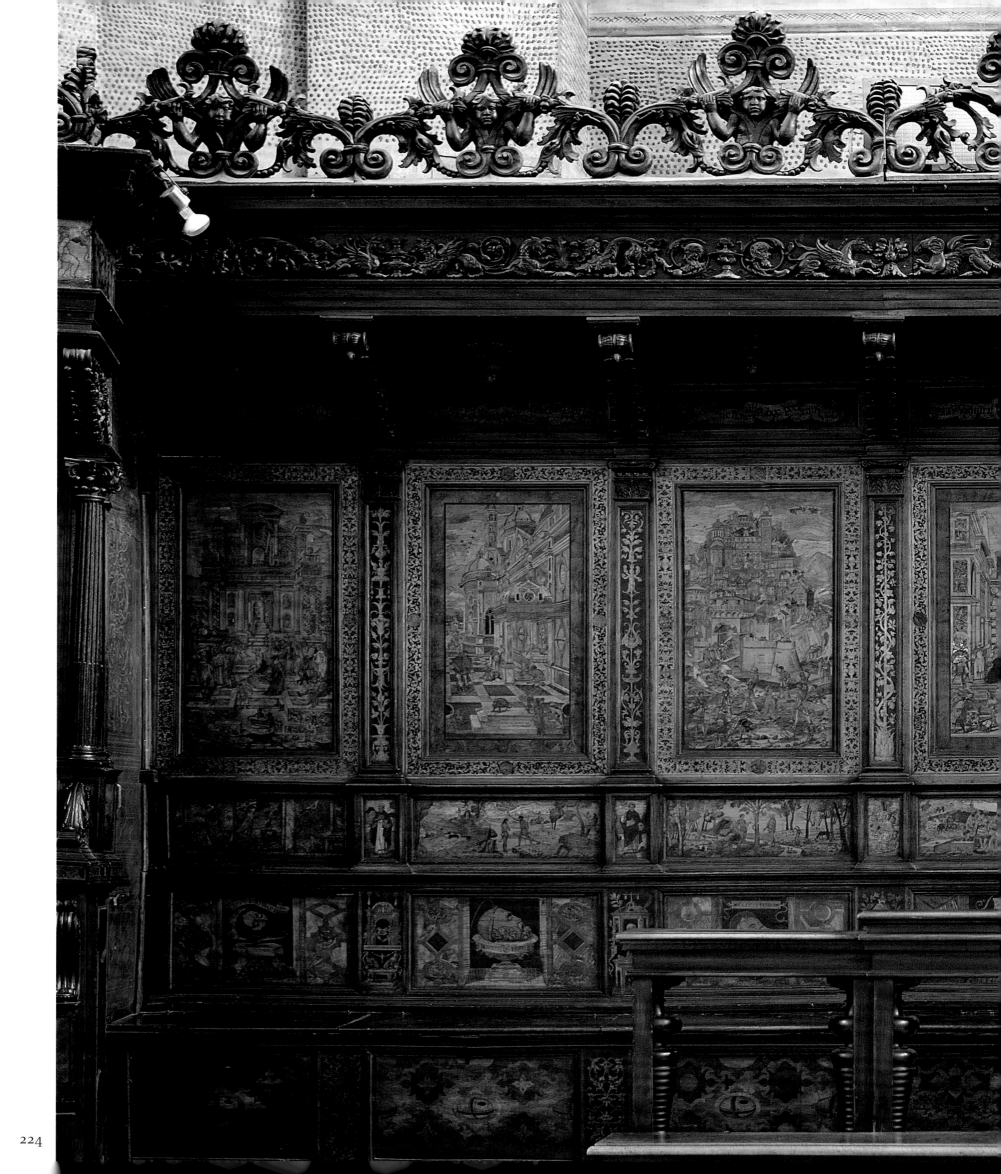

virtuosity, narrative imagination, compositional variety, and wealth of iconographic models, many of which remain to be precisely identified. Especially astonishing, as the sources attest, is the great tonal range and the passages of chiaroscuro that imitate painting, achieved by the skillful combination of many different types of wood, as well as various other materials, such as pewter and mother-of-pearl. Then there is the utterly modern desire to transcend the material aspect of the work in favor of a conceptual approach. The two impressive arms of the choir, while chronologically later and characterized by a more sober and economical spirit, attain results that are no less significant.

The seven panels of the *dossale* do not follow a logical narrative, but instead seem to have been conceived as an homage to the past and present history of the convent and the Dominican order; for example, in a nod to Prior Stefano Foscarari, one panel depicts the martyrdom of his namesake, Saint Stephen (plates 21 and 174). Oddly enough, the saint's torturers are attired as contemporary lansquenets; the Sack of Rome in 1527 must still have been very present to Fra Damiano's mind, although another of his intarsias celebrates the coronation of Charles V (plate 173), which took place in Bologna in 1530, precisely when he was working on the *dossale*.

The compositions of the *dossale* are structured by bold architectural perspectives, sometimes to the point that the figural narrative, which recalls a "Raphaelism mediated by a knowledge of Raimondi,"[7] seems almost ancillary, as in the panel depicting the miracle of Saint Nicholas of Bari (plate 177). The influence of Sebastiano Serlio on these architectural perspectives has been pointed out by many studies.[8] "The scenic layout of the intarsiated stories by Fra Damiano in the *dossale*," writes Sabine Frommel, "is in fact precisely illustrated and even illustrated with drawings in the architectural treatise (1537) of the Bolognese artist."[9] She continues, "The articulation of the space according to the rules of the 'modern stage' is a specific characteristic of the intarsias with the *Miracle of Saint Dominic* [plates 22 and 179] and the *Martyrdom of Saint Catherine* [plate 176],

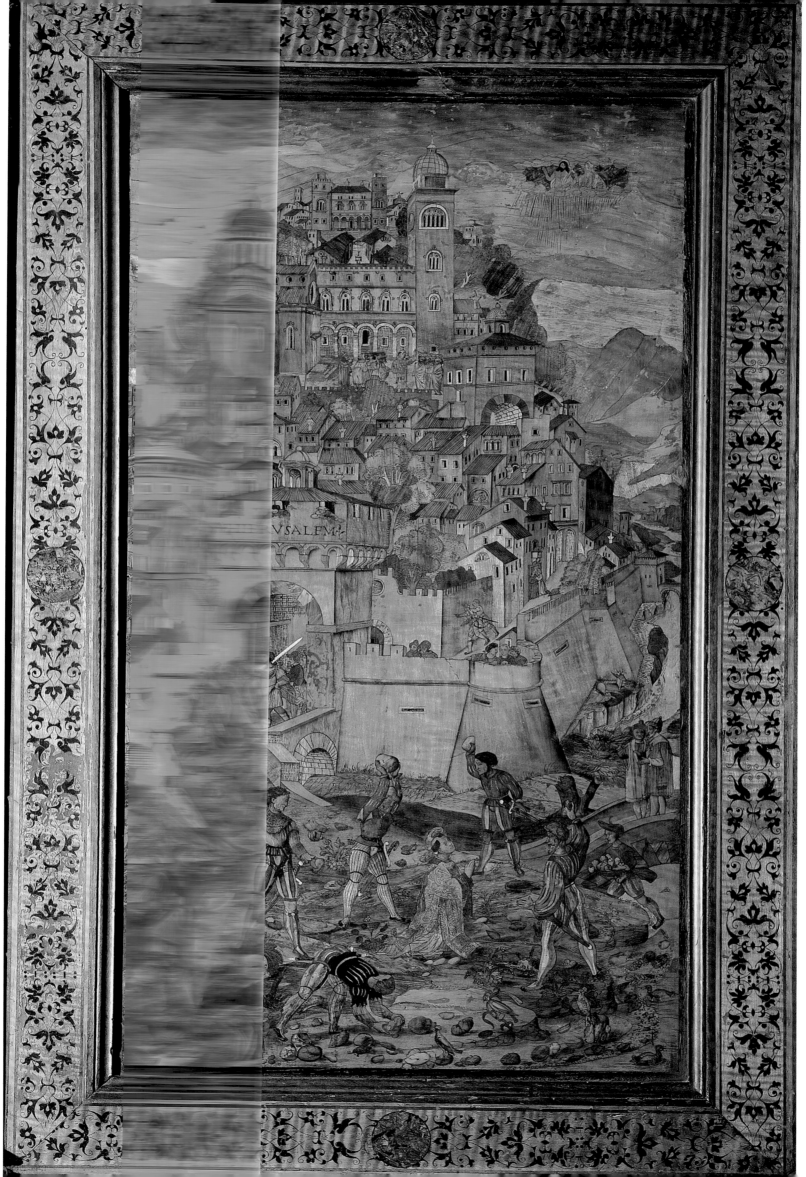

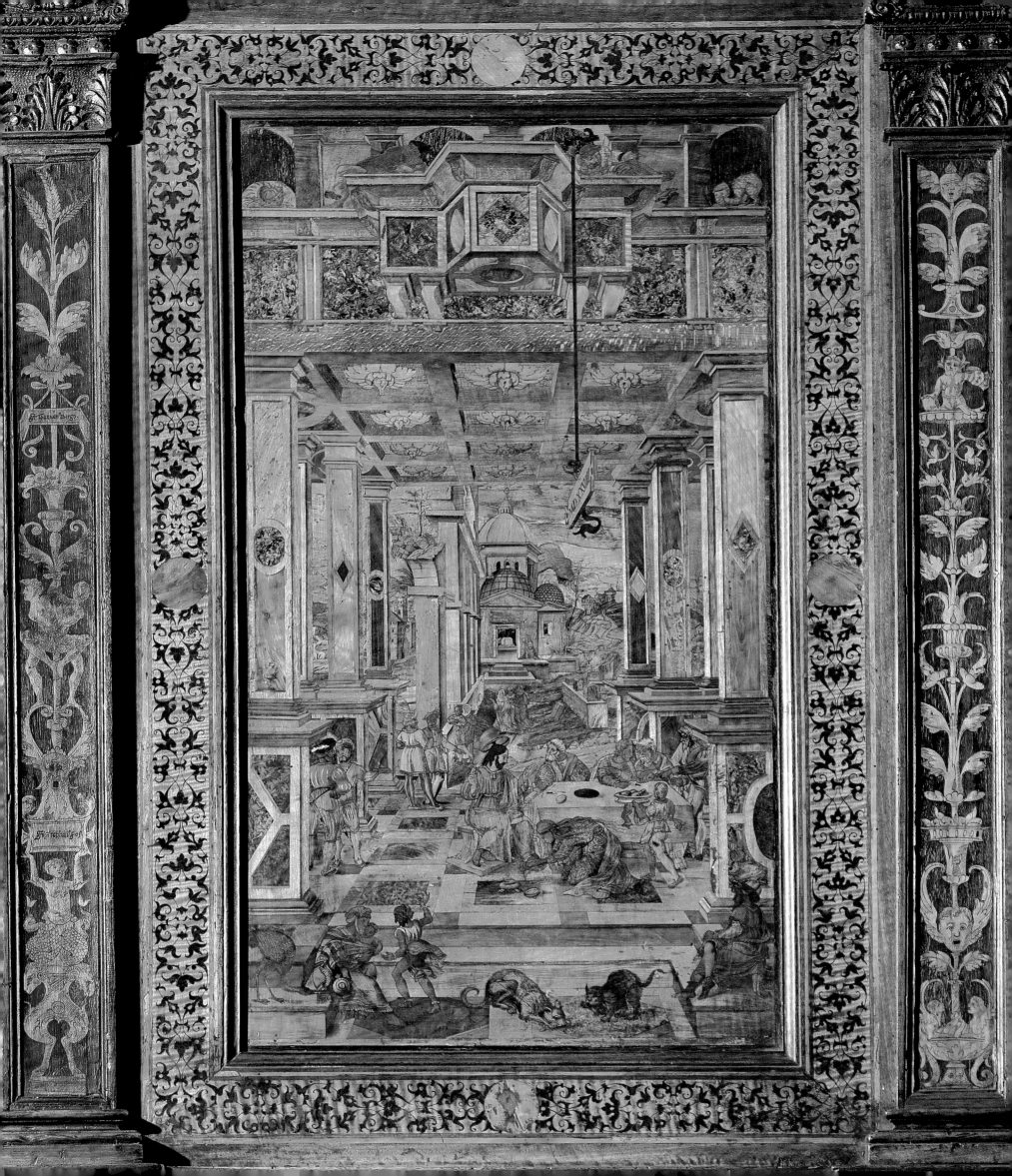

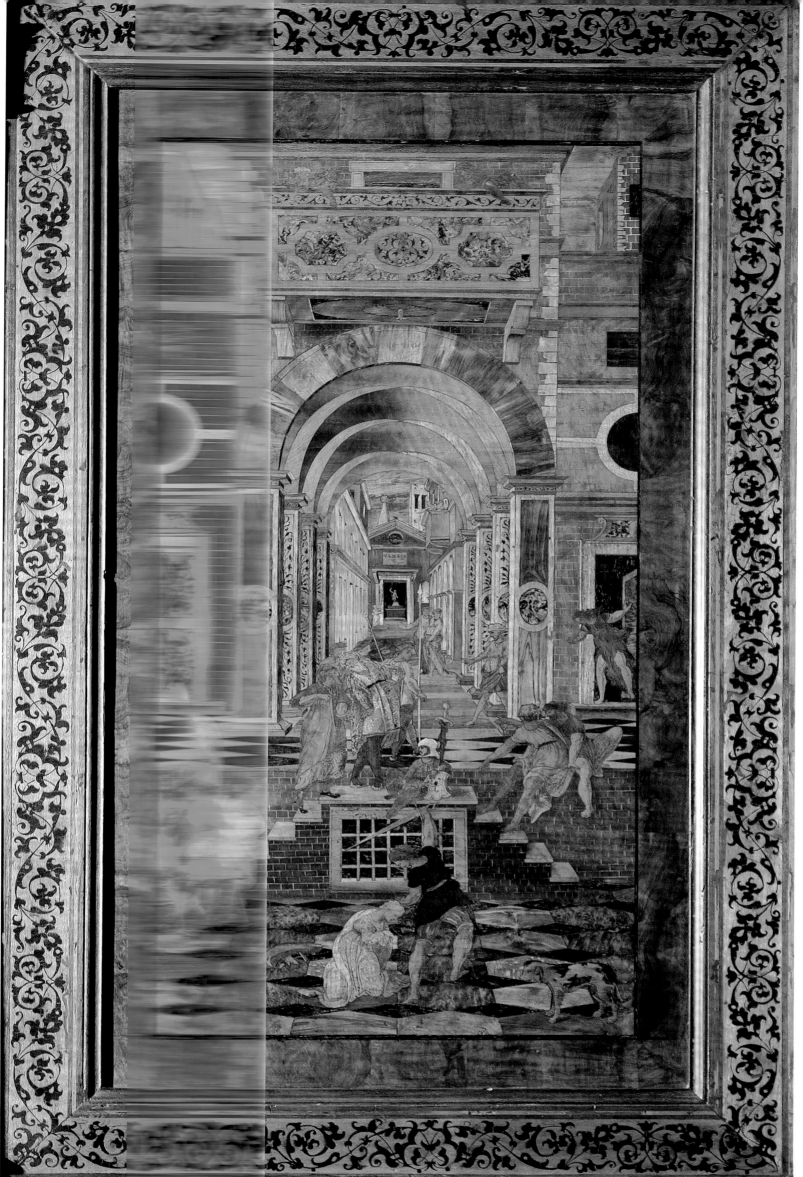

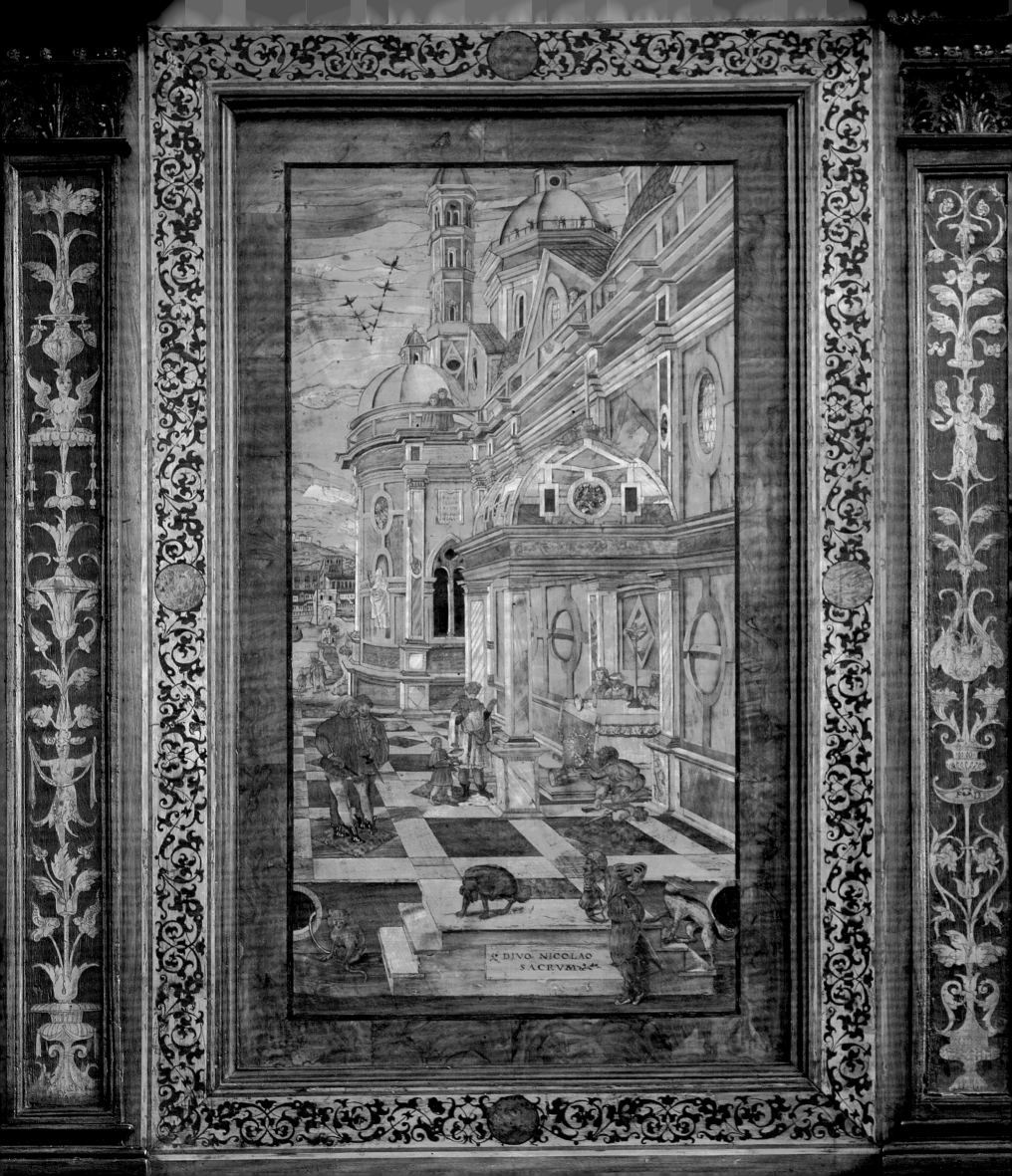

DIVO · NICOLAO
SACRVM

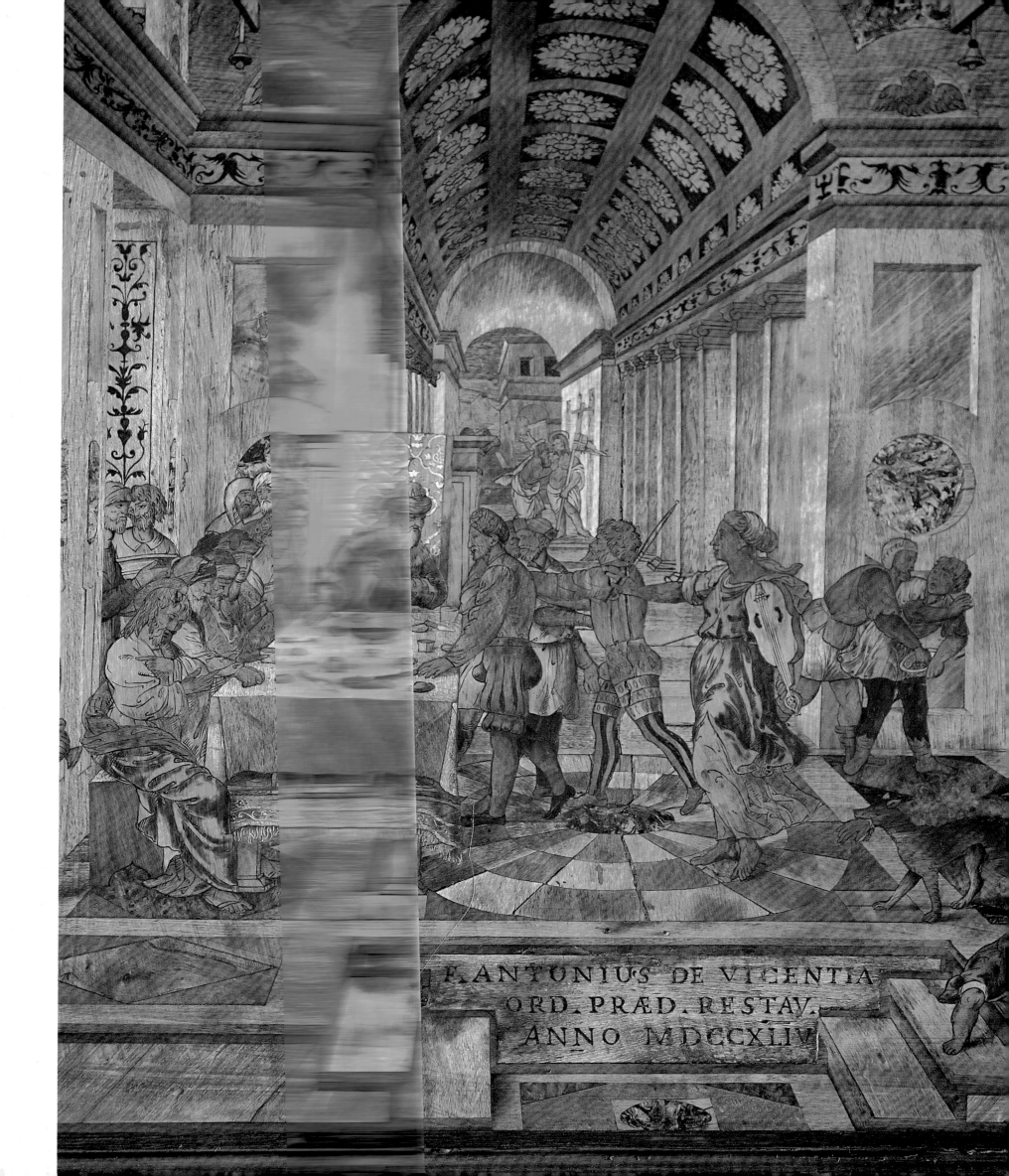

F. ANTONIUS DE VICENTIA
ORD. PRÆD. RESTAV.
ANNO MDCCXLIV

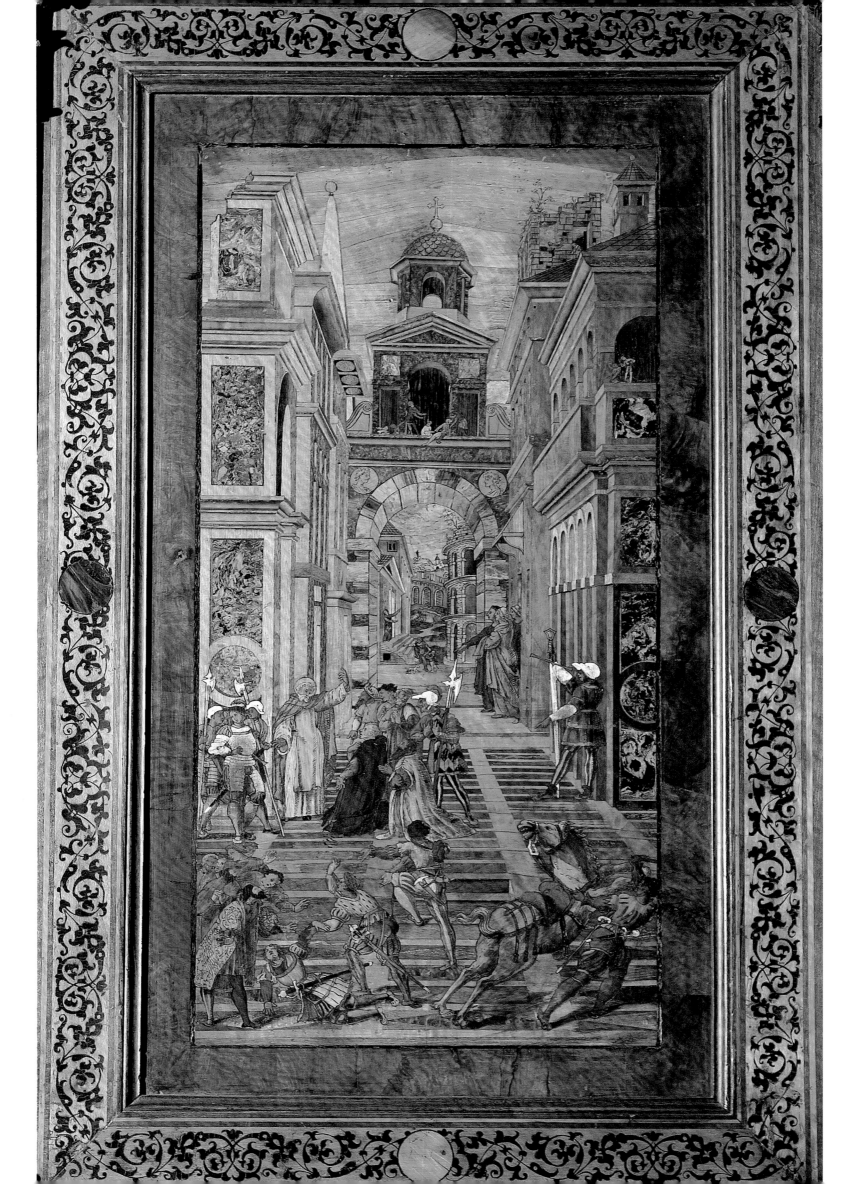

evidence of a collaboration with S_____, who is in_____
tensely involved with this proble_____ ____ for some
time."[10] But in the case of the in_____ _____ depicting
Saint Mary Magdalene (plate 17_____ which bears
the date 1528, when work on the _____ began,
it is instead the architect Vignola _____ name is
invoked.[11] Meanwhile, the archite_____ _____
tive of the *Incredulity of Saint Tho_____ _____ ___
replicates that of Fra Damiano's _____ ___ ___
Virgin at Santo Stefano in Bergam____ ____ __ ___
ing attributed to the Lombard art__ _____
Thus Fra Damiano not only freely _____ ___ ___
toons from his older choir in Berga____ ___ ____ __
riches his Bolognese intarsias with ___ _____
of the modern painter-architects. "___ _____
of the Bramantesque and Lombard _____
narration thus achieve a greater _____ _____
sity," Ferretti explains. "Grafted o___ _____
Bramantesque and Roman develo_____ ___
thus also those of Peruzzi—that w____ _____

almost an elective identification between perspec-
tival representation and the new theatrical scen-
ery."[12] Ferretti has also proposed Serlio's name
in connection with the "qualities almost recall-
ing the comic stage"[13] that may be discerned in
certain architectural backdrops in the *spalliera* of
the Arca.

Information about the *spalliera*, including all
the expenses incurred in its creation, was recorded
by Fra Ludovico da Prelormo in a volume known
as the Libro dell'Arca, which still survives. The
man who inspired this undertaking, and its true
patron, was the Bolognese historian and humanist
Fra Leandro Alberti, who, in his *Historie di Bolo-
gna* (1541–43), himself describes the *spalliera* as
a "work of marvelous artifice in wood" and ex-
plains the unusual choice of subjects represented
in its intarsias: "[The *spalliera*] shows many noble
figures, recalling certain miraculous works that
said Patriarch [Saint Dominic] did while living,

which are compared to others described in the stories of the Old Testament." According to Ferretti, in the biblical and hagiographic stories on the *spalliera*, unlike those on the *dossale*, "the narrative interest prevails over the preoccupation with architectural perspectives, just as the pursuit of open landscapes as settings for the adventures of the figures purposely eludes formal researches."[14] While Father Alce assigns the *Baptism of Saint Dominic*, *Saint Dominic Preaching*, and the *Debate with the Heretics* to Serlio in his 1969 volume,[15] in his 2002 publication he writes that "all the panels of the *spalliera* present absolutely new figurative compositions, unlike the other major works of Fra Damiano."[16] In fact, on December 12, 1530,

Fra Ludovico da Prelormo notes the purchase of paper by Fra Damiano for the drawings for the *spalliera*. The cartoons for the intarsia panels were provided, probably at the request and expense of Leandro Alberti, by certain artists active in Bologna with whom he was in contact. Among the most likely names proposed by the scholarship is that of Vignola, to whom are assigned the cartoons for the *Finding of Moses*[17] and the *Death of Saint Dominic*. In any case, as Ferretti has justly noted, "one should not place too much importance on the question of the authorship of the cartoons. In reusing them, at least in part, it is the intarsist who shifts the pieces of the perspectival play."[18] And so, as Alce observes, "the full responsibility for

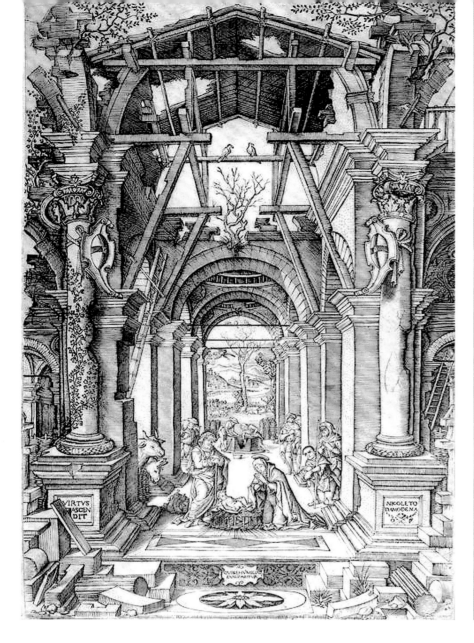

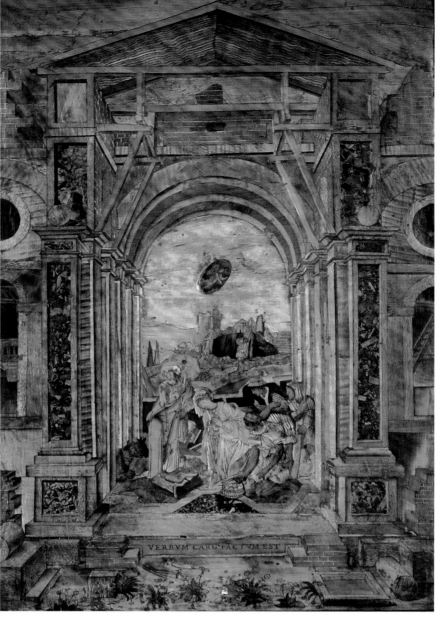

ABOVE LEFT
183. Nicoletto da Modena, active
c. 1490–1520
Nativity, c. 1500
Engraving

ABOVE RIGHT
184. Fra Damiano Zambelli,
c. 1480–1549
Nativity, 1541–51
Basilica di San Domenico, Bologna;
choir

OPPOSITE PAGE
185. Fra Damiano Zambelli,
c. 1480–1549
Tools of Intarsia, 1538
Basilica di San Domenico, Bologna;
choir door

the final outcome of the work falls on the intarsist Fra Damiano, who is stamped with a distinctive artistic personality."[19]

This is not the place to verify the possible models for Fra Damiano's intarsias, but an interesting comparison can be made between his panel of Jonah's flight to Tarshish (plate 182) and a painting in the Musei Civici in Padua that depicts the expedition of the Argonauts (plate 181), attributed to Lorenzo Costa of Ferrara[20] and probably once the front panel of the Guidotti-Bentivolgio wedding chest. The ship of the Argonauts in the foreground of the latter work—seen, unusually, from the stern—resembles the craft in the intarsia, albeit in reverse. The same type of fifteenth-century vessel, known as a *cocca* (cog) or *nave tonda* (round ship), also served as the model for a silver incense boat found in the Franciscan Basilica del Santo in Padua, as well as the ship in a bas-relief by Agostino di Duccio in Rimini, in which the vo-

lutes of the waves recall those in Fra Damiano's intarsia.

The sixth priorate of Fra Stefano Foscarari, the patron of the Bolognese choir, coincides with the resumption of work on the project in 1541, after a suspension of activity that had been ordered on April 12, 1534. The new directives from the council of the convent called for Fra Damiano to finish the remaining parts of the choir—the lectern, the door of the *pontile*, and the two sections with the stalls—"excluding, however, curious and superfluous things from those furnishings" and imposing on the artist a different stylistic orientation, inspired by the order's traditional spirit of poverty. Indeed, the essentiality of the intarsias on the lectern (plates 186–90) and the door of the *pontile* (plates 169 and 185)—now the door of the choir—reflects this new orientation, which does not, however, diminish their technical and artistic excellence. Likewise, the two arms of the stalls

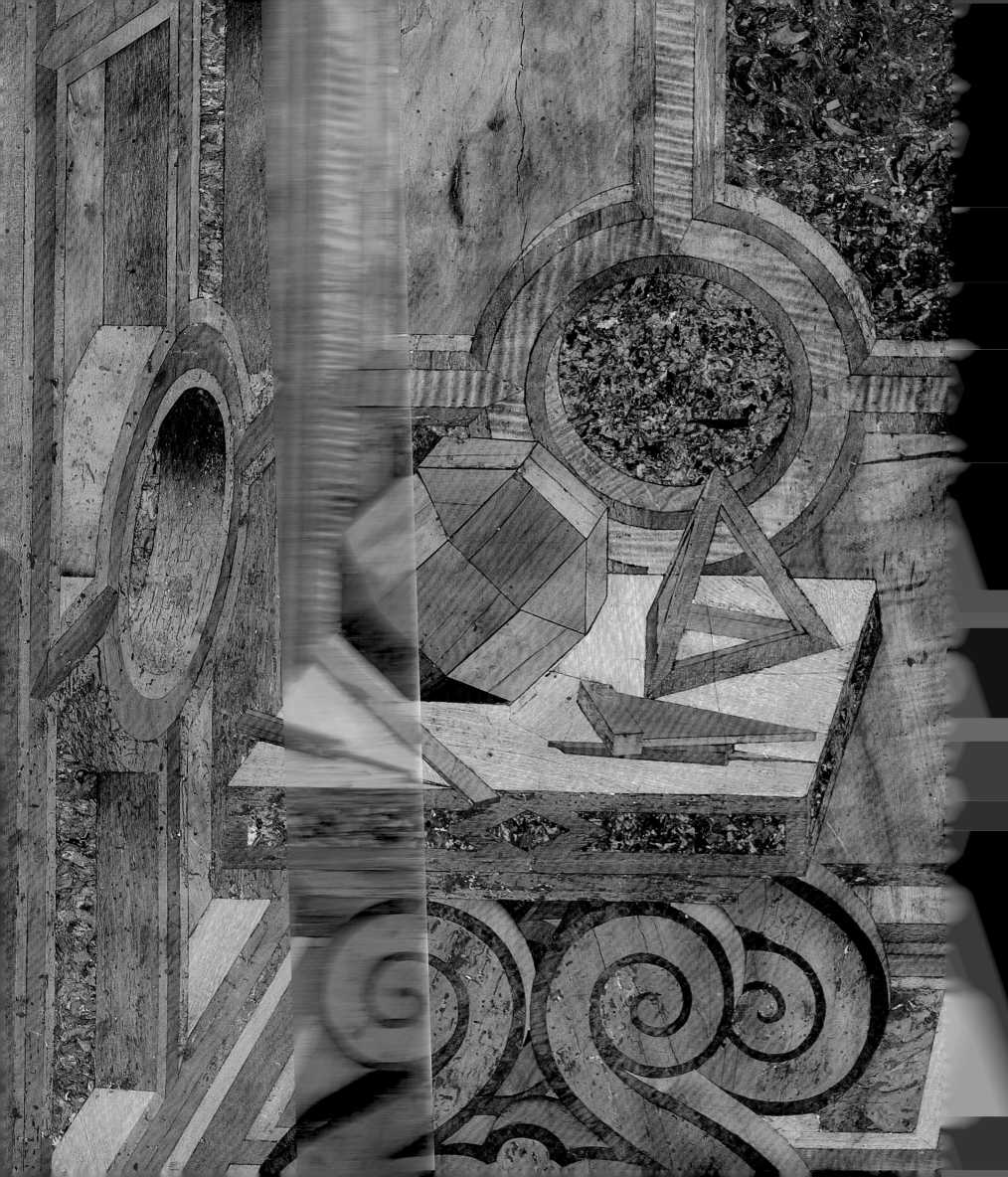

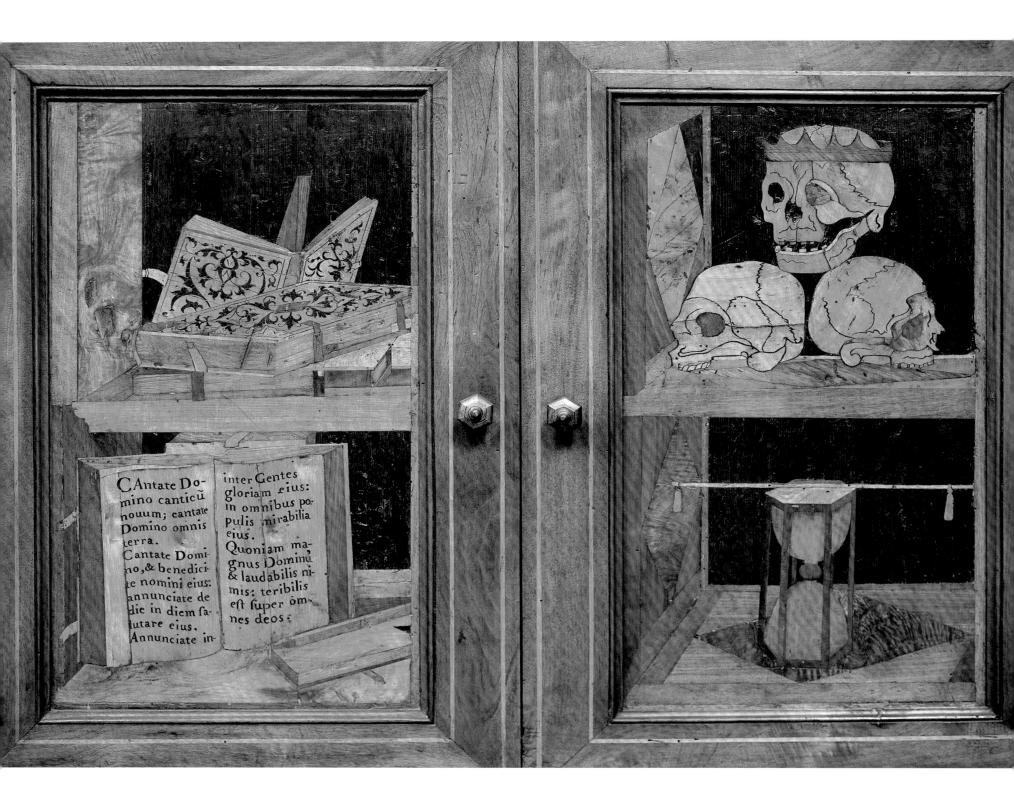

The image within shows text on a book:

C Antate Do-
mino canticũ
nouum; cantate
Domino omnis
terra.
Cantate Domi-
no, & benedici-
te nomini eius:
annunciate de
die in diem fa-
lutare eius.
Annunciate in-

inter Gentes
gloriam eius:
in omnibus po-
pulis mirabilia
eius.
Quoniam ma-
gnus Dominũ
& laudabilis ni-
mis: teribilis
eft fuper òm-
nes deos;

(plates 170, 171, and 192), the most conspicuous but least appreciated part of the choir, while perhaps more uneven, maintain a very high quality of execution, revealing "new openings to culture and imagination, which show that the artist was quite active and present in the complex development of the visual culture of the first half of the Cinquecento."[21] This is seen clearly in the unusual similarity between the intarsia panel with the Nativity (plate 184) and the well-known engraving of the same subject executed by Nicoletto da Modena (plate 183) around 1500. These final works at San Domenico represent the artistic maturity of the artist-monk, whose virtuosity "reached the limit of perfection of the art of intarsia."[22]

Laudate Dominum omnes gentes: laudate eum omnes populi. Quoniam confirmata est super nos misericordia eius: & veritas Domini manet in æternum. Gloria Patri, & Filio, & Spiritui sancto.

Cantate Domino canticũ novum; cantate Domino omnis terra. Cantate Domino, & benedicite nomini eius: annunciate de diem ... eius. Annunciate inter Gentes gloriam eius: in omnibus populis mirabilia eius. Quoniam magnus Dominũ & laudabilis nimis: teribilis est super ōmnes deos:

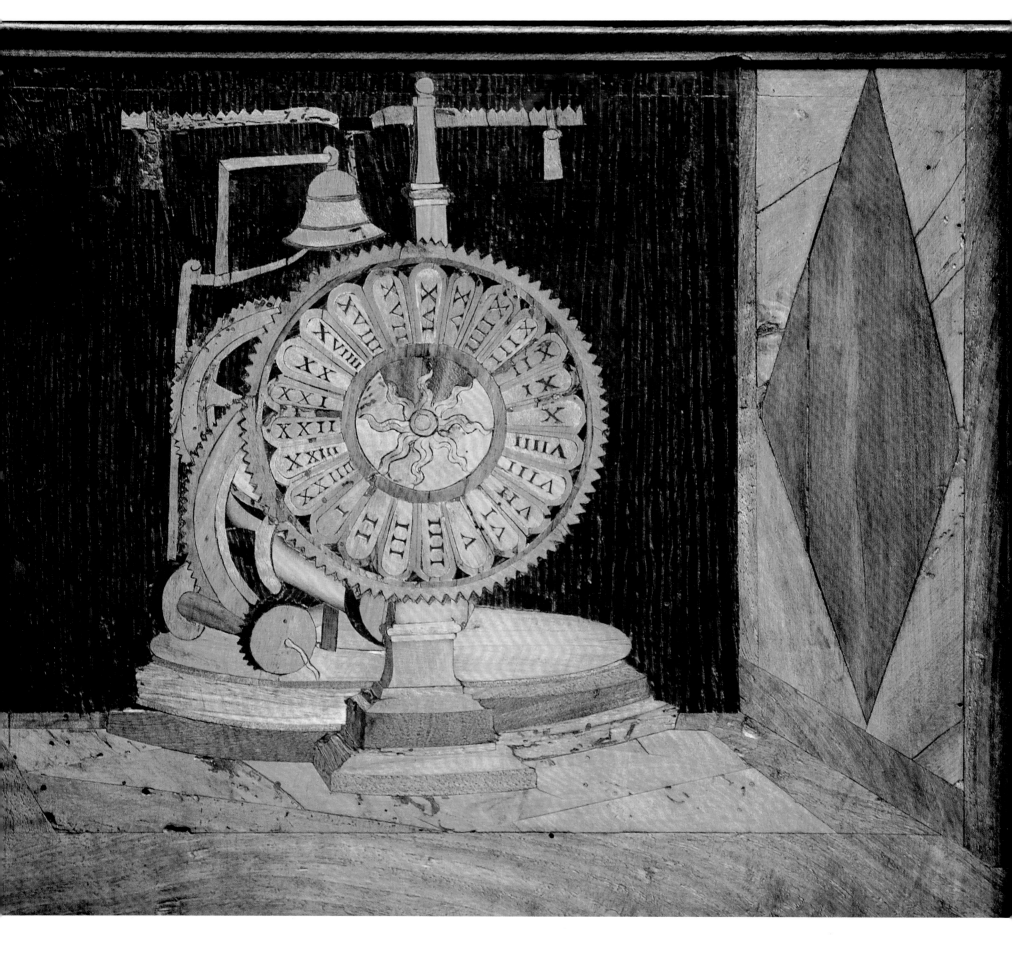

ABOVE
189. Fra Damiano Zambelli, c. 1480–1549
Clock, 1537
Basilica di San Domenico, Bologna; choir
(lectern)

OPPOSITE PAGE
190. Fra Damiano Zambelli, c. 1480–1549
Ladder and Instruments of the Passion, 1537
Basilica di San Domenico, Bologna; choir
(lectern shutter)

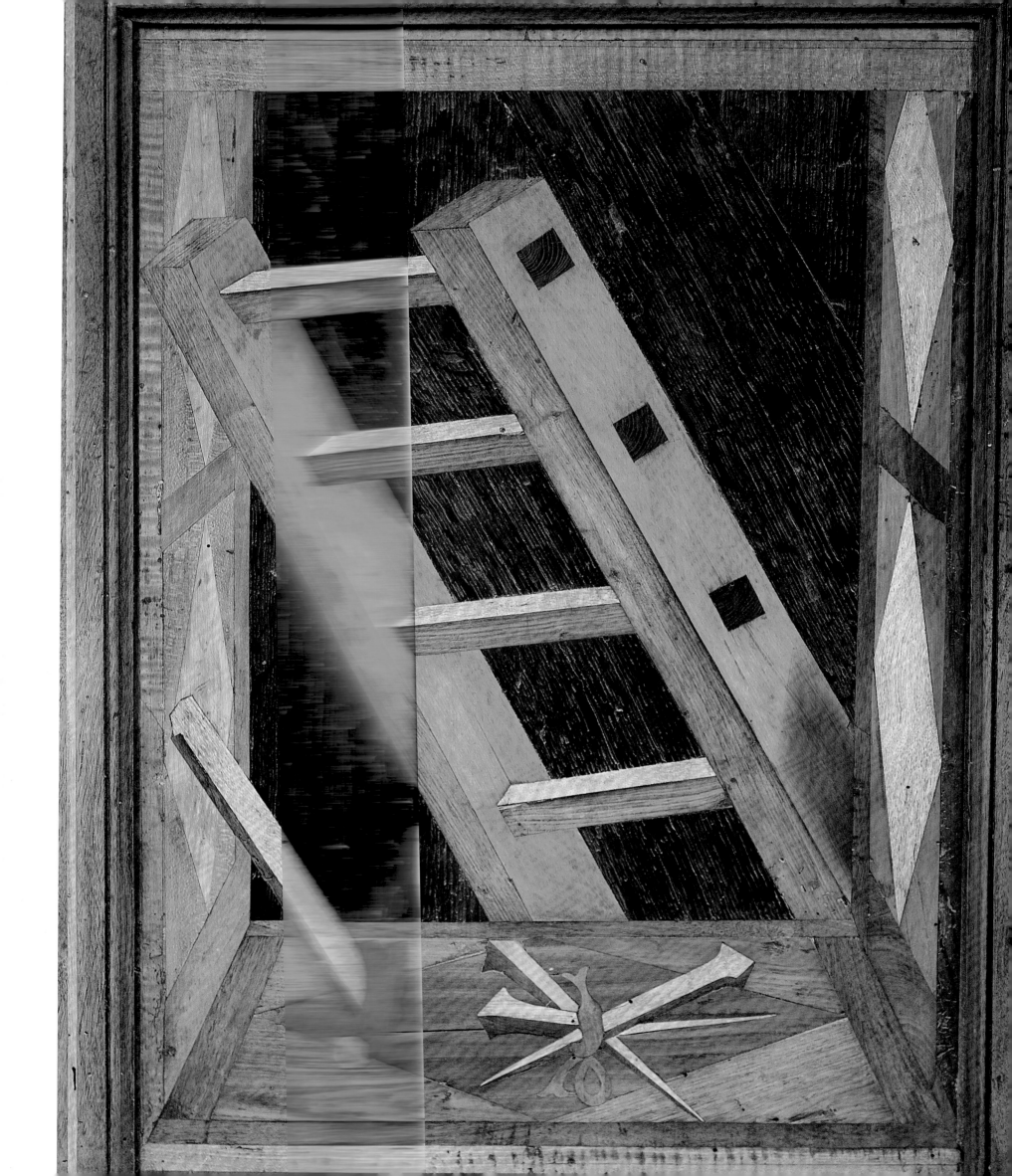

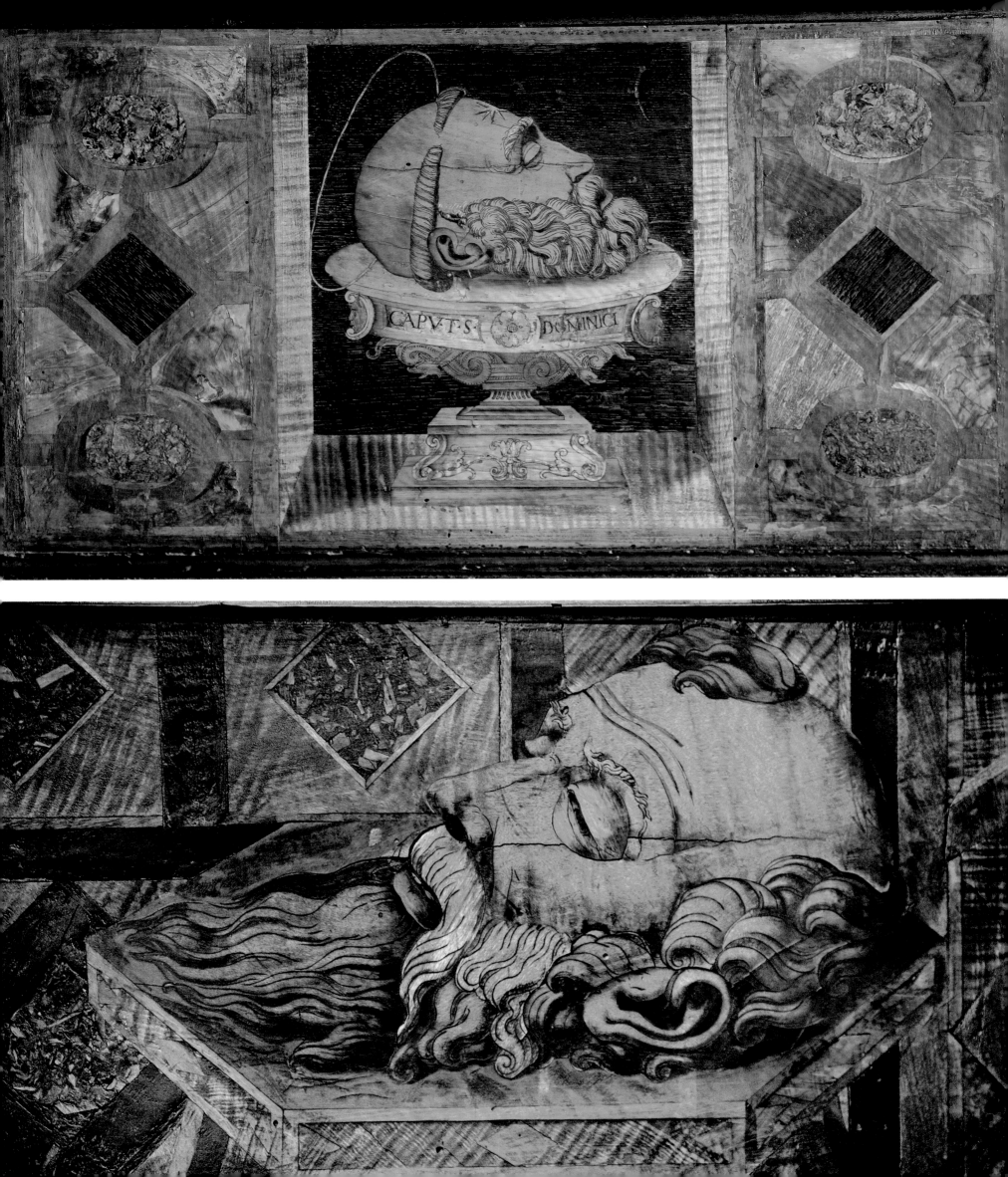

OPPOSITE PAGE (TOP)
191. Fra Damiano Zambelli, c. 1480–1549
Head of Saint Dominic, 1528–30
Basilica di San Domenico, Bologna; *dossale*

OPPOSITE PAGE (BOTTOM)
192. Fra Damiano Zambelli, c. 1480–1549
Head of Saint John (or *Saint Dominic*), 1541–51
Basilica di San Domenico, Bologna; choir

1. This phrase appears in the signature inserted into the intarsia of the patriarch Jacob blessing his sons, once part of the *spalliera* in the Chapel of the Arca di San Domenico. It is probably from the eulogy by Fra Leandro Alberti.
2. Vasari speaks of "designs with most beautiful and imaginative fantasies" that were then "put into execution in tinted woods inlaid after the manner of tarsia"; see Vasari [1568] 1793, p. 220. (English translation from De Vere, VIII, p. 237, 1914.)
3. Barocchi 1978, pp. 2924–26. (English translation from F. Hamilton Jackson, *Handbook for the Designer and Craftsman: Intarsia and Marquetry*, p. 74, 1903.)
4. Michiel 1800, pp. 49–50. According to Ferretti, the hypothesis that Fra Damiano had studied with Sebastiano da Rovigno is unlikely, due to the Olivetan monk's death in 1505; see Ferretti 1982, p. 555.
5. A "clearly wonderful thing," Leandro

[...] in his *Descrit-* [...] entire quota- [...] 1969, p. [...] destroyed in [...] of its intar- [...] ecorate the [...] of San Bar- [...] re they still [...] tion, see [...] ibliography. [...] now in San [...].

6. [...] pp. [...] known [...] t works to [...] attributed [...] ibed to [...] nphasizes [...] s in the [...] ntarsias, [...] xchanges [...] ct, for [...] Age in his [...] 1), Cesare [...] position [...] gamo.

Ferretti acknowledges that Cesariano was perhaps one of the "other" artists not named by Michiel.

7. In the oldest sections, the point of reference for the figures is the circle of Raphael, mediated by the engravings of Marcantonio Raimondi, while the architecture revisits Bramantesque motifs; see Walcher Casotti 1960, I, pp. 8–19.
8. The reference to Sebastiano Serlio has been proposed for the following panels: the *Miracle of Saint Dominic*, the *Martyrdom of Saint Catherine*, the *Lives of Saints Cosmas and Damian*, and the *Miracle of Saint Nicholas of Bari*; see Alce 1969, p. 129ff.; and Frommel 1998, p. 78 n. 40 (with bibliography).
9. Frommel 1998, p. 42.
10. Frommel 1998, p. 54.
11. Alce 2002, p. 43 n. 33 (with bibliography). Walcher Casotti 1960, pp. 8–19; in the older group of intarsias he assigns to Vignola the following scenes: the *Incredulity of Saint Thomas*, the

Banquet in the House of Simon, and the *Miracle of Saint Nicholas of Bari*.

12. Ferretti 1982, p. 556.
13. Ferretti 1982, p. 556.
14. Ferretti 1982, p. 556.
15. According to Father Alce, three other intarsias may possibly be attributed to Serlio as well: the *Dying Jacob*, *Elisha Resurrecting a Child*, and the *Miracle of the Loaves*.
16. Alce 2002, p. 51.
17. In 1534, Fra Damiano created an intarsia of the Finding of Moses, after a drawing by Vignola, for Francesco Guicciardini, governor of Bologna; today this work is in the Metropolitan Museum of Art in New York; see Alce 2002, p. 58 n. 59.
18. Ferretti 1982, p. 557.
19. Alce 2002, p. 52.
20. Tosetti Grandi 1991, pp. 75–77.
21. The quotation appears in Alce 2002, p. 87, and is taken from Gnudi 1957, pp. 50–56.
22. Alce 2002, p. 87.

By Paolo Pizzati

These "paintings in wood," as Pier Luigi Bagatin recently called intarsia, continue to astonish, drawing the eyes of scholars and art lovers alike. "Paintings," indeed, whose execution was a true art, entrusted to the hands and creative judgment of highly skilled craftsmen. The technique of intarsia—which consisted, as we know, in the creation of an image through the combination of small pieces of wood of different types and colors—was extremely complex, requiring a sophisticated knowledge of the technical processes that were used to impart the desired aesthetic values to the work. It was an undertaking in which few artists could truly excel.

The slabs or tesserae of wood were cut according to a preparatory drawing that established the principal lines and forms of the image, with the borders of the forms being defined by the edges of the slabs, which were fitted together perfectly so as to create a clear demarcation. The tonal values, meanwhile, were rendered through the choice of woods or the various treatments applied to them.

Artistic effects could also be obtained from the grain and texture of the wood, which varied not only with the species, but also with the direction of the cut and the part of the tree that the lumber was taken from, whether near the roots, near the insertion of a branch, near scars resulting from earlier damage, or simply where the fibers were most regular.

During the Renaissance, people were extremely knowledgeable about wood, taking care to cut down trees in the winter months, and only during the waning phase of the moon, so as to limit the amount of nutritional sap in the wood fiber and, more important, to minimize the sugar content of the sap.

The perfect seasoning of the wood was in fact absolutely essential to the successful outcome and durability of the work, since the expansion of the material could warp the finished panel, while its contraction could create unattractive fissures between the tesserae. Timber could be seasoned naturally, by air-drying it for a period of years, or artificially, by immersing it in water for some months or boiling it, and then letting it slowly air-dry. These last two treatments also had the effect of changing the color of the wood, usually to a deeper tone, and weakening its structure, which could sometimes be useful in limiting the internal forces of the finished panel.

In choosing wood, it was also necessary to consider the color that it would have in the future, since boards that initially appeared similar could take on very different tones with age. In any case, the selection was made from the species found in Europe at that time, and usually—as is understandable—from those that were available locally. The number of woods employed could vary from ten or so to a few dozen, according to the artist's preference, and the range could be expanded by the chemical or thermal treatments applied to the slabs. To obtain more nuanced and controlled tonal effects, such as in the shadows cast by cylindrical or spherical bodies, the wood might be rubbed with a hot iron or scorching sand. The deep black that forms the background of many fifteenth-century intarsia still lifes was obtained by the use of bog oak, or oak that had been steeped in water for an extended period, allowing the tannin in the wood to be released and then to oxidize. This long submersion also greatly weakened the wood, causing the lignin to separate from the cellulose, and it is precisely bog oak that poses the greatest problems for restorers, tending as it does to crumble completely after five centuries.

The wooden tesserae, normally an eighth to three-eighths of an inch (3 to 10 mm) thick—although there are some notably thicker examples—were cut to shape with a frame saw with very fine teeth. Since even the thinnest saw blade was still about a millimeter thick, the tesserae then

had to be refined with chisels [...]
that their edges fit together [...]
and finished, all the pieces wer[...]
tended positions, and their sur[...]
in order to confirm the chroma[...]
they would have after being p[...]
preliminary test of the composit[...]
ing any necessary corrections [...]
with the hot iron or sand, th[...]
pieces down, usually with chee[...]
strongest types then available. [...]
by soaking fresh cheese in wat[...]
which allowed the casein to s[...]
oils. Further filtering and conc[...]
a thick substance capable of fo[...]
were extremely resistant yet st[...]
tic, a quality which helped to [...]
expansions and contractions of [...]
serae that inevitably resulted f[...]
the ambient humidity or temper[...]
were derived from the skin or [...]
a process that entailed a prolon[...]
alkaline substances and subseq[...]
One of the most surprising form[...]
use of eel skin preserved in salt,[...]
an exceptionally strong glue tha[...]
tant to moisture; in fact, surgeo[...]
skin glue to close up abdominal [...]
spreading it over a strip of fabri[...]
in any case, the glue was applied[...]
surface, but only at certain poin[...]
the tesserae, but only the princi[...]
ing a certain degree of freedom f[...]
tioned expansions and contractio[...]

The finished panel was leveled [...]
or scraper, a tool that is still in [...]

sisting simply of a thin, rectangular blade of steel. Held at the proper angle, the *rasiera* was passed repeatedly over the panel, removing fine shavings of wood until the surface was perfectly level. The wood was then smoothed by rubbing it with increasingly fine sand or, even better, the extremely abrasive skin of the shark, the coarseness of which varied according to the part of the animal it was taken from.

Another intarsia technique was that known as *tarsia a toppo*, in which long laths of different woods, with polyhedral cross-sections, were gathered into a compact, interlocking bundle and then glued together in a solid block, or *toppo*. When the glue had set, this block was cut transversely into thin slices, revealing the design created by the cross-sections of the laths. These slices could be placed together side by side to form a repeating pattern, as in the so-called *cornice a toppo*, or *toppo* frame, that surrounds many intarsia panels.

After being leveled and smoothed, all the wooden parts were polished with warm beeswax, which was applied and buffed with a woolen cloth. This finish allowed the light to penetrate the fibers of the wood, enlivened its veining and color, and imparted a soft, velvety luster to the surface. However, the darkening of the wax, the oxidation of the wood, and deposits of grime and candle soot have often led, over the years, to a loss of brightness and clarity in the images. Besides this gradual process of deterioration, intarsias are also vulnerable to fire and woodworms, not to mention human action, all of which necessitates a vigilant attention to the preservation of these valuable works of art.

MANUSCRIPTS

Faccioli, G. T. "Miscellanea di notizie bi-
ografiche di Domenicani e di Vicentin
scrittori e artisti illustri." Biblioteca
Civica Bertoliana di Vicenza, ms.
3189.

PUBLISHED WORKS

1525
Dragonzino, G. B. "Nobilità di Vicenza."
Venice, 1525.

1564
Fioravanti, L. Del compendio de i secreti
rationali, dell'eccell. medico & cirugico
m. Leonardo Fiorauanti bolognese, libri
cinque. Venice, 1564.

1590
Polidoro, V. Delle religiose memorie della
chiesa di S. Antonio di Padova. Venice,
1590.

1793
Vasari, G. Le vite de' più eccellenti pittori,
scultori e architetti. (Florence, 1568.)
Edited by G. Della Valle. Siena, 1793.

1800
Michiel, M. A. Notizia d'opere di disegno.
Edited by I. Morselli. Bassano, Italy,
1800.

1829
Pivetta, G. B. Le intarsiature dell'antico
coro della Basilica di S. Antonio di
Padova già deperito nell'incendio del
mdccxxxxix. Padua, 1829.

1853
Gonzati, B. La Basilica di S. Antonio di
Padova descritta et illustrata. 2 vols.
Padua, 1853.

1878
Caffi, M. Dei Canozzi o Genesini
Lendinaresi maestri di legname del
secolo XV celebratissimi: Memoria
pubblicata in occasione del monumento
eretto in Lendinara il 25 ottobre 1877
a Lorenzo Canozio. Lendinara, Italy,
1878.

1884
Michiel, M. A. Notizia d'opere di dis-
egno. 2nd ed. Edited by G. Frizzoni.
Bologna, 1884.

[column partially illegible]
...ovanni da Verona
...e di tarsia e della
...905.

...ste e Giulio II."
...December 1909):
...

...ristoforo da
...cuola." L'Arte 16
...340.

...iovanni Antonio
...a). Florence,
... of chapter from
...ti pittori, scultori
...orgio Vasari.

...lla storia dell'arte
... e XVI. Venice,

...lli. Florence,

...ana del
...ra di Pietro
...nio Michiel.

...ni e vicende
...a d'Este." Atti
...Accademia
...n.s. 21 (1929):

...Monte Berico: Le
...e della Vittoria,
..., 1929.

...ure simboli-
...della Rovere.

...degli Abati
...Bologna in-
...secolo."
...Accademia di
...Padova 393,
...4): 385–416.

1934
Cottafavi, C. "I Gabinetti d'Isabella
d'Este: Vicende, discussioni,
restauri." Bollettino d'arte del
Ministero dell'Educazione Nazionale 6
(December 1934): 228–40.

1937
Crispolti, V. Santa Maria del Fiore alla
luce dei documenti. Florence, 1937.

1938
Seznec, J. "Youth, Innocence and
Death: Some Notes on a Medallion
on the Certosa of Pavia." Journal of
the Warburg Institute 1 (April 1938):
298–303.

1940
Charbonneau Lassay, L. Le Bestiaire du
Christ. Bruges, Belgium, 1940.

1942
Arcangeli, F. Tarsie. Rome, 1942.

1950
Rotondi, P. Il palazzo ducale di Urbino.
Vol. 1. Urbino, 1950.

1953
Barbieri, F., R. Cevese, and L. Magagnato.
Guida di Vicenza. Vicenza, 1953.
Chastel, A. "Marqueterie et perspective
au XV siècle." Revue de l'Art 3 (1953):
141–54.

1953–54
Vesentini, P. "Rapporti fra il patriarcato
di Aquileia e la chiesa veronese."
Aquileia Nostra 24–25 (1953–54):
coll. 123–39.

1956
Arslan, E. Vicenza: Le chiese. Rome, 1956.
Barbieri, F., R. Cevese, and L. Magagnato.
Guida di Vicenza. 2nd ed. Vicenza,
1956.
Fiocco, G. "Le tarsie di Pietro Antonio
degli Abati." In Scritti di storia
dell'arte in onore di Lionello Venturi,
vol. 1, pp. 239–54. Rome, 1956.

1957
Gnudi, C. San Domenico: La basilica e
l'Arca. Bologna, 1957.

1959
Quintavalle, A. C. Cristoforo da
Lendinara. Parma, 1959.

1960
Ghidiglia Quintavalle, A. "Abbati
(dell'Abà, dall'Abà) Pietro Antonio."
In Dizionario biografico degli italiani,
vol. 1, pp. 26–27. Rome, 1960.
Walcher Casotti, M. Il Vignola. Trieste,
Italy, 1960.

1961
Carli, E. L'Abbazia di Monteoliveto
Maggiore. Milan, 1961.

1961–62
Causa, R. "Giovan Francesco d'Arezzo
e Prospero maestri di commesso e
prospettiva: Le tarsie del coro dei
Conversi nella Certosa di S. Martino."
Napoli Nobilissima, ser. 3, vol. 1
(1961–62): 123–34.

1961–64
Monducci, E. "Il coro ligneo della basil-
ica di San Prospero a Reggio Emilia."
Bollettino Storico Cremonese 22 (1961–
64): 236–77.

1962
Causa, R. Tarsie cinquecentesche nella
Certosa di San Martino. Milan, 1962.
Sartori, A. "L'armadio delle reliquie
della sacrestia del Santo e Bartolomeo
Bellano." Il Santo 2 (January–April
1962): 32–58.

1963
Lorenzoni, G. Lorenzo da Bologna.
Venice, 1963.

1964
Chastel, A. Arte e umanesimo a Firenze.
Turin, 1964.
Quintavalle, A. C. "Tarsia e urbanistica."
Critica d'Arte 9, nos. 67–68 (1964):
35–46.

1964–65
Menegazzo, E. "Per la datazione della
morte di Pierantonio degli Abati."
Atti e memorie dell'Accademia
Patavina di Scienze, Lettere e Arti 77,
no. 3 (1964–65): 505–8.

1965
Dani, A. Tarsie lignee di Pier Antonio
dell'Abate da Modena per la chiesa di
S. Maria di Monte Berico. Vicenza,
1965.

1966

Grabar, A. "Un thème de l'iconographie chrétienne: L'oiseau dans la cage." *Cahiers archéologiques: Fin de l'Antiquité et Moyen Age* 16 (1966): 9–16.

Yates, F. A. *L'arte della memoria.* Turin, 1966.

1967

Heydenreich, L. H. "Federico da Montefeltro as a Building Patron: Some Remarks on the Ducal Palace of Urbino." In *Studies in Renaissance & Baroque Art Presented to Anthony Blunt on His 60th Birthday*, pp. 1–6. London, 1967.

Puerari, A., ed. *Le tarsie del Platina.* Cremona, 1967.

1968

Hjort, Ø. "L'oiseau dans la cage: Exemples médiévaux à Rome." *Cahiers archéologiques: Fin de l'Antiquité et Moyen Age* 18 (1968): 21–32.

Lotto, L. *Lettere inedite di Lorenzo Lotto.* Edited by L. Chiodi. 2nd ed. Bergamo, 1968.

1969

Alce, V. *Il Coro di San Domenico in Bologna.* Bologna, 1969.

1971

Cuppini, M. T. *Pitture murali restaurate.* Calliano, Italy, 1971.

Olivato, L. "Per Serlio a Venezia: Documenti nuovi e documenti rivisitati." *Arte Veneta* 25 (1971): 284–91.

Parronchi, A. "Prima traccia dell'attività del Pollaiolo per Urbino." *Studi Urbinati* 45, nos. 1–2 (1971): 1176–93.

1972

Mezzetti, A. *Il coro del Duomo di Modena restaurato.* Modena, 1972.

1973

Janson, H. W. "The Putto with the Death's Head." In *16 Studies*, edited by P. Egan, pp. 1–38. New York, 1973.

1974

Rotondi, P. "Ancora sullo studiolo di Federico da Montefeltro nel palazzo ducale di Urbino." In *Studi bramanteschi: Atti del congresso internazionale, Milano, Urbino, Roma, 1970*, pp. 255–65. Rome, 1974.

1975

Capuani, P. "Capodiferro (De Cotiferinis, Codiferri, Codeferini, Capi Di Ferro)." In *Dizionario biografico degli italiani*, vol. 18, pp. 617–21. Rome, 1975.

Cennini, C. *Il libro dell'arte, o Trattato della pittura.* (Padua, c. 1400.) Edited by F. Tempesti. Milan, 1975.

Le Studiolo d'Isabelle d'Este. Edited by S. Béguin. Paris, 1975. Catalog for exhibition at the Musée du Louvre, Paris, May–October 1975.

1976

Conti, A. "Le prospettive urbinati: Tentativo di un bilancio ed abbozzo di bibliografia." *Annali della Scuola Normale Superiore di Pisa: Classe di Lettere e Filosofia*, ser. 3, vol. 6, no. 4 (1976): 1193–1234.

Meroni, U., ed. *Lettere e altri documenti intorno alla storia della pittura: Raccolte di quadri a Mantova nel Sei–Settecento.* Vol. 4. Monzambano, Italy, 1976.

Saccardo, M. *Arte organaria, organisti e attività musicale a Santa Corona: Precisazioni sul patrimonio artistico della chiesa.* Vicenza, 1976.

Sartori, A. *Documenti per la storia dell'arte a Padova.* Vicenza, 1976.

1977

Brown, C. M. "The Grotta of Isabella d'Este." *Gazette des Beaux-Arts* 89 (1977): 155–71.

Del Bravo, C. "La dolcezza della immaginazione." *Annali della Scuola Normale Superiore di Pisa: Classe di Lettere e Filosofia*, ser. 3, vol. 7, no. 2 (1977): 759–99.

Puppi, L., and L. Olivato. *Mauro Codussi.* Milan, 1977.

1978

Barocchi, P. *Scritti d'arte del Cinquecento.* Vol. 3. Turin, 1978.

Brown, C. M. "The Grotta of Isabella d'Este." *Gazette des Beaux-Arts* 91 (1978): 72–82.

Gli studioli di Isabella d'Este: Documenti, vicende, restauri. Edited by A. M. Lorenzoni, G. Mulazzani, R. Navarrini, and A. M. Tamassi. Mantua, 1978. Catalog for exhibition at the Galleria e Museo di Palazzo Ducale, Mantua, 1977.

Rognini, L. *Le tarsie di Santa Maria in Organo.* Verona, 1978.

Westfall, C. W. "Chivalric Declaration: The Palazzo Ducale in Urbino as a Political Statement." In *Art and Architecture in the Service of Politics*, edited by H. A. Millon and L. Nochlin, pp. 20–45. Cambridge, Mass., 1978.

1979

Carli, E. *Il Duomo di Siena.* Genoa, 1979.

Lorenzoni, A. M. "Contributo allo studio delle fonti isabelliane nell'Archivio di Stato di Mantova." *Atti e Memorie dell'Accademia Virgiliana di Mantova*, n.s. 47 (1979): 97–135.

Rigobello, B. "Il testamento di Lorenzo Canozio." *Appunti di storia polesana* 6–7 (1979): 64–69.

1980

Ciati, B. "Cultura e società nel secondo Quattrocento attraverso l'opera ad intarsio di Lorenzo e Cristoforo da Lendinara." In *La prospettiva rinascimentale: Codificazioni e trasgressioni*, edited by M. Dalai Emiliani, pp. 201–14. Florence, 1980.

1980–81

Daniele, U. "Antonio e Paolo Mola intarsiatori: La tarsia prospettica a Venezia e a Mantova tra Quattro e Cinquecento." Diss., Università degli Studi di Bologna, 1980–81. Advisor M. Ferretti.

1981

Bresciani Alvarez, G. "La Basilica del Santo nei restauri e ampliamenti dal Quattrocento al tardobarocco." In *L'edificio del Santo di Padova*, edited by G. Lorenzoni, pp. 83–124. Vicenza, 1981.

Cheles, L. "La decorazione dello studiolo di Federico di Montefeltro a Urbino: Problemi ricostruttivi." *Notizie da Palazzo Albani* 10, no. 1 (1981): 15–21.

Clough, C. H. *The Duchy of Urbino in the Renaissance.* London, 1981.

Dragonzino, G. B. *Nobiltà di Vicenza.* (Venice, 1525.) Edited by F. Barbieri and F. Fiorese. Vicenza, 1981.

Hyman, I. "Ciaccheri Antonio." In *Dizionario biografico degli italiani*, vol. 25, pp. 76–78. Rome, 1981.

1982

Cheles, L. "The Inlaid Decorations of Federico da Montefeltro's Urbino Studiolo: An Iconographic Study." *Mitteilungen des Kunsthistorischen Institutes in Florenz* 26, no. 1 (1982): 1–46.

Ferretti, M. "I maestri della prospettiva." In *Storia dell'Arte Italiana*, pt. 3, vol. 11, *Forme e modelli*, edited by F. Zeri, pp. 459–585. Turin, 1982

Winternitz, E. *Gli strumenti musicali e il loro simbolismo nell'arte occidentale.* Turin, 1982.

1983

Cheles, L. "The 'Uomini Famosi' in the Studiolo of Urbino: An Iconographic Study." *Gazette des Beaux-Arts*, ser. 6, vol. 102 (1983): 1–7.

Cortesi Bosco, F. "Riflessi del mito di Venezia nella pala Martinengo di Lorenzo Lotto." *Archivio Storico Bergamasco* 3, no. 2 (1983): 213–49.

Haines, M. *La Sacrestia delle Messe del duomo di Firenze.* Florence, 1983.

Rigobello, B. "Il testamento di Lorenzo Canozio." *Appunti di storia polesana* 6–7 (1979): 64–69.

Puppi, L. "Il viaggio ed il soggiorno a Venezia di Antonello da Messina." *Museum patavinum* 1, no. 2 (1983): 253–82.

Sartori, A. *Archivio Sartori: Documenti di storia e arte francescana.* Vol. 1, *Basilica e Convento del Santo.* Edited by G. Luisetto. Padua, 1983.

Trionfi Honorati, M. "Prospettive architettoniche a tarsia: Le porte del palazzo ducale di Urbino." *Notizie da Palazzo Albani* 12, nos. 1–2 (1983): 38–50.

1984

Bolzoni, L. *Il teatro della memoria: Studi su Giulio Camillo.* Padua, 1984.

Clough, C. H. "Federigo da Montefeltro: The Good Christian Prince." *Bulletin of the John Rylands Library* (University of Manchester) 67, no. 1 (1984): 293–348.

Dall'Ara, R. "La Società per il Palazzo Ducale ha restaurato la volta della Grotta della Musica." *La Gazzetta di Mantova.* November 18, 1984.

Franzoni, C. "'Rimembranze d'infinite cose': Le collezioni rinascimentali di antichità." In *Memoria dell'antico nell'arte italiana*, vol. 1, *L'uso dei classici*, edited by S. Settis, pp. 299–360. Turin, 1984.

Lucco, M. "Il Quattrocento." In *Le pitture del Santo di Padova*, edited by C. Semenzato, pp. 119–43. Vicenza, 1984.

1985

Brown, C. M. *La Grotta di Isabella d'Este: Un simbolo di continuità dinastica per i duchi di Mantova.* Mantua, 1985.

Polichetti, M. L., ed. *Il Palazzo di Federico da Montefeltro.* Urbino, 1985.

Rognini, L. *Tarsie e intaglia di fra Giovanni a Santa Maria in Organo di Verona.* Verona, 1985.

1986

Brown, C. M. "Public Interests and Private Collections: Isabella d'Este's Appartamento della Grotta and Its Accessibility to Artist's Scholars and Public Figures." In *Akten des 25: Kongresses für Kunstgeschichte*, pt. 4, "Der Zugang zum Kunstwerk: Schatzkammer, Salon, Ausstellung, 'Museum,'" edited by H. Fillitz and M. Pippal, pp. 37–41. Vienna, 1986.

Cerbeni Baiardi, G., G. Chittolini, and P. Floriani, eds. *Federico di Montefeltro: Lo stato, le arti, la cultura.* Rome, 1986.

Cheles, L. "'Topoi' e 'serio ludere' nello studiolo di Urbino." In *Federico di Montefeltro: Lo stato, le arti, la cultura*, edited by G. Cerbeni Baiardi, G. Chittolini, and P. Floriani, vol. 2, *Le arti*, pp. 269–86. Rome, 1986.

Cieri Via, C. "Ipotesi di un percorso funzionale e simbolico nel Palazzo Ducale di Urbino attraverso le immagini." In *Federico di Montefeltro: Lo stato, le arti, la cultura*, edited by G. Cerbeni Baiardi, G. Chittolini, and P. Floriani, vol. 2, *Le arti*, pp. 47–64. Rome, 1986.

Clough, C. H. "Lo studiolo di Gubbio." In *Federico di Montefeltro: Lo stato, le arti, la cultura*, edited by G. Cerbeni Baiardi, G. Chittolini, and P. Floriani, vol. 2, *Le arti*, pp. 287–300. Rome, 1986.

De Seta, C., M. Ferretti, and A. Tenenti, *Imago urbis: Dalla città reale alla città ideale*. Milan, 1986.

Ferretti, M. "'Casamenti seu prospectiva': Le città degli intarsiatori." In *Imago urbis: Dalla città reale alla città ideale*, by C. De Seta, M. Ferretti, and A. Tenenti, pp. 73–104. Milan, 1986.

Isaacs, A. K. "Condottieri, stati e territori nell'Italia centrale." In *Federico di Montefeltro: Lo stato, le arti, la cultura*, edited by G. Cerbeni Baiardi, G. Chittolini, and P. Floriani, vol. 1, *Lo stato*, pp. 23–60. Rome, 1986.

Lightbown, R. *Mantegna*. Milan, 1986.

Rosenberg, C. M. "The double portrait of Federico and Guidobaldo da Montefeltro: Power, wisdom and dynasty." In *Federico di Montefeltro: Lo stato, le arti, la cultura*, edited by G. Cerbeni Baiardi, G. Chittolini, and P. Floriani, vol. 2, *Le arti*, pp. 213–22. Rome, 1986.

Tenenti, A. "Dalla città reale alla città ideale." In *Imago urbis: Dalla città reale alla città ideale*, by C. De Seta, M. Ferretti, and A. Tenenti, pp. 169–93. Milan, 1986.

1987

Bagatin, P. L. *L'arte dei Canozi lendinaresi*. Trieste, Italy, 1987.

Barbieri, F. *Vicenza città di palazzi*. Cinisello Balsamo, Italy, 1987.

Centro Culturale San Bartolomeo. *La pala Martinengo di Lorenzo Lotto: Studi e ricerche in occasione del restauro*. Bergamo, 1987.

Chastel, A. "Nelle città di legno: Mosaici di legname cioè tarsie." *FMR* 50 (1987): 76–82.

Cortesi Bosco, F. *Il coro intarsiato di Lotto e Capoferri per Santa Maria Maggiore in Bergamo*. 2 vols. Bergamo, 1987.

De Seta, C. "Nelle città di legno: Le belle prospettive." *FMR* 50 (1987): 83–104.

Limido, G. "Un nuovo contributo all'iconografia dello 'studiolo' di Urbino." *Arte cristiana* 75, no. 718 (1987): 427–32.

Tardito Amerio, R. "Storia e vicissitudini della pala." In *La pala Martinengo di Lorenzo Lotto: Studi e ricerche in occasione del restauro*, by the Centro

tolomeo, pp. 54–59.

_iolo: Storia e tipo- culturale*. Modena,

_'appartamento _." *Palazzo _ museo* 2 (1988): 1. _ction with exhi- _ Ducale, Mantua, _January 8, 1989. _ a in Organo.

_to dell'Abbazia _giore*. Cinisello

_anozi lendina- Italy, 1990. _*La pittura nel _rocento*, edited _621. Milan,

_rbino: _osmo princi- _1991. _lo come luogo _e il Principe: _nento padano, _lfino and M. _3. Modena,

_. "Les por- _du Studiolo _uste de _." *Revue du _2–114. _Costa." In _pinti dei _la metà _el Seicento*, _D. Banzato, _1991.

Marti- _on catalog. _o e nel _cescani." _orti rina- _Poggetto, _atalog for _cale and _Battista, _1992. Cie _co da _o, Piero _d by P. I _nice, _t the P _io di

San Giovanni Battista, Urbino, July 24–October 31, 1992.

Cuscito, G. *Martiri cristiani ad Aquileia e in Istria: Documenti archeologici e questioni agiografiche*. Udine, Italy, 1992.

Posio, V. "Dodici anni di attività per Mantova: Breve racconto su quanto fatto dalla Società per il Palazzo Ducale di Mantova dal 1980 ad oggi." In *Palazzo Ducale: I novant'anni della Società*, pp. 27–36. Mantua, 1992.

Sacchetti, A. "Cristoforo Canozi e le tarsie del duomo di Parma." Diss., Istituto Universitario di Architettura di Venezia, 1992. Advisors C. Balistreri and P. L. Bagatin, coadvisor P. Pizzati.

1993

Paolucci, A. "Tesori d'arte dentro Santa Maria del Fiore." In *Alla riscoperta di Piazza del Duomo in Firenze*, vol. 2., *La Cattedrale di Santa Maria del Fiore*, edited by T. Verdon, pp. 89–109. Florence, 1993.

Pernis, M. G. "Neoplatonismo in alcuni programmi iconografici del palazzo di Urbino." In *Studi per Pietro Zampetti*, edited by R. Varese, pp. 153–62. Ancona, Italy, 1993.

Rattin, A. "Pietro Antonio degli Abbati e le tarsie di San Bartolomeo a Vicenza." Diss., Istituto Universitario di Architettura di Venezia, 1993. Advisor C. Balistreri, coadvisor P. Pizzati.

1994

Acidini Luchinat, C. *Il Battistero e il Duomo di Firenze*. Milan, 1994.

Fioretto, F. "Le tarsie del coro della Chiesa di Santa Corona a Vicenza." Diss., Istituto Universitario di Architettura di Venezia, 1994. Advisor C. Balistreri, coadvisor P. Pizzati.

Guidobaldi, N. "Court Music and Universal Harmony in Federico da Montefeltro's Studiolo in Urbino." In *Musikalische Ikonographie*, edited by H. Heckmann, M. Holl, and H.-J. Marx, pp. 111–20. Laaber, Germany, 1994.

Isabella d'Este: Fürstin und Mäzenatin der Renaissance. Edited by S. Ferino-Pagden. Vienna, 1994. Catalog for exhibition at Kunsthistorisches Museum, Vienna, 1994.

Rognini, L. "Lorenzo da Salò 'eccelente intagliatore' ed il coro di Sant'Anastasia a Verona." *Verona illustrata* 7 (1994): 15–31.

1995

Alce, V. *Fra' Damiano intarsiatore e l'ordine domenicano a Bergamo*. Bergamo, 1995.

Bolzoni, L. *La stanza della memoria*. Turin, 1995.

Polli, V. *Le tarsie di San Bartolomeo in Bergamo del frate Damiano Zambelli*. Clusone, Italy, 1995.

1996

Bartalini, R. *Le occasioni del Sodoma: Dalla Milano di Leonardo alla Roma di Raffaello*. Rome, 1996.

Benzi, F. "Lo studiolo ligneo del Duca di Montefeltro ad Urbino: Una collaborazione tra le botteghe lignarie di Baccio Pontelli e Francione." In *Roma nella svolta tra Quattro e Cinquecento*, edited by S. Colonna, pp. 399–410. Rome, 1996. Proceedings of the Convegno Internazionale di Studi, Rome, October 28–31, 1996.

Ciardi Duprè Dal Poggetto, M. G. "Considerazioni e ipotesi sulle tarsie dello studiolo di Federico di Montefeltro a Urbino." In *Città e corte nell'Italia di Piero della Francesca*, edited by C. Cieri Via, pp. 47–57. Venice, 1996. Proceedings of the Convegno Internazionale di Studi, Urbino, October 4–7, 1992.

Fiore, F. P. "Piero della Francesca e Francesco di Giorgio nel palazzo Ducale di Urbino." In *Città e corte nell'Italia di Piero della Francesca*, edited by C. Cieri Via, pp. 245–63. Venice, 1996. Proceedings of the Convegno Internazionale di Studi, Urbino, October 4–7, 1992.

1997

Bagatin, P. L. "Le tarsie del coro ligneo di San Prospero." In *La basilica di San Prospero a Reggio Emilia*, edited by G. Buccellati, pp. 61–69. Milan, 1997.

Brown, C. M. "'Fruste et strache nel fabricare': Isabella d'Este's Apartments in the Corte Vecchia of the Ducal Palace in Mantua." In *La corte di Mantova nell'età di Andrea Mantegna*, edited by C. Mozzarelli and R. Oresko, pp. 295–336. Rome, 1997.

Daniele, U. "La città prospettica: Spazi urbani e trattatistica nelle tarsie venete di fine Quattrocento." In *Lo spazio nelle città venete (1348–1509): Urbanistica e architettura, monumenti e piazze, decorazione e rappresentazione*, edited by G. Guidoni and U. Soragni, pp. 227–36. Rome, 1997. Proceedings of the Convegno Nazionale di Studio, Verona, December 14–16, 1995.

Fiorio, M. T., ed. *Museo d'Arte Antica del Castello Sforzesco: Pinacoteca*. Vol. I. Milan, 1997.

Franzoni, L. "Presenza dell'antico e sue diverse valenze nel tempo nella cultura e nella letteratura urbane veronesi (XIV–XV)." In *Lo spazio nelle città venete (1348–1509): Urbanistica*

e architettura, monumenti e piazze, decorazione e rappresentazione, edited by G. Guidoni and U. Soragni, pp. 33–42. Rome, 1997. Proceedings of the Convegno Nazionale di Studio, Verona, December 14–16, 1995.

Humfrey, P., C. Pirovano, and M. Lucco. *Lorenzo Lotto: Gli affreschi di Trescore*. Bergamo, 1997.

Leone de Castris, P. "Napoli capitale mediterranea: La pittura al tempo di Ferrante e Alfonso d'Aragona." In *Quattrocento aragonese: La pittura a Napoli al tempo di Alfonso e Ferrante d'Aragona*, edited by P. Leone de Castris, pp. 13–44. Naples, 1997. Catalog for exhibition at the Museo Civico di Castelnuovo, Naples, September 18–November 18, 1997.

Zanchi, M. *Lorenzo Lotto e l'immaginario alchemico: Le "imprese" nelle tarsie del coro della basilica di Santa Maria Maggiore in Bergamo*. Clusone, Italy, 1997.

1998

Baldissin Molli, G. "Fra Giovanni da Verona e l'arredo della sacrestia 'più bella . . . che fusse in tutta Italia.'" *Arte Cristiana* 86, no. 788 (1998): 353–66.

Calore, A. "Il coro e il presbiterio della basilica del Santo: Vicende storiche e artistiche nel sec. XV." *Il Santo* 38 (1998): 69–98.

Daniele, U. "Rappresentazione architettonica e simbolismo nelle tarsie marciane." In *Tarsie lignee della basilica di San Marco*, pp. 11–49. Milan, 1998.

Frommel, S. *Sebastiano Serlio architetto*. Milan, 1998.

Humfrey, P. "Gli affreschi." In *Lorenzo Lotto: Il genio inquieto del Rinascimento*, edited by D. A. Brown, P. Humfrey, and M. Lucco, pp. 53–57. Milan, 1998. Exhibition catalog.

Lorenzo Lotto: Il genio inquieto del Rinascimento. Edited by D. A. Brown, P. Humfrey, and M. Lucco. Milan, 1998. Exhibition catalog.

Lucco, M. "San Domenico risuscita Napoleone Orsini, nipote del cardinale di Fossanova"; "Cristo deposto nel sepolcro"; and "Lapidazione di santo Domenico." In *Lorenzo Lotto: Il genio inquieto del Rinascimento*, edited by D. A. Brown, P. Humfrey, and M. Lucco, pp. 108–12, catt. 12, 13, 14. Milan, 1998. Exhibition catalog.

Martin, E. "Un cantiere europeo: Giusto di Gand, Pedro Berruguete; I 'ritratti di uomini illustri' dello Studiolo di Urbino." *Kermes* 11, no. 33 (1998): 60–62.

Pepe, E. "Le tre cappelle rinascimentali in Santa Maria di Monteoliveto a Napoli." *Napoli nobilissima*, ser. 4, no. 37 (1998): 97–116.

Zaupa, G. *Architettura del primo Rinascimento a Vicenza nel laboratorio veneto*. Vicenza, 1998.

1999

Il Rinascimento a Venezia e la pittura del Nord ai tempi di Bellini, Dürer e Tiziano. Edited by B. Aikema and B. L. Brown. Milan, 1999. Exhibition catalog.

Mihályi, M. "Appunti sul tema iconografico della *cavea cum ave incluso*." In *Arte d'Occidente: Temi e metodi; Studi in onore di Angiola Maria Romanini*, vol. 2, edited by A. Caldei, M. Rigetti Tosi Croce, A. Segagli Malacart, and A. Tomei, pp. 891–900. Rome, 1999.

Raggio, O. *The Gubbio Studiolo and Its Conservation*. New York, 1999.

Sensini, C. "Fra Giovanni da Verona maestro d'intaglio e d'intarsio." *Bullettino senese di storia patria* 106 (1999): 189–270.

2000

Bagatin, P. L. *Preghiere di legno: Tarsie e intagli di Fra Giovanni da Verona*. Florence, 2000.

Bandera, L., and A. Foglia. *Arte lignaria a Cremona: I tesori della Cattedrale*. Azzano San Paolo, Italy, 2000.

Colalucchi, F. "La rovina del palazzo." *Venezia Cinquecento* 10, no. 20 (2000): 73–94.

Cuscito, G. "I martiri aquileiesi." In *Patriarch: Quindici secoli di civiltà fra l'Adriatico e l'Europa Centrale*, edited by S. Tavano and G. Bergamini, pp. 49–50. Milan, 2000. Exhibition catalog.

Gentili, A. "Lotto: Cariani e storie di scoiattoli." *Venezia Cinquecento* 10, no. 20 (2000): 5–38.

Piglione, C. "Centri di produzione in Italia tra Rinascimento e Manierismo." In *Arti minori*, edited by L. Castelfranchi Vegas and C. Piglione, pp. 37–40. Milan, 2000.

2001

Bergamo: L'altra Venezia; Il Rinascimento negli anni di Lorenzo Lotto 1510–1530. Edited by F. Rossi. Milan, 2001. Exhibition catalog.

Facchinetti, S. "Madonna con il Bambino e santi." In *Bergamo: L'altra Venezia; Il Rinascimento negli anni di Lorenzo Lotto 1510–1530*, edited by F. Rossi, pp. 248–49. Milan, 2001. Exhibition catalog.

Haines, M. "I 'maestri di prospettiva.'" In *Nel segno di Masaccio: L'invenzione della prospettiva*, edited by F. Camerota, pp. 98–110. Florence, 2001. Catalog for exhibition at the Galleria degli Uffizi, Florence, October 16, 2001–January 20, 2002.

Kanter, L. B., T. Henry, and G. Testa. *Luca Signorelli*. Milan, 2001.

Manni, G. *I maestri della prospettiva*. Mirandola, Italy, 2001.

Rognini, L. "Giovanni da Verona." In *Dizionario biografico degli italiani*, vol. 57, pp. 260–63. Rome, 2001.

2002

Alce, V. *Il coro intarsiato di San Domenico a Bologna*. Bologna, 2002.

Bagatin, P. L., ed. "Siena." Special issue, *Il Legno nell'Arte* 1, no. 1 (June 2002).

Pirovano, C. *Lotto*. Milan, 2002.

Rognini, L. *La chiesa di Santa Maria in Organo: Guida storico-artistica*. Verona, 2002.

2003

L'Occaso, S. "Le decorazioni da Ludovico II a Isabella d'Este." In *Il Palazzo Ducale di Mantova*, edited by G. Algeri, pp. 137–50. Mantua, 2003.

Zanchi, M. *La Bibbia secondo Lorenzo Lotto: Il coro ligneo della Basilica di Bergamo intarsiato da Capoferri*. Bergamo, 2003.

2003–5

Sensini, C. "Le tarsie di Fra Giovanni da Verona nel coro del Duomo di Siena." *Quaderni dell'Opera* 7–9 (2003–5): 309–45.

2004

Bagatin, P. L. *Le pitture lignee di Lorenzo e Cristoforo da Lendinara*. Treviso, Italy, 2004.

Barbieri, F., and R. Cevese. *Vicenza: Ritratto di una città*. Costabissara, Italy, 2004.

Bugini, E. "Un intarsio di lira, una lira intagliata: Qualche puntualizzazione su fra Giovanni da Verona e Giovanni d'Andrea Veronese." *Verona illustrata* 17 (2004): 43–63.

Frommel, C. L. "Il Palazzo Ducale di Urbino e la nascita della residenza principesca del Rinascimento." In *Francesco di Giorgio alla corte di Federico da Montefeltro*, edited by F. P. Fiore, pt. 1, pp. 167–96. Florence, 2004. Proceedings of the Convegno Internazionale di Studi, Monastery of Santa Chiara, Urbino, October 11–13, 2001.

Jungman, J. A. *Missarum Solemnia: Origini, liturgia, storia e teologia della messa*. 2 vols. Casale, Italy, 1961–63. Facsimile edition, Milan, 2004.

Mallet, M. "Federico da Montefeltro." In *Francesco di Giorgio alla corte di Federico da Montefeltro*, edited by F. P. Fiore, pt. 1, pp. 3–13. Florence, 2004. Proceedings of the Convegno Internazionale di Studi, Monastery of Santa Chiara, Urbino, October 11–13, 2001.

Miglio, M. "Federico da Montefeltro e lo Stato della Chiesa nel Quattrocento." In *Francesco di Giorgio alla corte di Federico da Montefeltro*, edited by F. P. Fiore, pt. 1, pp. 15–26. Florence, 2004. Proceedings of the Convegno Internazionale di Studi, Monastery of Santa Chiara, Urbino, October 11–13, 2001.

Vasari, G. *Le vite de' più eccellenti pittori, scultori e architetti*. [Florence, 1568.] Unabridged. Edited by M. Marini. Rome, 2004.

2005

Bagatin, P. L. *Le tarsie dello Studiolo e del Palazzo Ducale di Urbino / The Inlays of the 'Studiolo' and of the Ducal Palace of Urbino*. Treviso, 2005.

Brown, C. M. *Isabella d'Este in the Ducal Palace in Mantua: An Overview of Her Rooms in the Castello di San Giorgio and the Corte Vecchia*. Rome, 2005.

Felicetti, S. "Frate Giovanni da Verona 'magister lignaminis' in Umbria: Nuove acquisizioni documentarie (1481–1488)." *Il Legno nell'Arte* 1, no. 1 (October 2005): 29–42.

Ferretti, M., and E. Monducci. "Il coro e altri lavori d'intaglio e tarsia per San Prospero (secoli XIV–XVI)." In *San Prospero: La basilica del patrono di Reggio Emilia*, edited by M. Mussini, pp. 134–71. Milan, 2005.

Grassi, G. "L'architettura della basilica cinquecentesca." In *San Prospero: La basilica del patrono di Reggio Emilia*, edited by M. Mussini, pp. 26–49. Milan, 2005.

Monducci, E. "I cori e gli altri legni della basilica: I documenti." In *San Prospero: La basilica del patrono di Reggio Emilia*, edited by M. Mussini, pp. 172–79. Milan, 2005.

Quintavalle, A. C. "Cristoforo da Lendinara: La città neoplatonica e quella storica." In *Basilica cattedrale di Parma: Novecento anni di arte, storia, fede*, pp. 211–63. Parma, 2005.

2006

Arasse, D. "Frédéric dans son cabinet: Le 'studiolo' d'Urbino." In *Le sujet dans le tableau*, pp. 27–55. Paris, 2006.

Camerota, F. *La prospettiva del Rinascimento: Arte, architettura, scienza*. Milan, 2006.

Filetti Mazza, M. "L'Arte del legnaioli: Intagli e tarsie fiorentine." *Minuti menarini* 324 (March 2006): 1–2.

Genovesi, A. "Due imprese di Isabella d'Este da leggersi insieme." In *A casa di Andrea Mantegna: Cultura artistica a Mantova nel Quattrocento*, edited by R. Signorini, pp. 272–81. Cinisello Balsamo, Italy, 2006. Catalog for exhibition at the Casa del Mantegna, Mantua, February 26–June 4, 2006.

Höfler, J. *Il Palazzo Ducale di Urbino sotto i Montefeltro (1376–1508): Nuove ricerche sulla storia dell'edificio e delle sue decorazioni interne.* Urbino, 2006.

Mantegna e le arti a Verona 1450–1500. Edited by S. Marinelli and P. Marini. Venice, 2006. Exhibition catalog.

Porzio, G. "A proposito delle tarsie del coro dei Conversi nella certosa di San Martino a Napoli." *Studi di storia dell'arte* 17 (2006): 37–66.

2007

Rognini, L. *La sacrestia di Santa Maria in Organo: Le vicende storiche e artistiche della "più bella sacrestia che fusse in tutta Italia."* Verona, 2007.

2008

Barbieri, F. Introdution to *"Ekfrasis" e storia: Sul Santuario di Monte Berico ed altri scritti di storia dell'arte,* by A. Dani. Padua, 2008.

Bertelli, P. "Disiecta membra: Itinerario tra le opere sopravvissute delle collezioni camerali." In *Dai Gonzaga*

[...] *ventario del 1714 di* [...] y G. Malacarne, R. [...]aso, and P. Bertelli, [...]ga, Italy, 2008.

[...]rini di Isabella [...]cchia: Ipotesi e [...]olsi l'antico: Uno [...]ova di Andrea [...]lla d'Este, edited [...] D. Gasparotto, [...] 2008. Catalog [...] Appartamento [...] Corte Vecchia, [...]tua, September [...] 2009.

[...]oria: Sul [...]erico ed altri [...]rte. Padua, 2008.

[...] diacronico nelle [...] In *Dai Gonzaga* [...]ario del 1714 di [...] Malacarne, R. [...] and P. Bertelli, [...] Italy, 2008.

[...]l Quadrivium [...]olo del Palazzo [...] Ornatissimo

codice: La biblioteca di Federico di Montefeltro, edited by M. Peruzzi, C. Caldari, and L. Mochi Onori, pp. 119–27. Milan, 2008.

Rognini, L. "Appunti su Vincenzo Dalle Vacche e Francesco Orlandi, intarsiatori, allievi di fra' Giovanni da Verona." *Verona illustrata* 21 (2008): 73–85.

2009

Kirkbride, R. "Perspectives of Memory in the Urbino 'Studiolo': Material and Mental Craft in the Late Quattrocento." In *L'arte della matematica nella prospettiva,* edited by R. Sinisgalli, pp. 199–215, 415–17. Foligno, Italy, 2009.

Lucco, M., ed. *L'armadio intarsiato di Giovanni Maria Platina.* Collezioni del Museo Civico di Cremona. Cinisello Balsamo, Italy, 2009.

Zanchi, M. "Quasi un teatro della memoria: Le tarsie di Lorenzo Lotto in Santa Maria Maggiore a Bergamo." *Art e Dossier* 24, no. 253 (2009): 64–69.

2010

Fatigati, G. "Il coro dei Padri: Avvio alla conoscenza del manufatto, per la sua analisi tecnica e conoscitiva." *Annali* (2010): 361–423.

Restaino, C. "Le tarsie lignee della certosa di Padula: Rapporti tra immagini e testi nei cori dei Padri." *Annali* (2010): 261–360.

2011

Grassi, G. "Note sulla tarsia e l'intaglio a Mantova tra Quattrocento e Cinquecento: I de la Mola." *La Reggia: Giornale della Società per il Palazzo Ducale di Mantova* 20, no. 3 (October 2011): 6–8.

Zanchi, M. *Lotto: I simboli.* Milan, 2011.

PUBLICATION FORTHCOMING

Ferretti M., ed. "Intagli e Tarsie fra Gotico e Rinascimento." Proceedings from conference held at the Scuola Normale Superiore di Pisa, October 30–31, 2009. Publication forthcoming.

ACKNOWLEDGMENTS

Sassi Editore Srl wish to express their gratitude t̶o̶
tions, institutions, and public and private collect̶
kindly allowed them to photograph and reproduce̶
possession. In particular, they would like to tha̶
priest of the church of Santa Maria in Organo in̶
Giuseppe Zaupa, prior of Monte Berico in Vicenza;̶
Avagnina for Santa Corona in Vicenza; Professor Le̶
and the Veneranda Arca del Santo for the Basilica d̶
Museo Diocesano in Padua; Dr. Agnese Vastano f̶
of Federico da Montefeltro in Urbino; Father Edu̶
the Ufficio per i Beni Culturali Ecclesiastici della D̶
for Sant'Anna dei Lombardi in Naples; Stefano I̶
Giuseppe Pezzoni, chairman of the Fondazione Mia̶
of Santa Maria Maggiore in Bergamo; Monsignor ̶
and Dr. Fernando Miele of the Ufficio Diocesano̶
Ecclesiastici della Curia Vescovile di Reggio Emili̶
pero in Reggio Emilia; Dr. Fernanda Capobianco, Dr̶
Superintendent Dr. Lorenza Mochi Onori for the̶
Martino in Naples; Dr. Anna Maria Emanuele and̶
Mario Scalini for the Abbey of Monte Oliveto; Di̶
of Capitolo Fiorentino for the Sacrestia delle Mess̶
of Florence; Dr. Giuseppe Giari of the historical ar̶
library of the Opera di Santa Maria del Fiore in Flo̶
rita Ruocco and Superintendent Dr. Stefano Casci̶
of Isabella d'Este in Mantua; Maria Chiara Bassi̶
Pellegrino of the Ufficio Fondo Edifici di Culto at t̶
Bologna for San Domenico in Bologna; Father Faust̶
the prior of San Domenico in Bologna.

Thanks are also due to the following institutions̶
to publish properties under their superintenden̶
Culturali della Diocesi di Reggio Emilia–Guastalla̶
della Misericordia Maggiore di Bergamo, with aut̶
the Ministero per i Beni e le Attività Culturali; Foto̶
B.S.A.E di Siena & Grosseto; photo library of the̶
Speciale for the P.S.A.E. and for the Polo Musea̶
Naples; Ufficio per i Beni Culturali Ecclesiastici del̶
poli, with authorization from the Ministero per i E̶
Culturali; Soprintendenza per i Beni Storici, Artisti̶
pologici for the regions of Mantua, Brescia, and Cr̶
thorization from the Ministero per i Beni e le At̶
Soprintendenza per i Beni Storici, Artistici ed Et̶
for the regions of Pesaro and Urbino, with author̶
Ministero per i Beni e le Attività Culturali; Fondo̶
Prefettura of Bologna; Capitolo Fiorentino; Vene̶
Santo; Musei Civici di Vicenza.

Further thanks to Professor Loredana Olivato for̶
to write the foreword to this book, Paolo Pizza̶
ous contribution explaining the techniques of wo̶
Giancarlo Grassi for his valuable suggestions.

For the original edition
Editorial director: Luca Sassi
Text editor: Natalie Lanaro

For the English-language edition
Editor: David Fabricant
Copy editor: Amy K. Hughes
Production editor: Audrey Schomer
Production manager: Louise Kurtz
Composition: Kat Ran Press
Jacket design and typographic layout: Misha Beletsky

First published in the United States of America in 2012 by
Abbeville Press, 137 Varick Street, New York, NY 10013

First published in Italy in 2011 by Sassi Editore Srl, viale Roma
122/b, 36015 Schio (VI)

First edition
10 9 8 7 6 5 4 3 2 1

Library of Congress Cataloging-in-Publication Data
Tarsie lignee del Rinascimento in Italia. English.
 Renaissance intarsia : masterpieces of wood inlay / edited by
Luca Trevisan ; photography by Luca Sassi ; translated from the
Italian by Marguerite Shore. — First edition.
 pages cm
 Summary: "The first modern survey of a fascinating yet
underappreciated art form, abundantly illustrated with new color
photography. In this volume, a team of art historians trace the
evolution of Renaissance intarsia through a discussion of twelve
of the most important intarsia cycles"— Provided by publisher.
 ISBN 978-0-7892-1126-2 (hardback)
 1. Marquetry, Renaissance—Italy. 2. Marquetry—Italy—
History—15th century. 3. Marquetry—Italy—History—16th
century. I. Trevisan, Luca, 1979– editor of compilation. II. Sassi,
Luca, illustrator. III. Shore, Marguerite, translator. IV. Title.
 NK9924.I8T3613 2012
 749'.5—dc23
 2012017862

For bulk and premium sales and for text adoption procedures,
write to Customer Service Manager, Abbeville Press, 137 Varick
Street, New York, NY 10013, or call 1-800-ARTBOOK.

Visit Abbeville Press online at www.abbeville.com.

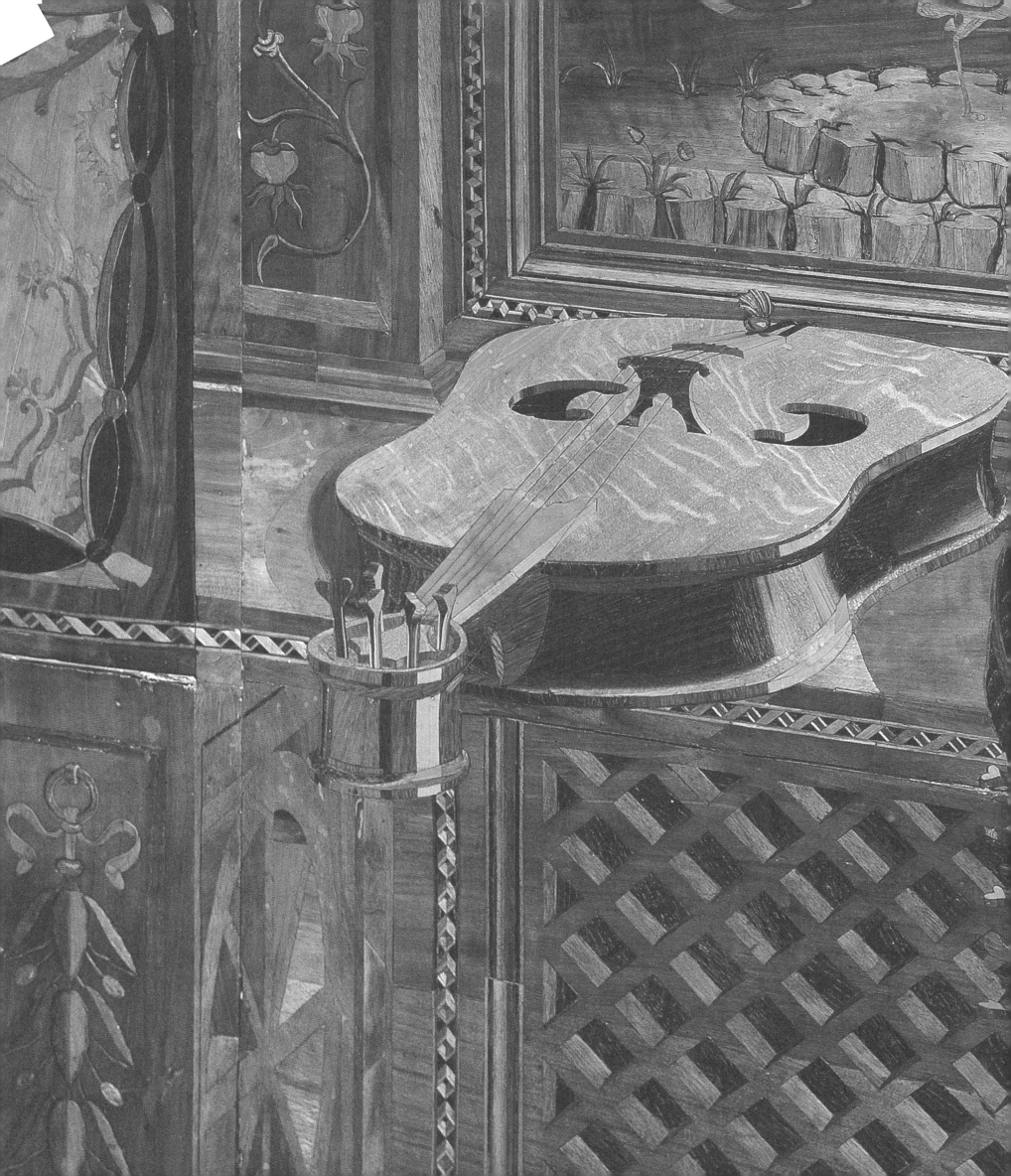